OUR
BEAUTIFUL,
DRY, and
DISTANT
TEXTS

ALSO BY JAMES ELKINS

JAMES ELKINS

OUR BEAUTIFUL, DRY, and DISTANT TEXTS

ART HISTORY AS WRITING

ROUTLEDGE
NEW YORK/LONDON

Published in 2000 by
Routledge
29 West 35th Street
New York, NY 10001

Published in Great Britain by
Routledge
11 New Fetter Lane
London EC4P 4EE

Originally published in 1997 in hardcover by The Pennsylvania State University
Press. This paperback edition published by arrangement.
Copyright © 2000 by James Elkins

Printed in the United States of America on acid-free paper.

10 9 8 7 6 5 4 3 2 1

ISBN 0-415-92663-7

Cataloging-in-Publication Data is available from the Library of Congress.

CONTENTS

LIST OF ILLUSTRATIONS

1. The Neolithic ring fort of Dún Dubhchathair, Inishmore, County Galway, Ireland. Courtesy Bord Fáilte.
2. El Greco, *Feast in the House of Simon,* detail. Art Institute of Chicago.
3. Titian, *Martyrdom of St. Stephen,* detail. Lille.
4. Carlo Crivelli, *Madonna and Child,* 1480–85. Washington, D.C., National Gallery of Art, no. 375.
5. Broken bâton from Le Placard, Charente. 7½". Musée des Antiquités Nationales. From Alexander Marshack, *The Roots of Civilization: The Cognitive Beginnings of Man's First Art, Symbol, and Notation* (New York: McGraw-Hill, 1972), 91, figs. 21 and 22a. © Alexander Marshack. Used by permission.
6. Bâton from Le Placard, detail. From Marshack, *Roots of Civilization,* 92, fig. 23. © Alexander Marshack. Used by permission.
7. Bâton from Le Placard, detail. From Marshack, *Roots of Civilization,* 90, fig. 22b. © Alexander Marshack. Used by permission.
8. Bâton from Le Placard, schematic diagram and correlation with a lunar calendar. From Marshack, *Roots of Civilization,* 93, figs. 24 and 25. © Alexander Marshack. Used by permission.
9. Engraved fragment of a rib from the Grotte du Taï, schematic diagram by Alexander Marshack. From Marshack, "The Taï Plaque and Calendrical Notation in the Upper Paleolithic," *Cambridge Archaeological Journal* 1, no. 1 (1991): 31, fig. 5. © Alexander Marshack. Used by permission.
10. Bâton from Le Placard, schematic diagram of back by Alexander Marshack. From Marshack, *Roots of Civilization,* 94, fig. 26. © Alexander Marshack. Used by permission.
11. Detail of the extreme upper-left corner of the rib fragment from the Grotte du Taï, schematic diagram by Alexander Marshack. From Marshack, "The Taï Plaque," 46, fig. 17, detail. Lowercase lettering added. © Alexander Marshack. Used by permission.
12. Engraved pebble from Barma Grande, Grimaldi, schematic diagrams by Alexander Marshack. From Marshack, *Roots of Civilization,* 83, fig. 16a, b. © Alexander Marshack. Used by permission.
13. Bâton from Mezherich (Ukraine). Mammoth ivory. 19.7 cm. End of the

PREFACE

This is a book about the vexed relations between art historical writing and attempts to account for that writing. I am interested in what it means to move from studying artists and artworks to considering interpretive methods and historiography, and especially in the unanchored moments when I am neither absorbed in the objects nor entirely satisfied by some version of what that encounter might be like. I consider art historical writing as the result of decisions about what counts as history, but also as a kind of expressive fiction—as a novel, or a diary. Art historical writing is strange, and interesting partly because of that strangeness: it is infused with curious qualities, with stifled confessional eloquence, a sometimes fevered desire to capture art objects in words, and an unrequited love for science and its dryness. And since writing involves the writer, my central argument draws close to the old Socratic claim that we should try to see that we do not know what we claim to know about ourselves. Who are we who spend our lives looking at pictures and producing dry monographs in response? When Phaedrus asks if Socrates believes in the fabulous stories of mythology, Socrates changes the subject: "I investigate not these things, but myself, to know whether I am a monster more complicated and more furious than Typhon or a gentler and simpler creature, to whom a privileged and quiet lot is given by nature."[1] This is what I would like to do here. It seems to me that our texts are often monstrous, in that they are woven with an exemplary, even "furious" complexity; and then it also appears that such complexity works to preserve a certain simplicity, a "privileged and quiet lot."

Some of the questions that mark the boundaries of art historical thinking are, naturally enough, native to several disciplines if not to philosophy as a whole. For that reason the first five chapters have to do with topics that are ongoing concerns in various branches of contemporary thought. Later chapters engage issues that may not be less important, but I have made less of an effort to show how they might be modified to be read outside art history. Each chapter is an independent inquiry and can be read in isolation; but the book also moves through the

1. *Phaedrus* 230A, modified from the translation by Harold North Fowler (Cambridge, Mass.: Harvard University Press, 1977), 423, reading "divine" as "privileged."

issues of art historical writing in a continuous argument from the "outside," the philosophic perspective, toward the "inside," regarding what happens in the act of writing, when the writer is immersed in the objects.

The opening chapter, "Dialogue with a Saturnian," is an attempt to say why it can make sense to stop writing or studying visual theory for a while, in order to understand what it means to account for a discipline at all. In theoretically inclined texts written in and around art history, it is common for authors to prescribe certain interpretive regimens—to advocate semiotics, for example, or political explanations, or kinds of psychoanalysis. But at the least it is odd that we can say so readily what theories might be best for a given image or for art history in general. The opening chapter tries to formulate some questions that might be asked of that kind of conviction: How do we position ourselves outside the discipline in order to weigh the theories in the first place? What is involved in speaking for any discipline, in the name of any theory? Essentially I argue that philosophic accounts of disciplines such as art history are compelled to mistake certain figures and moments in the texts for incomplete or inappropriate philosophic theory, and that such an act of misrecognition is a condition for the enterprise of studying and applying theories at all.

A large portion of this book, and most of its arguments, were prompted by what I take to be limitations of contemporary accounts of art history. In particular I find it significant that texts by Donald Preziosi, David Carrier, and others do not come close enough to the concerns of many working art historians to be taken as adequate descriptions of what art historians do. In their very different ways, Preziosi and Carrier keep a certain distance from their versions of the discipline— they shy away from its manner of engaging with details, or from its attempts at weaving those details into narratives of history—so that it could be argued that art history does not possess a broadly acceptable account of what it is about. Most art historians, I would wager, do not find themselves well described by most recent writing about the discipline. That situation is a primary rhetorical concern of this book, since I have tried to write a text that would make sense to a very broad range of writers and researchers: both those who would not normally find time for theoretical accounts of any sort and those who might prefer to avoid close engagements with objects or archives. I mention this here because any such project must entail the use of certain categories that are largely suspect for some readers, but natural and even indispensable for others. If we are to take the project of understanding art history seriously, I think we must also risk employing constructions that cannot consistently appear well founded or useful to the very writers whose work they seek to describe.

So I want to make it clear from the outset that "inside" and "outside," "theory" and "practice," "art history" and "philosophy" are all working notions, formulas that must be negotiated if it is going to be possible to write about the

discipline in a way that can be recognizable and plausible to a wide variety of readers. The "we" that inevitably comes to stand for some consensus within the discipline is an expository necessity, whose meaning can be statistically constrained (as it is in Chapter 1) or made as fluid as the contexts permit. "Theory," or "visual theory," is another instance of a concept so elusive that its very existence might be questioned by some readers. The anthology *The Point of Theory* variously denies, avoids, and defines theory, without reaching any agreement, and likewise in this text, "theory" is sometimes a shifting specter or unprofitable generalization, and other times a specific doctrine, ideology, or text.[2] If anything, "philosophy" is even less stable, since it ends up denoting any self-conscious critical thought—and by so doing, it opposes itself naturally, but entirely illogically, to "practice," which is forced to become uncognized experience.

In every case the purpose of using such terms is to begin to talk. Without the commonplace concepts, no dialogue can begin, and conversely no inquiry can become fundamental without allowing itself radically to question those very concepts. Accordingly, several terms I introduce in the first chapter traverse the project of this book rather than provide models for it, and there are places in this book where each term is questioned at the root level of sense and use.[3] I invite readers to consider the necessity of these negotiations in place of the more self-consistent, perhaps more stable, but ultimately less helpful accounts that begin by doing away with dichotomies such as "theory" and "practice," or holistic generalizations such as "art history."

The second chapter, "The Sameness of Theory," begins the critique of concepts by taking up the question of the origin of an artwork's meaning, its communication from the artwork to an observer, and its reception by the observer. If art history and visual theory can be said to possess a common theory of meaning, it may resemble the formula recently named the "logocentric paradigm," positing that artworks appear as the site of meaning and that viewers position themselves to be the readers of that meaning. Even when it is stated carefully, the paradigm has proved exceptionally difficult to critique. Chapter 2 assesses those problems, and proposes that if the paradigm stands, it may be less because of its intractable nature and more because we do not *want* to unseat it. What we desire, in effect, is to continue writing in a certain way—in a conceptually and rhetorically uniform manner that I call *sameness*. That uniformity is important enough that the ostensive subject of historical research—the grainy, recalcitrant detail of actual artworks—is sometimes excluded from art history in its name.

2. See *The Point of Theory: Practices of Cultural Analysis*, ed. Mieke Bal and Inge E. Boer (New York: Continuum, 1994), especially Jonathan Culler's essay, "Introduction: What's the Point?" 13–17, and the comments by individual authors, 285–91.

3. Part of this formulation is Stephen Melville's; I thank him for a patient and insightful reading of the first chapter.

Chapter 3, "On the Impossibility of Close Reading," continues and concludes this line of thought by examining the supposition that there may be no such thing as a truly close, nuanced, and textured approach to visual artifacts. In the humanities and the sciences it is commonly assumed that close reading is to be desired no matter what the subject matter might be; Chapter 3 takes up Alexander Marshack's interpretations of Neolithic artifacts—arguably some of the most diligent close readings that have ever been made—and shows how the very notion of exhaustive, vigilant, perfect, or unimprovable closeness circles back on its reader and raises questions about reading itself. By way of casting doubt on the entire notion of close reading, I close with several observations about the analytic impossibility of the concept itself.

Chapter 4, "Saying Who We Are," and Chapter 5, "Saying What We Are Doing," are complementary, and they may be taken as two questions that a Socratic interlocutor might put to art history. Chapter 4 is an attempt to argue that one of the most abstract questions of philosophy, the critique of the philosophic subject, is at the heart of some of the most important issues that are currently debated in art history. If questions of social art history, iconography, or style are pushed far enough, they raise the issue of the nature of the thinking subjects that allow such methods to make sense in the first place. Chapter 5 balances Chapter 4 by trying to show that it is insufficient to answer the question of what art historians do by naming any of the usual suspects (art historical theories, methods, and approaches, the politics of the discipline, the gender constructions, and so forth). As art historians, we assume we have possession of all these things, that they are our intellectual or social property. I argue that may not be the case, and that we can only partly explain what we do.

Chapter 6, "Unease and Disease," examines the persistent figure of art history as a marginal, old-fashioned, or parochial discipline, and the sense of unease that idea continues to generate. I would locate the figures of unease, disease, and crisis in the very scene of writing, and especially in its mixture of theoretical reflection (which diagnoses and prescribes) and historical practice (which listens, and sometimes resists). To dismantle the medical metaphor, I argue we would need to attend to the unvoiced reasons why we set up this scenario of patient and doctor, symptom and diagnosis. Often enough physical complaints are only secondary signs of psychological or systematic problems that cannot be discussed. On the other hand, the very fact that we persistently construct the scenario, and ask for the prescriptions of theory, may also be taken as evidence that we wish things to remain as they are.

Chapter 7 initiates a sequence of reflections on the forms of art historical texts. "The History and Theory of Meandering" asks how art history is thought to be structured through time. Is the discipline moving forward, building an account of art's history? Are we going in a nameable direction or in several directions?

These possibilities are traditionally contrasted with their opposites,
which art history is a rambling conversation or a kind of fiction th.
move in any single direction. Both choices entail rather crude repr
of the discipline, in part because they have as their ultimate mode₁ _ough
opposition of logic and fiction. "The History and Theory of Meandering" tries
to find a place for art history between these two, so that it does not collapse
into one or the other. The metaphor of meandering is a way to describe how
art history drifts from topic to topic in an unhurried, directionless, and yet not
entirely uncontrolled manner.

Chapter 8, "The Brancacci Chapel and Spider Webs," continues that inquiry by
considering of the mixture of logic and illogic in art historical writing. It begins
from a model of art history as a conglomeration of argument and unspecified
supporting prose. The former is assigned to the realm of logic, and the latter
becomes a miscellaneous category that ends up including style, rhetoric, and
narrative. The chapter critiques that notion by asking how the logical base is
related to the nonlogical ornament in a particular instance, the five centuries
of writing on the problem of the Brancacci Chapel. With the help of three
metaphors—one of them being the construction and evolution of spider webs—I
argue that what has guided the authors over the past five centuries is not the
logical frame of discovery, attribution, and fact, but the "ornament," which I
identify as the carrier of our informal, intuitive sense of the artists and artworks.
In this view the claims become expressive in their own right, participating in the
project of transforming intuitions into the narratives required by the discipline.

Chapter 9, "The Avaricious Snap of Rhetoric," concerns an aspect of this
issue that was first exposited by Jacques Derrida in the final chapter of *Truth in
Painting:* the notion that the act of putting words where there are none becomes,
in certain literatures, the desire to possess or repossess the artwork in the name of
some historian, some period, or some idea or ideology. Derrida calls this "resti-
tution," denoting a particularly violent form of the inescapable desire to respond
to visual works with words, and in art history it is more commonly known as
attribution, interpretation, or identification. The purpose of Chapter 9 is to see
what those ideas might tell us about the relation between our desire to possess
artworks and the ways we write. Ours is often a snappy, precipitous, avaricious
rhetoric, fraught with epistemological and tonal consequences. Considering art
history this way, as if historians write in order to answer some call for grounding
or attribution that they hear in the works themselves, is among the clearest ways
to see that unthematized desires shape arguments. The chapter closes with a close
reading of one of Michael Fried's texts, to show how it is possible to bend the
demands that pictures seem to make into the form of the writing.

Each chapter is intended to develop a new reason why art historical writing
is more intricate than it is often taken to be, and with each step I take away

a little conscious control from the author. There are theories of inadvertence, partial awareness, and repression in every chapter, beginning in Chapter 1 with the supposition that it may not be possible to speak about art history at all. The sense of the self, the manipulation of theories, the possibility of attending closely to objects, the play of rhetoric, and the use of arguments are each partly beyond our control. Above all, we are only intermittently aware of the expressive voice in art historical writing. These complaints, I think, are systematic, and art history is a structure of uncognized decisions, misconstrued theories, and repressed or unnoticed meanings. The two final chapters offer general models for that condition. Chapter 10, "Writing as Reverie," describes the curious effect that the subject of garden history has had on art historians, provoking in them a kind of sweet half-sleepy state in which ideas follow one another with less than the usual regard for conceptual rigor. This garden reverie is a problem in the historiography of gardens, but also a model for the more general condition of art history itself: when art historians encounter objects, reverie (or absorption or empathy) blurs some of our control over our own thoughts and opens the way to a state that is halfway between control and inadvertence.

The final chapter, "On Half-Consciousness," is a formal attempt to solve the same problem, and also a reflection on the limits of self-reflection as I have tried to practice it in this book. It concerns a ruling metaphor in Erwin Panofsky's book *The Life and Art of Albrecht Dürer,* which imagines Dürer as an artist in the alternating grip of Northern and Southern ways of conceiving art. I read that idea as an example of what I call a *half-conscious structure:* a theory or concept that is partly understood by the historian (and therefore investigated) and partly unconscious (and therefore rehearsed or exemplified in the text). In the example, that structure is doubled, since it is partly Dürer who is afflicted with an inability to think beyond the North/South dichotomy and partly Panofsky who is led along the same path. Both Panofsky's and Dürer's states of mind are undecidably between "theory" and "practice," South and North, and I mean to offer their twinned state as a last, best model of the way that history presents itself.

There are texts that seem to exist for their final pages, and even their last lines. Joyce's *Finnegans Wake* is such a book, and in a more unguarded way so is his short story "The Dead." In both there is a great variety of effects in the body of the text, but when a reader has finished, it becomes clear that there is a fundamental disparity between the many pages of writing and the final few lines. Even in a work as rich as *Finnegans Wake,* the six hundred pages leading to the last half page can seem to be a great lumbering machinery, a kind of outlandish support for the tiny flourish at the close. In literary criticism those perorations would be called lyric moments, and Joyce called them epiphanies. I do not particularly like either term in this context, since I am struck mostly by the odd *effect* produced

by thinking back on those many pages—with their kaleidoscope of styles, their dialogues and descriptions and felicitous phrases—and weighing them all against the last hundred words. What could cause such a strange imbalance? Sometimes an idea just cannot be given voice, and often enough thoughts that might move quickly are weighted and dragged by the necessities of scholarship.

These are thoughts that cross my mind on rereading this text, and writing this preface. I mention them because the subject of this book is writing, in the ordinary (and ordinarily ill-defined) sense. For any number of reasons I would not write this book again in the style that I had to write it the first time around; but I hope I will never feel like retracting the final page.

I am alternately engrossed by my chosen profession and surprised at the way we take theories to be sufficient explanations of what we do. It seems to me that the major modes of interaction with visual images—psychoanalysis, semiotics, gender studies—are also partly forms of repression preventing us from coming to terms with what we are, what kind of writing we are producing, and how we are spending our lives. In this arena light reverie, meandering, the gentle deliquescence of ideas, and the allure of half-conscious structures are faithful supports for our chosen condition: they are ineluctable, since they cannot be solved, and they are immobile, in that they cannot be fully apprehended. They show just enough of themselves to ensure that art history remains the absorbing object of interest. Just outside them is our nascent awareness of who we are.

PREFACE TO THE ROUTLEDGE EDITION

The book you're holding is a strange introduction to art history. Strange because it fails to round up the usual suspects like social art history, psychoanalysis, feminism, deconstruction, or postcolonial theory. Strange, too, because it omits some of the leading work in the discipline. It may need more of an introduction than I first gave it, so I am adding a few words here of encouragement and apology.

The three basic arguments of the book can be put succinctly. First, I am dissatisfied with the usual way of learning the discipline, in which students study parts of some theory (say Lacanian psychoanalysis) whenever it seems helpful for interpreting the art that interests them. That practice leads to monographs that read like tours of different theories: a little linguistics from Jakobson, then some semiotics from Saussure or Barthes, an anthropological account of liminality or hybridity, and perhaps some reference to performative speech-acts. I am exaggerating a little, but not much: it has become normal in art history to move from one interpretive model to another, in a deterritorial fashion. Various names drift in and out of the writing, giving historians licenses to proceed in various directions: Benjamin, Warburg, Riegl, Foucault, Deleuze, Bhabha. In a sense, that state of affairs is unobjectionable—after all, it serves the practical goal of finding the best words to describe the art. Several of the most interesting books of the last decade—I am thinking of writing by historians as different as Wu Hung, Louis Marin, and Rosalind Krauss—move easily between various theories, finding and adapting them in quick succession. Behind this successful practice is a very simple assumption, which I think should be deeply troubling: that it is possible to tell which theories are appropriate, and to know how and when they should be applied. I doubt that the motives or methods of interpretation are as well controlled as is often thought. That is the reason I avoid exposing individual theories in this book. The idea is to stop applying theories, or even studying them, and look at the whole discipline more abstractly. I want to ask: What tells me that I have found an optimal way to interpret a work? Do I know why I am

attracted to this theory, or that one? It strikes me that art historians are confident about these questions, and one purpose of this book is to reflect on that confidence until it disappears.

The second theme enlarges the first: I want to argue that much of art history (and not just the manipulation of theories) is not entirely conscious. Most of this book is a meditation on the ways art historians meander among the works, only half in control of the discipline that leads them. Thinking about art and history, I think, is like daydreaming: we drift in and out of awareness of what we're doing. Sometimes it may be clear what impels me to write a certain passage; other days, I have very little idea why a certain theory rings true, or a certain phrase sounds right. This book is a compendium of reasons why art historians are not in full control, and in that respect it runs strongly against the grain of contemporary theorizing, which remains rational and confident in the face of any number of post-structuralist accounts of the breakdown of intentionality and perfect rationality. Some readers of the first printing of this book thought it was unnecessarily pessimistic and anti-logical. For me, those aren't bad things: I am half asleep when I look at art, and when I try to write about history. That's the maziness of it, the lovely hopelessness of ever understanding my reactions to art outside of art history.

The third and last theme is the most important, and it is the reason I am happy to see this book reprinted, even with all its unresolved conundra and odd backwaters. In the end, art history is a kind of writing. It has its blindnesses and its moments of control just like any other writing, and it expresses the lives and the thoughts of its writers just as much as any fiction. Normally art historians don't think about the writing as writing, because it seems more important to convey the facts of the past that are being recovered and displayed for the present. Yet there is no way around it: what we write, as art historians—as academics of any sort—expresses who we are. By not thinking too much about the expressive dimension of our writing, we end up writing poorly. From a writer's point of view, the writing in a typical art history journal might well seem beautiful, but it probably also sounds dry and emotionally distant. In other words—to put it as directly as I can—to an outsider art history will often seem like bad writing, concocted by someone uninterested in the writer's self, and unaware of the writer's voice. Some contemporary art historians are at work on this problem, but the recent interest in first-person writing has only made matters worse because it has injected an unmodulated confessional voice into a setting where it just doesn't fit. Good writing, as the rarity of good writers attests, is harder than that. Does this matter?

Well, it doesn't if the only purpose of writing art history is to learn about the past. But if you ask yourself what you are actually producing, what you are spending your life making, then it starts to matter more than anything else. I've said this as strongly as I can in the last page of this book, and I still think that page is worth the price of admission. The rest is a thicket of problems that can have no clear solutions: if they were clear, they wouldn't be art history.

J. E.
June 1999

ACKNOWLEDGMENTS

These meditations date back to my first curiosity about my profession, when I was a graduate student, so it is hard to count the people who have influenced them. I can only name some of them, and I cannot do justice to any; at the very least, there are echoes of opinions and some major critiques by Earl Rosenthal, Barbara Stafford, Joel Snyder, Stephen Melville, Ermanno Bencivenga, David Carrier, Mark Roskill, Tom Mitchell, Joan Hart, John Dixon Hunt, Bill MacGregor, and Patricia Reilly. It never makes much sense to acknowledge only people the author happens to know, because a book is born from thoughts that are strong enough to occupy the mind for months or years at a time. Among the people who I do not know personally, but who have a generative share in these ideas, the most important are Donald Davidson and Paul Ricoeur.

Previous versions of Chapters 2, 3, 6, 10, and 11 have appeared in *Histoire de l'Art, Kritische Berichte, Qui Parle, The Journal of Garden History, Current Anthropology,* and *SubStance.*

1 Dialogue with a Saturnian

In the life of any discipline, there are the moments when the machinery seems to be invisible, and nothing can be seen but the task at hand: writers are hard at work, thinking about their objects, absorbed in their novels or sonatas or altarpieces, bent like monks over their copywork, oblivious—or so it seems—of their surroundings. Interpretation may come hard, but its rules are automatic, natural, almost uncognized. Between the eye and its object there is nothing.

And then there are other moments when the work stops, or becomes suddenly difficult, and something seems wrong: a distance has opened between the object and its admirer, between the text and its reader, and the writer starts to reflect about the discipline, about its possibilities and limitations. It is then that thoughts turn to work habits, prejudices and predilections, assumptions, methods and methodologies, ideas and ideologies, institutional conventions and constraints, species of discourse, interpretive strategies, rhetorical frames, historical and historiographical precedents. The discipline itself, once a transparent excuse to work, becomes an object of inquiry.

This is a familiar story—not only because it happens continually in the course of writing (historical writing might even be defined as the vacillating consciousness of this distance), but also because it is the melancholy progression from childish wonder to circumspect familiarity that is part of the story of every encounter with the world. It is the meliorist progression of self-consciousness first described by Hegel: the story of the pure naïve consciousness, amazed at the mere existence of an object, becoming sullied and then refined by reflection. And there are other ways of telling this story: in the briefest terms, it could be the negotiation of the unsymbolized excess that Jacques Lacan calls the *objet petit a* or the inevitable surplus of meaning that Jacques Derrida calls the *supplément*. It might also be read as an institutional story, as the emergence of disciplinary criticism in any practice. If I were to search for a historical origin of the custom of interrogating modern academic disciplines, I might find it in Kant. The sense that it is sometimes necessary to ask about the foundations or the coherence of a

discipline derives from the Kantian *Kritik,* with its demand for "cleared ground" and its desire to comprehend the "conditions of the possibility" of an object of cognition. For reasons that will become apparent, I do not want to ally this narrative of emerging self-awareness with any particular history or theory, and I especially want to avoid saying that it is best understood as a philosophic problem of any sort. To begin, I would rather consider it as a story that is told in many different ways, one that happens whenever it is possible to begin an account by talking, as I have, about a subjectivity and how it might represent itself.

Like any story, this one seems in need of resolution: it sounds like the first two acts of a three-act play. Though there was probably never a practice that did not already have its moments of self-awareness and self-doubt (since the act of identifying an activity *as* a practice entails those possibilities), there are certainly those who feel self-consciousness as an unwanted, even a debilitating, pressure. In art history one talks about the objects, and also about the activity of talking about the objects, and it is never clear what the relation between those two kinds of talking should be. The discipline becomes an object of attention, competing with the original object—even when it is not apparent how or why the one should compete with the other. Some writing about objects has to be displaced to make room for some writing about writing—again, without a sense of how that might be managed.

This unhappy consciousness, this state of mingled naïveté and reflection, this sense of conflict without the possibility of conflict, marks several contemporary academic disciplines. Some are tormented and entranced by the interplay, and they would not be recognizable without it. In art history the moments of absorption are especially crucial and unusually powerful because they involve nonverbal, bodily encounters with visual objects. What is it to linger between intimate encounter and abstract philosophical argument? In a sense, it is nothing more or less than being an art historian: art history *is* this irresolution, since it does not—I would like to say, cannot—resolve its native attraction to images and its imported attraction to accounts of itself. Our physical distances from artworks are metaphors for our mental distances: we walk toward objects, glance over our shoulders, turn around, step back to some proper vantage (some theoretical vantage, where we can see our discipline clearly), and then we turn again, and walk back to the objects. . . . This is not a question that has a resolution; there is no impending fusion of theoretical reflection and intuitive attraction, no *Aufhebung.* Instead, what I am describing is an endemic condition, and so the object of our attention should be its rules and its possibilities rather than some solution that may seem to be provided by either side.

And this brings me to the entry point for this book, since I would like to start by asking what it means to write about any discipline, from the point of view of any theory. The most interesting question here is not what the theory is to be, or

even what practice is being observed, but the nature of the drama itself: the idea of practicing a discipline in part by talking about it. Those who observe disciplines—and those who feel themselves being observed—tend to take for granted that it is possible to write about a discipline. No matter how difficult it may seem to integrate a theory's abstract observations with what goes on in a discipline, it is generally beyond question that method or theory is a place—a point of view—that can be occupied, and that a practice or discipline is a place that can be observed. This is true regardless of the way a given writer might wish to construe the relation between theory and practice (even if that relation is denied and the two are imagined to be inextricable): at some moment thinking about a discipline will entail the metaphor of moving outside some practice, arriving at some theory, looking back, and describing what is visible. Examples abound in every text that recommends, proposes, advocates, "opens," or otherwise identifies with some theory, approach, method, ideology, interpretive strategy, agenda, perspective, or purpose for any existing practice. From this most general vantage, there is effectively no difference between theories: advocating political interpretation is equivalent to supporting semiotics.

Thinking of things this way, it is worth recalling that this is the fundamental motion of any act of reflection. To comprehend self-consciousness, Hegel makes use of a position "outside" or "beyond" the emerging consciousness. To see the iconography in art history, Erwin Panofsky moves "outside" his usual writing, so that he can consider the discipline, its iconography, and other hermeneutic possibilities all in a single glance. To recommend semiotics, Norman Bryson speaks temporarily from the perspective of linguistics. Reflective thought needs these three indispensable components: the seeing subject, the seen object, and the space between them. (And it needs other concepts as well, which I would like to keep in the background for the time being: the metaphor of sight and the troubled identities of sight and thought, reflection and thought, and position and thought.) Here the reflecting subject is the historian considering the discipline; the visible object is the discipline of which the historian was once a part (and to which he or she will return, after reflecting); and the "space between," what Heidegger called the *Zwischen,* is the distance that has mysteriously opened between the two. These minimal requirements are what allow us to stage explanations and accounts of disciplines and disciplinary practices in terms of any theory.

Yet everything in this scenario, I think, is suspect. What is a discipline, that it can be spoken about? Who are "we" who step "outside"? By what motion do we exit a discipline, or put distance between itself and us? How do we know when we are sufficiently "beyond" the discipline, rather than "beside it" (recalling Stephen Melville's *Philosophy Beside Itself*) or lingering in its "margins" (as in Derrida's *Margins of Philosophy*)? And what kind of distance is this? How is it

measured—is it a matter of inches, or concepts, or tropological differences? How do we move through this distance? When we turn back toward the discipline, how do we know when we are facing it? And then how do we address it? In what language? And how do we return? Can we return? And what is there, after the acts of observation and intervention, to return to?

I do not think it is possible to overestimate our confusion about these issues. They have to do with the most basic questions of identity, reflection, and language, and what is written about disciplines such as art history tends to take all those philosophic constructions for granted in order to get on with local revaluations of some methodology or with diagnoses of some "crisis" in the discipline. Art historians write about semiotics, hermeneutics, literary theory, structuralism and poststructuralism, narratology, style analysis, formal analysis, political and social interpretation, institutional studies, feminism, reception theory, deconstruction, social and psychoanalytic art history, each of them divisible into several different schools (from now on, I will often call these our "theories" for short, deferring the question of a more precise formulation), generally without also speaking about what it means to address these methods to a set of practices and norms that are said not to possess them, or to possess them in an incomplete fashion, or to have some wrong version of them—or to practices that are said to want to possess them, to need to possess them, or to be possessive of them. Before making a methodological diagnosis, before seeing whether our disciplinary meditations have any use, before questioning whether we want to use terms like "theory" and "practice," before deciding how to integrate methodological inquiries into conventional narratives, before taking up the problem of the direction of the discipline—before any of these common questions, I would suggest that we need to think about the conditions under which it is possible to speak about a discipline such as art history at all. First, as both Hegel and Freud would remind us, come the questions of who we are, and who we are speaking to, and how we have become separated from what we are addressing. These first chapters are devoted to those questions, in the hope of stalling the more "pressing" issues about optimal interpretive strategies until they can begin to make more sense.

Speaking to, Speaking for, Speaking In

The most common, and I think least satisfactory, form of disciplinary critique consists of an exposition of the state of a discipline, followed by a complementary review of the state of a theory, leading to an examination of places where the two might fruitfully intersect. In this transaction it is not the names that matter

(the theory might appear as method, tradition, strategy, or precedent, and the discipline might be an oeuvre, a single text, a passage, or even a hypothetical interpretation), but rather the economics: the discipline is whatever lacks, and the theory is whatever supplies the lack. This approach, which I call the *three-step critique*, can take place whenever a reader seeks to adjust the interpretive strategy of an art historical text. There are as many forms of this critique as there are theoretical positions to be occupied and applied to the discipline; in the history of art positivism has corrected connoisseurship, iconology has corrected style analysis, and semiotics has corrected social art history. It is not necessary that a nameable theory be involved: a writer might note that a survey text contains some imbalance; in that case, what is lacking is a certain list of names and works that might not belong to any specifiable theoretical agenda.

Within the general model of the three-step critique I would locate a crucial moment between the second and third stages of the transaction, when it comes time to explore the ways that the new theory might make up the lack in the discipline. In order for that moment to find its place in the economy of the interpretation and not delay or jeopardize the entire procedure, the argument must operate under the assumption that the corrective may be applied to the existing practice. The discipline must appear as something that can admit the new theory, and the theory, at least temporarily, needs to appear as something that can be moved into the practice. In art history disciplinary critiques tend to elide this question and continue as if there were no immediate or relevant difficulty in applying theory to practice except the expected institutional and conceptual resistance. At times, the third step is omitted altogether. In texts by David Carrier, the application of theories to art historical texts is entirely beyond the interpretive horizon, and he contents himself with step one (here is art history) and step two (here are some new ideas).

We might call this general motion *speaking to*, since it is a way of addressing a discipline directly, in a voice that originates somewhere outside the discipline. Although it sometimes makes sense to call that voice a theory, in the most general sense it belongs to the world of rational analysis, correction, adjudication, and assessment: in the end, it belongs to philosophy. In the terms I use in these first chapters, philosophy speaks, and the discipline is spoken to. Yet when a discipline is addressed, there is also a sense that it does not, or cannot, represent itself, and for that reason speaking to is also *speaking for*. Theory speaks for art history when art history's texts and objects appear as if from a great distance or when they are reviewed so quickly that they cannot find effective voice in the critical text. In this way even a conscientious approach can become condescending or polemic as the discipline in question begins to appear as an object that is outmaneuvered, helpless, defective, mute.

When an author acknowledges these problems in whole or part, the gulf between steps two and three of the three-step critique (that is, between the

identification of a diagnostic theory and its application to the discipline) can begin to look daunting, and it may become difficult to continue to speak to or for the discipline. In this way the act of description will itself appear as a problem. The distance, the speaking voice, and the occasionally mute object will reveal themselves as players in a drama, one that needs to be considered in its own right. For the purposes of argument let me call the principal alternative to these problems *speaking in,* denoting the attempt to remain at times inside some art history and some philosophy, while retaining the right to speak to or for them when it seems possible. The oddness of this phrase, speaking in, hints that there will not be an easy way to negotiate this kind of speech. Speaking to and speaking for are universal modes. Professors speak to students, though generally not for them. Doctors speak to their patients, and when the patients are gravely ill, doctors have to speak for them as well. Lawyers routinely speak both to and for their clients. Speaking in, on the other hand, pertains first and foremost to inner dialogue. I *speak in* myself when I counsel myself or debate with myself, and any train of thought that I consciously perceive as such divides me into a speaker and an auditor. There is no easy way to change speaking to or speaking for to speaking in, even when it presents itself as the best option.

How to Speak In

Let me try to get at this difficulty by considering the opening of an essay by Stephen Melville called "The Temptation of New Perspectives."[1] I take it that one meaning of the title is that new theories have tempted both theorists and art historians into believing that they would afford "new perspectives," but that in order to achieve those new perspectives, one also has to believe that it is sufficient to "speak to" the discipline about theory. Even though Melville's essay is "very much a work in progress," it is also an exemplary setting of the principal issues that I think are at work in contemporary thinking about art history. He presents the text in part as "a sort of story about an interest literary theory might take or discover in art history," and by putting it that way he conjures the world of fiction, perhaps letting us imagine "literary theory" (here standing in for what I have been calling, in a more general sense, theory or philosophy) and "art history" (significantly uncharacterized here at the beginning) as "characters" that might be finding new ways of getting along with one another. This is a specific way of being wary of "the temptation of new perspectives," and it is

1. Stephen Melville, "The Temptation of New Perspectives," *October* 52 (spring 1990): 3–15.

made explicit in the next sentence: "It is, I think, important here that this is not a story about the portability of theory or method but more a story about the way in which what is sometimes called theory reshapes or rediscovers itself within its new occasions." At the risk of reading too slowly, I would like to ask about the two words "reshapes" and "rediscovers," which would take the place of the automatic or unmediated "portability" of theory. The sentence suggests that theory is not conceived here as something that can be applied, or used, or taken from one discipline to another, and that when it is imagined that way, the result is a different kind of "story"—presumably a story that involves an impoverished or careless model of the relation between what would then still need to be called theory and practice. The words "reshapes" and "rediscovers" name alternate relations or stories, and they imply two fates for theory: either it may be changed, perhaps into something quite different, or it may be shifted, while remaining similar enough so that it can "rediscover" itself. Though these alternates may slip toward one another, they might also be quite different. A reshaping can be cosmetic, or it can be a full-fledged metamorphosis—an irreparable ontological shift, a change beyond the limits of recognition. Theory might become something else that would no longer properly be called theory. Likewise a rediscovery may be trivial (as when we lose a sock and then find it again), or it may be profound (as when we recognize someone we have not seen for decades). I name these possibilities in order to edge the reading toward accounts I will be developing of terms such as metamorphosis and translation, and also to suggest that they emphasize the problematic nature of "speaking in" in ways that Melville does not want to explore at this point.

His wariness about what I am calling "speaking to" comes forward again when he says that one of the common reasons literary theory has "entered art talk" is that it is thought that literary theory can be brought "to bear upon the consideration of visual objects." That enterprise, which he connects with the name of Norman Bryson, is rendered suspect simply by the construction "to bear upon," with its connotations of more or less unproblematic use.[2] In another passage Melville asks if Derrida's *Truth in Painting* "is of any conceivable interest to art history." "Interest," I think, is not the expected word here: one would normally see "use," as in a College Art Association panel chaired by Bryson and entitled "What Use is Deconstruction, Anyway?" In the first passage Melville might have said "used" instead of "brought to bear upon," but he could not in the second, because that is what was in question; but if it is mistaken to think of art history as something that "uses" theory, it is not yet apparent what "interest"

2. Ibid., 5.

is. The word bears echoes of the impossibility of Kant's "purposiveness without purpose," and the "interest" one takes in aesthetic objects.

Part of the reason Melville decides in favor of "reshapes" and "rediscovers" and against "metamorphoses," "translates," or any number of other words may be that he wants to evoke the way that meaning is inevitably preserved and altered in any encounter; and it also seems that other words would be a little too specific for the first paragraphs of an informal account of the field. Yet his careful choices may also be markers of a limitation imposed by his choice of "stories." His words are both gentle and generous: which is to say they wish to name the more negotiable aspects of what might happen when theory meets art history, rather than the disruptive possibilities that he also means to imply. That tendency may be confirmed by the final word in the sentence I quoted above—that theory "reshapes or rediscovers itself within its new occasions." We can perhaps get a sense of why Melville chose "occasions" by thinking of the alternates: "occurrences" or "sites" or "settings" would favor the idea that theory fundamentally "rediscovers" itself, moving from place to place, rather than "reshaping" itself. "Occasions" is a more careful word, and to the extent that it belongs to the world of diplomacy, it is negotiable: that is, it is both something that happens when theory meets art history and something that may be described within the same narrative that "negotiates" "stories" of "art history" and "theory."

If we were to continue this reading, it would be interesting to describe how the essay positions itself in relation to art history and literary theory in order to be able to talk in these terms. And there is a fundamental difference in orientation lurking here, since "The Temptation of New Perspectives" is also about avoiding the temptation of perspectives themselves, and underscoring how "theory" and "practice" only encounter one another meaningfully in individual texts. In this book I often risk other uses of those words by speaking from the "outside" about encounters in general. At the moment, however, I just want to stress how opaque the possibilities of "speaking in" remain. It is clear that "speaking to" is problematic and that theory is not going to be imagined in Melville's essay as a "portable" object, but I would note how difficult it is to say exactly what "reshaping" and "rediscovering" might become or what "interest" entails. An answer that is available within the text itself is that they may behave like narrative forms or characters and weave themselves around the various appearances of theory. But they are also uncontrollable, because they cannot be prevented from becoming unmanageably radical (so that the word "theory" would be forced to disappear from the text) or specific (so that the "story" would have to be suspended in favor of some ill-fitted example). "Reshape" and "rediscover" acknowledge that disruptive power without explaining why it needs to be acknowledged but does not need to be pursued.

METATHEORESIS

At this point it may look as if there are limited choices open to those who wish to say something about art history as a discipline: either we position ourselves near some theory and speak to or for art history in the hope of saying something "useful"—and thereby play the role of master discourse, with all the cruel and careless possibilities that can accompany the brute application of theories—or else we set out into the untracked realm that I have only marked by saying that it involves the ambition to "speak in" art history and theory. Metamorphosis and translation might be helpful tropes for speaking in, since they both conjure the idea of a thorough change. Still, metamorphosis is not an optimal choice, since I would like to leave open the possibility that what happens to theory is not limited to formal or structural alteration (a metamorphosis is a reshaping, and hence a rearrangement, a topological shift). Nor is the linguistic metaphor of translation entirely appropriate, because I want to say that practice is partly nonverbal and nonpropositional. "Metempsychosis" might be better, except that we are not yet dealing with matters of spirit. That is my excuse for coining a new term, *metatheoresis:* I want it to denote the possibility that something that could once be recognized as theory may become something else, beyond a simple structural or expressive change, when it is applied to a practice. A theory may change so unexpectedly and so thoroughly in a new setting that it can no longer be rediscovered as an instance of the theory, or even as theory. If such a change is conceivable, then the application of theory to a discipline, or the use of theory by a discipline, may not only entail unhelpfully rough stories of what theory and practice are, it may also involve the destruction of one term or the other, rendering the interaction meaningless as such. That in turn might let us make more sense of speaking in.

Since there is a nearly universal assumption that theories, once applied, remain theories, it may be useful to give an example of what I have in mind. It could be argued that the Lacanian discourse on the gaze has found its way into art history and film theory in ways so outlandishly distorted that it no longer makes sense to refer the new texts back to their originals. Since the art historical texts no longer harbor something that can be usefully recognized as an example of Lacanian concepts, they have become effectively detached: words such as "Lacan" and "gaze" remain, showing the traces of a connection, but the set of concepts that we might want to call the Lacanian theory of the gaze is too disfigured to be of use. In another few generations of texts it is possible the Lacanian words might be too disrupted to be located at all. What would it mean, in that case, to call such a text Lacanian, to identify its sources in the *Seminar,* or to offer to correct it by reapplying Lacan's ideas? The third step of the three-step critique (the application of theories to the discipline) would be jeopardized if the first step (in this case,

the identification of a lack of correct theory in the discipline) and the second step (here, the identification of correct or original versions of the theory) could not be linked.

I would not want to claim that metatheoresis is the result every time a discipline ingests some theory, since it is an everyday occurrence to come across patches of recognizable and even useful theory in art history texts. Certainly theory can be imported in ways that let readers rediscover it in the texts, and it can be exposited carefully enough so that it can retain living connections to its original texts. The proof of this is the art historians who learn their theory by reading art history rather than reading Saussure, Heidegger, or Derrida (and it could be argued that learning relevant theory by remaining within the discipline and reading secondary texts is a preeminent strategy in the humanities). But theory can also seem to be present in a text and yet be something radically other than what it appears. It can be shifted so that it is unreadable or so misshapen that it cannot be reconnected with its original sources in any sensible way.

There is also an opposite movement, which leads toward deeper problems. Theory has to be able to see what it is looking at: a theoretical account needs to be able to make some sense of a discipline in order to know what needs to be said about it. In the normal course of events, a reader finds a theory in the discipline and pronounces it inadequate (that is the first step of the three-step critique). But is that act of recognition free of problems? What can a philosophic account recognize in an art historical text? What is visible may be limited to certain strategies, structures, and terms that are, roughly speaking, indigenous to the discourse of the theory or of philosophy more generally. In philosophy, those recognizable terms may be philosophemes (the common or generative technical terms of the discourse), and the recognizable structures may be species of logical arguments. To say, in abstract terms, that a discourse can only recognize itself in another discourse is not to name a limitation but to identify an elemental characteristic of language and cognition: the condition for any exchange between accounts is the appearance of recognizable common elements. Philosophy has to find something of itself in a discipline in order to see the discipline at all: in order to see it as a discipline, in order to see something in it, in order to see that some theory might be right for it. Speaking in is related to "seeing in" and "reading in," with their connotations of wishful thinking or projection; philosophic discourse has to discern something in the practice that may not exist aside from its need to find it. I use the phrase *demands of philosophy* to characterize this motion, and I want to imply that those demands might interfere with the very project of describing a discipline, whether the purpose is to correct it or merely describe it.

The three-step critique, to summarize, faces problems at each step. If the first step is to identify a lack in some discipline, then it needs to be asked how a given theoretical discourse *reads* a discipline and finds something it can recognize as a

lack. It is possible to end the analysis with the second step, the identification of a theoretical position that might remedy the lack; but most accounts go on and apply the theory to the discipline, raising more problems about the ways that theories exist "in" disciplines, and whether or not the act of applying some new theory might change both the theory and the practice beyond recognition.

NORMAL ART HISTORY

I have spent many happy hours looking up bibliographic matters.
> —Nabokov, "The Nearctic Members of the Genus
> Lycæides Hübner (Lycænidæ, Lepidoptera)"

At this point it is expedient to interrupt the argument and identify a little more precisely what I mean by the "practice," or "discipline," of art history. Each of the possibilities I have entertained so far is scripted, in the sense that I have been telling stories about characters named theory, method, practice, art history, philosophy, literary theory, and so forth. Without the license to find an object and name it art history, theory, or philosophy—a license that some theoretical discourse seeks to rescind altogether—these accounts could not get started. Though I recognize these stories as particular emplotments of the relation between certain practices and theories, it remains necessary to retain the script and the characters in order to proceed with the account I want to make.

At the same time, the characters are not limited to introductory roles, and there is no way to discard the dramaturgy entirely once it becomes clear that words like "theory" and "practice" are interpenetrating. The reason has to do with the self-descriptions of the discipline itself. Art historians continue to work as if something called art history could exist in *anyone's* eyes, and abstractions such as philosophy and theory play analogous roles. They promote certain kinds of dialogue that I would like to understand, and for that reason I do not try too hard to tailor my uses of them to fit any particular theory about the status of theory. "Philosophy" and "theory" are my general terms for whatever texts are brought to bear in any given case on the writing of whatever is called art history, as opposed to those texts that enter as evidence *for* art history (for example, archival documents). On the other hand, I usually employ the term "art history" in these pages to denote that portion of the institutionally defined discipline whose authors are relatively mute about "philosophy" and concerned largely with objects. This is not to deny that this portion of the discipline cannot also be construed as being involved with theory, since it involves nascent or

uncognized methodologies and ideologies. But in this art history, those concerns
are either uncognized or unwritten, or both. As a general rule philosophy does
not appear in these texts, and "theory" denotes books, including this one, that
do anything other than approach the objects according to whatever methods
have become so customary that they have ceased to appear as mediations at
all. Partly for convenience, but also from conviction, I call these texts *normal
art history.*

At times people deny that this art history still exists, and they prefer to see
the discipline as a thriving field, suffused with theoretical explorations. I think
it is important to realize that it does exist and that it is demonstrably the major
mode of art historical production worldwide. Some rudimentary bibliographic
criteria can help frame this "normal" practice. Its subjects are well known; they
include some iconography, social history, style analysis, archaeological reporting,
archival documentation, transcription, annotation and translation, biographical
summaries, chronologies, hypothetical reconstructions, conservation studies, *cat-
alogues raisonnés,* identifications of patrons, histories of subject matter, types,
and symbols, surveys of periods and schools, and connections with literature,
religion, popular culture, and politics. Though there are twilight genres that
approach a condition of heterodoxy, blending visual theory and art history
(for instance, *Rezeptionsgeschichten,* intellectual biographies, analyses of texts,
historiographical studies, the history of art history, and writing with strong
theoretical platforms), still the outlines of the great mass of art historical writing
are clear enough.

Normal art history in this sense can also be distinguished by its journals, which
still constitute the majority of periodicals classified as art historical. The least
heterodox include *Acta Historiæ Artium* (Budapest), the *Annual Report of the
American Academy in Rome, Antike Kunst, Artibus Asiae, Ars Orientalis,* the
Zeitschrift des Kunsthistorisches Institut in Florenz, Hesperia, the *Burlington
Magazine, Master Drawings, Oud Holland, Simiolus, Studies in Iconography,
Antichità Viva, Antologia di Belle Arti, Archivo Español de Arte,* the *Römisches
Jahrbuch für Kunstgeschichte, Dumbarton Oaks Papers, History of European
Ideas, Bollettino d'Arte,* and *Storia dell'Arte,* together with various discontinued
journals such as the *Zeitschrift für Bildende Kunst,* the *Jahrbuch der Preussischen
Kunstsammlungen, Rassegna Antica e Moderna,* and *Repertorium für Kunst-
wissenschaft,* and various museum publications of the Rijksmuseum, the Louvre,
the Freer, the *Bulletin du Músee Hongrois des Beaux-Arts,* the *Getty Museum
Journal,* and so forth. Some prominent journals are less uniform: *Art History,* the
Art Journal, Art News, Artibus et Historiae, the *Zeitschrift für Kunstgeschichte,*
the *Oxford Art Journal, Res,* and the *Art Bulletin* are examples. (More con-
sistently theoretical papers appear in peripheral journals such as *New Literary
History,* the *Journal of the History of Ideas, Critique, Representations, Word &*

Image, Critical Inquiry, October, the *Journal of Aesthetics and Art Criticism, Diacritics, Qui Parle,* and *SubStance.* For the most part, when I refer to normal art history, I am not referring to those journals.)

Unless I am concerned with a specific text or context, this is the art history that will be appearing in these pages as the object of attention of various writers whom I will generally call theorists. Though it is certainly a fictional construct when it is considered en masse, as a single object, it is not at all a fiction that the majority of art historical texts continue to exclude anything but the most perfunctory acknowledgment of their mode of approach to objects. A word about my own work may also not be irrelevant for the accounts that follow: I have tried to write for journals that are as diverse as possible, for *Representations* as well as for the *British Journal of Aesthetics,* for the *Journal of the Warburg and Courtauld Institute* and also *Qui Parle,* for the *Zeitschrift für Kunstgeschichte* and also *M/E/A/N/I/N/G.* Though I have not found any reason to bring those specific experiences into this text, I take it that some such experience is indispensable for speaking about work "inside" and "outside" art history, since the question often turns on what kind of practice still remains possible given specific knowledge of assumptions, theories, and other possibilities. The exercise of writing for a variety of journals can also be salutary for observers of the discipline who speak of writing as a borderless activity and doubt the depth of difference between normal art history and the various "new art histories." The best way to see the weakness of the claim that theory infuses all practice, or that there is no untheoretical art history, is to test the institutional and narrative constraints by writing a feature article for *Acta Historiæ Artium* or the *Römisches Jahrbuch für Kunstgeschichte.* And conversely, the existence of the large body of "normal" art history is attested by the relatively small number who try to write for journals such as *October* or *Critical Inquiry.*

The Demands of Philosophy

Having said this, I want to return to the business of this chapter and continue developing an account of what happens when something that calls itself philosophy or theory encounters something it calls practice or art history. My text here is part of an interview with Jacques Derrida; in the portion I want to read, Derrida, having been driven on by a series of programmatic questions, finds himself providing a mnemonic formula, or a capsule summary, of the utility of the entire project of using philosophy in other disciplines. The interviewer, Richard Kearney, has inquired about the project of deconstruction, claiming that it "prevents us from asserting or stating or identifying anything." Derrida replies

by listing several reasons why philosophy is relevant to nonphilosophic disciplines
(I have numbered parts of his reply):

> Philosophy, as logocentrism, is present in every scientific discipline and the
> only justification for transforming philosophy into a specialized discipline
> is [1] the necessity to render explicit and thematic the philosophic subtext
> in every discourse. The principal function which the teaching of philos-
> ophy serves is [2] to enable people to become "conscious," to become
> aware of what exactly they are saying, what kind of discourse they are
> engaged in when they do mathematics, physics, political economy, and so
> on. [3] There is no system for transmitting knowledge which can retain
> its coherence or integrity without, at one moment or another, interrogat-
> ing itself philosophically, that is, without acknowledging its subtextual
> premises; and this may even include an interrogation of its unspoken
> political interests or traditional values.[3]

There is a certain lack of modulation to this reply that would make it unsuitable
for an extended account of Derrida; it would be easy to show how other things he
has written undermine these rather unguarded pronouncements. But that quality
also makes this an exemplary text for inquiring into common thoughts about the
relation between philosophic critiques and "nonphilosophic subjects" in general.

The three claims, as I have numbered them, are a trinitarian doctrine of
philosophic intervention. The first requires that a "philosophical subtext" "in"
the nonphilosophic discourse be identified and that it be made "explicit and
thematic." In this scene, philosophy searches through a nonphilosophic discourse
and finds something there: but when it locates a passage, a quotation, a chapter, or
a parenthetical remark that presents itself as philosophically significant, then it
reads it as an excerpt from a continuous discourse that has then to be called
a "subtext" and located somewhere "in" the text. The subtext is presented
as existing below the text, or inside it—buried, embedded, or embodied, to
use the customary metaphors, each of which elides the question of position.
It is not entirely lost; but unlike other parts of a text, the subtext cannot be
directly recovered. There is something vague or incomplete about it, so that
the philosopher has to work on it, make it "explicit" and "thematic." This
word "explicit" is itself vague: Does it mean a subtext has no words? Or lacks
propositional form? Or merely needs to be given grammatical assistance? To say
that the subtext needs to become thematic may mean that it needs to find or refind

3. Richard Kearney, *Dialogues with Contemporary Continental Thinkers* (Manchester: Manchester
University Press, 1988), 114–15.

its connection to the stated themes of the text, but if so, how does the philosopher know how to make that reconnection? Can anything be made "thematic," even if it is not a subtext?

I am playing with these ideas to show how the notion of a subtext does not make sense unless it is attached to a specific overlying text. Once we are given a text, we can be shown a subtext, and then we may be easily persuaded that the latter is "in" the former, and that it can be made "explicit" and "thematic." But in the course of a specific reading, we may lose sight of just how strange these demands of philosophy can be. At the least, it is necessary to assume that a subtext is an object even before it is extracted and altered: it must be in the language of philosophy, or once have been in that language, or it must be close enough so that it can be recognized by philosophy, if not as philosophy.

In this account the nonphilosophic discipline takes on an inner structure, and becomes different from part of itself. Philosophic explanations relate the embedded theory in art history, which functions as the unknown object of inquiry (the *ignotus*), to a preexisting philosophy (the known object, *notus*), and explain art history by accounting for the *ignotum per notius*. Though the philosophic critique concentrates on the nature of the subtext, it is unclear what remains after the subtext has been removed. The unreadable supplement and the full text of art history remain in the background as a kind of third term. If the philosophic subtext is *ignotus* and philosophy outside art history is *notus,* then the text itself remains *inexploratus*. The subtext may be something created by a strong misreading (if there is such a process as metatheoresis, then philosophy's "recognition" of itself in the "subtext" might be entirely misguided, misguided in ways that philosophy cannot adjudicate), but at least it is seen: the *inexploratus,* the refuse or invisible supplement, is by definition whatever the philosophic account ignores, discards, or omits.

Derrida's second claim is that philosophy's "principal function" is "to enable people to become 'conscious,' to become aware of what exactly they are saying, what kind of discourse they are engaged in." If, as the account implies, nonphilosophic disciplines are structured by the interplay of unconscious and intentional utterances, then it is not immediately apparent that it would be a good idea to try to bring people to fuller "consciousness." It is possible, for example, that a nonphilosophic discourse might come to depend on a certain economy of intentionality and inadvertence, just as Derrida was depending on a certain balance of measured assertion and ill-considered haste when he made this interview. If so, then such a discourse might be predicated on the repression of its "subtext," and the act of rendering it "explicit and thematic" could do some fundamental violence to the discipline. The object that philosophy perceives as a subtext may need to remain below ground if the discipline itself is to continue

to make sense, either to itself or to the philosophic critique. Each recovery of a subtext would be an exhumation and a revivification—acts of violence in those exact places where the texts may depend upon peaceful oblivion.

These two concepts together illuminate Derrida's third point, that a discipline needs to "retain its coherence or integrity" by philosophic interrogation. The terms "coherence" and "integrity" take their meaning from the internal structure that is implied by the existence of a subtext within a text. The philosophic or prephilosophic subtext is given a supporting role: it creates the possibility of structure, and therefore of coherence and integrity, and it implies the necessity of "retaining" a certain configuration of that structure by means of a philosophic intervention.

Though philosophy can describe a lack of integrity or a state of incoherence, when it does so it necessarily privileges coherence—if only in the negative formulas: "lack of integrity," "resistance," and "incoherence." This is so especially when the coherence that philosophy finds takes the form of a narrative about a certain state of incoherence or disunity. Several texts by Donald Preziosi can be understood as intentionally partly disordered accounts of the conceptual disorder of art history; in *Rethinking Art History*, Preziosi says that art history is a collage of methods, and he offers "sketches" or "probes" by way of descriptions, remarking several times that they are themselves a "bricolage."[4] His text claims for itself a slightly higher degree of coherence than the art history it describes, so that even here, where gaining order is a subtle matter of describing disorder, the articulation of incoherence still privileges coherence over originary incoherence.

Together these three demands are fundamental in philosophic critiques of "nonphilosophic" discourses such as art history. A great deal of what I have to say in this book is aligned against them: often I am not sure it is a good idea to say that there is such a thing as a "philosophical subtext" in art history, that historians need to become "conscious" of what they do, or that the discipline needs to be interrogated in order to retain or obtain or increase "coherence." The art history I describe has no unambiguous subtext, is only inconsistently conscious, and has little to do with the philosopheme of coherence. From a philosophic standpoint it depends, I argue, on these three "failures."

None of this is to say that art history, or even "normal" art history, *should* remain unaware of what philosophy sees as its "subtexts," "unconsciousness," or "incoherence." Nothing I have to say in this book is judicative, and I often tend to find encounters between disciplines more interesting than the relatively smoother progress of writing within any given discipline. (An earlier book, *The Poetics of Perspective*, is centrally concerned with the interdisciplinary nature of

4. Donald Preziosi, *Rethinking Art History: Meditations on a Coy Science* (New Haven: Yale University Press, 1989).

perspective in Western thought.)[5] But I remain intent on two points that weigh against change in the ways it tends to be imagined in recent theoretically inclined texts. First, as I have been arguing here, it is not at all easy to see how change might be effected, controlled, or understood. The demands of philosophy are also demands that may transform aspects of art history into *unpredictably* different practices: not in the ordinary sense that the new theories might lead to unexpected discoveries, but in the more troubling sense that the discipline itself may change unexpectedly into something that would bear no legible traces of the theory. That possibility makes the entire project of applying theories potentially incoherent, since the prescription of a theory would be like the prescription of a random drug. In addition, the internal structure of normal art history is not like that of a pellucid lake, where static concepts and methods may sink into a peaceful and uninteresting oblivion. It is a turmoil of somnambulant ideas, mingling with uninspected customs, odd assertions, and unchallenged dogmas.

Keith Moxey has suggested that I have advocated leaving art history undisturbed, chained to its Hegelian assumptions and uninterrogated by the many methods proposed in recent visual theory.[6] On the contrary: often the most challenging and interesting course is to open closed practices to new opportunities. But in doing so we need to be careful not to lose sight of that fact that we do not have the slightest idea *what* we are opening, or how we are opening it, or what we are creating by the act of opening it. We scarcely understand our own positions, and we have virtually no sense of what might happen to our theories when they are transplanted into the rich and alien soil of "normal" art history. Those portions of this book that may seem overly preoccupied with the meanings and conventions of normal art history are not neoconservative gestures but preliminary work intended to see what it could possibly mean to advocate change.

It is also worth remarking that the demands of philosophy continue to operate even in more carefully articulated situations than Derrida's interview. Although I cannot argue it here, I think they can be found even in the most vigilant cultural theory, such as Homi Bhabha's or Stuart Hall's writings on postcolonial discourse. (Colonial discourses are rife with "subtexts" that need to be made explicit by theoretical intervention.) In one form or another, the "demands" are inevitable wherever something that identifies itself as "theory" encounters a "practice." In a more recent interview, for example, Derrida makes some of the same points in a more reflective way, asserting that each time he has become interested in a nonphilosophic discourse, he has tried to discover what "liberates it from

5. James Elkins, *The Poetics of Perspective* (Ithaca: Cornell University Press, 1994).
6. Keith Moxey, *The Practice of Theory: Poststructuralism, Cultural Politics, and Art History* (Ithaca: Cornell University Press, 1994), xi–xii.

philosophical authority." In that way philosophy itself can begin to reveal how "each field, whether it be what we call psychology, logic, politics, or the arts," contains "the possibility of emancipation from the hegemony and authority of philosophical discourse." By trying to find "whatever in the work represents its force of resistance to philosophic authority," philosophy can counter its own impetus toward sovereignty over all discourses.[7] The formulas in the later interview are much closer to the ones I develop here, but I would still want to ask if the demands of philosophy do not continue to speak even in their search for self-effacement. Philosophy still interrogates nonphilosophic disciplines, even though it is now imagined as an attempt to verify non- or antiphilosophic gestures instead of potentially philosophic ones. The phrase, "whatever in the work represents its force of resistance to philosophic inquiry," still requires there to be something *else* in the work that remains legible and essentially *philosophic,* so that the work or discipline is still structured as text and subtext.

AN INSTANCE OF METATHEORESIS

Having voiced my skepticism that philosophic critiques can locate their "subtexts" in normal art history, I want to provide an example of the kind of trouble I have in mind. In conventional art historical fashion, Erwin Panofsky's 1949 article "Who Is van Eyck's 'Tymotheos'?"—a short, well-researched, but otherwise unremarkable essay—avoids direct references to his "larger" philosophic program of iconology.[8] This is a common move in which writing that would be perceived as overtly theoretical is placed in margins or footnotes.[9] It is a simple strategy for excluding theory, and I would argue it effectively robs philosophic accounts of their easiest access to a legible philosophic subtext. Naturally there are elements of philosophic discourse in the essay, and the essay as a whole can even be plausibly conceived as a rational proposition, if not a philosophic argument in any fuller sense: it presents a thesis (that Jan van Eyck's painting represents the composer Gilles Binchois) and supports it by some identifiable methods (iconography, physiognomic analysis, textual comparisons). Several philosophemes appear to be at work—among them objectivity, adjudication, supposition, falsification, and verification. However, most are not named, few

7. "The Spatial Arts: An Interview with Jacques Derrida," in *Deconstruction and the Visual Arts: Art, Media, Architecture,* ed. Peter Brunette and David Wills (Cambridge: Cambridge University Press, 1994), 10.

8. Erwin Panofsky, "Who Is van Eyck's 'Tymotheos'?" *Journal of the Warburg and Courtauld Institutes* 12 (1949): 80–90.

9. For other examples, see my "Art History Without Theory," *Critical Inquiry* 14 (1988): 356 n. 5.

are thematized, and none is consistently present throughout the text. So although Panofsky's essay has elements that a philosophic critique might want to claim as philosophical, their mode of existence in the text is not immediately clear. There is no place where Panofsky gathers his methods and concepts, and no moment of self-reflection on the relation between those methods and his purposes or conclusions.

The concept of objectivity provides an example of the difficulties that lie in wait for a philosophic critique that is unwilling simply to "read in" a subtext where none is explicitly present. An account of the "Tymotheos" essay that sought to explore its relation to objectivity would require, to begin with, a working version of the philosophic concept of objectivity. Objectivity has been stabilized by specialized inquiries within the philosophy of history, and a reading of the "Tymotheos" essay would have a choice of several sources. William Henry Walsh's *Philosophy of History,* for example, names objectivity as a "notion" and "idea" and "concept" that can have a "strong sense" and can exist in both "scientific" and "historical" versions. Walsh gives his "objectivity" a global definition: a body of propositions, he says, is " 'objective' " (in quotation marks) if the individual propositions "warrant acceptance by all who seriously investigate them."[10]

Assuming, for the purposes of this account, that a philosophic reading might wish to employ this definition, where in "Tymotheos" could it find such a concept? The "Tymotheos" essay neither employs the word "objectivity" nor alludes to philosophers such as Walsh or even Wilhelm Dilthey, who was writing about the concept when Panofsky was a student. Hence, to inquire about objectivity is no longer to ask about the concept, but about something unwritten that would have to be taken to have guided the production of the text. This *ideal of objectivity,* as I call it, is not a concept like objectivity, because it lacks the contexts that might allow us to speak of application or misapplication. If an art historian tells a student, "Try to be as objective as possible," "objectivity" exists as a vague goal, something that the student can hold before him- or herself while writing. Such ideals are not closely scrutinized by most art historians, in part because they are impossible to attain (or, more precisely, meaningless), and their absence from texts might be explained the same way.

There is no limit to the kinds of reading that might locate this ideal of objectivity in the "Tymotheos" essay. Panofsky admired van Eyck's painting as

10. William Henry Walsh, *An Introduction to Philosophy of History* (London: Hutchinson University Library, 1958), 94ff. See also Maurice Mandelbaum, *The Anatomy of Historical Knowledge* (Baltimore: Johns Hopkins University Press, 1977), pt. 3, 145ff. Another possible source that stabilizes a concept of objectivity is Peter Novick, *That Noble Dream: The "Objectivity Question" and the American Historical Profession* (Cambridge: Cambridge University Press, 1988), and see Thomas Haskell, "Objectivity Is Not Neutrality: Rhetoric Versus Practice in Peter Novick's *That Noble Dream,*" *History and Theory* 29, no. 2 (1990): 129ff.

a psychological document, the record of an intellect he could sympathize with (he writes, "It is not an intellectual face but a pensive and lonely one, the face of one who feels and produces rather than observes and dissects"),[11] and from related passages in books such as *Early Netherlandish Painting* a reader can come to understand something of the way he valued such qualities. Panofsky may therefore have had what would have to be called a personal interest in securing the connection with Binchois, a composer he knew and admired. In this way a biographical or psychobiographical reading might be launched in order to claim that "Tymotheos" somehow lacks the ideal of objectivity; but how could such an interpretation be related to philosophic accounts of objectivity?

In art history, the ideal of objectivity is occasionally taken to inhere in certain methodologies, such as archival research or iconography, so that writing that employs those methods, as does "Tymotheos," might be associated more strongly with objectivity than would be a text that eschewed them. Critiques of art history are sometimes content to name methods in order to characterize a given text as (relatively) objective or objectivist in intention. But how can we know how to connect theoretical expositions of methodology, such as Panofsky's writing on iconology, with passages in the texts that we might wish to understand as applications of those methods? Which one shows the ideal of objectivity more strongly? And in which case would the ideal be closer to the concept itself?

The painting by van Eyck bears the French inscription "leal sovvenir" (loyal remembrance), and Panofsky closes his paper by comparing Binchois's *chansons* to the words *leal souvenir,* hoping to find the same words written by Binchois. One *chanson* in particular seems to be a close match:

> We should go too far in speaking of "quotation"; but we may be justified in speaking of "assonance," in language as well as in sentiment:

> > Car par ma foy, quelque part que je soye,
> > Autre de vous amer ne pouroye.
> > Vous estes celle que adès veul servir,
> > Vous estes tout mon joyeux souvenir.[12]

The " 'assonance' in language as well as in sentiment" is a particular judgment of objectivity, not susceptible to generalization outside this context: Panofsky has permitted himself this comparison because it is the poetic envoi of a bagatelle, rather than the formal conclusion of a monograph.

11. Panofsky, "Who Is van Eyck's 'Tymotheos'?" 88.
12. Ibid., 90.

Because contexts matter so much to any careful account of a philosopheme such as objectivity, I would say there are three versions of the concept: the philosopheme itself, which exists in the cultural background to the "Tymotheos" essay; the ideal of objectivity that seems to be tied to particular methods whose traces can be found in "Tymotheos"; and something even more fugitive and subject to mercurial changes—something that evokes the concept differently in each passage. I call this third form *unmeasured objectivity*. Because it depends on style and choice of words, there are as many examples of it as there are passages in the text that can be given independent readings.

Panofsky mentions two alternate readings of the half-effaced inscription

TYM. ΩΘΕΟ·

which can be discerned in the painting. Charles de Tolnay read it as "TYMOTH-EOI," and the German scholar G. Münzel proposed

TYMΩ ΘΕΟΝ

which could be construed as "I honor God." Panofsky's solution is

TYMOΘΕΟⳞ

reading the fragmentary vertical at the end of the inscription as a "square sigma."

Various rules of thumb guide Panofsky's summaries of the earlier opinions in this passage: he considers Byzantine and fifteenth-century Flemish confusions over Σ, Ⳟ, Ι, Υ, Ω, Ο, as well as the unaccountable gap in the middle of the inscription, and criteria of intelligibility. And there is more, because Panofsky orchestrates not only rules for choosing relevant detail and historical context, but rules for acknowledging the work of colleagues. He calls Münzel's suggestion an "ingenious hypothesis" and says that it would be "commendable" if it were true, but that it is "unfortunately untenable" because a fragment of the top stroke of the square sigma is visible after the omicron. All of these contribute to an evanescent, composite, unmeasured sense of the objectivity of his own hypothesis. Unmeasured objectivity in the decipherment of the inscription involves rules for summarizing, complementing, deciding relevance, defining historical context, as well as rules for knitting those rules together. Not only is unmeasured objectivity different from philosophic and ideal objectivity; not only is it local in application and multiple within any text; but it is also so intricate in any given case as to be effectively indescribable.

From such distinctions it is apparent that a concept like objectivity cannot be "found in" or "applied to" the text in the linear fashion that a philosophic account might propose. Indeed, it is difficult to be sure exactly what it means to "find" the "concept" of "objectivity" "in" such a text at all. It would not be enough to acknowledge the difficulty of finding objectivity and then to continue with an analysis of the concept; to do so would be to occlude precisely those features of the text that are at issue. The recurring art historical exclusion of thematized methods and concepts is madness to philosophy—literally so, because the historical texts seem to dissolve the elements of rationality that allow philosophic readings to gain their meaning. There is a dissolution of ideas in the writing, an inexorable ruleless drifting away from anything that philosophy can recognize.

Here I cannot do more than suggest that the elusive trifurcation of the concept of objectivity is common to other philosophemes and art historical methods and to disciplines other than art history. What happens when a discourse adopts a philosophic theory and embodies it in texts is largely unknown. The greater aporia lies just around the corner, since, if we have so little idea of how we read a concept like objectivity in the "Tymotheos" essay, it is also possible that we are mistaking nontheory for theory and misreading traces of theory as text. Metatheoresis is not a supposition that can be demonstrated, as a philosopher might point to an occurrence of the word "objectivity" in another philosopher's essay and show how it was mistakenly applied. Instead, it is like the theory of black holes: many signs indicate the existence of such objects, not least of which is the ease with which it is possible to show that philosophic concepts cannot always be traced in texts that seem to embody them.

Before I leave "Tymotheos" it may be relevant to say a few words about the choice of objectivity as an example. Objectivity may seem a particularly vexed example, since it is central to many accounts of history, science, cultural studies, and literature. In a particularly interesting text, Walter Benn Michaels has taken several writers to task for involving themselves in contradictions about objectivity. Cary Nelson's *Repression and Recovery,* Michaels says, is "contemptuous" of the idea of objectivity and neutral historical knowledge. To Nelson, every piece of information serves some ideology, and every act of persuasion helps to build a canon. He urges himself and his readers to become more "self-critical" and "self-aware," and he tries *not* to be persuasive, so as to avoid urging some new canon. Michaels comments: "[I]t's hard to see how increased self-consciousness is supposed to rescue us from the illusion of objectivity. In fact, the value of self-consciousness seems to depend upon an appeal to objectivity, since the moment when you self-consciously recognize the interested character of all your beliefs can have value only if that recognition is itself disinterested. . . . This could be put more generally by saying that the

commitment to objectivity has, in the work of most literary theorists, survived the critique of objectivity by becoming the critique of objectivity."[13] Michaels's analysis is tied directly to the texts—since they contain the words "objectivity," "ideology," disinterest," "historical knowledge," and "facticity"—so that his reading can remain within what Derrida would call philosophy. Both Nelson's and Michaels's texts can employ "objectivity" as a philosophic concept and imply it as an ideal. In contrast, the "Tymotheos" essay, like many art historical texts, cannot even reach the ground on which Michaels can disagree with Nelson: it tries to be objective, and it is also unselfconscious about its omission of the word "objectivity."

Perhaps largely because it is often unwritten, objectivity can remain one of the most important ideals among the aspirations that guide art historical writing. It might be argued that a great deal of art historical thinking is haunted by an ideal of objectivity derived from versions of nineteenth-century science, the psychology of perception, and physiology and neurophysiology. All of them mingle *outside* the texts and gather in evanescent ways in our habits of reading. In responding to an essay by Norman Bryson, Stephen Melville calls art history's "developed sense of objectivity" one of its "central strengths." In contrast to Bryson's attempt to articulate objectivity by reference to "scientific" or "theoretical" norms, Melville suggests a "commitment to disciplinary, rather than 'scientific' or 'theoretical,' objectivity." I would read this commitment as entailing at least three things. At first, Melville wants to point out that Bryson's account is constrained by his relatively unquestioned sense of objectivity as a matter of the verifiable constraint on perception and depiction. But that constraint is not to be understood only as an inappropriate or unproductive appeal to terms in neighboring discourses. Other notions of objectivity at work within art history might be more appropriate gauges of what art historians want to continue to call objective. And there is a third sense here as well, which I take to be the most important: Melville may also be concerned that it may not make sense to appeal to scientific or other external sources of objectivity, because we do not yet have a clear idea of how they may be addressed or how they relate to forms of objectivity that have arisen within the discipline. Since we are not in possession of a theory that would let us say how different ways of understanding objectivity exist within the discipline— a theory that, in my terms, would amount to a theory of metatheoresis—then it makes sense to concentrate on what is happening within the discipline: "It seems to me that the real questions facing art history as it looks to literary theory lie not in particular methodological stances or theoretical propositions but [in]

13. Walter Benn Michaels, "The New Modernism," *ELH* 59 (1992): 259, reviewing Cary Nelson, *Repression and Recovery: Modern American Poetry and the Politics of Cultural Memory, 1910–1945* (Madison: University of Wisconsin Press, 1989).

making out the general shape of the objectivity of art history."[14] As in the case of Walsh's definition, I do not offer this as a necessarily optimal way to think about objectivity, but as evidence that a central concept is discussed so variously as to have no commonly held sense. And that variousness is itself a sign that the concept of objectivity shifts and dissolves in our texts, at least until it reaches the diffuse intangible form I have called unmeasured objectivity, and then perhaps passes over into unrecognizable metatheoresis.

QUIET TEXTS, WRAPPED IN THE STYLE OF THEIR SILENCE

> Whichever stone you lift—
> you lay bare
> those who need the protection of stones . . .
> Whichever word you speak—
> you owe
> to destruction.
> —Paul Celan, translated by John Felstiner

In this reading of the "Tymotheos" essay I have not intended to argue that we should stop writing about the ideal of objectivity or any other construct: rather, I mean that philosophic accounts have to acquiesce to certain fictions in order to locate subtexts and that they must rest content with a degree of violence against what actually happens in the texts. At the same time, my reading has been imbalanced or open-ended, since the stages from concept to ideal and unmeasured ideal, and finally to the vanishing moment of metatheoresis, are also figures for increasing sensitivity to context. If I were to keep arguing in this way, I would finally be constrained to say that a philosophic reading sees *nothing* but illusions, and practice can only be understood in its own terms—in *all* of its own terms. Philosophy would owe any word it spoke "to destruction," and silence would become the inescapable final scene of philosophic interpretation. The slower the reading, the more concepts would be smothered, until a reader would arrive a point where the text would shine forth like a sphinx—an obdurate and unmoving block of words that could no longer be mined for "concepts" or "ideals."

In the arenas of Anglo-American philosophy, this position (were I to go on to espouse it) would be an instance of radical contextualism, and at its most extreme

14. Stephen Melville, "Reflections on Bryson," in *Visual Theory: Painting and Interpretation,* ed. Norman Bryson, Michael Ann Holly, and Keith Moxey (New York: HarperCollins Icon Editions, 1991), 77.

it would entail what is called the "inextricability thesis"—the idea that contexts hopelessly enmesh concepts instead of just supporting them. The inextricability thesis has been put most elegantly by Willard van Orman Quine, in relation to science: "The unit of empirical significance," he says, "is the whole of science."[15] When it is not put in such a provocative manner, contextualism can make good sense, especially because it implies that the level of context can be adjusted to suit a given reading. In accounts of art history, it would seem best to pay a reasonable amount of attention to the absence of philosophemes in essays like "Tymotheos" and to avoid either hallucinating philosophic subtexts or doubting every attempt to identify passages that imply versions of philosophemes. But the problem here, as I argue in detail in Chapter 3, is that there is no way to know *how* to increase sensitivity. Reading slowly is reading differently, and when the concepts disappear, their meaning and force become unclear. An unmeasured ideal does not harbor concepts that might be extracted and quoted, nor do descriptive passages gather into unmeasured ideals. What happens to theory in art history is not linear, and there is no external reason to suppose that a reading is more or less sensitive, more or less true, when it pays attention to context.

I would prefer to see each of the stages from the explicit concept to its deliquescence as the marker of a different kind of reading. According to some protocols of reading, art historical texts might harbor something that could sensibly be called theory, and according to others (which I am stressing here), theory might be distant or unrelated to what happens in the texts. One reading might operate by uncovering concepts, and another could begin by avoiding that temptation. But if something like metatheoresis is at work in normal art history, it does not make sense to try to become more sensitive to the relation between the texts and the various accounts of them. My sketch of the "Tymotheos" essay would not be a recipe for resisting visual theory, but a collage of mutually incomparable stories about theory's encounter with art history.

And in addition there is a paradox here, since the demands of philosophy—the very conventions of reading that define the entire field of philosophic interpretation—also call for their own dissolution. The philosophic readings that I have been positing throughout have their own rules of coherence and clarity, and it is *those rules,* and nothing intrinsic to the texts, that suggest it might be best to be cautious about assuming subtexts and other philosophemes where they do not appear. Philosophy sets the agenda for interpretation itself, for the excavation of meaning, and for the articulation, coherence, and self-consciousness

15. Willard van Orman Quine, "Two Dogmas of Empiricism" [1951], reprinted in *From a Logical Point of View: Nine Logico-Philosophical Essays* (Cambridge, Mass.: Harvard University Press, 1953), 42. See also Michael Dummett, "On the Significance of Quine's Indeterminacy Thesis," *Synthese* 27 (1974): 365. My exposition here is aided by Robert Kirk, *Translation Determined* (Oxford: Clarendon Press, 1986), 85ff.

of nonphilosophic discourses: and when it appears that such a project might be doing violence to the discourses, philosophy turns its conceptual apparatus against itself and makes the very act of interpretation seem doubtful—all without any word from the nonphilosophic texts themselves. It seems to be impossible to know what practice says about philosophy, or if it says anything at all. On one side there is meaning, reading, and theories of both; and on the other there is nothing but passive practice, "wrapped," as Paul Celan also said, "in the style of its silence."

DIALOGUE WITH A SATURNIAN

The best work I know that addresses these questions is an essay by Donald Davidson, "On the Very Idea of a Conceptual Scheme," which is an argument against conceptual relativism as it occurs in writers such as Benjamin Whorf, Thomas Kuhn, and Nelson Goodman. For Davidson, the question in those authors is whether there exists such a thing as a way of organizing experience, a "conceptual scheme," so alien that it cannot be understood at all. Whorf has said as much about the conceptual world implied by the Hopi language— that it cannot be translated into English, that it conceives the world in a way that is incommensurate with Western languages. Kuhn's paradigm shifts are, according to Davidson, a similar case, since periods of normal science cannot be mutually intelligible to one another across the gaps of scientific revolutions. And Goodman's "well-made worlds" are distinct conceptual systems that—again according to Davidson, who considers all three theories symptoms of a single misconception—are logically distinct from one another. Davidson doubts these claims and argues that whatever is not irrational is comprehensible: even the most conceptually distant "world" can be explained, unless it does not make sense in and of itself. Relativism on the matter of conceptual schemes is a "heady and exotic doctrine, or would be if we could make good sense of it."[16] In fact, Davidson insists, Whorf *can* explain what the Hopis think, and he does so in English; and if Kuhn's "paradigms" and Goodman's "worlds" are rational, they too can be explained.[17]

This is a central argument for my purposes because I have been claiming most things in art history that visual theory construes as philosophemes are something

16. Donald Davidson, "On the Very Idea of a Conceptual Scheme," in *Inquiries into Truth and Interpretation* (Oxford: Oxford University Press, 1984), 182; see generally 183–98.

17. Thomas Kuhn, *The Structure of Scientific Revolutions* (Chicago: University of Chicago Press, 1962). For Nelson Goodman's idea of "well-made worlds," in which different "systems of symbols" obtain for different spheres of activity (physics, labanotation in dance, painting, sign language, lyric poetry) and make ontology "evanescent," see Goodman, *Languages of Art* (Indianapolis: Hackett, 1968).

different, having undergone an irrecoverable radical change. In Davidson's terms, this must be half-mistaken: either whatever has suffered metatheoresis can be described and therefore understood in the terms of the interpretive discourse, or else it cannot and parts of art history are babble or madness. By this logic, it is also possible that all of normal art history is madness, either because its apparently rational elements might have been read into the text by a theoretical agenda eager to find some purchase or else because genuinely rational elements are inextricably dependent on their irrational neighbors.

Davidson considers a language the exemplary form of a conceptual scheme, and translation the exemplary mode of correlating different schemes, and I would like to follow him in that without claiming that language has some conceptual priority over other conceptual schemes or even that it counts as an example of a larger category to be called "conceptual schemes." To prove the nonexistence of "purported cases of complete failure" of translation, Davidson posits three languages, English, Saturnian, and Plutonian. Plutonian is the "exotic" conceptual scheme, taken to be untranslatable into English, but Saturnian can be translated into English or Plutonian. Davidson imagines this from the point of view of the English speaker waiting for the Saturnian to report on what the Plutonian is saying. Adapting this to my problem, I postulate English as the language of philosophy and the Saturnian language as the site of concepts, ideals, and other fauna that philosophy somehow finds in the texts of art history. My reading of the "Tymotheos" essay produces a Saturnian text, hovering somewhere between the philosophic discourse on objectivity and the full Plutonian text of "Tymotheos" itself. It is an analytic virtue of Davidson's scenario that it posits Saturnian as an independent language, neither practice nor philosophy, but a hybrid that may connect to both. (I assume, just for the duration of this thought experiment, that philosophy, art history, and philosophic accounts of art history are each like single languages. Things are, of course, much more fragmented than that, and it would be better to speak of dialects and pidgins within each planetary discourse. As Ermanno Benvicenga points out, one of the weaknesses of Davidson's position is that he likens individuals to individual languages—an unrealistically unified way to conceive of people.)[18] Davidson assumes that English speakers claim Plutonian is untranslatable—a reasonable facsimile of philosophy's traditional relation to what it takes to be nonphilosophic writing. That leads him to wonder how English speakers know whether the Saturnian is translating at all—how we know he is not doing something else entirely, like dancing or divining. (In our terms, the Saturnian text might be an unaccountable fictional construct, built of fantastical concoctions about Plutonian.) And then again, if Plutonian is untranslatable, then "it would occur to us to wonder whether our [English]

18. Personal communication, 1994.

translations of Saturnian were correct."[19] (In our terms, the philosophic account would begin to doubt the ways it finds concepts and ideals in the discipline.)

Yet as long as we are agreed that the Saturnian is translating Plutonian and that we can all read Saturnian, then Plutonian is translatable, and there can be no sensible claim of the kind of conceptual relativism that Davidson doubts. Art historical practice would have to be regarded as a species of philosophic discourse, even if it were misguided, riddled with inconsistencies, crowded with nearly impassable logical flaws and irrelevancies. Probably no one would want to write English texts that provide full explanations of Plutonian, even if they could be conceived and executed; but the practical consequence of this verdict is that problems "in" art history could ultimately be referred outside the discipline for adjudication. Art history would be fully subject to "interrogation," as Derrida says, by philosophic lights.

Another conclusion, and one closer to my own sense of things, is that Plutonian is not a language and that art history is somehow insane—that is, irrational— and therefore legitimately untranslatable. If I entertain this possibility, then it also begins to seem that the *Saturnian* might be insane—or perhaps both the Saturnian and the Plutonian are more or less crazy. If Saturnian, the language of philosophic accounts of the discipline, is fundamentally irrational, then it may make sense to construe my accounts of concepts, ideals, and unmeasured ideals as wild readings, hallucinations brought on by the encounter of philosophy with the texts of art history. In that case the hallucinations would still be theorists' only legitimate mode of knowledge of those aspects of art history, even though they would have no way of assessing the connection between the Saturnian hallucinations and the Plutonian discipline. On the other hand, even if the Saturnian account is fundamentally rational and the Plutonian is irrational, it follows that our concepts, ideals, and unmeasured ideals may not be names for rational structures in Plutonian at all. They may be names for gibberish or for unexpected mixtures of babble and reason. If Plutonian is not a language, then our names for it may not denote what we take them to denote.

I am playing with these ideas, not in order to close in on a hypothesis about philosophy and art history, but to indicate how epistemologically desperate the situation is for anyone who embarks on an explanation or a revision of a disciplinary practice. The strength of Davidson's analogy is that it underscores how fully we may fail to understand what we are doing. One of the themes of this book is that art history is strongly, even irreparably, irrational; and as I develop that claim I will sometimes want to say that parts of art history are genuinely untranslatable into philosophic prose—that they are, in the metaphor, insane. But at the same time, I will not know whether that is true, since there is always

19. Davidson, "On the Very Idea of a Conceptual Scheme," 186.

the possibility that philosophic versions of the discipline (that is, Saturnian texts) may be the very sources of irrationality. Several times in later chapters it appears likely that the highest degree of reasoned criticism of art history produces the pitch of unreason, so that accounts of art history that focus on rational flaws come to seem deeply flawed themselves. That coincidence—that is what it is—is an indication that something is wrong with the idea that we are dealing with rational structures. In Davidson's terms, the Saturnian may be lying to us about his ability to translate, or he may be dancing or singing instead of translating.

What Is Plutonian Like?

The object of our fascination, the intransigent Plutonian, now seems even farther from us than before—orbiting at the limits of vision, so far away that nothing certain can be said about it. There are at least two more reasons why we cannot know how well a philosophic account can understand a practice like art history. If the Plutonian is speaking at all, it is neither a language that an English speaker can immediately recognize (as the Saturnian claims to do) nor a language that we can recognize *as a language* (as it appears from the English speaker's point of view). As in Wittgenstein's example in the *Philosophical Investigations,* when asked to count by twos, a Plutonian may count by twos to 1,000, and then continue "1,000, 1,004, 1,008, 1,012 . . .": "We say to him: 'Look what you've done!' —He doesn't understand. We say: 'You were meant to add *two:* Look how you began the series!' . . . [but] suppose he pointed to the series and said: 'But I went on the same way.' —It would be no use to say: 'But can't you see . . . ?' "[20] Wittgenstein's example here has been interpreted by Saul Kripke as an instance of naturally, or "intrinsically," unintelligible behavior, and as such has been connected with Wittgenstein's ideas on private language.[21] An account of this passage by Henry Staten stresses instead Wittgenstein's interest in other "forms of life":

> Kripke cites this remark in support of his own point that we can't under-
> stand the deviant, but Wittgenstein's point is not that we can't because the
> deviant's behavior is unnatural or intrinsically unintelligible, but rather,
> that we can't because our minds are closed to some other way of doing
> it. . . . The important distinction is not between two intelligent human

20. Ludwig Wittgenstein, *Philosophical Investigations,* trans. G.E.M. Anscombe, 3d ed. (New York: Oxford University Press, 1968), §185.
21. See Saul Kripke, *Wittgenstein on Rules and Private Language: An Elementary Exposition* (Cambridge, Mass.: Harvard University Press, 1982).

beings, both of whom receive the same training, one of whom grasps the rule in a natural, intelligible way, the other in an unintelligible, deviant way; but between one person who is already initiated into a practice and sees it as natural, and another who is not yet initiated into it.[22]

The mental state of the Plutonian cannot be verified, since he responds erratically, but that does not necessarily imply that he is irrational. Wittgenstein's example shows that unaccountable behavior may also imply a variant sense of what is "natural"—that it is unavailable for critique because it is invisible to the reader.

And in addition to all this, there is another potential obstacle: perhaps the Plutonian is actively trying *not* to communicate. In accord with Davidson's model, we cannot know, though the account of art history I develop depends on the possibility not only that large numbers of practicing art historians write without thinking about what a theorist might think of what they do—a reasonable thing not to think about—but that they write in such a way as to block certain kinds of rational accounts.

THE VIOLENCE AND *GAUCHERIE* OF REPRESENTATION

I have been arguing two related points: that it is more difficult to describe a discipline such as art history than it has sometimes been taken to be, and that we can never have a reliable sense about how far off a description might be. I take it that the second is a fundamental problem and by its nature has no solution. Among the lesser of my aims, I hope to make it a little harder to describe art history, so that philosophic accounts might proceed slowly enough to include some assessments of the damage they do to art historical texts.

Describing unmeasured objectivity or the more radical change I have been calling metatheoresis is like a problem in deep-sea diving: the difficulty is to bring samples up from the depths with as little distortion as possible. Benthic fish are brought to the surface in small pressurized containers so they do not explode. Living abyssal fish can be represented by photographing them in their pressurized containers or *in situ* from a submarine. But in the simplest, most unavoidable sense we still have no idea what the fish look like, because the abyss is lightless: such fish do not "look like" anything at all. The enterprise of representing nonphilosophic writing needs continuously to recall that it cannot reproduce a lightless world. In biology as in philosophy, representation is related

22. Henry Staten, *Wittgenstein and Derrida* (Lincoln: University of Nebraska Press, 1984), 101.

to autopsy. Those who couple the acknowledged with the unacknowledged might wonder about the unhealthiness of their acts: as Mary Shelley knew, things that do not articulate themselves are not the same when they are prodded into motion.

I use the image of the abyssal fish as a way of questioning the philosophic metaphor of emerging consciousness—the middle term of the three demands of philosophy. As Hegel said, all cows are black in the night, and when the dawn comes, the cows have color and shape. But there is no dawn in the abyss, and the creatures that live there never see themselves. They have no appearance, and when they can see each other—when they are brought to the surface—they are about to die. Like biology, philosophy insists on seeing the objects of its attention, and I am not just suggesting that we grope about, hoping to get some better sense of what it is like to live in darkness. There is an ancient complicity between theory and vision, and everything that I describe about art history is also something I can see. But this seeing is violence, and I do not want to forget that the desire to see may not be benign.

Another way of thinking about these interpretive problems is by stressing their *gaucherie*—the willful way some philosophic accounts have of pushing at solutions where no problems have been offered. Wittgenstein encountered this aspect of the issue when he wrote about Freud's *Interpretation of Dreams*. He was unhappy with Freud's habit of interpreting dreams by explaining them in their entirety, and he complained about the kind of theoretical reconstruction that seeks to see the whole object, or to make the fragmented object cohere. In dreams, Wittgenstein says, "it is as though we were presented with a bit of canvas on which were painted a hand and a part of a face and certain other shapes, arranged in a puzzling and incongruous manner. Suppose this . . . is surrounded by considerable stretches of blank canvas, and that we now paint in forms: say an arm, a trunk, etc. leading up to and fitting onto the shapes in the original . . . and that the result is that we say: 'Ah, now I see why it is like that, . . . what those various bits are.' "[23] Wittgenstein's point is not only that Freudian dream analysis is suspect on account of its desire for familiar pictures, it is also that the Freudian technique is gauche. Such interpretation gradually erases the fact that the canvas originally represented only fragments and was by nature incomplete. Elsewhere Wittgenstein comments that "what is intriguing about a dream is not its causal connection with events in my life [as Freudian dream analysis posits], but rather the impression it gives of being a fragment of a story . . . the rest of which is still obscure."[24] That "impression" is not recoverable in the kind of analyses that are required by reason in order to understand the places and reasons why

23. Ludwig Wittgenstein, *Lectures and Conversations on Aesthetics, Psychology, and Religious Belief,* ed. Cyril Barrett (Oxford: Basil Blackwell, 1966), 45–46.
24. Ludwig Wittgenstein, *Culture and Value,* ed. G. H. von Wright, tr. Peter Winch (Chicago: University of Chicago Press, 1980), 68.

philosophic critiques fail. One of Wittgenstein's favorite sayings was "A thing is what it is and not another thing": an inapplicable maxim (if it is consistently applied, all comparisons are meaningless), but one that can serve to remind us of the possibility that what we seek in a philosophic representation of art history may be a sense of completion that is not present in the texts.[25]

Much of what I have to say in the remainder of this text is impelled by the three images of the deep-sea fish, the fragmentary dream, and the inaccessible—and possibly insane—Plutonian. I am well aware of the motions they sometimes impose on my argument, and of their implication in the grammar of the sublime (Wittgenstein's texts in particular reach back to late romanticism as well as forward to surrealism). As figures of transcendence, they name impossible conditions. But I retain them as signs of a preferred direction: instead of staying close to the strictures of theory and letting art history escape, I would like to risk some distance from theory, and especially those theories that insist on their ability adequately to comprehend some art historical practice. The harder it is to interpret confidently, the better chance we stand of seeing how little we comprehend—or ever can comprehend—of even the most "normal" art history. Since I spend the following chapters interpreting, I can never endorse true, radical contextualism or claim that the texts are wholly and irreparably irrational. But I do edge as close to that conclusion as I can.

25. Wittgenstein, *Lectures and Conversations*, 24–27. The maxim, which is due to Bishop Butler, probably reached Wittgenstein by way of G. E. Moore. It appears as the epigraph of Moore's *Principia Ethica* (Cambridge: Cambridge University Press, 1903).

2 THE SAMENESS OF THEORY

Consider the meaning of any work: for example, the prehistoric ring fort known as Dún Dubhchathair on the Aran Islands, Ireland (Fig. 1). Dún Dubhchathair is a half-circle of limestone blocks, built so that its open side faces a hundred-foot cliff above the ocean. Most writers have considered that the fort is primarily defensive, so its makers' intention would have been to provide themselves with the greatest advantage from attack. On the landward side, the wall is surrounded by a *cheval-de-frise,* a field of irregular stones set upright at close intervals. They would have made it difficult to storm the fort (and they impede walking, even today). But the intention of the makers is not entirely clear. As in other Irish ring forts, Dubhchathair has several shorter stepped walls within the half-circle of its principal wall (at right in the photograph). What purpose could they have served? The supposition that they aided in repairing the fort is untenable: the high outside walls are relatively easy to repair with a hoist, and dragging stones up the successive walls from the inside only adds to the labor. The shorter walls could not have been defensive, because an enemy who managed to break down the outermost wall would have an easy time with the shorter walls inside it.[1] Dubhchathair could have been defensive or symbolic, military or ritual; and at different times from the Neolithic to the seventeenth century, when the ring forts were last constructed, they may have been used for everything from emblems of tribal power to the storage of grain.

Art history, archaeology, anthropology, and other disciplines involved with visual objects construe meaning in such a uniform fashion that this single example can serve for the generation and reception of meaning in any visual object. In accord with the protocols of historical writing, all the initial questions are directed at the makers' intentions and the initial public use. Did the makers of Dún Dubhchathair mean it to be a defensive structure, or do its inconsistencies imply they intended it to be a ritual reminder of a working fortress? Could

1. Tim Robinson, *Stones of Aran,* vol. 1, *Pilgrimage* (London: Penguin, 1986), 39, and Michael J. O'Kelly, "Problems of Irish Ring-Forts," in *The Irish Sea Province in Archaeology and History,* ed. Donald Moore (Cardiff: Cambrian Archaeological Association, 1970), 50–54.

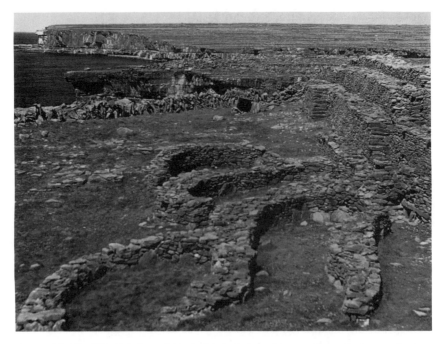

Fig. 1. The Neolithic ring fort of Dún Dubhchathair, Inishmore, County Galway, Ireland

it have been both, and if so, how could we deduce that from the remaining structure? From here the questions branch and divide into the intriguing region where intentionality has not entirely been left behind, but is somehow occluded or deferred. Inexactly repeated habits, repetitions sliding into new forms, dying conventions, and uncognized practices can all be half-intentional, shifting between purpose and purposelessness. A psychoanalytic historian might speculate on unconscious meanings, and an artist might be mostly concerned with the illogical idea of stepped walls or the impracticability of the *cheval-de-frise*. Folklorists are sometimes more interested in the history of suppositions about Dún Dubhchathair than in its actual original meanings, since ring forts have been ascribed variously to cannibals, to the Vikings, to the Picts, and to the legendary Fir Bolg, a prehistoric tribe whose name occurs in medieval chronicles.

And finally, intentional meaning can be entirely canceled, either because it may seem best to declare that Dubhchathair's meanings are lost to history or because the historian might choose to work without privileging intentionality in the first place. It is possible to study a ruin like Dún Dubhchathair for its intrinsic structural or semiotic properties: a semiotic account might focus, for example, on the slight departures from the perfect concentric semicircle and compare those

asymmetries to related ring forts elsewhere in Ireland. A conceptual artist such as Richard Long might try to understand Dubhchathair as an abstraction, a floating signifier of Celtic antiquity, a particular harmony with natural forms, or a form of the sublime, "weighed down by the centuries, sleeping on its sea cliff." (Long constructed his own circle of stones nearby.) The decisive break in the meanings of Dubhchathair is not between any of its possible original uses, but between *all* the possible early uses and its current functions as archaeological site, abstract sculpture, or tourist attraction: that is, the meaning divides between constructions that approach intention and those that try to avoid it.

THE QUESTION OF MEANING ITSELF

These are the lineaments of the question of meaning in any visual object. The same conflicting constructions of intention and accompanying methodological clashes are repeated throughout art history, and at this level they offer no hope of a stable resolution. In thinking about the ways that intentional meanings guide and inform art history, it helps to begin by widening the question as much as possible: to stop thinking about which interpretive strategy might be best for discovering intention or how full intention might be divided from fractional versions of itself or even, as in Derrida, which theory might provide the best argument *against* the centrality or importance of intention, and to ask instead about the larger problem of meaning itself. Intentional meaning is only one kind of meaning, and in the end the most important questions cluster around what Nelson Goodman would call the routes of reference: that is, the ways that art historians and others imagine that meaning of any sort is conveyed from the artwork to the recipient. The matter of intentionality that so preoccupies disciplines such as art history is a subset of the deeper problem of the production and reception of meaning itself.

The issue is well put in one of the most informed recent assessments of the discipline, Whitney Davis's review of Donald Preziosi's *Rethinking Art History*. Preziosi refers to the way the discipline "poses" artworks as the expressions of intended meaning, so that a work appears as an object that already contains its own meaning. There are many ways to say this, and Davis collates some things Preziosi says into a single sentence: "Art works, necessarily understood as vehicle, medium, sign, trace, production, or 'working,' somehow reflect, reveal, express, represent, articulate, enunciate, project, communicate, transfer, or deliver what may be called references, meanings, perceptions, concepts, intentions, or signifieds."[2] To Preziosi, "the business of the discipline is addressed above all

2. Whitney Davis, review of *Rethinking Art History*, by Donald Preziosi, *Art Bulletin* 71 (1990): 161, and citing Preziosi, *Rethinking Art History: Meditations on a Coy Science* (New Haven: Yale University Press, 1989), 15, 18, 22, 29, 83, 110, 118.

to the task of reading objects so as to discern produced meaning, to hear the Voice behind what is palpable and mute." The assumption that voice is at the origin of meaning prompts Preziosi to christen this art history's "logocentric paradigm."[3]

Since the verbs in Davis's epitome are in the active voice ("reflect, reveal, express, represent, articulate, enunciate, project, communicate, transfer, or deliver"), the historians who interpret artworks are cast as passive recipients of meaning apparently generated before them. The predetermination of meaning—even if it is not all meaning, or only recoverable meaning—disallows any mutual production of meaning by subject and object and bars the conceptual entanglement of viewer and viewed. For those reasons alone, the paradigm presents itself as an inadequate model.

Both Preziosi and Davis agree that the paradigm needs to be recast in order to open it to other ways that meaning is produced. The immediate strategy, in Preziosi's view, is to disrupt the paradigm by expanding it; he calls for a larger number of methods and subjects, a broader sense of artworks, a "deeper level," something less "reductivist" (20, 48). Davis takes note of Preziosi's observation that the formula's two "end-points," "meanings on the one hand [the predicates of the sentence] and their receivers/producers on the other [the subjects] tend to be studied at the expense of the 'material,' intermediate steps of production [the verbs]." Art history, Preziosi believes, must look intensively for whatever it has misread, bypassed, excluded, or ignored. He wants art historians to study the "total activity" of communication.[4] At one point Preziosi puts it this way: "[I]t is necessary to attend to the entire set of processes whereby artifacts are produced and reckoned with in the engenderment and sustenance of individual and collective realities (that is, ideologies), if we are to (1) see the logocentrist and instrumentalist paradigms in a clearer and more enhanced light; (2) reverse the parochialism of focus so endemic in the modern academic discipline; and (3) reconnect the contemporary discipline with its prewar engagement in important philosophical, cognitive, and psychological issues" (51). There are echoes here of the demands of philosophy: the idea that there is some theory in the text of art history (here, the "logocentrist and instrumentalist paradigms") and that one of the purposes of "rethinking art history" is to make those paradigms "clearer" and show them in a "more enhanced light." This is the voice of philosophy speaking for the text of art history, demanding light in order to see the paradigms that reside in dark parochial depths.

Yet this is no way out of the "logocentric paradigm," Davis replies, because "even if we were to concentrate on the 'total activity' of communication or on

3. Preziosi, *Rethinking Art History,* 16, and see also 185 n. 38 and 199 n. 72, each time citing Derrida.
4. Davis, review of *Rethinking Art History,* 161, citing Preziosi, *Rethinking Art History,* 46–47, 85, 118, 148.

the materiality and textuality of the trace itself, as Preziosi recommends, this does not in itself guarantee that the trace has not simply become the seat or site of Intentionality," so that the artwork remains the source of intended meaning. It is not a bad idea to be "as material and economical about the 'presence' of meaning, intention, or communication as possible," as long as we realize that in doing so we are not also launching a critique or even an analysis of the logocentric model of meaning. "Such an analysis," Davis concludes, "remains to be written in art history."

In its general outlines, the logocentric paradigm is as close as art history has come to a theory of meaning in the visual arts. The specific formula that Davis offers is heuristic, but it is also exemplary—an epitome of the way that art historians of all persuasions tend to think about meaning. It is at one and the same time skeletal (it expresses the apparent origin of meaning in the voice, or intentionality, and its reception "afterward") and preposterously complicated (since it does not control or even predict the path of meaning in any given case). That dualism presents problems for writers like Preziosi, who want to call on art history to think more inclusively. On the one hand, attention to the "materiality and textuality of the trace" or to the "'intermediate' steps" in the production of meaning would break the grip of the formula's simple grammar; but on the other hand, they would be quickly ushered into place among the lists of nouns and verbs. The few ancillary words in the formula underscore its apparently infinite capacity to absorb amendments and critiques. As Davis puts it, "Art works . . . *somehow* reflect . . . *what may be called* references": the "somehow" and "what may be called" operate as cushions for the possible insertion of new terms. Whatever is marginal in art theory is at once immediately dangerous and entirely untroubling, strongly alien and deeply familiar.

Even though *Rethinking Art History* has radical and wide-ranging purposes, Preziosi's suggestions might well function as patches or local salves, without the power fundamentally to unseat the logocentric paradigm. I would understand this curious situation as a sign that we have not yet found a strong enough critique of the formula and that we are constrained to imagine grammatical variants rather than conceptual revisions. It is relevant here that the difficulty of critiquing the logocentric paradigm had been considered long before Preziosi's book: Heidegger took up the question in 1935, in *The Origin of the Work of Art.* Here is Jay Bernstein's account of Heidegger's thinking on this point:

> Heidegger concedes that the relation of being and human being has not been adequately thought through in the essay; and that this failure has something to do with his failure to conceive adequately of the artist and work as equiprimordial, co-responsible; that in the setting-into-work of truth it remains "undecided but decid*able* who does the setting or in

what way it occurs." This decidability entails making one of the terms subject (active and productive) and the other, therefore, object (passive). Since subject/object dualism, which requires representation and sets it in place, is a central strand in the metaphysics of presence, its overcoming is possible only if a point of *un*decidability can be demonstrated to be constitutive for both presence and absence, the same and the other, identity and difference.[5]

To Heidegger, this "unsuitably conceived" relation between "Being and human being" has been "a distressing difficulty . . . since *Being and Time*."[6] Heidegger does not offer a solution, and it is Bernstein's contention that Derrida aims several passages in *Truth and Painting* at this portion of Heidegger's text, intending to contribute some of his terms ("hymen, *pharmakon, supplement, différance*" in Bernstein's numeration) to develop the "undecidability" that Heidegger had in mind. Whether or not that is a good reading of Derrida, the passage in *The Origin of the Work of Art* provides the clearest reason why Preziosi's tactics are insufficient, at least as long as the issue remains within the horizon of Heidegger's project. Heidegger's quandary shows that the problem is not to be solved by elaboration, emendation, attention to detail, to "intermediate steps," or to the "whole process" of signification. Anything that we choose to say about the "materiality and textuality of the trace" will only collapse back into the paradigm. What is required is a *demonstration of undecidability:* we must find a way to say why the formula is insufficient as it is, and also as it is not, so that being and human being can be "equiprimordial" and "co-responsible."

If the logocentric paradigm is a model that some art historians, archaeologists or anthropologists want to resolve or remove, Heidegger's text is the place where they might begin; but I am not convinced that we have a firm enough conception of what it means to critique the formula in any fundamental sense. It is not at all clear to me, for example, what the activity of art history would look like if the paradigm were rescinded or decisively critiqued. What would it mean to relinquish decidability (regardless of what we might decide in any given instance)? What would we understand by representation, object, or meaning? And do we have such a secure knowledge of what the paradigm allows us to say, or even what it disallows? The fact that Michael Fried's project, which is one of the few that involve thoroughgoing reformulations of the paradigm (in his case, and for the purposes of this account, I would say his work shows a consistent unwillingness to accept a passive, detached observer), has proved so difficult to assimilate into

5. Jay M. Bernstein, *The Fate of Art: Aesthetic Alienation from Kant to Derrida and Adorno* (University Park: Pennsylvania State University Press, 1992), 138.
6. Martin Heidegger, *The Origin of the Work of Art*, trans. A. Hofstadter (New York: Harper, 1971), 87.

the body of art history may be taken as evidence that we do not know exactly where we want to go with our dissatisfaction.

A CERTAIN SELF-SIMILARITY

Heidegger's cul-de-sac also shows that no explicitly or consistently philosophic thinking is likely to change the ways the paradigm is conceived. That, at least, is my initial excuse for suspending any search for meaning in the propositional content of the paradigm and for considering it instead as writing—or, in the terms of the first chapter, as a kind of practice. Consider, for a moment, what the paradigm looks like apart from its ostensive meaning, when it is read as an empty grammatical structure filled with meaningless words.

In the form Davis gives it, with seven subjects (the synonyms for artworks), ten verbs, and six objects (the synonyms for meanings), the paradigm could yield three hundred and sixty distinct sentences—such as "artworks reveal perceptions" or "signs project concepts"—and it would not be difficult to generate several times as many. Despite that complexity, the choices have a certain consistent level of generality. Compare the verbs, for example: "project" sounds like "communicate," which sounds like "transfer." Reference is similar to meaning, and both overlap intention, concept, and signified. The choices resemble one another in their degree of abstraction, even aside from their conceptual affinities or discordances. On occasion most art historians will have used most of them, and sometimes the choices between near synonyms are a subtle matter of tone or style rather than of stricter meaning. The logocentric paradigm is grammatically exacting but vague in a uniform way—like the windows of a building that reflect the same view.

The paradigm is more than a compact formula for an informal theory of meaning: it is an exemplar of qualities that I would like to say are characteristic of visual theory in general. The abstraction, uniformity, repetition, overlap, and grammatical simplicity of the formula are shared by the visual theory that is set in motion by some version of it. I call this constellation of properties *sameness,* loosely denoting a measure of rhetorical impoverishment, the privileging of the simpler forms of logical argument, and a steady, sometimes nearly constant level of abstraction among the leading critical terms. As an epitome, the paradigm has these features in condensed form. Strict logical exposition, which appears in the formula as its irreducible grammatical structure, recurs in visual theory in the form of lists, polarities, antinomies, binarisms, and trichotomies, together with the avoidance of more intricate or open-ended arguments. The uniform level of abstraction in the paradigm's leading concepts finds its complement and

expression in the philosophical staples of representation, language, perception, object, and meaning that inform visual theory.

I would like to propose that this sameness is more than a dubious formal property of some philosophic discourse. It is significant, I think, whenever it helps make the kinds of sense a historian wants to make of artworks. In other words, I would use sameness to open a deeper critique of the logocentric paradigm: instead of saying we are compelled to think along certain lines because we are under the sway of logocentrism, it may be better to say we want to remain under the influence of the paradigm in order to continue to write in a certain way. The logocentric paradigm is a synecdoche of a general sameness in visual theory and theories of visual meaning: it is an abbreviated name for a kind of writing that we enjoy or desire. That preferred writing requires sameness: art historians obey strictures of self-similarity in matters of theory in order effectively to exclude the possibility of finding what Heidegger called the moment of genuine undecidability. When we argue about art historical theories of meaning, in other words, we not only want to understand or critique what we do, we also want to find ways to continue as we have been.

At first it may not seem that sameness, vagueness, abstraction, and generality are promising places to begin discussing fundamental strategies for rethinking meaning. They appear almost like *aesthetic* qualities of the paradigm—matters that should be referred to rhetoric, style, or taste. But if philosophic, historical, and logical assaults on the logocentric paradigm have all left it in place, might not the problem be in the nature of the questions that have been asked? And especially in the supposition that each of the questions has made—that the logocentric paradigm, or any one of its myriad forms, is a *proposition about meaning,* or a statement about the way that meaning happens? What if the paradigm is not a statement about truth or meaning at all, but an excuse, a *waiver* that allows historians to name their chosen activity in a variety of ways? One form of evidence for this is what happens when art historians step outside the bounds of sameness by adopting a radically heterogeneous, rhetorically diverse, grammatically unstable discourse—in the example I pursue, the language of the studio. In such cases the formula's conceptual engine subsumes much of the new material; but at the same time, and for reasons that cannot be accommodated to the logic of the formula, other phenomena are expelled from historical discourse, returning it to its insistent sameness.

In Heidegger's terms, undecidability is not yet available for thought. In the more local terms of the logocentric paradigm, that implies that no effective critique is *conceivable* within art history. All changes that are directed at the logocentric paradigm *as a proposition* (denials that intentional meaning is important or accessible, claims that we overlook the "total activity" of communication, assertions that the paradigm is too simple or too rigid) will fail. I agree with

Davis that Preziosi's ideas are too easy: no close attention or structural analysis will begin to break down the paradigm. And sameness, I think, is the apparently irrelevant property that allows the logocentric paradigm to appear as if it were an intractable condition of meaning itself.

Bryson's Crystalline Argument

As an opening example of the effects of sameness I take Norman Bryson's "Semiology and Visual Interpretation," an essay in the collection *Visual Theory.*[7] Bryson's essay is a position paper in favor of semiology and against both "Perceptualism" ("the notion that artistic progress can be described exclusively in terms of cognition, perception, and optical truth") and "social history" (which contends that art "cannot be understood without analysis of the social, and in particular the economic, base"). His argument is driven in part by an interest in securing complexity, so that he criticizes Perceptualism for making art "banal, since its view never lifts above ocular accuracy," and "trivial, since the making of images seems to go on . . . out of society . . . in some eddy away from the flow of power" (63). Models such as *"base* and *superstructure,"* which determine thinking in both Perceptualism and social history (the latter, for example, seeing the base as the economic structure and the artwork as its elaboration, expression, and result), are described as poor models because they simplify a more intricate dynamic. (I note, in passing, the outlines of the logocentric paradigm in the models of meaning, and also some elements of Preziosi's critique, in that Bryson means to argue for greater complexity.)

To describe the semiological approach that he prefers, Bryson distinguishes *"classical* and *projective"* models of sign activity: the former conceives a sign as an anterior idea and a posterior manifestation of that idea as a word or other mark, and the latter acknowledges dissemination, and the inexorable mutation of signification. These two aspects, Bryson says, give art history a "double mandate," both "archival" and "hermeneutic." The former must involve not only patronage and archival research, but "scientific, medical, intellectual and religious practices," legal, political, and class structures, "sexuality and economic life" (72). The latter is bounded by the "domain of *pragmatics,"* meaning the decisions we make about whether to privilege the search for original meaning, to regard dissemination as anarchic, or to countenance relative historical contexts.

7. Norman Bryson, Michael Ann Holly, and Keith Moxey, eds., *Visual Theory: Painting and Interpretation* (New York: HarperCollins Icon Editions, 1991).

The essay moves forward according to a geometric progression of argumentative strategies: it opens with a trifurcation of the methods of art history (semiology, Perceptualism, and social art history), moves to a polar critique of two of them (in the distinction between base and superstructure) and a bifurcated description of the third (the "classical" and "projective" models of semiotics), leading in turn to another bifurcation (the "archival" and "hermeneutic" mandates) and a list (the topics of each mandate, including "scientific, medical, intellectual and religious practices"). The dialectic forms are fairly consistent and self-contained in the narrative—the case is made through a succession of unities, oppositions, triads, and lists. I would locate the sameness of this text in the particular relation between this self-similar geometric argument and the consistent level of generality of the operative terms (philosophemes such as "historical" and "dissemination," and names of institutions such as science, medicine, and religion). This correspondence has no immediate meaning—no rule binds their coincidence to any conclusion or purpose—but it becomes significant when the text itself calls for increased complexity and the argument does not respond. The configuration of terms at a certain level of generality and argumentative strategies at a certain level of clarity remain comparable from the critiques of Perceptualism and social history through the exposition of semiology. Bryson's explanation of the semiotic position is a point of special tension because semiotics is said to achieve the complexity and avoid the banality, triviality, and poverty of the Perceptualist and social history models, but it does so by means of a theoretical stance that is structured at a level of generality uniform with that of the preceding theories. The particular sameness of the text differs from the lack of self-similarity in its theme of the varying complexity of art historical methods, and the easiest way to explain that disparity is to consider Bryson's "Semiology and Visual Interpretation" as an example of a writing that wishes to remain untouched by the variegated surfaces of the objects it describes. Its sameness is not a constraint imposed by some philosophy, but a defining ideal, maintained against pressure exerted by the subjects at hand.

Sameness also exerts a strong force on essays that might be written in response, since it provides a guide for the level of generality that could be taken as a direct reply. Stephen Melville resists this in his "Reflections on Bryson," but the strictness of Bryson's rhetorical uniformity ensures that when Melville succeeds he also defines places where possibilities of further dialogue are in danger of being extinguished. Part of Melville's response is in line with the crystalline dialectic structure of Bryson's essay, as when Melville calls Bryson's approach "a certain programmatic emplotment" of the "interplay between literary theory and art history," or when he identifies the "gap between prescriptive and descriptive" as a fundamental aspect of the schemata on which Bryson's arguments rest. What I mean to say is that observations like those not only take up the same

lexicon as Bryson uses, but they also involve crisp argument, proposition and counterproposition: that is, they respond in kind to the terminology and the clear argument that Bryson prefers. But the force of Melville's response works in a direction away from those conventions. He notes the generality of Bryson's lexicon, by way of saying that a "commitment to the specificity of their objects" causes other historians such as Rosalind Krauss and Michael Fried to recognize "their role as writers within a history" (76). Melville also opens the possibility of speaking not about the truth of painting but about the truth of painting to art history, leading to the observations on "the general shape of the objectivity of art history" that I quoted in the first chapter. I read these moments not so much as attempts to may out a field of engagement for some extended exchange, but more as markers of a critical impasse common to much writing that attempts to bridge these distances between visual theory and art history. Barring changes in narrative, further discussion is largely precluded, not because Bryson could not accommodate dialogue about what Derrida might call the "truth in art history" as opposed to the "truth of art history," but because the route to that discussion must lead through a different specificity than is countenanced in "Semiology and Visual Interpretation." In this way, and for these particular texts, the quality of sameness delimits discussion as effectively as any direct disagreement might. One further example will serve to show not only that our critical sameness affects discussion within and between art history and art theory, but that it also restricts what some theory can say about artworks.

WOLLHEIM'S VAGUENESSES

Like Bryson's text, Richard Wollheim's *Painting as an Art* operates at a fairly consistent level of abstraction, as if it were hovering some distance above the paintings—never dipping too close to their details (to what Melville calls "the thicker prose of the world"), or drifting too far into aesthetic discourse that would have no need of examples.[8] The illustrations in *Painting as an Art* exemplify that distance: the text has almost four hundred plates, and the great majority of them are referred to rapidly, as examples of ongoing arguments. At one point, Wollheim illustrates paintings by Rogier van der Weyden, Romney, de Hooch, Grünewald, Monet, and Fantin-Latour, all just to show the variety of painters who could achieve "the naturalistic effect," and he pairs Antonello da Messina's *Portrait of a Young Man* with a portrait from Fayum in order to say that each is "a portrait

8. Richard Wollheim, *Painting as an Art* (Princeton: Princeton University Press, 1987). Stephen Melville, "The Temptation of New Perspectives," *October* 52 (spring 1990): 8.

of a particular person, and the fact that probably no one will ever know who does not alter this fact" (71–77).

It is not easy to describe the logical, rhetorical, and conceptual sameness that permeates this text without quoting from it at length, and so I will limit what I say here to a few observations. The text is divided into lettered sections (A, B, C, . . .) with numbered subdivisions (1, 2, 3, . . .), and paragraphs tend to begin with the logical outline of the argument ("In the first place . . . ," "Secondly . . . ," "Thirdly . . ."). The majority of arguments in the book have a clean geometric structure in accord with these divisions. Wollheim's habitual practice is to write out a sentence as fully as it needs to be written in order to avoid any possibility of ambiguity of reference or meaning. An example can serve to indicate the way this sounds and also to show the kind of abstraction that rules throughout the text:

> 6. That representation is grounded in seeing-in is confirmed by the way seeing-in serves to explain the broad features of representation. For the most general questions about representation become amenable once we start to recognize that representation at once respects and reflects the nature and limits of seeing-in—so long as we also recognize that seeing-in is itself stretched by the experience of looking at representations. (59)

I want to be careful about my critique, since I recognize that style analysis, especially when it is disconnected from questions of content, has rarely seemed relevant to philosophy. A modern reader might ask if it matters how a nonfiction text is written as long as its ideas are clear. Is there a cogent reason to object to a consistent level of conceptual abstraction? Do all technical discourses not develop fairly uniform lexica? Is it significant that Wollheim's arguments are almost always simple opposites, polarities, and lists of two or three points? (I doubt, for example, that Wollheim would say that his style of argument possesses transeunt powers over his claims except where an unclear style might hamper the efficient and unambiguous communication of those claims.) But the disconnection of form and content is only viable for readings that are detached from questions of *writing:* from style, texture, expressive capacity, voice, and rhetoric. As Cicero and Quintilian knew, no text is an innocent witness to this interplay: form *is* content, and any question of form raises symmetrical questions of content.

Wollheim remarks that his accounts only reach as far as language can easily go, so that he describes only what can be put reasonably well into words. "I have considered only the grosser aspects of painting," he writes, meaning ideas "that readily get captured in words." Further points are described as "too fine-grained for language to follow"; they elude "the grasp of language" (25, 80). This would be a reasonable assumption, except that he sometimes claims that

what happens out beyond his descriptions is similar to what he can easily put into words. Speaking of moods and feelings, he describes two photographs— one of an isolated castle, the other of "tall poplars, water-meadows, and broken fences"—by saying "a mood of loneliness and despair, finely shaded to match the differences between the two landscapes, creeps over us" (81). But such descriptions, and their accompanying theories of expression, take their meaning from the assumption that moods or feelings are effectively linear continua, so that other, more "fine-grained" moods might lie beyond "loneliness and despair" in the same direction.

Sameness, exemplified by the text, extends beyond the domain of words and into moods; and it also extends into the nonverbal moments of artistic production. In the opening two chapters Wollheim sets up a polarity between "What the Artist Does" and "What the Spectator Sees." A key concept is "thematization," which is roughly the process by which the artist becomes aware of a mark-making activity, so that it becomes intentional and contributes "to guiding his future activity" (20). The concept of thematization leads to a discussion of the ways that the artist becomes a spectator of his own work, reflecting on it as it is being made and developing marks that will eventually be seen by others. In the second chapter, Wollheim draws some fundamental conclusions from these possibilities. "The artist paints," he says at one point, "in order to produce a certain experience in the mind of the spectator" (44). Now, from the perspective of his developing account, this seems reasonable, since the artist is conscious of himself, his thematized marks, and the potential spectators that will see them; but from the perspective of an artist it may appear strongly counterintuitive. It is not that some artists do not paint with "certain experiences" in mind or that they do not paint for spectators; but often, painting is a much more confused activity than that, and there is no thought of "a certain experience" that is known and that needs to be communicated, not to mention an experience that needs to be communicated to a certain spectator. Often enough, a person paints *in* a certain mood, not to communicate that mood; and in accord with the nature of moods as Heidegger and others have tried to describe them, there is no secure awareness of what the mood (or feeling) may be. I might paint, thinking of my breakfast or daydreaming about *I Love Lucy,* and there would be no way for me to explain how those thoughts might be connected to the closely analytical, even ludic, possibilities of producing "a certain experience in the mind of the spectator." Wollheim's way of putting things is consistently conceptual, conceptual in a consistent way, and it does not allow for what a student of mine once called the "sticky goo" that he feels between his ears while he paints, or for the experience of absorption as opposed to the production of that experience. According to Wollheim, pleasure is one of the "certain experiences" that painters aim to produce. In that case, he says, the painter "has a firm grasp" on "what

a pleasurable experience is like": but why assume that? Even when a painter aims to produce pleasure, how "firm" can the grasp of pleasure be? "He tests the experience he has before the picture to see whether it meets the standard," Wollheim continues (but is "tests" the right word for a partly uncognized give-and-take?). "If it does, then the painter concludes by analogy that the painting will produce a pleasureful experience in others" (45) (but does the painter really "conclude" any such thing, not to mention "by analogy"?).

Though I do not find this account of painting convincing, I am not raising these objections in order to argue directly against Wollheim's claim. Instead, I want to suggest how the sameness of his prose prohibits him from considering these less orderly options. It might be objected that by setting up the interplay of mark, thematization, experience, painter, and spectator, Wollheim only wants say what is needed to get started, to begin describing "what the spectator sees." This is all we can say, he might reply, or else it is all that can be said clearly. Yet in order to be a model of "what the artist does," or even how paintings mean, it also has to apply beyond itself, in places that elude the "grasp of language." But is it only slightly wrong to say an artist has a "firm grasp" of an idea of pleasure, that he "tests" it and "concludes by analogy" when it will work? Or is it entirely wrong, an egregious misrepresentation of what came before analysis?

I would not know how to argue that Wollheim's account does or does not slide smoothly toward the reaches beyond the "grasp of language." It may be that his terms are not only necessary words for what happens there, but also appropriate ones; or it may be that they are deeply unrelated to what happens while works are being produced. But the coherence of Wollheim's theory is entirely dependent on his mode of argument: his sameness. If we step outside the scene in which an artist works intentionally, "thematizing" marks, trying to create an "experience" in a "spectator," then none of this makes sense—and I assume Wollheim would concur. The question I would like to insert here, between the dependable machinery of his argument and the "sticky goo" that might be just beyond it, is this: Is it not possible that the sameness of his argument is predicated not only on the intrinsic limits of language but also on a desire to say certain things and to remain at a certain distance from the artworks?

On Waywardness

So far I have done several things, adumbrating this account of theoretical sameness. First, I considered a theory—the logocentric paradigm—which is a compressed version of art history's central account of meaning. I proposed that it may be insoluble (as Heidegger thought), but that we may not want to solve it,

and that if part of art history's purpose is to preserve the paradigm, one way to do that would be to preserve its level of abstraction. "Sameness" is my term for uniformity in conceptual abstraction and also in complexity of argument, and I tried to indicate how sameness characterizes and supports certain theoretical accounts. My purpose is to describe some visual theory as an activity less concerned with encountering artworks or dismantling central accounts of meaning than with preserving its own mode of writing. Sameness is what some theory wants. Naturally, by insisting on rhetoric and levels of abstraction instead of attending to the declared meanings of the texts, I am running some risk of seeming both intransigent and impertinent. Sameness is partly in the eye of the beholder: some people take Wollheim's account to be a reasonable version of what happens in painting, and others, I have found, think its uniform conceptual machinery strays from painting's waywardness. But sameness is also demonstrable, both within the texts—by the kinds of rhetorical readings I have begun here—and by contrast with other approaches that try not to be self-similar. I turn now to an example, the conceptually disheveled world of the art studio.

The studio may be the place most feared and excluded by visual theory and art history: it has virtually no part in philosophic accounts of art, and it has only a limited role in art history, where it generally serves as a well-worked mine for information about historically significant artists' techniques. There are both historical and philosophic reasons for that exclusion: studio practice is difficult to connect to historical themes, since the personal and largely inarticulate discoveries made in the studio do not seem applicable to finished works that exist in history; and studio talk is riven by ungrammatical statements, illogic, and nonverbal communication by gestures and marks that conspire to make it nearly illegible to philosophic inquiry.

If art historians or philosophers wished to disassemble the logocentric paradigm, studio practice could provide an exemplary opportunity: it is intimately related to visual art and strongly different from existing discourse in visual theory and art history. I would take the fact that the language and the discoveries of the studio have barely trickled into art history, and have not even appeared in philosophy, as additional evidence that the logocentric paradigm is not functioning as a proposition, but as a license—in this case, as the name of the meaning that is desired outside the studio. The resistance to what the studio might offer takes two forms, which I want to examine in succession. First is the institutional problem, which can be put as a hortatory question: Why should art historians draw? The second, philosophic problem arises when studio work produces insights that might be applicable to historical work but are excluded on specific thematic grounds. I want to approach the second through the first, and begin by asking about the institution of art history and its traditional marginalization of studio work.

A number of art historians draw, sculpt, and paint, but virtually none find ways to incorporate those experiences into their historical and theoretical texts. Social art historians sometimes find that production bears on meaning, but that does not imply they need to make frescoes in order to write about them. Art historians who write about certain periods or artists' careers may research the development of media, but only a few try their hand at working the relevant media, and none that I know present their experiences as integral parts of their research. Even so, it may be deeply relevant that some of the best art historians are also artists: to name only three, David Summers, Joseph Koerner, and Leo Steinberg each draw and paint. (So, most famously, did Meyer Schapiro.) Steinberg has said he copies works before he writes about them, but he has not said what he gleans from that experience.

It is worth emphasizing how untenable this position is. Though art historians acknowledge the contingent importance of artistic practice, and though they explore the connections between production and artworks, it is a commonplace in the discipline that it is not necessary to reproduce in order to write.[9] In most graduate art history curricula, artists' techniques are represented by a "methodology" course involving lectures, readings from histories of technique, firsthand examination of artworks, and some demonstrations.[10] Ordinarily students do not copy artworks, and most images are seen as slides.[11] In structuring courses

9. In 1863 L. Alvin, a Belgian art critic, claimed that Raphael had no need to learn weaving in order to design cartoons for tapestries. Nikolaus Pevsner, reporting this opinion, calls it "disarmingly naïve and yet indisputable," and he approvingly cites William Morris as saying that a designer "ought to be able to weave [for] himself." The debate about the relevance of practice to "industrial" and "applied" arts has been joined since the early nineteenth century (and largely resolved in favor of practice), and the present essay is a continuation of that exchange into the domain of the history of art. I do not, however, think that the question of the relevance of practice to working artists can be profitably applied to the question of the relevance of practice to working scholars. See L. Alvin, L'alliance de l'art et de l'industrie (Brussels, 1863), 48, quoted in Nikolaus Pevsner, Academies of Art, Past and Present (Cambridge: Cambridge University Press, 1940), 259 and 263.

This essay may also be placed in the tradition of aesthetics that critiques the "paradigm of the contemplative spectator" who is a passive observer rather than a participant; but again, I have not found the aesthetic arguments germane to the case I want to make here. See R. G. Collingwood, The Principles of Art (Oxford: Oxford University Press, 1938); T. J. Diffey, "Aesthetics and Aesthetic Education (and Maybe Morals Too)," Journal of Aesthetic Education 20, no. 4 (1986): 42ff., citing A. Berleant, "The Historicity of Aesthetics," British Journal of Aesthetics 26, nos. 2 and 3 (1986); and Andrew Harrison, Making and Thinking: A Study of Intelligent Activities (Sussex: Harvester Press, 1978).

10. For art history curricula in general, see Willibald Sauerländer, "Kunst oder Geschichte?" Kritische Berichte 13, no. 4 (1985): 61–65; and W. Pilz, "Unhistorische oder kunsthistorische Verbildung?" Kritische Berichte 12, no. 4 (1984): 25–41, on Heinrich Wölfflin. For related material on Germany, see Willibald Sauerländer, "L'allemagne et la 'Kunstgeschichte': Genese d'une discipline universitaire," Revue de l'Art 45 (1979): 4–8; and on Italy, G. C. Argan, "Strumentazione e metologia," Storia dell'Arte 24–25 (May–December 1975): 79–82. For the question of studio practice, see E. C. Larkins, "An Experimental Study of the Effects of a Learning Laboratory Strategy for Teaching Art History: Criticism for College Freshmen" (Ph.D. diss., Florida State University, 1977), abstract in Dissertation Abstracts International (1978): 1491.

11. It is interesting that our use of slides is so much better studied than our use of studios. See, for example, H. B. Leighton, "The Lantern Slide and Art History," History of Photography 8, no. 2 (1984): 107–18; J. Adhemar, "L'engeignement par l'image," Gazette des Beaux-Arts 97 (February 1981): 53–60,

this way art historians make two implicit assumptions: that techniques are an essential part of an art historian's knowledge, and that art historians normally do not actually have to make works in order to learn what they need. Thus the matter of technique is divided in two: on the one hand is everything that has been written down, from artists' formulas to conservators' reports, and on the other are the inchoate or uncognized artists' "tricks" and the unlistable lessons of experience. In Aristotelian terms, the former branch is *technē* proper, specifically denoting whatever "art" or "craft" can be taught; and the latter is *empeiria*, that which depends on unteachable "knacks" or "tricks."[12] Unfortunately this ancient distinction is a little confusing for my purposes, because historians have come to call artists' techniques *technē*, so that Aristotle's distinction ends up finding a *technē* within a *technē*.[13] I prefer instead to retain the usual *technē* for artists' techniques and to distinguish within it a *theoria* and a *praxis*, meaning that which has words and that which does not.

The "practice of technique" is periodically examined to provide information that can be codified into historically useful theory, so that it comes to seem as if the quarry of practice is nearly empty. Whatever has connection outside of practice—to style, to history, or to analysis—has been given words, and what appears as the nonverbal residue is at once essential to artistic practice and irrelevant to writing. Examples of this legitimately unpracticed residue abound. Cennino Cennini requires that tempera paintings be repeatedly covered with thin layers of gesso and then sanded. That experience—which takes about four weeks, following Cennini's instructions—nourishes a kind of cherishing: even before it is completed, the object becomes important, almost as if it is accruing sanctity. But since that quality is homogeneous (it is the same every time a panel is prepared), it cannot be readily applied to specific works. Art historians are therefore justified in not making panels in order to study tempera paintings by Piero della Francesca or Fra Angelico.

For several years I have taught a course in which art history graduate students copy artworks and we attempt to make connections between the experience of replicating marks and the historical and expressive meanings of the works. The great majority of the things students learn do not seem to have a connection to the literature on the works they copy; they are outside art history in a particularly resilient fashion. A student copying a painting by Max Beckmann noted an

on visual teaching in the sixteenth and seventeenth centuries; W. M. Freitag, "Early Uses of Photography in the History of Art," *Art Journal* 39, no. 2 (1979–80): 117ff.; and Irene Below, ed., *Kunstwissenschaft und Kunstvermittlung* (Giessen: Anabas-Verlag, 1975).

12. Aristotle *Rhetoric* 1.1, and P. O. Kristeller, "The Modern System of the Arts: A Study in the History of Aesthetics," *Journal of the History of Ideas* 12 (1951): 498.

13. And there is the further confusion that *ars*, the Latin equivalent for *technē*, came to mean "art" in the modern sense. See J. J. Pollitt, *The Ancient View of Greek Art: Criticism, History, and Terminology* (New Haven: Yale University Press, 1974), 22, on *technē* as a "combination of knowledge and orderly procedure."

unexpected prevalence of very soft, tentative, feathery strokes in an otherwise violent, expressionistic canvas. I could construct a hypothesis that gave her observation a chance of historical meaning, but it would probably not be fruitful or especially persuasive. (I might posit that Beckmann's violence to the nude figure in the painting, to the morals it represented to him, and to the paint itself was meliorated in his mind by a "secret" delicate touch.) But even if that hypothesis might begin to make sense and other paintings could be shown to have the same delicacy, would a historian need to copy such a painting to write about it? I do not think so, because the hypothesis itself would be enough; it could merely be cited, and the historian could save the trouble of testing it.

What is learned in studios seems to bear mainly on connoisseurship—and therefore to be allied with a discourse that remains ideologically suspect. The first time out, copying an oil painting in a museum or a marble sculpture in a studio, one learns respect and frustration. Later, with increased ability, one learns some of the innumerable tricks of the trade: how to make cross-hatching in a woodcut by slicing small rectangles, how to control the burin in a steel engraving, how to chisel into the marble and back out in a single compound stroke. Such knowledge is rich and meaningful, and it strengthens private looking at works: but is it relevant to art history? Is it useful, for instance, to know exactly how Bellini made his *grisaille* (monochrome) underpaintings? What connection might that have to social or iconological concerns? As usual, the inchoate "practice of *technē*" appears to be sealed off from the theory. It would appear from such examples—and many more could be adduced—that there is seldom a reason to copy artworks in order to research them.

I do not pretend that there is a hidden oral tradition of practical knowledge out in the studio waiting to be codified. It is not at all easy to make the case that art historians should actually copy works instead of "merely" studying them, unless we are to be content with the simple claim that any professional should know as much as possible. But it seems to me that it is important to argue these issues, because a clear conception of the relation between art historical writing and artistic practice is necessary for an understanding of what art historians do and how they imagine historical writing.

WHAT ARE DRAWING AND PAINTING TO ART HISTORY?

I begin with several examples that possess only a modicum of power to interrupt art historical writing. Late El Greco paintings are made by a continuous process of overlapping in which a dark contour strengthens a passage of continuous

tones only to be blurred by a color area and restrengthened. His outlines shift like flames, or like "flaming ice," as a contemporary put it, and it is possible to argue that the flickering *contrapposto* is to be imagined as a Manichean conflict of light and dark, good and evil.[14] For this reason there is a great difference in El Greco between putting a light into a dark and darkening something that is already light: the former is a metaphor of creation, and the light "knows" and "resists" the dark; and the latter is a figure of destruction or death, because the dark suffuses the light and threatens to extinguish it (Fig. 2). When darkness forms inside light "but knows it not," the working of the paint is a repetition of Christian prayer, and when light is surrounded and swept away by darkness, the painter's gestures can narrate a loss of faith, or even a moment of Gnostic pessimism. Copying is a way of reenacting this and unfurls a drama that is not accessible to those who see only the completed struggle. A dialectic of dark and light is frozen into the paintings, but in the process it becomes a living exchange, a prayer, a story, a dialogue, or the silent exposition of an inner *agon*. Every inch of the painting, as well as each moment of copying, plays out a part of that nameless drama. Copying the passages reproduced here, a painter has to struggle to keep the silvery white from melting into the ultramarine darkness. That drama is largely lost to someone who only looks at the finished work, though there are enough clues to give a sense of it. All that is clearly visible is the last moments of the *agon*: El Greco painted sharp comets of light over fields of darkness, and comets of darkness over the highlights.

Titian's late paintings are entirely different but no less eloquent witnesses to the relation between process, mark, and meaning. As a rule Titian softens the narrow strips on either side of his outlines, melting figure into ground, fusing the two into a single shade. (In Figure 3, the figure's far leg and his garment show that late technique, and the near leg retains the crisp outlines more typical of earlier work.) The candent highlights between the contours hold the strongest colors, and they fade in intensity and value as they approach the blurred outlines. In this way Titian's technique mirrors the (often overstated) Venetian concern with *colorito* and relative unconcern with *disegno;* but a firsthand knowledge of the technique reveals something other than the static polarity of theory. In Titian, *disegno* is something that is given, in the sense that it is present at the beginning of the painting process, and he effaces contours with repeated low-chroma glazes of dusky blues, siennas, and umbers—that is, the contours are dissolved in an act that has no strong connection to either term of the theoretical polarity. The erasure and softening of contours does not require effort, and is more like a

14. For El Greco's vocabulary of light and shade, see, for example, Fernando Marías and Agustin Bustamante Garcia, *Las ideas artísticas de El Greco* (Madrid: Catedra, 1981), 92ff. (with a mention of "las sombras que descubren el todo"), and Richard G. Mann, *El Greco and His Patrons: Three Major Projects* (Cambridge: Cambridge University Press, 1986), 82, 137, and elsewhere.

Fig. 2. El Greco, *Feast in the House of Simon,* detail. Art Institute of Chicago

laying-down of force, and a way of increasing the distance from outline, light, and color. *Colorito*, on the other hand, is an active struggle, something that must be strengthened by force. Color areas are built up slowly, sometimes with the ribbed gloss that comes from rubbing with the fingers (fingerprints provide the characteristic gloss), and the boundaries of color areas are occasionally hard-edged and at variance with the blurry directions of the contours that they would be expected to echo. The energy spent on *colorito* can also appear as bright glazing over a highlighted area or as sharp wet highlights within a field of color, but it is always strenuous work. (Here, for example, the legs and garment are strongly articulated, with highlights vying with each other.) Color is *drawn*, and even sculpted, and so it does not oppose Florentine *disegno*, which is often allowed to collapse into weak pools of indifferent shadow. And again, the act of doing is the only way to make these claims clear and to articulate the way the theoretical dynamic is rethought in the studio.

Art history could readily assimilate such findings by developing accounts of Manichean *contrapposto* or the transformation of *disegno* and *colorito*. But the meaning is in the moment-by-moment unfolding of the process, and I cannot see how a text on Titian or El Greco could find a place for a review of the variegated *agon* of light and shade as it is played out in a few square inches of canvas. When those struggles happen in some fold of drapery, far away from the painting's center, they are "meaningless"—apparently not worth recounting in their specificity. How could such a drama be told, and if it were, what could it mean? Still it is important that the experience of copying an El Greco or a Titian and observing these plays of meaning is not entirely a nonverbal or intuitive experience. Each moment has its words, but they fail to connect with what art historians continue to want to take as the paintings' legitimate meanings.

The copyist's body mimes the artist's movements, and often it is possible to find verbal equivalents for that experience by describing what the body feels like when it tries to reproduce an artist's gestures or by guessing at what mental states might correspond to those motions. If only a few of those descriptions can find their way toward the kinds of meaning that are explored in art history, it may be because the logocentric paradigm is largely a disembodied construct: it countenances visual signs, not bodily ones, and it is concerned with the transmission of the *logos*, not the body. Meaning that comes from the *copyist's* body and flows back into the work would invert the paradigm by displacing the source of meaning from the seen trace to the act of tracing.

An example comes from fifteenth-century painting, where the act of copying reveals an unexpected delight in passages, such as patterned fabrics, that would be, to a modern painter, inexpressible tedium. It is not so much the painters' attention to unique objects (such as chalices, crowns, thrones, and jewels) that seems difficult to fathom as their relish in repeated forms (brocades, baskets of

Fig. 3. Titian, *Martyrdom of St. Stephen*, detail. Lille

identical flowers or fruit, finicky architectural ornaments). Often it is said that such details were given to assistants, but we may mistake our reaction for theirs by implying that the assistants would therefore have been given a kind of drudgery.[15] Certainly the artists and patrons alike delighted in the fastidious labor of repeated ornament. Would we want to say that Carlo Crivelli, an especially fastidious painter of detail, thought of brocaded drapery as a kind of work, something requiring patience (Fig. 4)? And does it make sense to say that he enjoyed the bizarre touches that have contributed to his fame (the little flies, glistening pearls, and wrinkled fruit) more than the passagework that links them?

The experience of copying Crivelli shows that what we see in his works is not so much inattention provoked by drudgery and meliorated by moments of freer invention as *two species of attention,* with complementary virtues. One is an utterly unhurried meditation, a uniform myopia, much as in some medieval illumination. The copyist's body is not cramped, but also not relaxed; it has the

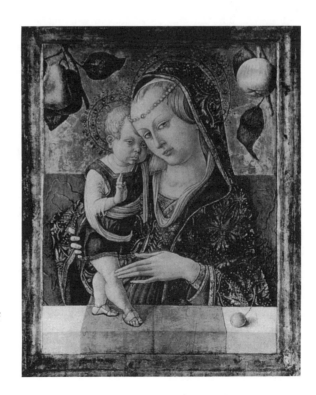

Fig. 4. Carlo Crivelli, *Madonna and Child.*, 1480–85. Washington, D.C., National Gallery of Art

15. This is explored in my "On Modern Impatience," *Kritische Berichte* 3 (1991): 19–34.

kind of working tension that happens in any repetitive task. Like actual weaving or mending, the brocades in Crivelli's paintings are the objects of steady, patient attention. The other kind of attention, the one given to the odd details, is an occasion for special concentration. The body hunches up, the fingers cramp, the eyes squint, and the face wrinkles. It is unpleasant but also exhilarating, and it punctuates the longer periods required for more measured work.

The two species might be retrieved for art history by drawing a parallel with two aspects of religious devotion: Crivelli's endless brick walls and patterned fabrics may be visual rosaries, species of prayer. Roberto Longhi saw signs of a declining art in the "decorative exuberance" of vines and flowers in Crivelli's *Madonna della Candeletta,* but they may also signify a measured, ritualized devotion; one counts the pears and oranges as one counts beads in a rosary.[16] The second kind of attention is not unlike homilies, the sacrament, and other moments of articulation of the Catholic Mass. A few cherries and pearls punctuate the *Madonna della Candeletta* as the sacrament punctuates the mass: they belong to the same fabric, but they command a different kind of meaning or reverence.

It may well be that this is overconceptualizing two kinds of uncognized habits of the arm and eye. But such meanings could be brought into art history more readily than the "meaningless" local dramas of light and dark in El Greco, because each orange and each pearl might be given a meaning (each might be the visual equivalent of a rosary bead or a sacrament). They are visible in the completed paintings, rather than half-erased traces of something that happened before. But again, this is not evidence that art historians should draw before they write about works, since it would be unnecessary for an art historian to reexperience these ostensive acts of reverence: if the reading seems to make sense, it can be cited and added to any essay on Crivelli.

Another example may indicate how bodily experiences can become increasingly difficult to reshape into historical narrative. Matthias Grünewald, best known for his Isenheim altarpiece and other paintings, also produced a number of drawings that make use of a bewildering variety of marks. At times he allows the force of his hand against the paper to trail away to nearly nothing, so that his silverpoint just touches the surface or flits above it, like a gnat tapping the skin. Other passages are done by compulsively scoring or scratching; they remind me of a compulsive, violent motion more like Lady Macbeth's rubbing than controlled drawing. The common late medieval "iron filing" marks (short aligned strokes), made with a tightly clenched hand, are expanded at times into Italianate gestures using the entire forearm in large light feathery motions. Grünewald also rubbed his drawings, and some passages are scraped with the back of the metalpoint tool.

16. Roberto Longhi, *Viatico per cinque secoli di pittura veneziana* (Venice: Sansoni, 1946), 57, discussed in Pietro Zampetti, *Carlo Crivelli* (Florence: Nordini, 1986), 291.

There is a kind of unstable psychology at work in these choices. Faint tapping, I think, is the antidote to energetic rubbing. A whisking mark that scarcely touches the paper is a way of making an atmospheric drawing, but it is also a tactic for avoiding the temptation to rub. Often the act of copying will tire specific muscles, and that can be taken as a clue about how the drawings were made. Late medieval drawings can provoke cramps in the hand and the neck, as the copyist spends hour after hour hunched close to the paper or parchment. Italianate drawing can induce a general fatigue, in line with the Italian practice of a differentiated engagement with the work, including both details and broad gestures. The muscles' memory of making a Grünewald drawing is neither cramping nor fatigue. Instead, I would describe it as a dissatisfaction with musculature itself, an unwillingness to settle for a single moderate pace or set of paces. Sometimes one sits hunched-up over the table; other times one draws loosely, perhaps even standing up. There is no satisfactory or ideal position or gesture: it seems Grünewald moved from a cramped hunch to a leisurely inspection, from a delicate touch to a determined attack that at times even pierced the paper.

If I were to assimilate this to art history, I might say Grünewald's giddy swinging between extremes and his concomitant anxiety about their relation is typical also of his stylistic affinities and his particular historical position as a self-contradictory amalgam of medieval and Renaissance traits. In that case the schizophrenic marks could be understood as ways of expressing a certain historical position, hung up between Renaissance and medieval sensibilities. An art historical account might take up these parallels or embark on a more psychological or psychoanalytic interpretation, but it would probably only do so at the cost of the intricate dynamic of tense tapping and abandoned rubbing and of the unsteady effort directed at controlling and balancing the two.

These meanings conjured by bodily states in Crivelli and Grünewald may be more resistant to art historical narratives than the less somatic and more intellectual vicissitudes of color, light, and contour that I named in El Greco and Titian. There are examples even less amenable to history than these; two more will help frame the conclusions I want to make. Like a fresco, an engraving is done passage by passage, but unlike fresco, the unworked parts of the engraving are invisible, since they are covered with paper to avoid fingerprints. Engravings too have *giornate,* not literally days' labors, but areas worked all at once. Hence the experience of engraving involves a mnemonic exercise: one tries not to reproduce forms invented elsewhere, and at the same time, one recalls and varies solutions from other parts of the plate. A more detailed account of engraving than art history currently possesses could address the similarities and dissonances that occur because the artist needs to remember what has been done. There are very few nameable examples of this. Dürer is an interesting example, since he develops homomorphic relations between objects such as clouds, skulls, rocks, and roots,

and that may be partly because he does not quite remember forms that have been covered with paper.

Memory also plays a part in traditional oil painting. Some Renaissance oil paintings were begun with *grisaille* underpaintings, which tended to be fastidious in the late medieval manner. Some were done in tempera, and they could be rather polished, with thin dark tones through which the preparatory underpainting (the imprimatura) might shine. But the painting proper, which went over the *grisaille,* could differ radically from those delicate underpaintings. The experience of copying such paintings shows how much memory and anticipation have to do with that kind of layered painting. No portion of the canvas or panel will look like it is intended to until the last layer is set down; and that is in strong contrast to modern *alla prima* painting, where a portion of the painting—say, a face in a portrait—might be completed, when the rest is hardly begun. A painting that uses imprimaturas and a *grisaille* has to be planned with an eye to what cannot be seen: the color of the imprimatura has to be thought through, so that it can lend just the right darkness to the shadow areas of the completed picture, and the *grisaille* needs to be kept on the light side, so that the darkening local colors will balance the painting's value to the proper point. In process the painting is lighter, less intense chromatically, and less well defined than it will be when it is finished.

These are experiences of memory and of visualization, and they have had little interest for visual theory or art history. Even though memory has connections with the Renaissance and baroque history of ideas, from the *ars memorativa* to the Jesuit spiritual exercises, these acts of memory are nonnarrative. Religious and secular arts of memory had to do with remembering verses, doctrines, prayers, or narratives, but these painterly acts of memory typically leave no discernible traces on the narratives or formal arrangements of the artworks. There can be no visible difference between those original areas of a painting that have been executed by a graded series of layers, none of which will look right until the last one is in place, and passages of that same painting that have been repaired in the contemporary restorer's fashion by painting in a single layer. Memory and anticipation are evanescent accompaniments to creation, and they remain behind as memories when the artist or copyist looks at the finished work, but they are usually invisible and unavailable when it comes to art historical interpretations.

The nameless local dramas of light and shade (in El Greco and Titian), the mediation of the body (in Crivelli and Grünewald), and the filtering of experience through memories (in engraving and fresco) are more or less outside the meanings art historians assign to pictures. Each of them can be partly excerpted from the studio and placed within existing art historical narratives. But the parts that remain are untranslatable or "meaningless," and so I take them as clear markers of the ways that art historians might go in order to leave their conceptual

sameness. If, as historians, we do not follow such leads, it is not because the logocentric paradigm somehow compels us to remain behind: it is because we do not want to overturn the orderly flow of meaning in our texts.

TWO SMALL STONES, PLACED IN A V

It is important not to underestimate the coercive power of our sameness. Art history can exert a strong pressure on these unruly sources of meaning, bringing them back into the fold of conventional meaning. Particularly strong evidence for that is the fact that any observation made in the studio that can be written in sufficient detail can then be appropriated into the corpus of art historical writing, where it is apt to become yet another argument why students need not practice studio techniques. The entirety of these examples, even though they are partly inassimilable, is subject to citation, and if a gesture in the "practice" of *technē* can be written as a concept in the "theory" of *technē,* it will become the property of history, and there will be no pressing need to obtain it again in the studio. It may be that others will discover that there are things to be done in the studio that both are and are not part of writing—things that cannot be systematically pressed into language but that can still find ways to connect with writerly concerns—but I have not found examples of such marginal acts. In general, if an act can be given historical meaning, the conceptual apparatus of art history can pull it back, away from the studio and into the world of texts, slides, and libraries.

As I walk away from Dún Dubhchathair, I can look back and see its form on the horizon, perched at the top of its cliff. It is a peculiar site, lonely, somewhat lost in history—the dates for Irish ring forts vary from 1500 B.C. to A.D. 1500—and relatively neglected even on its island in favor of the more spectacular fort of Dún Aonghasa. The ring forts are continuously battered by tourists, winter winds, sheep, and local inhabitants in search of rabbits, and they are built up again by groups employed by the Board of Works. Most of the larger forts had buttresses added in the nineteenth century, and in many cases it is no longer possible to know what they originally looked like. Several times I have paused at a portion of broken-down wall and rebuilt it using the scattered stones I found within arm's reach. When I rebuild, I try to follow the patterns I see on the rest of the wall, but they are elusive. In some places the walls were made by randomly heaping stones, but more commonly there is some trace of a pattern in the making: if I stand back far enough, I can see rough pyramids of stone with random fill between, or a ragged zigzag of flatter stones heaped with large stones, or irregular piers with random fill. Each time I have put a stone back, and each time I have read about dry-stone construction, my understanding has changed.

The act of rebuilding in turn changes the fort and changes my perception of it. Though I can see what is wrong with some previous efforts at restoring the walls, I am not confident that my own version is any closer to the original, and I restrict myself to small jobs. But even two stones laid one against the other in a V-shape alters the structure. It is my contribution to the fort's meaning: too minor, too subtle, too poorly cognized, too "meaningless" to be worth mentioning in an archaeological report, and too specific, too private, too expressive of my own late place in history to find a place in an art historical account. It is a fragment of meaning that passed from my hands to the monument, a small shard of meaning as hidden from art history as the makers of the fort itself.

There are many partial solutions to Heidegger's criterion of undecidability that can make Being and human being momentarily "codependent," if not "equiprimordial": each of those I have named involves an inassimilable interaction between mark and meaning, and several also blur the mark and its maker. Copying itself blends the painter and the beholder, the artist and the historian. Even so, examples like these drain away into art history or back into the studio, and they are generally not perceived as challenges within art history or philosophy. It seems to me that the law by which art historians exclude such ostensibly intractable elements is nothing as profoundly abstract as Heidegger's speculations. As Philippe Lacoue-Labarthe has argued, Heidegger's manner of writing can also be understood as a defense, a choice whose reasons extend beyond his ostensive arguments and reach into a fear of difference, illegibility, and ultimately insanity.[17] Sameness is intimately related to sanity, and texts such as *Painting as an Art* are also pleas—or demonstrations or certificates— of a particular kind of reasoned sanity in relation to the unreasonable nature of painting.

What we want to call theory (and, sometimes also, history) is a kind of writing that maintains a certain speed and keeps a certain distance from the pictures. It is measured, careful with itself, smooth, uniform, and self-similar. The logocentric paradigm is the name of the license that permits us to preserve the flow of meaning from object to observer, to retain workable distinctions between mark, maker, and observer, and above all to accomplish a measured isolation from works and texts. We write as we please. It is under the rubric of that pleasure that I would locate the most persuasive reasons why theory sees some objects and is blind to others; but before we go in that direction, I want to consider a case where sameness breaks down entirely in the name of superlatively close reading.

17. Philippe Lacoue—Labarthe, *Heidegger, Art, and Politics: The Fiction of the Political* (Oxford: Oxford University Press, 1990).

3 ON THE IMPOSSIBILITY OF CLOSE READING

Close reading of visual images is a constant ideal in art history and criticism: it is virtually never questioned, and in general it seems to be a good idea in any field, for any purpose, and under any theoretical regimen. Its genealogy begins where art history does, with antiquarianism and connoisseurship in the seventeenth and eighteenth centuries, and ascends through nineteenth-century Morellian methods, branching and proliferating in the twentieth century into style analysis, formalism, and iconography.[1] Carlo Ginzburg's overread essay on Morelli, Freud, and Sherlock Holmes remains the principal source for the history of the idea, though Ginzburg's concatenation of connoisseurship, psychoanalysis, art history, and detective novels could have been expanded by consideration of the way the same term is used in philology and literary criticism—including Ginzburg's own essay, which becomes an example of the method it exposits.[2]

It is questionable how much sense it makes to call such far-flung practices a "method," as Ginzburg does; instead, I would say that different methods grow from the enabling concept of close reading. The transparent nature of that concept would seem to forestall any direct analysis or critique; whatever a close reading may be in practice, the concept of close reading remains nearly intangible. Accuracy and even insight are intuitively tied to the closeness of a reading, regardless of disputes about evidence or theory. The unobjectionable universality of close reading is most apparent in our inability to think what kind of visual artifact (or text, or crime scene, or narrative) might not be best understood by close examination. In short the purposive vigilant scrutiny of every mark or sign seems to be a foundational principle of understanding, whether the object is the most recent installation art or the oldest markings on stone. After close reading, reading can relax, and there are many ways to interpret quickly, to make epitomes and outlines, to paraphrase and abbreviate, to schematize and

1. Among other sources, see Roland Kany, "Lo sguardo filologico, Aby Warburg e i Dettagli," *Annali della Scuola Normale Superiore di Pisa, Classe di Lettere e Filosofia,* ser. 3, vol. 15, no. 3 (1985): 1265–83.
2. Carlo Ginzburg, "Morelli, Freud, and Scherlock Holmes: Clues and Scientific Method," *History Workshop* 9 (1980): 5–36.

summarize and condense and abstract: but each one of them is dependent on the possibility of a logically prior close reading.

When readings are questioned for their closeness or sloppiness, the purpose is usually to elicit the historians' covert agendas and to show how theory determines what and how we see. But that kind of critique has more to do with the construction of history than with close reading itself. It is possible to doubt that someone's reading is as close as it might be, or to claim it is skewed by prejudiced seeing, and at the same time never begin to doubt close reading itself. Here I try to open a critique of close reading, rather than the purposes to which it is put. In the end I argue that in effect close reading does not exist: in the strict sense it is impossible because any reading is composed of echoes of looser accounts and suppressed promises of even closer readings. I do not mean that close readings exist, even though each close reading is tied to looser and tighter readings: instead, I mean that close reading does not exist, that no close reading has ever been made, because what we understand as a close reading is a promise, something that is evoked and intimated, a specter that can only be grasped by conjuring and then repressing other kinds of reading. That which appears as close reading in innumerable texts—including Ginzburg's—is a moment of incomplete awareness, built on self-contradiction and the resurgent hope of intimacy with the object.

As an example I take the work of the archaeologist and art historian Alexander Marshack, and I would like to imply—though I do not argue this directly—that Marshack's methods make him one of the most important art historians of the century, one whose work deserves the attention not only of all art historians but also of anyone involved in the project of seeing and interpreting as finely as possible.[3] Marshack's questions are especially exemplary for art historians who are engaged in analyzing gestural brushstrokes, individual marks, color areas, facture, and other phenomena that are taken to be minimal components of pictorial meaning—lexemes, in the semiotic term, out of which the larger signifying units of pictures are built. Semiotic art history in particular needs to be clear about the place where "subsemiotic" signs leave off and minimally semiotic signs begin; and I suggest at the end that Marshack's analyses press that point as no others have done.[4] Marshack's approach takes some introducing; after examining one of his analyses, I outline the kinds of response he has received and sketch the reasons why his work exemplifies the conceptual impossibility of close reading.

3. See "Before Theory," my review of *Masking the Blow,* by Whitney Davis, *Art History* 16, no. 4 (1993): 647–72.

4. For a way of distinguishing subsemiotic from semiotic and suprasemiotic (i.e., aggregative) signs, see Mieke Bal, *Reading "Rembrandt": Beyond the Word-Image Opposition* (Cambridge: Cambridge University Press, 1991), 400–401 n. 16.

MARSHACK'S READINGS

Marshack's accounts of marks on Upper Paleolithic and Mesolithic bones, slate, and amber are among the most careful analyses in all of archaeology as well as in art history and criticism, visual theory, connoisseurship, and conservation.[5] He looks closely, literally with a microscope, but unlike painting conservators he also looks at *every* mark on a surface or artifact, and his looking does not cease until he has satisfied himself that he has distinguished all intentional marks from unintentional or random marks, ordered the intentional marks in chronological sequence, distinguished directions in which marks were made, noted where tools were lifted from the surface and where they remained in contact, and determined how many tools or cutting edges were used to make the marks. His analyses are lessons in looking: forcible patient attempts to see *everything*, together with a concerted effort to conclude *nothing* that cannot be empirically demonstrated.

Marshack's central claim is that many Paleolithic markings—even tiny ones, at the threshold of unaided vision—are notations recording the observational points of the lunar cycle. A notation might be started, for example, at new moon and continue as an accumulation of marks, grouped according to observational points in the cycle such as half-moons, new moons, or full moons.[6] It is a hypothesis that might appear to be readily susceptible to various counterclaims, and in fact Marshack presents it as a reasoned scientific hypothesis of exactly the kind that should be open to empirical falsification. Yet that genuinely scientific attitude has gone largely unread, and scholars have been more struck by the persistence with which he has explicated his thesis over a period of more than thirty years. The archaeologist Denise Schmandt-Besserat, for example, has said that Marshack's theory of lunar records "cannot be proven or disproven nor can it be ignored."[7] Whitney Davis dedicated a book on late prehistoric Egyptian art to Marshack, whom he says "has been asking questions that I am not sure any archaeology or art history could answer."[8] Donald Preziosi has recently used

5. Alexander Marshack, *The Roots of Civilization: The Cognitive Beginnings of Man's First Art, Symbol, and Notation* (New York: McGraw-Hill, 1972). The second edition (Mount Kisco, N.Y.: Moyer Bell, 1991) contains several significant revisions and a new section at the end.

6. This is different from the claim, which I had initially taken Marshack to have been making, that the Paleolithic notations record the phases of the moon in the way a modern astronomer might. The point is rather that the Paleolithic engravers had a "tendency" to begin or end their sets of marks at observational points: hence their "completed" artifacts need not be arithmetically accurate, but will tend to dispose themselves in groups according to potentially observable lunar sequences. The lunar model, in turn, is astronomically correct and can therefore be employed to test possible correlations with Paleolithic markings. See Marshack's reply to James Elkins, "On the Impossibility of Close Reading: The Case of Alexander Marshack," *Current Anthropology* 37, no. 2 (1996): 211–14.

7. Denise Schmandt-Besserat, *Before Writing* (Austin: University of Texas Press, 1992), 160.

8. Whitney Davis, *Masking the Blow: The Scene of Representation in Late Prehistoric Egyptian Art* (Berkeley and Los Angeles: University of California Press, 1992), xvi. Davis doubts a number of Marshack's

Marshack's research uncritically, as an example of the most interesting kinds of questions art history can ask.[9] (It is characteristic that these positive assessments are not accompanied by further close readings. Preziosi calls Marshack's work "emblematic of the poststructuralist critique of verbocentrist structuralism," but he omits a discussion of the "detailed arguments" that would support the point.[10] It is a typical effect of extremely close readings that they pass outside the normal protocols of interpretation and are skipped in more general accounts.)

It was praise like this that first attracted me to Marshack's writing, and what kept my attention was a strange dynamic that has repeated itself over the years as archaeologists have raised objections and Marshack has replied and gone on to make new, even more detailed analyses. The lunar hypothesis often seems patently unlikely, but Marshack's detractors seem to have no purchase on his methods and no power to overturn his conclusions.[11] It seems easy to say that Marshack is seeing too much and trying, for example, to interpret careless decoration or meaningless tool-sharpening marks as deliberated calendrical notation. But when these and other problems are brought up, the result is almost invariably the same: the people who object are led to see that they have been operating with certain preconceptions about how accurate marks should be, or what decoration is, or how it is different from notation. What appear to be glaring mistakes in Marshack's method turn out to be unresolved aspects of our habits of seeing. The critics are silenced, in effect, by unanswerable questions: What should a Paleolithic image look like? What is decoration, and how does it differ from notation? Marshack's analyses, perhaps more than any others in the history of

particular methods, assumptions, and conclusions, as he has said in essays in *Current Anthropology* and elsewhere. But he finds Marshack's questions often unanswerable within art history as it is constituted. See also my review, "Before Theory."

9. Donald Preziosi, *Rethinking Art History: Meditations on a Coy Science* (New Haven: Yale University Press, 1989), 133–42.

10. Preziosi, *Rethinking Art History,* 141. Marshack's "detailed arguments," Preziosi writes, "will not be followed here; for our purposes, Marshack's conclusions and some of their implications will suffice"; and he directs the reader to a 1979 exchange in *Current Anthropology* for an "overview of the issues involved." The problem here is that the millimeter-by-millimeter way that Marshack reads offers the only possibility of understanding his ostensible methodological breaks with structuralism. See Preziosi, *Rethinking Art History,* 141–42, and 231 nn. 34 and 44, citing Marshack, "Upper Paleolithic Symbol Systems of the Russian Plain: Cognitive and Comparative Analysis," *Current Anthropology* 20, no. 2 (1979): 271–95, with comments and Marshack's reply on 295–309.

11. The work of Francesco d'Errico—for example, "Paleolithic Lunar Calendars: A Case of Wishful Thinking?" *Current Anthropology* 30 (1989): 117—is cited as the most serious challenge to Marshack's work. D'Errico works with an electron microscope, and some of his objections are cogent; but from the point of view I am adopting here, his analyses raise more problems than they solve. They are extremely idiosyncratic, both graphically and methodologically, and they deserve a separate study rather than a precipitate comparison with Marshack's work. See also Marshack's full-scale study, "The Taï Plaque and Calendrical Notation in the Upper Paleolithic," *Cambridge Archaeological Journal* 1, no. 1 (1991): 25–61.

art, force these questions into the open and allow us to begin to see how we see and what we think images are.[12]

In what follows I am going to do what has, significantly, I think, seldom been done in the literature up to this point: I am going to make a reading of one of Marshack's readings that is closer than his own reading. Since the original text I analyze is less than a full page (though it is interrupted by illustrations and occupies parts of four pages), I quote it in full, so it can be read within my text as a sequence of indented paragraphs.[13]

The Bâton in the Musée des Antiquités Nationales

In *The Roots of Civilization*, from which this example is taken, Marshack sets the stage for each new object with a brief narrative. In this case he has just discussed a large bâton made of a bone, sculpted into a fox's head at one end, pierced with a hole, and engraved in rows of notches. The text continues:[14]

> In cabinet number one at the Musée des Antiquités Nationales, not far from the large bâton, lies a smaller, fragile, better-worked bit of bone, discolored a dead grey with time. It is the handle of a bâton, with the head and hole broken off, but with the arc of the hole visible at the break. It too comes from Le Placard, apparently from the Magdalenian IV, and may be a few years, a few hundred years, or a few thousand years later than the bâton with the head of a fox. Since it is a fragment, it has not been considered an important find. It is marked with what has been traditionally called decoration in a "geometric" style [Fig. 5, top].

Marshack directs the reader to an overall shot of the front face of the bone (Fig. 5, top). Then the reader is invited to move in on the object and review its markings more attentively (Fig. 5, bottom):

12. I am only considering these issues from the point of view of the question of close reading. For recent archaeological and historiographic work on this topic, see Whitney Davis, "Beginning the History of Art," *Journal of Aesthetics and Art Criticism* 51, no. 3 (1993): 327–50, revised in Davis, *Replications: Archaeology, Art History, Psychoanalysis* (University Park: The Pennsylvania State University Press, 1996).

13. The plate numbers in brackets in my quotations replace figure numbers in parentheses in the original text; they are not interpolated references. I have redrawn the line drawings in Marshack's text.

14. To avoid confusion, since I cite the text in its entirety, I have omitted page numbers. The discussion begins on page 91 of *The Roots of Civilization* (first edition) and ends on page 94. Marshack's photographs have been retained here, though their numbers have been changed in my quotations.

The bâton has been worked to create four flattened sides, and on one of these there is a raised platform on which the markings were made. The handle itself is unbroken and the markings on it are complete. It is possible, then, that we have all the markings originally made.

The next paragraph announces the results of microscopic analysis. Virtually all of Marshack's studies are done with a microscope; he makes photomacrographs and photomicrographs, and uses them to help modify and complete the notes he makes in the presence of the object. This particular paragraph is interrupted in a spectacular fashion: the first sentence is interrupted by the end of the page, and on turning the leaf the reader is confronted with a full-page, marginless illustration of a tiny portion of the bone, at a magnification of about fifty times (Fig. 7). Marshack continues:

> Microscopic analysis of the main face [Fig. 5, bottom; Fig. 6] revealed sets of parallel lines made by 10 different [engraving] points, with groups that seem to contain "symbols" and "signs."

As a first step in the microscopic analysis Marshack distinguishes several series of marks made by different burins:

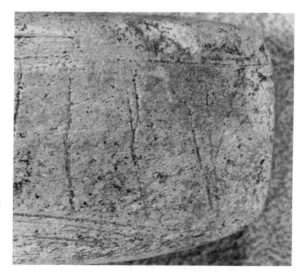

Fig. 5. Broken bâton
from Le Placard, Charente.
7½". Musée des Antiquités
Nationales

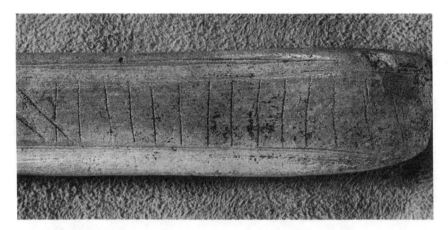

Fig. 6. Bâton from Le Placard, detail

At one place a mark at the end of a series of 14 lines, all made by a sharp, thin point, is crossed over by another that point that scratched a flat floor with two small points at each side [Fig. 7].

The reference here is to the full-page photograph, which is enlarged so much that at first it is difficult to tell that the marks sloping up and to the left are a single stroke of the burin, leaving a double line and a corrugated "floor." The purpose of the large illustration is to make the point that different engraving tools were used—a crucial step in the argument that this is not "decoration in a 'geometric' style." The paragraph continues:

> This broad stroke begins the next series. Since the broad stroke occurs over the fine stroke, it must have been made later, and the full sequence on this face begins at the right and reads to the left, towards the hole.
>
> The sequence begins with an odd, delicately scratched sign, visible under the microscope (see [Fig. 5]):

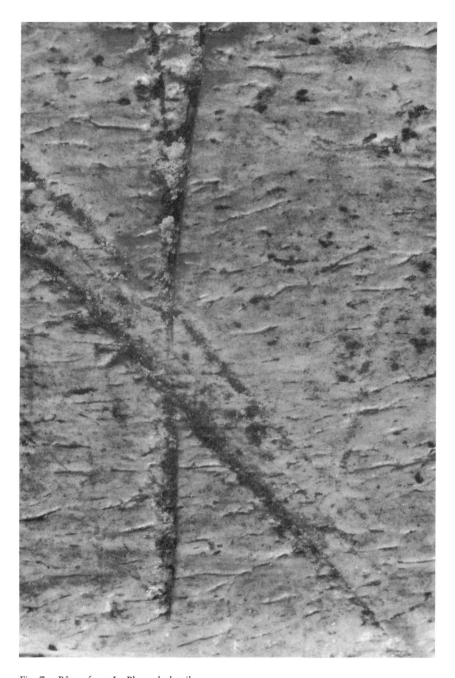

Fig. 7.　Bâton from Le Placard, detail

The figure reference here is to yet another detail, this time of the right-hand end of the bâton. This is the first moment that Marshack's reconstructions have to be taken for granted, since in my copy of *The Roots of Civilization* the best that can be discerned from the photograph is something like this:

But the marks are very indefinite in the photograph. The word "sign" does not appear in quotation marks this time, since the configuration is presented as the "odd" object that begins the first sequence; but by way of anticipating what he is about to do, he counts the nine component marks in the "odd, delicately scratched sign":

> It is composed of 9 strokes. This is followed by a somewhat curved "Y" of 2 strokes, made by another point:

Again the marginal picture in his text implicitly instructs readers about the limits of their participation in the decipherment and about the limits of Marshack's accuracy. The "Y" in Marshack's photograph is clearly different, something more like this (Fig. 5):

At this point it is apparent, as it would already have been for a reader who had followed *The Roots of Civilization* up to this point, that Marshack is relatively uninterested in the shape of the marks. I say relatively, since he is interested in shape insofar as it affects relative position—whether a mark is right or left of another, or above or below another in order of marking—and he is concerned with the shape of the floor of the mark itself. But the morphology of each mark is of less interest, because he is not going to be comparing configurations of overlapping or juxtaposed marks to other instances that might represent the same "sign" or "symbol." Marshack continues:

> This is followed by a series of 14 strokes, made by still another point; the last ends with 2 small appended strokes:

The regularity of the drawing of the twelve vertical strokes, as compared with the wobbly progress of the twelve marks as they appear in the accompanying photograph, makes it clear that Marshack's drawing presents what he calls elsewhere a "schematic rendition" rather than an exact rendering. He uses the phrase for line drawings that employ different symbols (such as x or +) to discriminate between marks made with different burins, and he uses it in the captions that elucidate his proposed lunar sequences (48, 193). This kind of linear schematization is purposely normative, and it is intended to make an underlying pattern visible. What it does in this example is erase whatever subtleties of arrangement might also have been meaningful, in favor of a more or less regular parade of equal marks. Here, more clearly than before, the formal qualities of the bâton are being regimented in favor of the notational hypothesis.

> The next series, made by another point, has 1 appended stroke at the end.
> The full sequence on this face, with the counts by changes and differences of point, is shown in [Fig. 8, top]. At the end of the series there are 10 strokes made by two points, in a 5 and 5 breakdown. Then, as though this fills out all the available notational space on this side of the bâton, *over* this, and between the last 5 long strokes, there are added 10 light strokes.

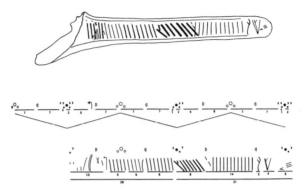

Fig. 8. Bâton from Le Placard, schematic diagram and
correlation with a lunar calendar

These last ten strokes place further restrictions on the reader's participation in
the analysis, since a look at Figure 5, top, shows something entirely different. I
would give it schematically like this:

The most important difference is that the two faint parallel lines in Marshack's
drawing (Fig. 8) seem clearly to be continued upward through the X that he
draws above them, and there are two very similar marks a little to the right that
he nearly omits altogether. From the photograph it seems irrefutable that these
two sets of parallel marks are made by single strokes and that their apparent
doubleness is merely the double floor created by the burin that made the marks
in the middle portion of the bâton. Several dozen other marks can be discerned in
the photograph, all of them fugitive and dependent on the quality of reproduction
in the book; but the sets of parallel lines seem to be as dependable as any form
that he reproduces in his sketch.

So again, in this case for the last time, the reader is warned away from too
close a viewing, or too close a reading of Marshack's text. It turns out this last
discrepancy is the most important:

All the marks on this face are intentional. It is obvious that this odd sequence of figures, counts, and groups is not ornamental or decorative, and that it is notational.

Here as elsewhere in *The Roots of Civilization,* the "ornamental" and "decorative" are disjoined from the "notational": nothing can be both decorative and notational. Decoration is imagined as an activity with its own agenda and rules that are incompatible with notation. The word "intentional" has particular valence in Marshack's writing, since he does not only mean it in a rigorous philosophic sense (as a mark interpreted to have been made with conscious purpose). He also intends something like "careful," since presumably a decorative treatment of this bâton would have shown evidence of being more sloppily and quickly done, with one burin, at one time. Again the status of the "signs," "figures," and "symbols" is in doubt, since there is an implication that the kind of care that went into making this notation is partly evidenced by the "signs"; but Marshack is about to ignore completely the signs in favor of merely counting their component marks.

Is it lunar? Assuming one stroke per day, we lay the sequence against our lunar model [Fig. 8, bottom].

The "lunar model" is the same throughout *The Roots of Civilization,* since it functions as an astronomically correct schema against which naked-eye observations can be matched.[15] Beneath the model Marshack places his schematic rendition of the marks on the bâton. The assumption, that one stroke equals one day, is consistent throughout the book and never defended as anything more than a working hypothesis.[16] In order to analyze the notation, both "signs" are

15. In one place Marshack is particularly emphatic about the difference between his claim to have found notation and his hypothesis of the lunar calendar: "Of the hundreds of incised stones throughout Europe that I have studied in the last quarter of a century . . . , not one has provided evidence for a linear, sequential 'lunar' notation." Alexander Marshack, "On Wishful Thinking and Lunar 'Calendars' " (reply to Francesco d'Errico), *Current Anthropology* 30, no. 4 (1989): 491.

16. Among the issues I do not touch on here are symbols and "symbol systems." See Alexander Marshack, "Upper Paleolithic Symbol Systems of the Russian Plain: Cognitive and Comparative Analysis," *Current Anthropology* 20, no. 2 (1979): 271–94, with replies on 294–311. One of the letters responding to that essay, by Zbigniew Kobyliński and Urszula Kobylińska, tries to define "symbol" as a "representational sign that is semantically opaque, i.e., in the words of Roman Jakobson, has a poetic function, or, as Soviet semioticians would have it, is self-reflective; directly signifies sense perceptions; is multivocal; and has high capacity for modelling and evokes emotional-motivational states and therefore is perceived as identical with its referent" (ibid., 301). The exchanges tend to run aground on theoretical imprecisions as much as on the reading of the artifacts themselves; but the topics always return eventually to what I am calling the rudiments of images.

Another topic is the origin of representation; Marshack has claimed that the earliest representations are meanders, which he understands as a " 'point marker' or symbol of change." See Alexander Marshack,

dissected into component marks, one for each night's appearance of the moon. He then concludes:

> This is an absolutely perfect tally for 2 months, beginning at last crescent and ending on the first day of invisibility 58 days later.
>
> We seem to have in this series a development of notational technique—recalling the accumulation of cueing marks of the Taï plaque [Fig. 9]—in which the seeming "signs" or multiple marks, made by appended strokes of arms and groups of angles, are used to indicate points of change in lunar phase. How are they used? The lunar model reveals that on the day of an expected lunar observation around a phase point a small stroke is used, as though an observation of the moon was impossible on that day and the stroke represented a day of waiting. On the next clear day of observation the new series begins with a different stroking. Interesting also is the indication of a notational significance for the "quarter" moon, the visible half-moon. None of this is difficult to understand. It is once more a visual notational technique. It is non-arithmetical and it is cumulative. Remember also that the bâton was engraved some 5,000 years before agriculture formally "began" in the Fertile Crescent of the Middle East and some 10,000 years before the formal "beginning" of writing.

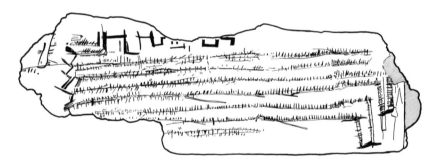

Fig. 9. Engraved fragment of a rib from the Grotte du Taï, schematic diagram by Alexander Marshack

"The Meander as a System: The Analysis and Recognition of Iconographic Units in Upper Paleolithic Compositions," in *Form in Indigenous Art: Schematisation in the Art of Aboriginal Australia and Prehistoric Europe*, ed. P. V. Ucko (Canberra: Australian Institute of Aboriginal Studies, 1977), 286–317. The quotation is from a reply by Joel Gunn, *Current Anthropology* 20, no. 2 (1979): 299. Marshack has treated naturalistic images in another essay, "Some Implications of the Paleolithic Symbolic Evidence for the Origin of Language," *Current Anthropology* 17 (1976): 274–82.

The account of the bâton winds to a close with an invocation of two further engraved sequences, on the back and on one side:

> On the reverse face of this bâton, scratched so faintly that even when held in hand most of the markings are invisible, yet clear under the microscope, is another unusual composition [Fig. 10]. Once more there is certainty of notation, apparently for two lunar months. The lines, however, are so faintly scratched that a ballistic determination of point differences is difficult, and some exceedingly faint lines are difficult to prove.
>
> This Magdalenian IV bâton reveals a further stage in the development of the notational technique and a possible development in the case and precision of lunar observation and use.
>
> A third style of marking, a development of that style of parallel stroking overengraved to make a crosshatching, occurs along one side of this bâton. It, too, gives a sum for two months.

The analysis ends in this way, with the puzzling "unusual composition" given a lunar phrasing of 27 + 30 days, and Marshack moves on to the next example.

COMING TO TERMS WITH THE LUNAR THEORY

As Marshack himself has noted on several occasions, a first encounter with the "lunar theory" can leave readers incredulous. I want to try to capture some of that in order to exhibit the unexpected dynamic that leads from the reader's certainty that Marshack is wrong to a nagging uncertainty about the act of interpretation itself. It is this motion, I think, that accounts for the idea that Marshack is unanswerable or that he cannot be disproved. Each of the important difficulties with his theory can be written as a problem of distinguishing—within

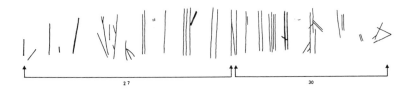

Fig. 10. Bâton from Le Placard, schematic diagram of back by Alexander Marshack

the mobile lexicon of the rudiments of visual configurations—between marks, icons, signs, schemata, notations, symbols, representations, and images. Over the course of his career Marshack has explored each of these, and they continue to be actively discussed in the field of Paleolithic archaeology; in this context I mention just three.[17]

1. *The problem of signs.* An initial difficulty, well exemplified in the analysis of the Placard bâton, is that the "signs" and "symbols" have no role in the final lunar tally: instead, they are picked apart into individual marks, and each mark is made equal to each other mark. At first that seems patently wrong: Why would a person arrange marks for appearances of the moon (or for any other phenomenon) into a carefully made, apparently intentional configuration, if all that was intended was a sequence of equal marks? It does not make sense, on the face of it, to propose that the meaning of the Placard bâton is a series of single marks, when it is composed of collected and arranged "signs" of various types. The reasoning seems no more defensible than if Marshack had taken apart a print by Dürer into its individual lines.

The apparent thoughtlessness of the analysis only seems worse when we consider what Marshack might reply. A reader of *The Roots of Civilization*, for example, might expect him to say that he is merely following good scientific procedure and taking one hypothesis as far as it will go. Marshack himself points out the "signs" and their arrangements—the first is called an "odd, delicately scratched sign"—before he goes on with an analysis that does not take them into account. The problem here, if we are to judge by the criteria of a scientific hypothesis, is not that he chooses to ignore the "signs," because no scientific theory need account for all phenomena presented by its sample—no close reading must be exhaustive. The "signs" have no meaning in the lunar schema, since both "signs" at the right of the bâton fall in the continuous period between the new moon and the first quarter. They may be meaningless, or they may have other meanings; Marshack could claim with perfect reason that they are not immediately under consideration.

But that does not justify the *way* he excludes the "signs." Marshack takes note of the relative positions of marks in two particular senses: he records how they cross over or under one another, and he is interested in the sequence of marks, in this case from right to left. He does not consider relative positions of marks in any other sense (say, their relative positions when they constitute a "sign"). The "signs" are collections of individual marks made from right to left. But positionality is what defines the shapes of the "signs," and so it does

17. For further development of this question of the influence of context on interpretation, see Alexander Marshack, "Reply," *Current Anthropology* 20, no. 2 (1979): 303, where he argues that such images may elude modern distinctions between "representation, icon, sign, and symbol."

not seem logically sufficient to disassemble them into their component segments without justification. In addition Marshack does sometimes interpret position in a wider sense. He notes the "appended strokes of arms and groups of angles" of some marks, and shows how they fit the lunar sequence. A "small stroke," he suggests, is used "on the day of an expected lunar observation around a phase point." These observations have to do with the height, faintness, and spatial positions of marks. Why do they matter in these instances and not in the case of the "signs"?

At this point it may seem that a critic would have a firm purchase on the analysis, both because marks are defined so oddly (in regard to some positions and ignoring others) and because the definition seems self-contradictory (since it variably excludes and includes spatial criteria such size). If size and depth and overlap of mark can matter, then why not also marks that just touch, as in the "signs"? But there are deeper problems that stall this kind of objection. Marshack can appeal to the specificity of the artifact: who is to say the marks were not made in a way that entails exactly this definition of position? After all, we are considering a period before writing and before signs; perhaps the configurations of marks were meaningless to their makers in precisely these ways. Everything is recent, and nothing is native, where Paleolithic artifacts are concerned: there is no cultural link, no shared tradition of meaning or marking. An intractable aporia is produced by the act of identifying and then declining to read "signs," since it must ultimately lead us to question the distinction between sign and mark, position-as-sequence and position-as-configuration.

It is also the case that Marshack *does* interpret "signs" and other sets of nonnotational marks in other notational contexts. His longest analysis—and one of the most intense and minute analyses of the semiotic elements of any visual object—concerns a four-inch bone fragment from the Grotte du Taï scored with hundreds of tiny nicks and grooves (Fig. 9). On that artifact Marshack finds notational marks—that is, the little hatches that appear here as vertical lines—and horizontal "containing lines" that serve to anchor the individual marks. But he also mentions " 'non-notational' directional cueing marks" defining the "direction and 'flow' " of the notation (at the lower right), "an initiating, 'non-notational' symbolic motif" perhaps representing "flow and motion" at the upper left, and "exceedingly fine engraved 'hair' lines" that "seem to mark the relevance of a day or period, but are distinct from the sequential accumulation of day units."[18]

Analytically, the most interesting moments in the account of the Taï plaque concern three further nonnotational forms in the object's upper-left corner, each one so small it is literally microscopic. The first is "a tiny horizontal containing

18. Marshack, *The Roots of Civilization* (1991), 28, 33, 47, 50, 60. Subsequent references in the text are to this edition.

line with 5 marks." In Figure 11, it can be found to the right of the letter B and just inside the enclosure of heavy black lines. Another is "a tiny short sequence of 8 to 12 strokes between parallel lines (a 'ladder')," visible immediately to the right of the "tiny horizontal containing line." Both of these, and especially the first, would be difficult to distinguish from the plaque's other containing lines and notational marks, but Marshack says they are "clearly not part of the central notation." In the far upper-left corner, above the letter A, is a minuscule rectilinear meander "form" with six marks inside and three more on one corner—a configuration similar to the "signs" that Marshack declined to interpret and determined to count in the Placard bâton. Here the configuration is treated as a "form" that may have "positional relevance" but is again not integral to the notation and therefore need not be counted (47). But why not? Because it is so much smaller than the other marks? But if so, then what determines the threshold of size beyond which a mark is no longer part of a notational sequence? The meander shape is also indistinguishably close to the " 'non-notational' directional cueing marks" at the lower right of the artifact, and the notational marks often miss their containing lines as these marks do. By what criterion is this not part of the sequence?

Before I draw a conclusion from these questions, it is worth noting that the answer cannot be historical. It is not sufficient to argue that "signs" of the type

Fig. 11. Detail of the extreme upper-left corner of the rib fragment from the Grotte du Taï, schematic diagram by Alexander Marshack

on the bâton are not likely to have meaning until the Neolithic, because at some point artifacts of the same age as the bâton will have had to have been analyzed and found deficient in "signs." Conversely, when representational signs occur— for example, the plant or "arrow" signs at Lascaux—their interpretation depends on assumptions about the *internal* rules of such images.

Marshack offers only a quick look at the back of the Placard bâton, but if we linger, we may begin to see the very "signs" and "pictures" that play such a large role later in *The Roots of Civilization,* where they are interpreted as "seasonal," "time-factored" images of plants. The little "sign" that looks like a bird's foot on the back of the bâton is quite similar to a sign at Lascaux that Marshack reads as a "simplified branch," in opposition to Leroi-Gourhan's interpretation of it as a schematic "feminine" vulva sign or the Abbé Breuil's reading of it as an arrow (223–24):

Meaningless
"sign" on the
Placard bâton

Branch in
Lascaux

Two configurations on the bâton that look like stalks (seventh and ninth from the left) are virtually identical to signs Marshack calls "plants" and "sprouts" in a later chapter (172, 216):

"Meaningless"
configurations on
the Placard bâton

"Plant" on a
bâton from Cueto
de la Mina

Marshack considers the problems of similar signs when it comes to Lascaux, since in that context he wants to show that plant signs on mobiliary artifacts might be close enough to some signs at Lascaux to imply they should be reinterpreted as plants (224). He does not reason that way about the Placard bâton, because

it is too early, but that does not explain why it is inappropriate to consider such possibilities in an analysis that presents itself as internal to the object.

To return to the questions about when "signs" should be read: once again— and I am only taking isolated examples from a large field of possible issues—the objection about the status of "signs" on the Taï plaque seems cogent, but it can only succeed in raising the issue of assumptions. The "tiny horizontal containing line with 5 marks" at the upper left of the Taï artifact is not read as notation, and the fourteen lines *are* read together as a "form," while the nine lines of the "odd, delicately scratched sign" at the right of the Placard bâton are read as notation. Each reading devolves from different assumptions about the possible relations of signs to individual marks. But what determines when marks are "executed differently" or may "represent a different category of marking"—as Marshack says in another context, justifying the nonnotational character of a set of marks—and therefore require a differing interpretation (59)? Certainly the relation of one mark to others is essential in any assessment, but how is it possible to determine when the "position within the frame" is different *enough* to cross the border between mark and sign? Any and all objections of this kind, which are the only objections that are cogent within the terms of the text, must appear as rival hypotheses, and in that capacity they return to the questioner in the form of counterquestions about the reader's axioms concerning the nature, relation, and disposition of marks.

2. *The problem of notation.* The lunar sequences have bothered readers of *The Roots of Civilization* a little each time they are shown, because the fit and the principles of correspondence between marks and model differ with each succeeding example. Absolute accuracy is impossible and therefore mean-ingless, because, as Marshack indicates, the lunar cycle does not factor evenly into days and because measurement without instruments is always a matter of guesswork: the crescent moon cannot even be seen earlier than fifteen hours after it is new, and there is a corresponding problem judging the hour of fullness.[19] But the absence of an absolute standard does not mean that relative accuracy cannot be measured or that the principles of posited correspondence cannot be compared.

Responding to Marshack's analyses, Arnold R. Pilling objected that Marshack had failed to provide evidence that "any two objects have on them the *same* notational system."[20] Every calendar is the same, and all astronomers agree on the moon's phases; hence it seems improbable that a "continent-wide *system* of

19. Marcel Minnaert, *The Nature of Light and Colour in the Open Air,* trans. H. M. Kremer-Priest, rev. K. E. Brian Jay (New York: Dover, 1954).

20. Arnold R. Pilling, reply to Alexander Marshack, "Cognitive Aspects of Upper Paleolithic Engrav-ing," *Current Anthropology* 13, nos. 3–4 (1972): 469; see also Mary Aiken Littauer, "On Upper Paleolithic Engraving," *Anthropology Today* 15, no. 3 (1974): 328.

notation" would not show more self-consistency.[21] The assumption here is that notation of a single phenomenon involves detectably uniform representation. But that is our own notion of notation, and it need not fit the Paleolithic one. In what sense are the lunar phases a single phenomenon, aside from our certainty that they are? To some readers, Marshack's analyses seem to be mathematically indefensible, since he accepts so many sequences as lunar cycles.[22] By modern standards of evidence, he is playing with numerological coincidences rather than requiring determinate ranges of fit; there is no mention of the usual scientific criteria for probabilistic matching, such as combined systematic and statistical error, quantified normative models, or standard deviations. In terms of scientific method, there are often more marks in a given artifact that do not correspond to meaningful phase changes than marks that do, and more inconsistencies than parallels. Statistically speaking, Marshack's hypotheses for objects such as the Placard bâton are a bad fit. Intermittently throughout *The Roots of Civilization* Marshack says he tried many different correlations and picked the best one, but the reader is left with the impression that others might be as good. In general, he claims to have done a great deal of empirical testing, which he has consistently not reported in his texts. There can be no doubt that he does perform such tests. In one passage, for example, a colleague mentions "[m]athematical, statistical, graphic, and sequential analysis of the results of . . . microscopic studies."[23] Still, in scientific terms these are serious, even crippling omissions. Marshack's principal attempt to redress that again omits the hypotheses and accounts of methodology that are standard in laboratory research.[24] "Tests can be tried, within a range of possibilities, by anyone interested," he remarks at one point.[25] That is not entirely an interesting prospect, since, if I were to try to rematch the lunar sequence, I would be reproving his hypothesis. Any rematch would be another instance of the same theory. There is no way to disprove the theory by adjusting the lunar sequence, and so the positioning comes to seem somewhat arbitrary. A reader of *The Roots of Civilization* will tend, I think, to find each sequence about as plausible as every other—a scientifically untenable situation.

But to all these questions, Marshack could ask in return what model and what criteria might be preferred in analyzing notations that are prearithmetical: the supposition is that they were made before there was such a thing as an arithmetical system that would allow the summing of numbers or sets of numbers

21. G. F. Fry, reply to "Cognitive Aspects of Upper Paleolithic Engraving," 464.

22. J. David Lewis-Williams and Thomas Dowson, "Theory and Data: A Brief Critique of A. Marshack's Research Methods and Position on Upper Paleolithic Shamanism," *Rock Art Research* 6 (1989): 42–50, esp. 49.

23. Hallam L. Movius, reply to "Cognitive Aspects of Upper Paleolithic Engraving," 486.

24. Marshack, "The Taï Plaque."

25. Marshack, *Roots of Civilization* (1972), 86.

greater than, say, the range from one to ten.[26] Wittgenstein thought of this problem, correctly, I think, as an instance of the more general question of understanding when someone is following a rule. At one point in *Remarks on the Foundation of Mathematics,* he even imagines a "cave-man" who makes surprisingly ordered marks for no clear reason:

> There might be a cave-man who produced *regular* sequences of marks for himself. He amused himself, e.g., by drawing on the wall of the cave:
>
> — · — — · — — · — — ·
>
> or
>
> — · — · · — · · · — · · · · —
>
> But he is not following the general expression of a rule. And when we say that he acts in a regular way that is not because we can form such and [such an] expression.[27]

For the present purposes, it is safe to ignore the phrase "he amused himself," since Wittgenstein probably meant it as a reminder that the caveman's intentions and language are inaccessible. Wittgenstein also imagines a thrush that "always repeats the same phrase several times in a song." Are we to conclude that "perhaps it gives itself a rule each time, and then follows the rule?"[28] The stories show that regular actions need not follow regular rules and that private "amusements" do not have rules in the ordinary sense. In the case of actual Paleolithic notations, there is no mathematical standard available to use as a criterion of adequacy, since marks give no evidence of the marker's conception of lunar phases—or, to say it a little less exactly, the marks *are* the marker's conception of notation. Should any notation be uniform, if notation itself was in its infancy? Should any fit be optimal, if the idea of representation itself was still inchoate?

In this way cogent objections about Marshack's lack of statistical rigor get turned into questions about the universality of quantification, numeration, and

26. There is no necessary one-to-one correspondence between marks and days, so that, in Marshack's words, "[s]mall sets of days could . . . be counted and marked at one moment and longer periods of observation would be marked each day without counting. This is the type of observation and counting common in many non-arithmetical calendars." See Marshack's reply to "On the Impossibility of Close Reading," 213; and idem, "The Chamula Calendar Board: An Internal and Comparative Analysis," in *Mesamerican Archaeology: New Approaches,* ed. Norman Hammond (Austin: University of Texas Press, 1974): 255–70, esp. 265; and also idem, "A Lunar-Solar Year Calendar Stick from North America," *American Antiquity* 50, no. 1 (1985): 27–51, and idem, "North American Indian Calendar Sticks: The Evidence for a Widely Distributed Tradition," in *World Archaeoastronomy,* ed. Anthony Aveni (Cambridge: Cambridge University Press, 1989), 308–24.

27. Ludwig Wittgenstein, *Remarks on the Foundation of Mathematics,* ed. G. H. von Wright, R. Rhees, and G. E. M. Anscombe (Cambridge, Mass.: MIT Press, 1983), 344.

28. Ibid., 345.

rigor itself. There have also been objections to Marshack's reliance on tiny marks, at the threshold of invisibility.[29] But why assume that the notations were referred to later or that they could be read? Perhaps these notations were kinaesthetic: their meaning, as we would put it, was in their making. In that case any size that the burin could scratch would count; and as a corollary, the engraver might be indifferent to the size of the marks within the limits of the register lines or the available surface. Our thoughts about clarity and legibility—concepts that loom large in current texts on graphic communication—depend on the notion of notation as something that can be efficiently read; but why assume it should be read at all?

Marshack is emphatic about the difference between his claim to have found notation and his hypothesis of the lunar calendar: "Of the hundreds of incised stones throughout Europe that I have studied in the last quarter of a century . . . not one has provided evidence for a linear, sequential 'lunar' notation."[30] If the claim and the hypothesis are kept separate, then the inadequacy of scientific objections to the lunar calendar becomes more obvious. The lunar calendar is susceptible to a number of critiques about methodology and falsification, but each of them has to appeal to a prior sense of notation. And what do we know about notation that might serve as a basis to argue against Marshack? Under what circumstances, with what evidence and what rules of interpretation, can we critique his assumptions?

3. *The problem of decoration.* If "decoration" could be kept in quotation marks (as it often is in the recent literature) or defined negatively as nonutilitarian, nonsymbolic, or nonnotational marking, then there would be no special problem.[31] But Marshack's work provokes the question of decoration because he sees so little of it in comparison to what other researchers would see. An artifact such as this pebble from Barma Grande (Fig. 12) might seem like a formal experiment: perhaps the engraver was matching and contrasting lines with the shape of the pebble, and then quickly filling in blank areas with hatches and crosshatches. It may look like what we expect of decoration; at any rate, it does not correspond well to the structure of Marshack's examples of Paleolithic notation, which are more one-dimensional even when the register lines snake back and forth. Yet in the first edition of *The Roots of Civilization* he interprets it as notation, in which every mark has notational value. He surmises the longer parallel lines were intended "to give the engraver an enclosed or separate notational area"—that is, a one-dimensional track—"and therefore to serve as a visual and kinaesthetic aid." He starts reading with the large curving set on the

29. Mary Aiken Littauer, "On Upper Paleolithic Engraving," *Anthropology Today* 15, no. 3 (1974): 328.

30. Marshack, "On Wishful Thinking and Lunar 'Calendars'."

31. Ibid.

obverse (Fig. 12, top), "since this central form or figure seems to take up the prime space on this face." It is also possible, however, that the "angle-marks at top and bottom, serving almost as edge-marks," might have been made first.[32] The two choices are based on two ways of approaching the surface: the person doing the marking began either by taking charge of the blank surface or by keeping to the edge. These are assumptions based partly on kinaesthetic hunches about ways of coming to terms with blank surfaces—and partly on assumptions about the ways images might be structured. The analysis moves forward with the discovery that every right-facing hatchmark within these register lines was made before every left-facing hatchmark; and so Marshack continues and eventually counts every line on the pebble. In the revised edition of *The Roots of Civilization* the Barma Grande pebble is omitted, but the question of reading developed two-dimensional patterns as notations remains.[33] Under what circumstances, and with what criteria, could a more or less uniformly marked surface be interpreted as a sequence of individual notational marks?

This example, a more fully used surface, shows what kinds of problems are involved in determining sequences; Marshack generally says little about the trial-and-error process of finding the best order of reading for a surface thoroughly scored in two dimensions. Upper Magdalenian images show "the ability to synthesize and compose a "sum of images" into "storied" surfaces—in other words, to make meaningful narrative pictures—although the order of reading for such "non-linear series" is generally indeterminate (192, 211). What I am calling an "image" (what he calls, in this context, "decoration") is something distinct from a notation, but the criteria of its difference are derived from very different kinds of artifacts. It seems Marshack is extending linear, one-dimensional configurations into two-dimensional multiples whose organizational laws cannot be derived from the one-dimensional cases. But what exactly are images, if not extensions of linear marks and linear accumulations of marks? And exactly how are images made, if not in this way?

It has seemed to some archaeologists that Marshack does not recognize decoration or allow for random, careless, and meaningless marking.[34] In several papers, he has described about two dozen "symbol systems," including meanders, "fishlike images" (which resemble lattices or nets), zigzags, and double lines.[35]

32. Marshack, *Roots of Civilization* (1972), 84.

33. See, for example, Marshack, "The Taï Plaque," 148, 158, 216, 248, 254, 434, and especially idem, "Öküzini: Categorical Variation in the Symbolic Imagery," in *Fouiles à Öküzini: Une site du Paléolithique final au sud de la Turquie* (forthcoming).

34. See, for instance, Francesco d'Errico, "Analyse technologique de l'art mobilier le cas de l'abri des Cabônes à Ranchot (Jura)," *Galla Préhistoire* 35 (1993): 139–76.

35. Marshack, "Upper Paleolithic Symbol Systems of the Russian Plain."

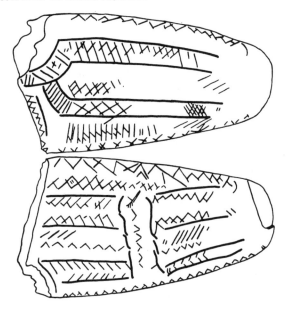

Fig. 12. Engraved pebble from Barma Grande, Grimaldi,
schematic diagrams by Alexander Marshack

But it can appear that he goes too far and enlists the majority of decorations
in the ranks of notations. Considering a bâton from Mezherich in the Ukraine,
which is engraved with several sets of parallel hatchmarks, Marshack opts for
notation over decoration even though the structure of the marking differs from
the normative containing line and crossing hatchmark (Fig. 13). It is relatively
neutral to say the bâton has "une accumulation de séries de marques gravées
selon des angles différents [an accumulation of sets of marks incised at different
angles]," with "marques auxiliaires non structurées à l'extrême gauche [unstruc-
tured, subsidiary marks at the far left]." But the purpose of putting it that way
is to emphasize the deliberation and internal structure of the marking: without
actually counting the marks, he concludes that the bâton "représente un style
personnel et idiosyncratique d'accumulation de *séries* de marques [represents a
personal and idiosyncratic style of accumulating *sets* of marks]." It may represent
"une accumulation mnémonique pour un rituel ou un mythe, ou la consignation
de jours et d'événements [a mnemonic accumulation for a ritual or myth, or a
record of days and events]," but either way, "la structure interne . . . suggère
que la surface n'est pas 'décorative' [the internal structure . . . suggests that this

composition is not 'decorative'].["36] To others, the markings on the bâton might appear sufficiently loose and unstructured so they could be classified as non-notational, if not intentionally "decorative." "It seems that practically nothing is random," one observer complains, "and very little is decorative."[37] Others have objected that "more evolved ornamentation" can be "just as intentional, cumulative, and sequential" as some artifacts Marshack presents as notation.[38] But where, Marshack might ask, do we get our ideas about the nature and frequency of decoration? Why can't notation be the norm, and decoration be the uncommon counterexample?

Marshack thinks that a "complex sequence of events, microscopically determined, eliminates the possibility of decorative intent or 'art.'"[39] But why would he not see the Mezherich bâton as a less carefully made artifact? Like the Placard bâton, it looks like it might have been the work of a few minutes, and therefore, by our standards, is likely "unthinking" nonsemiotic marking or loose decoration.[40] I can imagine decorating a strip between two register lines by making right-sloping marks after left-facing marks, as in the Barma Grande pebble, or, as in the Mezherich bâton, by making a few sets of hatches, adding a register line, and moving on to the next set. But these are sliding scales: it is difficult not to see decoration as a kind of careless or immediate activity, as opposed to notation, and it is even more difficult to conceive notation as a potentially careless, quick, or relatively unstructured act. Decoration seems to

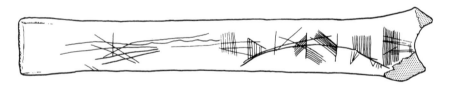

Fig. 13. Bâton from Mezherich (Ukraine). Mammoth ivory, 19.7 cm. End of the Upper Paleolithic

36. Alexander Marshack, "L'évolution et la transformation du décor du début de l'Aurignacien au Magdalénien final," in *L'art des objets au Paléolithique*, vol. 2, *Les voies de la recherche*, ed. Jean Clottes (Paris: Musées de France, 1987), 149; see generally 140–62. (The translation is my own, as are all subsequent translations unless otherwise noted.) See also idem, "Paleolithic Image," in *Encyclopedia of Human Evolution and Prehistory*, ed. Ian Tattersall et al. (New York: Garland Publishing, 1988), 421–29, esp. 427, and idem, reply to A. M. Byers, *Current Anthropology* 35, no. 4 (1994): 386–87.

37. Thomas Lynch, reply to "Cognitive Aspects of Upper Paleolithic Engraving," 467.

38. Slavomil Vencl, reply to "Cognitive Aspects of Upper Paleolithic Engraving," 470.

39. Alexander Marshack, "Reply" (to the critics of his "Cognitive Aspects of Upper Paleolithic Engraving"), *Current Anthropology* 13, nos. 3–4 (1972): 474.

40. See Whitney Davis, "The Origins of Image Making," *Current Anthropology* 27, no. 3 (1989): 193–215.

entail a "regular design" made "rapidly and simply," and notation is somehow its opposite.[41]

In the critical literature, the question of the difference between notation and decoration has focused on Marshack's claim to have found frequent changes of marking tools within a single surface, making it more likely that the surfaces were marked in a deliberated, "time-factored" way. But that is a slippery point; the technical evidence for those claims is not clear, and the performative aspect of notations and decoration is too variable to make the division stick. A hand might change grip on a tool in the course of a few centimeters of marks; and a person recording a notation might put down a few marks quickly and carelessly, and then make the next few marks slowly and with a different tool.[42] Francesco d'Errico and others have taken Marshack to task for his ways of distinguishing burins and his arguments about the intervals between sequences of marks. Since d'Errico uses an electron microscope where Marshack uses an optical microscope, d'Errico's readings are physically closer, and he has been extracting different kinds of empirical data. For a while it seemed as if the problem of Paleolithic notation would come down to the atomic scale in its search for dependable criteria. D'Errico claims, for example, to have identified "les stries parasites," the autographic marks of a single burin, so that he could tell definitively when a tool was reused or when, as Marshack claims, one tool was allegedly exchanged for another in the course of a protracted series of temporal notations.[43] But I would propose that the problem lies ultimately on an entirely different level: the concepts of decoration and notation are in some disarray, and they need to be addressed before any technical inquires can hope to make sense. D'Errico, for instance, uses a provisional tripartite classification of notations: those where "the elements constituting the system differ from one another," those where "the elements are identical but can be differentiated by their distribution on the surface," and those where "the marks cannot be differentiated," because they are identical and equidistant.[44] But these three criteria apply to any number of "decorative" objects, and in particular they apply, respectively, to the bâton from Le Placard, the Mezherich bâton, and the Barma Grande pebble. By d'Errico's working classification, each of them could be a notation. The question is not the analytical criteria for judging changes of tools, or the passage of time, or the slowness of the marking: it is

41. Francesco d'Errico, "Notation Versus Decoration in the Upper Paleolithic: A Case-Study from Tossal de la Roca, Alicante, Spain," *Journal of Archaeological Science* 21, no. 2 (1994): 185–200.

42. Marshack, "Reply," *Current Anthropology* 13, nos. 3–4 (1972): 474.

43. Francesco d'Errico, "Memoire et rythmes au Paléolithique: Le mythe des calendriers lunaires," in *Hominidæ, Proceedings of the Second International Congress of Human Paleontology*, ed. Giacomo Giacobini (Milan: Jaca, 1989), 507–10.

44. D'Errico, "Notation Versus Decoration in the Upper Paleolithic," 191.

the prior problem of the disheveled concepts that prompt those questions to begin with.

ARGUMENTS AGAINST CLOSE READING

These examples are enough to show the wonderful power that Marshack's readings have to turn confident criticism into rooted doubt, throwing our assumptions about images, marks, signs, notation, and decoration back at us instead of silently serving those assumptions. Excessively close readings can also begin to look lunatic or wrongheaded, and they may say more about the historian's notions of images and notations than about the artifacts under study. (That, at least, is my sense of Marshack's work, since its oddity strikes me forcibly as a twentieth-century quality. I find I have a firm sense of Marshack's use of these artifacts, and virtually no idea about their original meanings.) A feeling of mild pathology hangs over all close readings, from Sherlock Holmes to Panofsky, from Morelli to Marshack, and along with it there is a double attraction and slight repulsion at the activity itself. It is too much, and yet it is never enough.

Since my initial strategy was to show how a reading could be made more closely than Marshack's, it may seem as if I would advocate the closest possible reading—that is, the closest reading that could still seem to make sense—in any given case. Certainly that move effectively uproots assumptions and shifts the conversation from disputes about facts or methodology to the underlying conceptual base. But there is something seriously wrong with advocating closer reading, or closest reading, even aside from the fact that it might not be meaningful or helpful in a given interpretive discourse. In the study of visual artifacts it is tacitly assumed that readings, both close and far, are matters of choice. Each serves particular interpretive ends, whether or not they are the ones the interpreter might have described. In each instance there is the moment when the anthropologist, archaeologist, or art historian declines to read a given mark or to read it as a certain kind of mark, and then the argument can only proceed on the agreement that the semiotic system functions as it is imputed to do. The "closest" reading would depend on how the community of interpreters perceive the disposition of meaningless marks and meaningful signs, and how they choose to understand "mark" and "sign." That seems reasonable, and often enough it is true in practice, but it also harbors another assumption: that there are levels of reading that find meaning in successively smaller signifying units. One archaeologist might only care that the Placard bâton is a bâton and that it was found near another, similar one. Another might be interested in its size and shape, in relation to comparable examples. A third might notice the "decoration" on the handle. A fourth might be

drawn to the structure of the "decoration" (hatchmarks between register lines). Marshack notices each mark, and I have suggested there may even be more to see. The notion of levels of meaning is as clear here as it ever gets: oil painting is a morass by comparison, a single slurred continuous line from the name of the entire painting to the stray hairs of the paintbrush embedded in the paint. In both instances the point of unsurpassable closeness is a distance where the lenses of the interpretive machine can no longer focus, where for the purposes of the reading there are no finer marks, no further signs to be read. It is the place, in a semiotic account, where the lexeme (the meaningful unit, such as brushmarks that form a tree) gives way to the morpheme (the structurally defined but meaningless unit, such as a brushmark), or the character gives way to the mark, or—in the general case—the semiotic meets the non- or subsemiotic. Whatever the medium or the terms of the analysis, the hypothesis of various levels of reading culminating and terminating in a closest possible approach is necessary to make sense of the idea of close reading.

All three of these ideas—the notion of levels, of free choice among the levels, and of a final level—can be questioned. And here I want to switch disciplines because some of the most interesting work on close reading has been done not in anthropology or art history but in literary criticism. The critic Paul de Man's essays on poets, philosophers, and other critics are presented as exemplary close readings: those who carefully follow his arguments can be left with the impression that nothing could be closer. But in each case there remains a certain measurable distance between de Man's critical strategies and the texts he exposits. That distance is not an external one, which might be measured by contrasting de Man's versions of texts with other accounts, but an internal one, which appears between his versions of texts and alternate versions that can be read in those same accounts. In other words, there is at times a primary text, irregularly represented in his writing, that is more nuanced and articulate than the text as it is formally presented.

An excellent article by Henry Staten raises this question in regard to de Man's reading of Nietzsche's *Birth of Tragedy*.[45] Staten observes that a hierarchy of degrees of closeness are implicit in the terms of de Man's reading of Nietzsche. De Man, Staten says, views Nietzsche "from a middle distance," and Staten proposes to move in closer in order to discern "fissures . . . between unities of meaning," such as Nietzsche's apparently unified "Apollonian" and "Dionysian." Each distance has its own ideological force (it is a construction that can be shown to be used for a given purpose), although the meaning of the degree of closeness that de Man employs remains invisible to de Man himself for the duration of his reading. Other readings are suppressed by the text in a way that could be

45. Henrey Staten, "*The Birth of Tragedy* Reconstructed," *Studies in Romanticism* 29 (1990): 9–37.

recovered, but in Staten's reading de Man's particular "distance" is what he himself would call a moment of necessary blindness. It has to do, Staten thinks, with de Man's past and his "cold" refusal to listen to the " 'ecstatic call' of the 'Dionysian bird' ";[46] but however we may choose to explain it, Staten's reading demonstrates a way in which closer readings can be half-hidden in any account, and it locates a moment of blindness over the exact place that is understood as the closest approach to whatever text is under consideration.

I think much the same could be said of accounts of images, and I would suggest one of the reasons Marshack's readings have proved so difficult to critique effectively is that blindness concentrates where the reading seems closest. In reading Marshack's interpretations, I have deliberately made use of his own photographs in order to suggest that closer readings lurk in the text itself ("text" here taken as the sum of photographs, diagrams, and writing in the book). The photographs are evidence of variant readings, still unperformed, and they combine with the interpretation he gives to create a tension between his own interpretation, presented as the closest meaningful response to the artifacts, and something closer, which might yet be given words. Marshack's blindness is especially clear in a passage where he asserts that his work does not "read in" meaning: "Categorizing a sequence as a 'tally' or, more descriptively, as a possible hunting or gaming tally or even as a mnemonic device is not a form of scientific analysis. It is a form of analogic gaming, based on the matching of certain gross visual similarities. Intensive methodological analysis of each sequence, on the other hand, provides a body of internal data not requiring ethnographic comparisons."[47] It may seem that the problem here has to do with placing the border between "internal" and external data, so that everything inside inheres in the object, and is "scientific" and immune to analogy, and everything outside depends on unstable analogies.[48] But that border in turn depends on the location of the closest reading. The significant phrase here is "gross visual similarities": the distinction between reading and reading in is determined in advance by assumptions regarding what is gross and what is fine, what is vague and what is intensive. In other words, proper "scientific" interpretation is put in motion by an invisible decision regarding the location and nature of the finest available data.

When close reading itself is at stake, as it is in different ways in Ginzburg and in de Man, a writer's distance will necessarily be repressed rather than openly

46. Ibid., 37.

47. Alexander Marshack, reply to Mary Aiken Littauer, "On Upper Paleolithic Engraving," *Current Anthropology* 25, no. 3 (1974): 330.

48. Alexander Marshack, "The Analytical Problem of Subjectivity in the Maker and User," in *The Limitations of Archaeological Knowledge,* ed. Talia Shay and Jean Clottes (Paris: Université de Liège, 1992), 181–210.

declared as it seems to be, even though—and, in de Manian terms, *because*—other positions remain legible in the text. This could be put—a little extravagantly, but in the spirit of de Man's paradoxes—as the impossibility of close reading, since it goes to show that close reading is the name of a method that posits a number of distances from a work but does so in order to be able to remain blind to the one distance that is finally adopted. Marshack never addresses the appropriateness of his chosen level of close reading, except by saying that he studies every significant mark; in de Man's terms, he *cannot* address the question without writing an account that would be incompatible with the one he presents.

This helps explain the occasionally incoherent and unhelpful literature that is generated in the wake of concerted close reading: its analytic disjunction from the work at hand may best be assigned to the way that unimprovably close looking seems to be located within a field of blindness. The author of the close reading relies on the notion of levels or distances of reading and suppresses both the existence of closer readings and the assumptions about closeness that inform his chosen distance. Marshack is resourceful in describing his reading but less so in uncovering the assumptions that make it possible; and in a similar way, his critics have usually been quick to find alternate readings but hard pressed to say why their readings should be preferred to Marshack's.

A close or closest reading cannot succeed in erasing signs of closer *meaningful* readings (that is, not just closer looks at meaningless marks), and it cannot fully understand or exposit its own position. It may seem this is an acceptable aporia because it is also the description of a very adventurous place, fraught with risk and potential reward: having brought the critique forward along a series of known readings, the writer inhabits a foggy place where everything seems "closest" and there is no more room to move. Eventually someone else may find a way to assess this writer's account and push forward again. I put it as a dramatic scenario to bring out its suspicious rationality. It is a picture of interpretation that models itself on progress or exploration—both of them suspect ideals. A deeper critique, made by de Man himself in other texts, demonstrates that this last hope of close reading is also misguided.

At the beginning of *Allegories of Reading*, de Man sets out what amounts to a proof of the impossibility of unimpeded motion toward or away from the object:

> On the one hand, literature cannot merely be received as a definite unit of referential meaning that can be decoded without leaving a residue. The code is unusually conspicuous, complex, and enigmatic; it attracts an inordinate amount of attention to itself, and this attention has to acquire the rigor of a method. [Hence] literature breeds its own formalism. . . .

On the other hand—and this is the real mystery—no literary formalism, no matter how accurate and enriching in its analytic powers, is ever allowed to come into being without seeming reductive.[49]

A "naïve" reading of literature, which understands it as a mimetic project, is always at odds with the critical impulse, with its increasingly strict method. The dialogue between the two kinds of reading creates a state of affairs in which there are persistent attempts to reconcile the two into a general theory of reading. De Man resists that and remains skeptical of "false models and metaphors" about the "inside and outside" of literary representation. Barbara Johnson calls this "rigorous unreliability": the more rigorous a close reading becomes, the less reliable it is revealed to be.[50] There is no simple path from one side to the other: reading itself changes enroute, and it passes through the "conspicuous, complex, and enigmatic" acts of decoding and forgetting that make "method" possible. In a characteristic move, de Man understands this injunction in terms of his own theory about reading: the more rigorous he becomes about the "reconciliation" of the two kinds of reading, the less reliable his text becomes. The two are linked in a single motion—hence Johnson's phrase, "rigorous unreliability."

In art history, archaeology, and other disciplines concerned with visual images, it is a commonplace that any reading can become as close as it wants, that its only limit will be the texture of the work itself: I can claim any mark is significant, if I can make a persuasive case that it is a mark at all. In this way the limits of an ultimately close reading seem effectively only a matter of optics (What can we see when we get that close?), propriety (Is it appropriate to look at Monet through a magnifying glass?), or analytic coherence (Can we assign meanings to every gestural mark?). These working notions share a common figure in which the interpreter moves in by easy, gradual steps, through a known landscape, to a limit imposed by what are taken as semiotic requirements or by what I have called "propriety" or "optics." Much of contemporary art history and archaeology still believes in the possibility of adjudicating, in a reliable *and* rigorous manner, between "internal, formal, private structures" and "external, referential, and public effects." De Man's critique takes away the last hope that a close reading has to control itself: it cannot succeed in repressing closer readings; it cannot understand its own position; it cannot know how to move between positions; and it cannot avoid appearing "unreliable" in relation to more relaxed, "naïve," or general reading. And de Man's interpretation also suggests why close reading has to seem strange, especially when it is most entrancing: an unsurpassed close

49. Paul de Man, *Allegories of Reading: Figural Language in Rousseau, Nietzsche, Rilke, and Proust* (New Haven: Yale University Press, 1979), 4, quoted in Barbara Johnson, "Rigorous Unreliability," *Critical Inquiry* 11 (1984): 282.

50. Johnson, "Rigorous Unreliability," 285.

reading is an absolute refusal to negotiate the terms of reading. It is "reductive," as de Man says, and therefore also stubborn, intractable, obstinate, and difficult: all qualities Marshack's readers have felt when they have tried to come to terms with his work.

The Static and the Historical Image

Before I draw some conclusions from these readings, it may be helpful to say a few words about the kind of argument I am proposing here. An earlier version of this chapter appeared as an essay in the journal *Current Anthropology*, accompanied by a dozen responses written by art historians and archaeologists, Marshack among them.[51] One of the concepts under discussion there was the problem of context; Marshack in particular noted that my argument depends on a "static" reading of the artifacts, at the expense of their historical contexts. In effect what I have said depends on seeing the objects in isolation, without bringing "historical" settings and "diachronic" changes into play.

That is a fair and important point, and I would not want to argue too strongly against it. Meaning is seldom well made when it is made in isolation; or to put it more exactly, there is no such thing as isolation because both the artifact and the reading are always tied to some context. But at the risk of being misidentified as a formalist, I must register my doubt that the breadth of a reading can somehow strengthen the baselessness of its most rudimentary assumptions about how marks make meaning. When the richness of cultures and contexts overwhelms an interpretation, dry foundational assumptions about marks or signs can start to seem irrelevant. But what reading can be immune from problems that infect its very terminology? Readings of society or culture can shore up underdeveloped notions of notation, decoration, and so forth, but they only defer the moment when we need to ask how our own sense of those terms drives our inquiries. For example, I would want to know exactly which artifacts provide relevant examples of the parallel containing lines in the Taï plaque, and how Marshack decides which examples are close enough to what happens on the plaque to count as supporting material for his analysis. (The question becomes difficult at every turn, especially if no parallel is exact and "every notation in the Upper Paleolithic . . . is idiosyncratic"). And once I knew, I would probably want to say that the comparative examples only put off the moment when it is necessary to decide what, in a given context, qualifies as "sets of [notational] marks . . . engraved above and below . . . containing lines"—not

51. Elkins, "On the Impossibility of Close Reading."

to mention the even more difficult moment when it becomes necessary to ask why such distinctions seem natural.[52]

In general, then, I resist objections that would shrink the argument on account of the word "close" until it only applies to a certain formalism or to a small segment of prehistoric archaeology. It is more the other way around: prehistoric artifacts are interesting in large part because the context is wispy and unreliable enough to force attention back on the rudimentary issues that inform any interpretation. I entirely agree with Marshack when he says that "the 'impossibilities' of close reading are, actually, the questions, uncertainties, assays, inner discourses and arguments, and the tests that accompany the development of any innovative inquiry," but we disagree on the nature of those questions and uncertainties: to me, they circle back on terms such as marks, notations, and decoration. True, the historical contexts define them and give them whatever significance they have in any particular instance; but that does not mean that historical contexts vitiate the obligation or the possibility of looking into the substructure of argument.

A PRAGMATIC POINT

Close readings are the best places to begin to ask what is meant by the most fundamental terms that are used to describe images. At least at the beginning, such an inquiry could take a fairly rudimentary form, such as a simple list of assumptions about key terms. The list would have the virtue of turning conversations inward long enough in any given case to see what we expect of the central terms in our discourse about images. In regard to Marshack's work, a provisional list of assumptions might include the following ideas about notation, some of them still unexamined in the literature:

—Notation is composed of marks disposed in a one-dimensional manner, either in a straight line, in rows, in curving lines, along an edge, or between register lines. If a surface is notational and is entirely covered with marks, it will break down into one-dimensional sequences.

—Notation is "intentional," meaning each mark is carefully and deliberately made. Sloppy or haphazard markings are more likely to be decorative, though they are often notational. (For example, there are " 'sloppy' ritual markings" such as ritual "killings" of images, and apparently "unstructured" accumulations of " 'structured' motifs" can completely cover the surfaces of artifacts.)[53]

52. The quotations are from Marshack's reply to my "On the Impossibility of Close Reading," 211.
53. For this point, see ibid., 213.

—Decoration and notation are mutually exclusive, so that a marked artifact may be either decoration or notation, but not both. When a configuration of marks is "structural and sequential," the "laws of probability argue against . . . an 'artistic' intention." Decoration and "organized designs" do not usually show "unrhythmic crowding" of lines.[54]

—Notations are made over time, with measured pauses between each mark (they are "time-factored," in Marshack's phrase). Marks may be made all at once, but if they are notational, they will represent an accumulation of time intervals that would stand for longer intervals. (This is not a rigid rule, since motifs, sets of marks, " 'signs' such as hand prints, macaronis, 'tectiforms,' " and other "signs" might also be accumulated over time.)[55]

—Notational sequences show "internal irregularities" or divide into sets.[56] Conversely, entirely uniform marks are likely to be decoration.

—If a set of marks constitutes a notation, every mark is significant and must be counted unless it is first classified as a cueing mark, register line, or other notational guide.

—Notation does not make use of signs or symbols made of sets of marks. If a configuration is a notation, compound marks that appear to be signs or symbols need to be dissected into their individual marks.[57]

—The shape of a mark is generally not significant; it can be any size. Conversely, a shaped or representational mark will not normally be notational.[58] (This and the next two points have important exceptions when it comes to cueing and other ancillary marks, and exceptions also occur where smaller marks correspond to phase points in the lunar sequence. I mean these final points in a statistical sense, since they describe what happens most frequently in Marshack's interpretations as a whole and what constitutes the majority of his reading in any individual instance.)

—The orientation of a mark is generally not significant; it can be horizontal or diagonal in a sequence that is primarily vertical. Marks can be "feet" or complementary cross-hatching added to other marks that have already been laid down.[59]

—The position of a mark on a surface is generally not significant; a fully marked surface can sometimes be read by determining the order of marks, other times by trial and error.[60]

54. Marshack, "The Taï Plaque," 36, 51, respectively.
55. Marshack, *Roots of Civilization* (1972), 169ff., and idem, reply to "On the Impossibility of Close Reading," 213.
56. Marshack, *Roots of Civilization* (1972), 86.
57. Marshack, *Roots of Civilization* (1991), 39.
58. Ibid. (1972), 230–31.
59. Ibid. (1991), 149ff.
60. Ibid. (1972), 212.

These are the kinds of questions that need to be addressed first, or along with more practical or conventional interpretations, if the purpose is to increase our awareness of our own place in history and the expectations we have of artifacts (or, to say it the other way around, the meanings we "find" in them). That purpose is not always cogent, especially when interpretive communities are already posing and answering interesting questions; but when they become stalled with insoluble claims, as they have in Marshack's case, these questions can dissolve some of the obstacles to further dialogue.

On the Thin Space Between Normal and Pathological, Between Reading and "Reading"

There are many more things that could be said about close reading. It would be interesting, for example, to see what ideas other disciplines might bring to bear on habits of close reading, and to compare protocols of reading in religious exegesis, psychoanalysis, and medicine (all of which have highly developed lexica to monitor interpretive accuracy). Since my concern has been visual artifacts, I have not even opened the question of the particular meanings close reading has when its object is linguistic. I have said next to nothing about the history of close readings from Greek literary criticism to the present, even though it is often relevant to the suppositions of my own approach. Nor have I addressed the difficult correspondences between words such as "decoration," "notation," and "sign" and the terms of visual semiotics including sign, mark, trace, or their linguistic counterparts.[61] Given the almost unencompassable range of the ideal of close reading in activities as different as detective novels and surgery, it would also be important to explore how the problems I have described occur in disciplines other than archaeology, in order to see what properties might unite different senses of close reading.

But instead, I want to close by suggesting another way to take this subject further. In the *Current Anthropology* debate there was much discussion of the phrase "close reading." Since the artifacts are nonlinguistic, there can be no question of reading in the ordinary sense, but it seemed to several respondents as though Marshack were not "reading" in any sense and that "close seeing" might be a better term. But the field of things that can be read is very large and ill defined.

61. See my "Marks, Traces, *Traits*, Contours, *Orli*, and *Splendores:* Nonsemiotic Elements in Pictures," *Critical Inquiry* 21 (1995): 822–60, and "What Do We Want Pictures to Be? Reply to Mieke Bal," ibid., 590–602.

One of the respondents, T. J. Clark, pointed out that although interpretations necessarily take place within "some kind of linguistic field," Marshack's results are not at all a simple matter of literacy in some notational procedure: they shift "between registers of representation . . . from memory to prediction to inference to punctual insistence on the present state of things."[62] Marshack's "reading" is something we cannot quite name, but it would be premature to call it "seeing," when seeing is even less well understood.

Yet if Marshack is not reading, what is he doing? I think Whitney Davis puts it best when he says Marshack is "reading readability" or "taking the temperature" of a reading. In more Kantian terms, Marshack studies the conditions under which reading might be possible; or to say it as Wittgenstein might, he thinks about how many different kinds of responses could count as reading. Davis also suggests that Marshack "is reading writing as an index-gauge of readability" and that an artifact might possess an index of readability, or betray the "presence of Paleolithic-ese," without actually being read, being readable, or being writing in any sense.[63]

It is not at all easy to say what this "reading readability" is. On the one hand, it could be argued that Marshack does nothing of the kind, since he does not interrogate what the signs of writing might be: he is not concerned to say what might distinguish the various species of "curious signs" and marks, and he is not interested in asking about his own assumptions about what reading or notation might be. In that sense he does anything but read readability. On the other hand, he wants to stay at a certain distance from the final act of reading, when the reader actually deciphers, translates, or otherwise understands the sequence of signs themselves. Often it appears that he keeps his distance for sober archaeological reasons, since the intentions of the makers, and much of the context of the making, are lost. But he has other, less easily described reasons for wanting to leave the act of reading open. One reason the "lunar calendars" are so difficult for commentators to describe is that they aspire to occupy the twilight between approaching an object with the intent to read and actually reading. It is not difficult to inquire into the assumptions a reader might at any given time hold regarding what is to count as mark, sign, legibility, and so forth; I did as much in the *Current Anthropology* essay and elsewhere in more general terms.[64] But Marshack's readings are something other than that.

And when, exactly, is reading is not also "reading readability"? As Marc Redfield points out, my reading also seems not to be a reading (since I propose no

62. T. J. Clark, reply to "On the Impossibility of Close Reading," 203.
63. Whitney Davis, reply to "On the Impossibility of Close Reading," 204–7.
64. See my *Pictures, and the Words That Fail Them* (Cambridge: Cambridge University Press, forthcoming).

new interpretations of the artifacts), but it is a reading, since I take signs as "self-identical entities, available as such to the eye."[65] This is not the same as pointing out that I was searching for Marshack's assumptions but remaining unaware of my own: it is the claim that "reading readability" is always also reading. Redfield sees this as a move from "reading" to "seeing": he says I am "blindly confident" about my "claim to see" and that blindness is what enables my reading. I would probably rather think of this as a blind confidence in another kind of reading—a reading that is propelled by thoughts about reading.

These may seem to be overly subtle points, but to a large degree I think that they lead in the direction that needs to be pursued in order to further the discussion of close reading. With that in mind I suggest six notions that might form the starting point of a more careful discussion of "reading" prehistoric artifacts—or visual artifacts in general. The first five are different acts or modes of response that are not quite reading, and the sixth is reading "itself."

1. *Contemplating reading*. Thinking of the possibility of reading, I might scan a surface for marks that appear to be meaningful. Some might present themselves as notations or even elements of calendars, and others as iconic signs. It would not occur to me to wonder about how I know such things, because I would be concentrating on the surface itself. From this point of view, the act of reading and the theory of reading are equally distant. This is one of the senses in which Marshack "reads readability," for example, when he surveys an artifact with notations in mind but with none in immediate evidence.

2. *Testing the waters*. Then it might occur to me to test the possibility of reading, by trying out a reading on some part of the artifact. The experiment would not entail any awareness of principles: it would merely be a sample reading, a willful act of reading intended to discover whether reading (in some as-yet-undefined sense) is a good match for the marks. In Davis's metaphor, here reading is like sending up a weather balloon and seeing what happens; like the previous mode and the next one, it is also a way of "reading readability." Marshack's tests of the lunar calendar are this kind of activity, since they do not issue in the conclusion that the marks are lunar calendars.

3. *"Taking the temperature" of a reading*. Another mode, which mingles with the first two, is thinking about the plausible moments of reading. If an artifact seems partly well behaved as a notation and partly wayward or incomprehensible, I might be drawn to think about probable and improbable acts of reading. Can the straight rows of vertical lines in the Placard bâton be understood in the same way as the "curious sign"? What can possibly count as reading? When I use a

65. Marc Redfield, reply to "On the Impossibility of Close Reading," 214–15. Randall White also makes the excellent observation that Marshack's photographs are not evidence of any kind—I was doubting their veracity, not their status as evidence—but, rather, "visual arguments"; see White's reply to "On the Impossibility of Close Reading," 218–20, esp. 219.

barometer, I rarely wonder how it works—but the match or mismatch between the barometer and the weather changes my sense of the barometer, and vice versa.

4. *Interrogating my sense of "reading."* A next step might be to turn my attention inward and begin to question my own criteria for legibility. That is what I did in this chapter, and what Marshack does when he argues with d'Errico and others. It is clear that this kind of thinking is not the same as actually reading, but it is often not as clear that it is also different from the musings and confusions of the first three modes. The apparent rise in self-awareness that goes with this kind of introspection was one of the points of my *Current Anthropology* essay: blindnesses get shifted around, and suddenly many things are visible that were not when I was reading readability or otherwise thinking of reading.

5. *Interrogating the interrogation.* Anything that presents itself as systematic can be systematically interrogated, and it might then occur to me to think about how I have been thinking about the criteria of reading. The infinite regression that opens here is nothing more than the commonplace questioning of motives and possibilities that goes along with any self-reflective method. It is the mode of each of the comments and of this reply. As David Summers observes in his response to the essay, a reading that proceeds by alternately finding meaning and questioning its own meaning is the precondition both of Marshack's "time-factored" notations and of historical writing in general.

6. *Simply reading.* And finally, I might just settle down and read an artifact. Though it often seems as if that is what Marshack does, and though several comments imply as much about my essay, I think neither of us actually does in the cases under consideration. In other contexts, both of us read—with unsupportable confidence, and with complete oblivion about the other ways of thinking around and about reading. But the kind of reading I have done in this chapter (the reading that Redfield identifies) is not reading in this ordinary sense: it is an inevitable unseen accompaniment to the other modes, and especially those such as the fourth and fifth, in which I would normally strenuously deny I am reading.

I name these six modes to suggest that it is possible to think in a reasonably orderly way about the limbo between reading and "reading readability." Reading itself—the sixth response—is full of other kinds of problems: whether to read closely or cursorily, fast or slow, near or far, consistently or randomly. In his response to the essay, Michael Baxandall pointed out that close reading in the sense I employ it is truly pathological and fails to correspond to any actual looking. Certainly interpretation is much less predictable and uniform than what I have described, even when it attempts to be strict or rigidly uniform. (It would be interesting to try to give a phenomenological account of an extended and successful act of close reading, in order to say what really happens before art historians or archaeologists issue their apparently systematic and self-consistent results.) But the phrase "close reading" is not intended primarily as a plausible

model of ordinary, or even exemplary, looking but as a "case" whose extremity illuminates a common unexamined ideal in many encounters with visual artifacts. It is not so much a kind of reading (though it sometimes serves as a heuristic beginning for reading or a check on reading) as an extreme state at the borders of reading. It is the ideal that is at issue. We all wish, I think, to be able to see and describe as fully as Marshack and with the same piercing attention and untiring concentration—without knowing quite what that entails, and without wanting it single-mindedly enough actually to achieve it. There are many occasions for not reading closely, and most readings are not "close" in the sense I have been using that term here: but in the unremitting logic of reading, they have to be adjudicated by stepping outside reading and back toward the five other modes. Conversely, even the most abstruse meditations on reading lead back into acts of reading.

The deepest question here, the one with the widest application to the study of visual artifacts in archaeology, anthropology, and art history, is the problem of self-reflexivity. Whatever Marshack does, he does while remaining blind to certain aspects of reading. Any reading—even the informal shifts of attention and focus that Baxandall mentions—depends on not seeing itself, or not seeing itself equally at all moments. D'Errico's work, for example, is in every particular as dependent on assumptions about notation, mark, and sign as Marshack's: no amount of methodological care or technical innovation can avoid that.[66]

In the end there is little to be said for the single-minded pursuit of self-reflexivity: at the least, it has no necessary correlation with the performance of a convincing interpretation. This is a difficult point for much of anthropology, archaeology, and art history, where writing is often taken to be scientific or driven by empirica; but in the end, accounts of visual artifacts do not endure only because they are found to be largely true or because they present themselves as unsurpassably reflexive, vigilant, or rational. Closeness, care, thoroughness, and even correctness are necessary but not sufficient for writing that aspires to last, and self-reflexivity is often a recipe for weak reading.

There are good reasons why it is anathema in many fields to put the expressive value of writing above its truth value, and I argue them throughout this book. But here I want to insist on this point: if close reading operates as I have suggested, there is no epistemological reason to prefer one level or degree of closeness over another. Some respondents to the essay called my assessment of Marshack's work "overly generous"; but what initially drew me to his analyses was the power of his writing. Marshack can write with astonishing force, and his photomicrographs

66. See d'Errico's reply to "On the Impossibility of Close Reading," 207–8, in which he vehemently exempts himself from the issues raised by Marshack's work. I have no quarrel with d'Errico's new criteria for determining motions and sequences of points, but when it comes to drawing conclusions about notation and meaning, his work raises questions exactly analogous to those I raised about Marshack.

can be coercive "visual arguments." As far as I am concerned, there is still no book in the history of art that arrays its visual material with such compelling success as *The Roots of Civilization*. Ultimately it is that power, which scholars (excepting de Manians, among others) still denigrate with the word "rhetoric," that makes his work so intriguing. Part of its interest certainly comes from the nearly incomprehensible position it occupies between reading and "reading readability," and from its various methodological lacunae and unanswered questions. Part also comes from its sometimes dubious claims about cognition, "time-factoring," and the lunar calendar. Marshack's work may be deeply flawed in these and many other respects, but it continues to be fascinating even for those who reject many of his conclusions: as several respondents pointed out, there are other writers on prehistory whose works combine Marshack's myopic precision with a higher degree of methodological consistency, a greater openness to rival hypotheses, and a more systematic interpretive agenda.[67] But few writers can bring so much of their encounter with the object into their prose. Any of us—in archaeology, anthropology, literary criticism, philosophy, or art history—would be lucky if we could face objects with such sustained force. In that respect, this chapter is really an attempt to begin to understand how a truly successful account of visual objects might work.

It may seem that this has been an overly close examination of an obsessively close reader, but the ideas involved are widely applicable. Marshack's method is not an eccentric or marginal regimen, but the vigilant application of a central methodology of any discipline that works with what it takes to be a structured, "systematic" artifact of any kind, from Paleolithic artifacts to neo-Expressionist canvases and from graphs to literary texts.[68] Marshack does what we all say we should do, but he does more of it, and in many respects he does it better; and for that reason the difficulty that people have experienced trying to argue with him needs to be taken seriously.

One of the joys of Marshack's work is that it shows just how loosely we read the more commonplace images that occupy most of anthropology and art history. Anthropologists interpret cultural artifacts in accord with assumptions about decoration that allow them to get on with the business of writing, without stopping to count every welt in a scarified body or every bead in a necklace. The best way to reveal those kinds of decisions is to contrast them with other interpretations based on different concepts of adequate or close reading. Scarifications and beadwork, after all, are "time-factored": each bead takes a moment to string, and each piercing hurts. An interpretation that dissected a tattoo or a piece

67. George Flamand, *Les pierres ecrites* (Paris: Masson, 1921); Leon Pales, *Les gravures de la marche* (Bordeaux: Delmas, 1969).

68. See my "Visual Schemata," in *Encyclopedia of Aesthetics,* ed. Michael Kelly (forthcoming).

of jewelry into moments and gestures that fine might well appear as lunatic as Marshack's lunar calendars have sometimes seemed: but that response disguises a serious problem—a hollowness in the concept of interpretation itself. The same is true in my own discipline. Art historians and critics pay little attention to groupings, types, sequences, and series of marks, and virtually none to individual marks. Our smallest units tend to be images in their own right (depicted figures, portraits, objects, symbols), and when it comes to individual marks, as it does, for example, in Jackson Pollock's work, we generally prefer theorizing about the nature of the marks to studying individual marks. All these are signs of what we overlook in order to preserve a certain working notion of close reading. By Marshack's standards, our seeing is blurred and cursory, and our standards of looking are indefensibly lax. In literary criticism, where the concepts I have been exploring are most fully developed, the blindnesses of close readings affect the theory of close reading itself. Ginzburg is fully aware of his attraction to close reading in detective fiction, art history, and psychoanalysis, but only partly aware of the reasons why he is so attracted. His books replay that attraction by applying the method to various subjects, rather than delving into the critical questions of the place of his writing within the tradition, and the limits of self-reflexivity in any given instance. Like art historians, anthropologists, and archaeologists, Ginzburg prefers close readings to looser ones, and he sometimes becomes interested in the history of close reading itself; but that interest does not intrude on his chosen regimens of close reading, which are unimpeded by any potentially disruptive critical reflection.

Close reading is structurally pathological in relation to other modes of reading. Earlier I suggested that is a result of its position at the far end of a domain of ways of reading, a domain whose other extreme embraces "naïve" decoding without—as de Man says—interpretive "residue." A less exact way of saying this would be to point out that most of our readings are more or less—mostly more—lazy. Most of us want to escape the tyranny of prolonged close engagement with the artifacts or with our writing. Taking more ordinary encounters with objects as the standard, readings like Marshack's (or Morelli's or Panofsky's) are apt to seem a little strange. Yet stiflingly close reading is an imperative of humanist scholarship and of literacy more generally: it has to be possible in order for there to be such a thing as a text or an image, to understand; but it also has to be impossible, in order to let us get on with the vaguer meanings we all prefer.

4 Saying Who We Are

The question of the possibility of addressing a discipline, and the question of the production of meaning, are cornerstones for our sense of art history; but in addressing these two issues, I have been deferring another that is arguably more fundamental than either, and that is the matter of who *we* are who think about these things. In asking this I am not calling for the usual institutional definitions—that we are the group, defined by the conventional divisions of academia, who publish in the journals that I listed in the first chapter, who attend certain conventions, and so forth. Nevertheless, if the question, Who are we? were to be formally posed at a congress of art historians, it would probably be answered in terms of those institutional constraints. We might choose to account for ourselves, for example, by writing a history of the discipline or by finding ourselves in such a history. "We" would then be people who belong in a certain tradition of writing (from Pliny or Vasari or Winckelmann forward) or who thrive in some stream of intellectual history (concerning problems of the artwork in society, the place of the artist, the traditions of pictorial meanings) or who owe allegiance to certain streams of disciplinary history (from archaeology and anthropology, through connoisseurship and philology, to iconology and beyond) or who promote interpretive agendas (including constructions of gender, political and ideological stances, and semiotic approaches). A session titled "Who Are We?" might be expected to draw papers on any number of these self-definitions.

Despite their differences, these explanations have a reasonable degree of coherence, since they all refer to external constructs: to the history of institutions, texts, societies, disciplines, and ideas. In each an art historian is understood in relation to a particular setting. If the writer is a social historian, then the setting might be economics, politics, or social customs; if the writer is a psychoanalytically inclined historian, the setting could be gender, sexuality, or biography. Some individual historians might want to explain themselves as people engaged in the semiotics of artworks, and many contemporary historians might be well described as people working their way out of iconography.

The converse of this practice, and the approach I argue is fundamental (though certainly not sufficient for self-definition), is to rescind the notion that it is best

to define what art historians are by placing their work in some existing structure of ideas, and to address instead *internal* constructs: the nature of the thinking subject that is the collective "we" of art history or the singular "I" of the working historian. Another way to put this distinction is to note that the answers I have been imagining really respond to the question, What do we do? rather than the question, Who are we? Our parade of theories all describe our activities and our interests, but in order to do things, we first have to constitute ourselves as subjects: first there has to be a "we" or "I" that wants to do what we do. It is an open question how well we understand what we do, even though we have so many ways to talk about our activities; but I want to defer that question until the next chapter. Grammatically as well as logically, the question of the thinking subject comes first.

If the problem of self-definition is reimagined in this way, the questions become more difficult and interesting. The philosophic critique of the subject (that is, roughly, the study of the "self," "I," or "ego") casts a different light on our accustomed self-definitions and our familiar problems. The many ways art history has developed to account for itself can begin to appear as fictions—even evasive fictions—whose purpose is to let art historians talk about themselves without launching self-critiques that might strike too deeply. (The "logocentric paradigm" may be one such fiction, but I mean the much wider set of self-descriptions.) Conversely, the full range of our theories can be rewritten as problems generated by, and dependent upon, whatever ideas we hold regarding the viewing or thinking subject. In the first instance, historians need to make decisions—or act on assumptions—about the nature of the subjects they study. To ask, What does it mean to look for the intentional meaning of a work? is to be led toward the deeper questions, What is intentionality itself? What is intentional meaning? Or to put it informally, How are we to imagine artists' minds? Sooner or later, questions like these return to the person who asks them, and understanding history becomes a matter of understanding ourselves as subjects. How do we imagine our own intentions? Do we have free access to them? How are they related to the intentionalities and subjectivities we discover in history? For reasons like these I would claim the philosophic "critique of the subject," which has been underway since Descartes, is a third fundamental issue complementing the questions of disciplines and of meaning.

I do not think there is any immediate way to make the case that we need to reconsider our customary ways of accounting for ourselves, in favor of the abstract critique of the subject. In this chapter I try to make the point by showing how the critique emerges in many different guises when art historians think carefully about a range of apparently unrelated historical problems. What happens in art history, I think, is true of many fields, and I suggest that the critique has a tendency suddenly to appear as the underlying difficulty in various arenas

of modern philosophy. It is one of our figures of transcendence, a problem that seems to be unencompassable, and we address it, appropriately enough, by not addressing it—by disguising it as any number of easier problems or by finding conventional places where our critiques can come to rest without pushing on until they encounter the critique of the subject.

A brief text from outside art history can exemplify what I have in mind, and introduce the issue as a whole. A persistent misreading of Michel Foucault's essay "What Is an Author?" has it that Foucault means to displace the construction we label the "author" with a revived awareness of our habits of reading, so that texts can be "open" to alternate readings rather than "closed" around our idea of an author's personality. Instead of reading "through" a text to the intention or voice behind it (in accord with the logocentric paradigm), Foucault would seem to be asking us to see other possibilities and to avoid the sense that a text is the sign of an intention. "Those aspects of an individual, which we designate as the author," in Foucault's words, "are projections, always more or less psychological, of our way of handling texts."[1] The "projections," together with the fiction that there is some intention "behind" or "in" the text, are what Foucault calls the "author-function," to distinguish it from the naïve idea of a single, comprehensible author.

I call this a misreading because Foucault does not say that the "author-function" is dispensable: in fact he takes it as a condition for writing itself. Reading is an act that is enabled by the "author-function," whether or not it becomes an object of inquiry that we wish to name separately from the "author," and writing is dependent on the same fiction, whether or not it is addressed in the text. The "author-function" is a figure for the subject, and Foucault's essay may be read as a recent moment in the critique of the subject, a moment in which the subject seems to be denied but turns out to be a necessary "fiction" or "projection." "What Is an Author?" is a sometimes stark critique of the subject as author, but it is important to bear in mind that it only effects the most subtle revision. The "author-function" remains in place, at the enabling center of the act of reading.

In light of this motionless displacement, the phrase "more or less psycholog-ical" takes on exceptional importance. It is entirely typical that just where the subject reappears and asserts its importance, it looks ill defined. What is "more or less" psychological about the appearance of the "author-function"? Is the "function" something to be assigned to metapsychology, as well as a necessity of the text? Why call the process "psychological" at all? We "project" the "author-function" (in an operation defined by psychology), but who are "we" who know what we do is fiction, but need to continue to do it anyway?

1. Michel Foucault, "What Is an Author?" in *Language, Counter-Memory, Practice,* ed. Donald Bouchard (Ithaca: Cornell University Press, 1977), 113–38.

The philosophic critique of the subject becomes an ultimate term in Foucault's text: it is a problem that envelops the entire theory of the "author-function," placing it—at least here—in the realm of an unfounded "psychology." The sequence is worth noting, since we will see it again in art historical texts: first the subject as author seems to have been left behind, so that "What Is an Author?" appears to be a manifesto of the end of the author, but the author reasserts itself as a fictional function that remains exactly where it always has been, at the origin of the possibility of reading, accompanying us as we read, defining when we can cease to read. But the new "author-function" is problematic, since it is neither wholly a fiction nor entirely a necessity. It is not easy to see how to proceed, how to push Foucault's account forward. Both the reader and the author are now partly subjects and partly "functions," provisionally explained by an unmoored psychology.

This is the parable of the inescapable subject—something that appears to be lost, or out of sight, and then reveals itself, impossibly expanded, as the condition of our thought itself. The best image I know for the subject comes from a Chinese novel, *Journey to the West*. The central character is an impudent immortal monkey given to challenging the gods. In one scene he tries to escape from the Buddha himself. He runs swiftly, thinking he can outpace the overweight god, and he sees a row of giant pillars up ahead, looming like colossal jail bars. As he approaches, he recognizes the Buddha's fingers and understands he has been running along the Buddha's palm. The monkey stops, out of breath, and the Buddha closes his fingers around him. The critique of the subject has the same uncanny ability to envelop our thinking just when we imagine that we have outrun it. What seems to be a solid conceptual field, built of iconology, semiotics, and our miscellaneous theories, turns out once again to be the critique of the subject.

THE RESURFACING OF SUBJECTIVITY

I want to explore this within art history by continuing the reading of Whitney Davis's review of Donald Preziosi's *Rethinking Art History*.[2] Since I discuss Preziosi's text at fair length in the next chapter, I would like to consider Davis's review more or less independently of what he says about Preziosi—as if it were an abbreviated survey of the state of affairs in art history. I take it that is not a broad

2. Whitney Davis, review of *Rethinking Art History*, by Donald Preziosi, *Art Bulletin* 71 (1990): 156–66.

misreading, since his review is organized synoptically and topically rather than according to the order of Preziosi's book. What I would like to show is that the majority of topics Davis considers eventually come around to questions that can be put in terms of the subject, and that they stop there, naming the end of analysis in much the same way from case to case. The similarities between those moments are not addressed, so that they echo back and forth, and Davis does not propose any principle of parallelism for his review essay or for current problems in art history in general. In one sense, therefore, what I am going to suggest is that the critique of the subject is a thread in much of contemporary art history and that it is available to help show us what guides and delimits thinking about the discipline. In another sense, I want to demonstrate that the problem of the subject is still not quite visible, not quite close enough to us, not quite connected to what we want to say that art history does—and therefore, by the inverting logic of the subject, *too* close to be seen, too much a figure of ourselves to find a place in our theories. Davis's text is open-ended and friendly toward Preziosi's enterprise, despite their wide differences and Davis's sometimes trenchant critiques, and I will behave the same way toward Davis's account. In Davis's review, the critique of the subject is not enfolded in moments of blindness but is renamed and refigured in such a way that it appears as several distinct problems when the logic of the text does not demand that it be. For that reason I do not claim anything that I think Davis would not acknowledge in his own text: instead, this is a reading that brings out the fact that nothing in the text speaks *against* such a unification.

The review is divided by boldface headings, each naming a problem area. One subsection is titled "Logocentrism," and others are titled " 'Subjects,' " " 'History,' " " 'Art,' " " 'Sign,' " and " 'Meaning' "; most are in quotation marks in the original. The closest to a central term is intentionality, which figures prominently in the section on logocentrism. (At first, when the philosophic subject arises, it is the artist's intentionality that is in question. As the review progresses, it centers on the art historian.) Derrida's idea of "writing" (*écriture*) and his critique of metaphysics, Davis recalls, are ways of casting doubt on "the endemic 'logocentrism' derived from the Platonic nostalgia for 'origins' and 'presence,' " and so they are a principal starting place for numerous critiques of "sense, cause, logic, and history" and of works of art whose economies persist in figuring transcendence and "modern romantic mournings of all kinds" (158). When these general considerations are put in "more eclectic language," so that they can be more directly relevant to the writing of history, one might say that "a nonmetaphysical study of representation should try to avoid the entrenched study of its Intentionality in order to understand its materiality, historicity, bodiliness, genderedness, and productivity." The word "Intentionality" here is the primary signifier of that which we wish to avoid—as opposed, for example, to

its status in most of "normal" art history and in theoretical accounts by Wollheim and others.[3]

Davis calls intentionality a "difficult" concept and says it is best traced to Husserl, who held that intentionality signifies "the 'immediate presence' to consciousness of the way in which the mind is directed toward objects."[4] Derrida's critique of Husserl aimed in part at challenging "the notion that Husserl's contents of mental states could, strictly speaking, be immediately present to and in that very same consciousness rather than being somehow mediated and/or temporally displaced—implying, then that 'intentionality' can only be 'constituted' in a structure of deferments and repetitions." Even though Derrida's critique of the Husserlian sense of intentionality is "widely held" to have been "very powerful," it is also possible to argue that Husserl's account was in no need of such critique. "Post-Husserlian concepts of mental representation," Davis writes, "do not need the thesis of 'presence' and may actively repudiate it; they already rigorously distinguish, and subtly interrelate, the 'contents' of mental states and 'consciousness' of them." In Davis's account, Derrida's critique may have been "incoherent," and it was in some measure not necessary or aimed at "straw targets." In this way the "mediateness or mediatedness of cognition has always been recognized in traditional metaphysics," so that "to assume the self-presence and self-identity of consciousness in order to attack it" may be unnecessary or misguided (158 n. 9).

Now, the critique of Derrida's critique is widely known, even if it remains customary to see his early work as a dramatic encounter between naïve phenomenology and logocentrism. Those who note the counterarguments to that history reframe the problem: Derrida becomes more traditional, and sometimes, as in Davis's account, his attack on logocentrism is taken as something that is appealing in a commonsense way, while his attack on Husserl looks problematic and in some degree misleading. These adjustments are the purpose of Davis's comments (he wants to show the possibility of a certain misunderstanding on Preziosi's part), but I would like to mark instead the sense of intentionality that emerges from this passage—bearing in mind that the review is not a formal disquisition on intentionality, and allowing for the severe restrictions on the length of his account (this is, after all, a topic that is usually discussed in independent monographs). Roughly, then, intentionality would appear as a form of consciousness that is mistakenly described as "immediately present." The manner of its lack of presence is not decided in the text. Instead we are given several

3. Richard Wollheim, *Painting as an Art* (Princeton: Princeton University Press, 1987), 22. Davis capitalizes the word in order to follow John Searle's account (and also to echo Preziosi's unexplained use of the same orthography). Davis cites Searle, "What Is an Intentional State?" *Mind* 88 (1979): 74–92.

4. Davis, review of *Rethinking Art History*, 158 n. 9. Edmund Husserl, *Logical Investigations*, trans. J. N. Findlay (New York, 1970).

choices: in Derrida's critique of Husserl, the "contents of mental states" are "somehow mediated and/or temporally displaced," so that " 'intentionality' can only be 'constituted' in a structure of deferments and repetitions"; to Alphonso Lingis, "presence" is " 'dazzling' rather than 'transparent,' therefore escaping Derrida's strictures"; to Daniel Dennett, "the 'contents' of mental states" are distinguished from " 'consciousness' of them"; to Jerry Fodor, consciousness is " 'epiphenomenal' in relation to cognitive computations."[5] If Davis is interested in one of these accounts over another, he does not say so, and the way he describes them, they might be characterized as versions of the Derridean impulse to emphasize deferment and difference. In short, intentionality appears as an undetermined differential internal structure, something that is not "immediate," "transparent," whole, or "present."

What "a nonmetaphysical study of representation should try to avoid" is whatever sense of intentionality lacks such differential structures. This is a negative, unresolved definition in which intentionality ceases to be a relatively unproblematic known quantity (as it was, ostensibly, for Husserl) and becomes an unspecified field of possibilities. The indispensable sign of intentionality is its differential structure, meaning it defers and differs instead of remaining whole and immediately present; and it is a concept that can only be known through analyses of that structure. In this way a question that used to be framed as a matter of intuition, consciousness, and presence has come to appear as a question that is best assigned to the field of structural analysis. Both the mode of investigation of intentionality and the mode of its existence have become differential structures: a similarity between method and concept that is not without parallels to the sameness of theory I sketched in Chapter 2. This, I think, is a characteristic fragmentation and abstraction of the nature of the thinking self, both in art history and in some philosophy. For the moment I want to note what has happened and leave it, as Davis does, to one side.

Since I am interested in the ways that the critique of the subject resurfaces after it has apparently vanished, it is important to observe how some inquiries in art history seem to begin especially far from the problem of the subject and work their way around to it slowly or unexpectedly. Davis's next section, titled " 'History,' " opens with the idea of the "uneasy wedding" of nineteenth-century positivism and "idealist speculation," and Davis cites Willibald Sauerländer's way of putting this, as the "fateful interconnection of *Stilus* and *Chronos*"—

5. Davis, review of *Rethinking Art History*, 158 n. 9. Davis cites Rodolphe Gasché, *The Tain of the Mirror: Derrida and the Philosophy of Reflection* (Cambridge, Mass.: Harvard University Press, 1986); Staffan Carlshamre, *Language and Time* (Göteborg: Department of Philosophy of the University of Göteborg, 1986), 69–144; Alphonso Lingis, *Phenomenological Explanations* (Dordrecht: Nijhoff, 1986); D. C. Dennett, *The Intentional Stance* (Cambridge, Mass.: MIT Press, 1987); and Jerry Fodor, *The Language of Thought* (New York: Crowell, 1975).

that is, the mixture of idealist speculation on "intrinsic" style with supposedly positivist work on historical change.[6] At this point, the history of art history denotes this typical mixture. In the book under review, Preziosi suggests other nineteenth-century disciplines that could have been models for art history. But then the question becomes, which objects of history have served as "unified" elements for our histories? In Davis's words: " 'If art history is always the unity of a becoming' [as Derrida put it], art history assumed the 'centrality, continuity, and self-identity' [as Preziosi put it] of certain objects in, and of, history—artistic intentions and talents, ethnic and national characters, meanings, and now, socio-sexual difference" (159). Davis has been led to this list and to the idea of a unified history by his thoughts on possible alternatives to the oil-and-water mix of positivism and idealism. It is not accidental that intentionality is first in the list, since it is the exemplary instance of something that is traditionally taken to be unified. A subject is that which can have intentionality, and it need not be confined to a single person, artist, writer, or "author-function"; as Hegel and Freud knew, it can just as easily be transferred to "ethnic and national characters." The other two terms on the list, "meanings" and "socio-sexual difference," seem at first to be heterogeneous entries (surely, we might want to say, "meanings" could have been the only predicate, since the others are special cases of it), but they are subordinated and made reasonably alike in their dependence—so I claim—on the concept of the subject.

At this point intentionality has resurfaced but is not yet the dominant theme in the discussion of the history in art history. However, it soon turns out that various kinds of art history—and Davis names "one school of Marxist art historians" exemplified by Hadjinicolau, and another " 'social history of art' " exemplified by T. J. Clark—are dependent on the notion of a "historical actor" who is capable of "rationally optimizing his or her choices" from an " 'external' background or 'context' of socio-political affairs." In other words, to make a " 'social history of art' " one has to assume the "unity" of a subject, which appears against something that can be called a "background," and which is known to itself. (And this is true also of artworks themselves, when they are personified as "choices" bearing evidence of "strategies.") Davis calls this a "Cartesian psychology" and defines it minimally as the supposition of "agents" that "continue at least to know themselves as themselves" (159): they require the transparent species of intentionality in order to exist as subjects for art history.

At this point the problem of the subject emerges fully, moving from its disguised setting as the element of idealist and positivist history to its place as the problem proper to a heading called " 'History.' " The final paragraph of the section is

6. Willibald Sauerländer, "From Stilus to Style: Reflections on the Fate of a Notion," *Art History* 6 (1983): 266.

devoted entirely to the "knowing subject of Enlightenment philosophy," which now takes on the role of that which we want to avoid, since it underwrites the kinds of social and Marxist histories that achieve unity at the expense of a "Cartesian subject" that is resistant to critique. When it comes to searching for a different kind of subject, the analysis is at first structural:

> As some kind of alternative, it is certainly insufficient to imagine the "de-centered" or "fragmented" subject we find narrativized in many quarters today. So far, this identity [exists] as a topography of partially coordinated, intercommunicating homunculi, residing in the many mansions of Freud's structural theory, Klein's projective identifications, the Lacanian "registers" of Imaginary and Symbolic, and so forth. Each homunculus possesses its separate Cartesian identity—for example, "knowing" castration as "lack" (or, in Irigaray's alternative, its distinct pleasures), mirror-image as unity, desire as frustration, masculinity or femininity as anxiety, and so on. (160)

The various formulas are ways that the Cartesian subject can find itself again in different settings. Like a blob of mercury, it can be divided, fragmented, and decentered, but each smaller droplet will be similar to the first. In a note Davis proposes that Lacan's late theory imagining the psyche as a Borromean knot might go "beyond notions of the subject as centered/decentered," but he does not pursue the possibility.[7] On the surface it would appear that a knot is unpromising because it is explicitly topological; that is, it is yet another structural rearrangement, and therefore a "displacement" as well as a "topography" of the indivisible subject. The final sentence of the section lets the reader see for the first time the place of the subject at the end of analysis, the way the problem must be put when there is nothing else that can—at least in this context and for these purposes—be said: "The task, it seems to me, would be to imagine a subject that knows nothing, either as a whole or in any one place, space, or [Lacanian] register; indeed, subjectivity is not a space or place that could be (un)divided or (de)centered at all." This cancellation of the subject as something that "knows" would also cancel the sense of the word "subject" and transfer the dialogue to some other, unknown problematic. I read the radicalism of this sentence as a response to the unpromising field of structural and "topographic" analysis that had been presenting itself as the only alternative to the "Cartesian psychology," both here and in the section on intention. It is nearly a dead end, because it calls for a conversation so radically new that it could hardly find purchase on earlier

7. He cites Lacan, "R. S. I. [Seminar XXII]," *Ornicar?* 2 (1975): 87–105, and idem, "Le Sinthôme [Seminar XXII]," *Ornicar?* 9 (1977): 32–40, and 11 (1977): 2–9.

accounts. Davis cites Gregory Bateson for the idea that "scientific discussion of communicational and mental matters" should be carried on without the "false epistemology" of "spatial and physical metaphors"; but in this case, where would we possibly be without them?[8] A subject with no "place, space, or register" would no longer be a subject, and that which we want to avoid would have become unmanageably large. The end of analysis is implicitly acknowledged in the next sentence, asking for a fine-tuning of critical terms: "At any rate, a full treatment of this problem will require more than the crude categories of 'idealist' versus 'materialist' psychology or 'bourgeois' versus 'radical' notions of agency." But after everything that has been said, what grounds do we have to hope that an adjustment of the lexicon will let us form a viable new sense of the subject? The problem has proved intractable twice in these two sentences: first it seemed that the subject might be retrieved by canceling all its attributes (by prohibiting the use of its principal metaphors), and then it looked as if it might help to rethink the terms of the debate. It is significant that these are taken as reasonable places to conclude a discussion of history: they could only be so if the problem of the subject remains a little beyond the interpretive horizon. Its signs and symptoms appear, but it is not itself available for critique.

We recognize the term "meaning," which, in quotes, serves as the title of another section, from the list of things that history conceives as unified objects of attention: "artistic intentions and talents, ethnic and national characters, meanings, and now, socio-sexual difference." The section opens with a declaration of the importance of intentionality in any coherent account of art history: "Up to this point, we have perhaps only seen that, intellectually, art history has been very eclectic and often uncritical, a point no one, I suppose, would gainsay. We may well wonder, then, how this crazy quilt has managed to hold together at all. The answer lies in part, I think, in the fact that diverse perspectives on history, art, and the sign have converged in assuming Intentionality and meaning" (160). "Here too," as in the initial sketch of intentionality, "mediation is all," and to the degree that intentionality depends on the concept of the subject, the mediation will be structural in nature. Another satellite concept is the " 'logocentric paradigm' of signification, representation, or communication." In the formula ("art works, necessarily understood as vehicle, medium, sign, trace, production, or 'working,' somehow reflect, reveal, express, represent, articulate, enunciate, project, communicate, transfer, or deliver what may be called references, meanings, perceptions, concepts, intentions, or signifieds" [161]), "meanings" again takes its place in a lineup of dissimilar predicates, this time along with "intentions," though the preeminence of "meanings" is attested by the next sentence, characterizing

8. Gregory Bateson, "Double Bind and Epistemology," in *Beyond the Double Bind,* ed. Milton Berger (New York: Brunner, 1978), 42.

art historians as people who "attempt to uncover this 'originary fullness' of meaning, the 'presence of real being.'" This is a package of possibilities about the production of "originary" meaning, and if "intentions" and "meanings" masquerade as equal terms alongside "references," "perceptions, concepts," and "signifieds," it is because that is the way the field of possibilities sometimes looks. At other times the critique of the subject looks different: "[F]or one historian," Davis notes, "'intentions' are seen straightforwardly as political 'strategies,' for another, as unconscious 'desire.'" Here "meaning," intention, and other terms are in loose relation, but as the analysis progresses toward the questions I explored in Chapter 2, Davis's discussion converges once more on intentionality:

> As Preziosi shows, the two end-points in the paradigm, meanings on the one hand and their receivers/producers on the other, tend to be studied at the expense of the material, "intermediate" steps of production. But even if we were to concentrate on the materiality and textuality of the trace itself, as Preziosi recommends, this does not in itself guarantee that the trace has not simply become the seat or site of Intentionality. It would be just as well to be as material and economical about the "presence" of meaning, intention, or communication as possible; still, this is neither an analysis nor a critique of meaning as such. (161)

The critique of the subject has resurfaced in a slightly different manner. Here it is not a question of trying to get around the spatial and temporal metaphors of the subject (as it was in considering history) or adumbrating a structural critique (as it was in the case of logocentrism), but rather of a proposal to look again at the fine grain of our terms and arguments, in hopes of dismantling the concept at its "origin."

The section called "'Meaning'" ends with another long footnote, where the discussion continues into the substrata of marks and traces. The issue is what should be called intentional marks—when a trace is a sign of a subject. Derrida "places the problem at the core of his project," and he describes the trace "as the simultaneous 'breaching' and conservation of resistance that always already requires an expenditure of energy and . . . a goal-directedness" (162 n. 28). The repetitious expenditure of energy and the "directedness" are John Searle's two criteria of intentionality, so that Davis is reading his Derrida alongside his Searle. This is the beginning of a reasonable, "nuanced and clear" account of intentionality, Davis says, but it does not answer the question of when intentionality takes place. "The spacing of the repetitions will be definitive" (we may be reminded here of artifacts studied by Marshack that "suddenly" appear to evince intentionality), "but when and where a spacing deserves to be called 'an intention' or 'a meaning' will, it seems, be an ineluctable fictional, metaphysical,

and ideological decision." This is not, perhaps, as precise as it might be: there is no way to tell when intentionality will appear, not because it is "fictional" or "ideological" (both of those sources of meaning can be subjected to further analyses) but finally because it is "metaphysical," so that the analysis that has brought us this far is also producing the meaning. "One deconstructs metaphysics to find its metaphysicality."[9]

This time the subject has resurfaced as the primordial problem of the trace, the bearer of intentionality, and therefore—according to the telescoping focus of this section—of meaning. The sequence from meaning to intentionality to trace is apparently antimetaphysical, gradually escaping metaphysics and approaching materiality, the stroke and the mark. But it might not appear adequate to close on that note, if it were not that the trace is where we find ourselves back "inside" metaphysics, and therefore—for the time being—incapable of further motion. In the initial passage the problem of the subject came to a stop when it looked like it was about to become trapped in structuralism. In this section the end of productive thought is reached when it appears that we are becoming trapped in metaphysics.

A reader might expect that the section titled "Subjects" would come especially quickly to the critique of the subject, and it begins with a review of Preziosi's idea that all disciplines presuppose passive and static subjects, "viewing" the "archive" of their field from a particular position. But this is a problem of the position of the subject, and it recalls reservations about the impossibility of decisively critiquing the subject by "decentering" or "fragmenting" it. "The problem of subject positionality . . . is not only its place 'in an ideological formation' but also its necessity."[10] To say the subject is a "necessity," and not something that can be fully "positioned," is to deny the final coherence of any number of art historical practices that depend on such positioning, including the social art history he had mentioned earlier. Hence the approach here holds the most promise of developing into a decisive critique of the subject.

It turns on Lacan, and on the registers of the Symbolic and Imaginary. If the subject is entirely constructed by and in symbols, then it might be conceived as something apart from some construction of history; it might even be mobile, so that it could be positioned by the historian. But "the self can never be outside the Imaginary nor can the 'ideology' of the Symbolic wholly subsume it" (162).

9. There is a little more to this footnote, and therefore to the section on " 'Meaning,' " and it has to do with common errors that art historians make. Michael Baxandall's *Patterns of Intention,* Davis says, "unselfconsciously" adopts a "Gricean scenario, in which meaning-makers try to get viewers to recognize the makers' intentions through a picture designed to elicit a certain response." But substantially, the work of the section is done.

10. Here Davis is very gentle with Preziosi: though *Rethinking Art History* is deeply involved with the position of "viewing" subjects, Davis says that Preziosi "seems to recognize" the problem, even though he is "ambiguous" about it.

Davis gives three reasons. The second is that the mirror phase, which determines the ego, "occurs before and determines the self's entry into language," so that the ego is something that partly subsumes the Symbolic formulas about the self. The third is that the Symbolic cannot "overcome" the Real fact of sexuality, so that "unconscious sexuality establishes the very conditions of possibility for a subject's 'positionalities'" and its "sanity"—making sanity and sexuality unavailable for Symbolic repositioning. For these reasons (and for the first reason, which I will consider in a moment), "all *a priori* and abstract critiques of positionality—to be found both in subpsychoanalytic and sub-Marxist writing—insist on the ficticity of positionality at the expense of its factuality, its historical reality, and—dare I say it?—its meaning for desiring, alienated subjects" (163). Positionality is fictitious in the sense that it appears ideologically determined, but by the same token it can be manipulated, and the subject can be positioned for a determinate critique. If we follow Lacan, Davis is saying, there is also the Real and the Imaginary to take into account in all repositionings of the subject.

But the first reason is most important, and it turns on Lacan's *objet petit a*. Davis proposes to understand this "'algebraic sign'" to mean "objects in the life history of a person not fully differentiated by that person from (being part of) his or her own self," or objects "never completely grasped as independent of the self" (163 n. 33). Lacan's version of Freud's report of the *fort/da* game is the cited example, and it goes to show, in Lacan's words, that the *objet petit a* is "a small part of the subject that detaches itself" from the subject. Davis glosses this by adding that "it would be the burden of a Lacanian analysis of culture, among other things, to demonstrate the life-historical continuity between the earliest, most primitive *objets petit 'a'*—the mother's warmth, toys—and cultural objects more traditionally conceived." As such, the *objets petit a* cannot be subsumed into the Symbolic, and therefore, if the subject is constituted by the construction of such objects, it is a "necessity" that cannot be fully accounted for by an ideological critique such as Preziosi and other art historians employ.

"We still await a cogent account," Davis says, and he notes Preziosi's idea that a "renovated art history could examine how art works 'afford positions for subjects in signifying practice'"—that is, as I read Davis's citation, how the works seem to determine the viewers, as well as the other way around. But this would be "just the beginning" of a deeper critique of the subject, whose aim might be to see "Artist and Viewer as the *objets petits 'a'* of subjects whose Other is the *objet petit 'a'* of an art historian" (163). This extravagant-sounding formulation is really only an accurate way of putting things in accord with the reading of Lacan that Davis has been adumbrating. The objects of desire may appear as the constructions of Artist and Viewer (and, we might add, Artwork). They will most likely do that if the subject is an art historian, but it would be hasty to identify the subject with the art historian, since an "art historian" is also a construction.

Davis therefore says that the subject who desires such *objets* also conceives an Other, which can be understood as the *objet petit a* of "another" subject, that knows itself as an "art historian." There are promising ideas here, and I develop some of them later; but I want to take notice of the way that the text breaks off and the reasons that it seems right to do so. The *objet petit a* is by definition an intractable, inenarrable, "meaningless" object, and so it is not amenable to the kind of explication that Davis has been pursuing—that is, the disciplinary analysis of art history, including its "archive" and several of its methodological schools. Lacan might have toyed with these ideas, but I imagine him doing so at a much greater distance. It may be that a thought of this disparity had brought Davis's account up short with the formula of reciprocal *objets petit a;* this time the end of thought is brought on by a sense of alienation or distance: we have come so far from the familiar places and terms of art history that it is no longer possible to bring back what we have found in the reaches of the Lacanian texts. In the terms of Chapter 1, the Lacanian discourse appears as a different language, something that art history does not yet know how to translate. If this dead end does not appear as such, it is not only because the abbreviated format of a review prompts us to accept unexplained suggestions and images. It is also because the subject appears to be open to a decisive critique—more clearly and fully, at least, than Preziosi's account would seem to allow.

There are other moments in the review that repeat the motion I have been analyzing, but I have said enough to outline a general tendency. I would put it this way: if an inquiry into an art historical problem is made carefully enough, with sufficient energy and clarity, it is likely to encounter the critique of the subject. The subject—at first, the artist, and later, the art historian—will take its place as the defining issue for the historical problem, and when it does so, it will have two effects on the analysis: it will appear insurmountable, as an ultimate problem or as the most generalized and fundamental form of many other problems, and at the same time it will disarm critical thinking, causing it to lose energy and stop or to turn aside.

There are good reasons for this, since the problem of the subject has traditionally occupied terminal positions in Western epistemology, ontology, and psychoanalysis, and I am not suggesting that such arguments are somehow flawed. But an awareness of the sequence may help art history guard against the temptation to turn aside and find some other path, as Davis does once or twice when he considers embarking on a renewed critique of critical terms. And we might also be skeptical of promises to dismantle the subject, as Davis begins to do when he remarks on Lacan's Borromean knots and his *objet petit a.* The desire to escape from a trap or a dead end is an ingrained response, and it is repeated in many ways when it comes to the problem of the subject. The quickest escape is to pretend that the subject might simply be "positioned" so that it can be

monitored, as in some social history, or placed somehow out of the way, as in some misreadings of Foucault's author-function. More involved escapes attempt to analyze or deconstruct the once-unified subject, emphasizing structural difference, deferral, and *différance* (as Derrida recognizes, the discussion of these topics is itself a deferral). I am not suggesting that we abandon any of these strategies, even the ones that come to seem wrong or inadequate, but that we recognize all of them for what they sometimes are: reflexes, "flight responses," brought on by the inescapable unthinkable nature of the subject.

WHO COMES AFTER THE SUBJECT?

In 1986 Jean-Luc Nancy wrote a questionnaire asking a number of French writers to meditate on "the putting into question of the instance of the 'subject' " in modern thought, "from Descartes to Hegel, if not to Husserl."[11] The responses, published in English under the title *Who Comes After the Subject?* vary widely, and are often of exceptionally high quality. They show, in the "pure" language of philosophy, that Davis's suggestions for the critique of the subject are also ultimate terms in philosophic accounts, so that where he stops thinking, so do a number of writers who are concerned with the subject.

Gilles Deleuze's brief response lists two possibilities for the future of the subject. First, "knowledge and even belief" might be replaced "by notions like 'arrangement' or 'contrivance' . . . that indicate an emission and a distribution of singularities" (95). The "emissions" would be of the " 'cast of the dice' kind"; that is, they would be "constellations" of the kind Mallarmé describes as the outcome of "all thought" in *Un coup de dés*. Philosophy would become a *"theory of multiplicities"* that would "refer to no subject as preliminary unity." This possibility is nothing other than the "structural critique" first seen at the end of Davis's section titled "Logocentrism": it names the field in which the subject (or, in Davis's review, "Intentionality") is dismantled and distributed through a system of deferrals and differences. Husserl, Derrida, Dennet, Fodor, and Lingis have been at work on this project, disassembling transparent, unified intention into what I called an undetermined differential internal structure. The open-endedness of Davis's account at this point—the way he names several theories, without mentioning which is most persuasive—may be read as an entirely appropriate gesture in light of Deleuze's text. What is important is that there is "no preliminary unity," so that the subject is replaced by "pre-individual singularities"; any

11. Eduardo Cadava, Peter Connor, and Jean-Luc Nancy, eds., *Who Comes After the Subject?* (New York: Routledge, 1991), 5.

negotiation of particular structures is a secondary matter. If we take this seriously, as Mallarmé did, then the "structure" itself may become meaningless: to quote from *Un coup de dés,* it would be "nothing" but a random "configuration," a "number," a "constellation" of lights "on some vacant, superior surface."[12]

To Deleuze the second possibility is that we might cease to be able to make any sense of what is meant by "I" unless we think of it as "a grammatical fiction." In that case, we could begin to look for other principles of "individuation"— other objects that might be substitutes for the ego. "We wonder about what makes the individuality of an event: *a* life, *a* season, *a* wind, *a* battle, 5 o'clock." These things that are no longer persons or egos might be called "ecceities or hecceities," and we might begin to wonder if we are not also "ecceities" rather than "egos" (95). The annihilated ego, erased into a "grammatical fiction," is consonant with the prospect Davis entertains when he thinks of a subject that does not employ spatial or temporal metaphors, "a subject that knows nothing, either as a whole or in any one place, space, or register." Deleuze's meditation shows a possible next step: after the erasure of the subject, we will begin to see objects that look like subjects—"non-personal individuations," Deleuze calls them—wherever we look. These are the seeds of the reincarnation of the subject, as Deleuze certainly knows, because it will prove impossible to avoid transferring all our thoughts about the human subject (including, of course, its status as "grammatical fiction") to the lives, seasons, winds, battles, and o'clocks that we would like to call "non-personal." This is the scenario Davis has conjured in speaking about the critique of the Cartesian subject, saying that it will fragment into a "topography of partially coordinated, intercommunicating homunculi." Like beads of mercury, the little homunculi will seem very like the large drop they broke away from, and they will tend to return to it if they can. Again, Davis's account fades in the same places as Deleuze's. It is reasonable to propose that there might be a kind of subject that could be attributed to any "individuation," and that it might allow us to think of the old Cartesian subject as "useless or inadequate" (94). Indeed, that possibility is virtually built into the concept of the Cartesian subject itself, since it provides the model for inanimate "individualities" and nonpurposive "intentions." All that is necessary is to switch the original usage with the metaphorical one, so that "non-personal events" become the proper sites of "non-personal individuation" and the human "ego" becomes the metaphorical, "fictional" site of the Cartesian *cogito.* But once this is done, thought has to retreat because the very force of the metaphor will direct it to its original and "proper" place.

Similar moments occur elsewhere in *Who Comes After the Subject?* as those

12. *Dice Thrown Never Will Annul Chance* (Un coup de dés jamais n'abolira le hasard), trans. B. Coffey (Dublin: n.p., 1965), unpaginated.

who wish to frame the limits of thought either change the question entirely (from "who" to "what," from "subject" to "self" or "ego") or enclose it in a wider question. Vincent Descombes calls the question a "scholastic quarrel" that takes place "inside of the philosophy of the subject"; to him, the question is only "whether it is appropriate to humanize or dehumanize the philosophical subject" (129). He gives a sequence of three "periods of the philosophy of the subject": a "dogmatic" period in which "it is *I* who think: I am, when I think, not a human being, but a thinking subject"; an ensuing "critical" period, marked by the awareness that "what I am when I think is in no way a given, in no way immediately understandable"; and a final "paradoxical" period, characterized by the sense that "it is not *I* who thinks or who desires: the true source of these operations does not resemble a human being." This sequence divides the "human being" from the "I" and then centers questioning on the "I," the subject, which in the end appears so problematic that it must be abandoned. Descombes concludes: "According to this critique of the humanism of the subject, the error of earlier versions of the doctrine was to conceive the philosophical subject upon the model of the system of personal pronouns (*I, you, him, her*). In order to conceive of the philosophical subject in a nonanthropomorphic fashion, we must instead think according to impersonal uses of the third person. We should say, no longer 'I think,' but 'it thinks in me,' 'it thinks,' 'there is thinking,' 'thinking happens to us,' etc." (129–30). Here we have again arrived at the point where the subject has been given an unsatisfactory redefinition, and again it is the place where the analysis terminates (the final section in Descombes's essay pertains to ethical and political points). Since Descombes understands the critique of the subject as a "scholastic" matter, he is not constrained to ask how firm this "nonanthropomorphic" formula might prove to be; for my purposes, it is enough to note that it leads directly into the problems of Deleuze's essay.

I cannot undertake an extended reading of *Who Comes After the Subject,* which would involve also an assessment of more-recent texts by several important contributors, such as Mikkel Borch-Jacobsen; but I would suggest that of the various viewpoints Derrida's contribution is perhaps the most fruitful. " 'Eating Well,' or the Calculation of the Subject" is an interview designed to avoid the question by refusing to subscribe to the "cut" between "human," "subject," and "ego" in all their visible forms. "We know less than ever where to cut," he says, so we will "never know, and never have known, how to *cut up* a subject" (117). For the moment, at least, I read the refusals, the constructions, and the escapes of Descombes, Deleuze, and Derrida together as additional markers of the impossibility of thinking further within the problematic of the subject. It is not an ill-defined debate, and it is far from unimportant what we decide about it in any given place; but it is also a debate that exhausts itself, runs out of oxygen, ends up trapped in the Buddha's palm.

ON THE USELESSNESS OF THE LIMITS
OF THINKING

What I have been trying to show here is that the very terms of the philosophic discourse shut down thought at particular places in the critique of the subject. As Philippe Lacoue-Labarthe points out, "Who comes after the subject?" is an unanswerable question because we are never conscious to see what might be there: "who" is "enigmatically" and "ceaselessly prior to what philosophical questioning installs as a presence under the name of subject" (202). What happens in Davis's account is a sequence of thoughts that are, at least for the present, unavoidable in art history except by denial, haste, omission, or error, and I have presented them here in order to show how the debates more common to the discipline—about style, positivism, social art history, and the other topics that Preziosi raises and Davis reviews—are made possible by operating at a certain distance from philosophy, at a certain level of historical specificity, under a certain rigor and energy of argument. When the common agendas of art history are pressed, their terms and problems begin to seem misguided or unclear, and they fracture; and the discourse shifts to another set of problems. The end point of those shifts is the critique of the subject, where the argument encounters the issues I have been reviewing, and where it loses energy, falters, and stops. Knowing that, I think we can read our customary exchanges, our multicultural forums, and our warring methodologies as moments that are made possible by *not pressing* the argument on to its stultifying conclusions.

I want to close by mentioning several reasons why art history may not want to understand this material or control its critical possibilities. By locating the resurfacing subject, we can watch ourselves as we negotiate an art historical problem by avoiding the explicit critique of the subject. Seeing these things, we can understand our own arguments better and perhaps begin to see not only where we think and where we stop thinking but also where we mean to take art history in any given instance. But these acts of observation are not without consequences for the practice of art history, since they entail abandoning or refiguring more usual ways of putting art historical problems. The direction of this chapter repeats that motion: for example, instead of arguing within the terms of T. J. Clark's social art history, Davis wants to show its dependence on assumptions about intention and the subject; and what I have written only continues that motion away from art history by showing how Davis's findings can be positioned in relation to the philosophic critique of the subject. Davis loses the capacity to continue writing the kinds of art history that engendered Preziosi's book (and therefore his review), because their suppositions begin to appear unstable or incomplete. This is a common enough result of criticism, and it makes sense if Davis assumes that by critiquing the art historical theory he

has also come to understand it. At first, the critique of the subject underwrites that assumption by locating philosophy within art history and explaining what underlies a number of common interpretive strategies; but the critique begins to turn sour when it appears that the philosophic subject is not only universally debated at the most fundamental levels (so it can be of no immediate use) but also radically aligned against critical thought (so that after a certain point it renders thinking nearly impossible).

Those final and most dangerous effects normally remain invisible. Most art historical debates do not last long enough to witness the resurfacing of the subject, and so a story about that resurfacing may be exactly what art history does not need in order to go on debating its central issues. As art historians we routinely need fictions of immediacy and presence, as well as reliable, full, and transparent intention, in order to think, read, and speak (or as Lacan would say, in order to exhibit human symptoms). Recently we have also desired fictions of escape from those same strictures, but it is not yet clear where—if anywhere—that desire might take us. In everyday circumstances a measure of obscurity and conceptual laxity are probably required in order to preserve the force of our interpretive agendas. Even for a reflective account of art history, the task is not necessarily to press each argument on to its bitter end. Instead, it may be best to adjust terms and problems so that the discourse remains within a certain range, without giving out prematurely or shifting too far toward philosophy. I have tried to make a convincing argument that the philosophy of the subject is logically prior to virtually every important issue in the historiography and theory of art history as it is currently practiced, but that does not imply that each account of art history's more familiar problems needs to push onward as far as these abstract regions of speculative philosophy. Art history is evasion, and the critique of the subject is one of the most forceful ways of seeing that: we do not want to see all of our problems or all of ourselves.

5 SAYING WHAT WE ARE DOING

After the excursion into the philosophy of the subject and into the question of who "we" are, it may seem fairly easy to say what we are doing as art historians. There is no lack of interest in methodologies and theories of all sorts, and a wide choice of recent books describing those methods or putting them into practice. I would hope that the problems I have considered in these first chapters make it more difficult to know what to do with art historical theories, but at least it seems a straightforward matter to lay out the theories—to enumerate their claims, their uses, and their positions in relation to other theories. Here I argue against that as well, trying to show where convolutions in our usual ways of thinking about art historical methods prevent us from seeing how they actually operate or what we can do with them. We can certainly name our theories, but we cannot name them fully; we can think of applying new theories, but we cannot speak about how they are applied. At first I call this reticence, but as I go through the material, I reconfigure it as repression. To make the case, I undertake selective close readings in two texts: first, David Carrier's *Principles of Art History Writing,* and then, to develop the concept of repression, Donald Preziosi's *Rethinking Art History.*

ART HISTORY, IN A DARK MIRROR

Carrier's account of art history—set out in the last ten years in three books and a number of scattered articles—is decidedly eccentric. That is, it is off-center: out of the mainstream of art historical writing and off to one side of the discipline's theorizing about itself. The "art history" and "artwriting" he spies is so distant, so odd, that it can seem to be glimpsed through a telescope or a kaleidoscope. A reader "inside" art history is apt to be struck at first by the strange way that familiar images and texts are broken and recomposed, and then again by the peculiar purposes to which Carrier puts his cobbled references.

A recent book, *Principles of Art History Writing*, opens in a strongly non—art historical manner: "I began by asking two simple questions: Why does the argumentation of present-day art historians differ so dramatically from that of earlier artwriters? And since those modern historians often disagree, how is objectivity in art history possible?"[1] This sounds alien for a number of reasons. Sometimes art historians do begin by asking simple questions, but more often the questions themselves are hard to get at, requiring a fair amount of framing discourse before they can even be put in a reasonable manner. Carrier's quick opening belongs more to the cut-and-dried world of analytic philosophy than to the sometimes circumspect manner of history. His words, too, are odd. We occasionally think of our writing as "argumentation," but perhaps that is not the word that would immediately come to mind; our texts, we might say, are both more and less than arguments. They *contain* arguments, but it is probably not a good thing when an art historical essay is said to *amount to* some argument. Although there are strong contrasts in the history of art history, what we write does not always appear "dramatically" different from what others have written: even Vasari does not always seem "dramatically" distant. As I have shown in reading Panofsky's essay "Tymotheos," the word "objectivity" is rarely seen in art historical writing. When it does appear, it does not look right on the page.

So I think an art historian's initial reaction might be wariness at Carrier's unusual purposes, mixed with some unfocused misgivings about his style. In the opening paragraphs of the introduction, Carrier wonders if art history is a continuous discipline or if writers such as Crowe and Cavalcaselle might not belong to a species different from that of Panofsky and Gombrich. And then he says—and his abruptness here is also characteristic—that "the goal of all artwriting is to describe artworks truthfully" (4). Why does this sound so wrong? Perhaps because art historians do not routinely think of truth as a "goal," but rather as a condition, or even a quality, of good writing. Perhaps in our capacity as working art historians we do not imagine ourselves thrashing through untruths to get at something true. Something of the same misunderstanding might apply to the idea that art historians set out to "describe" works of art. It sounds correct in that it corresponds to the old division between descriptive art history and judgmental art criticism, but it also sounds too narrow. We do not set out to "describe," but rather to say whatever is of importance or interest about a work. I think most art historians would admit some measure of judgment into their enterprise, and some would say judgment and description cannot be disentangled. The idea that "all artwriting" does this is also strange, not because we would want to deny it but because it goes against the grain to name what we do in such

1. David Carrier, *Principles of Art History Writing* (University Park: Pennsylvania State University Press, 1991), 3.

an inclusive way. Our practice is richer, we might want to say, and some injustice is being done by naming it all at once.

Carrier's text never gets much closer to the ways I think many art historians tend to talk and write. (The third sentence of the book beds Vasari and E. H. Gombrich, as if they saw eye to eye on the progress of naturalism.) His manner of putting things is what Freud called "uncanny": it is strange, off-putting, even disorienting, and at the same time absolutely familiar. Many of our stock characters and scenes are here: Foucault on *Las Meniñas,* Fried on Courbet, Freedberg on Parmigianino, Flam on Matisse, Reff on Manet, Gilbert and Lavin on Piero della Francesca. There are Nochlin, Clark, Blunt, Schapiro, Steinberg, Panofsky, Riegl, Benjamin, Bryson, Baxandall, Greenberg, Ratcliff, Krauss, and Alpers. If anything, Carrier's notes seem a little *too* crowded, his citations some-how too dense—or dense in the wrong way, more like a collage than a sensible composition. There is a certain overpopulation in his footnotes. He misquotes, as we all do, but he also misconstrues, misrepresents, and mistranslates. Something is importantly wrong with his version of art history, though it is not at first clear what it might be.

We might try to explain our feeling of distance or mistrust by saying that Carrier is an outsider, looking toward art history from the vantage of analytic philosophy and aesthetics. Like all outsiders, he ends up asking the "wrong" questions or asking the "right" questions in the wrong ways. He tends to be too general when he should be specific, and vice versa. At times he just asks his questions too dramatically. Those, at least, are the archetypal gestures of the outsider, who pleads forgiveness in his preface—as Carrier in fact does—for whatever transgressions he might commit. If this is to be a sufficient explanation for Carrier's solecisms, his writing would not be addressed to us as much as to him: the passages and language we object to could be construed as warnings to him that certain moments in his text need work. His version of art history might offer isolated insights, but in general art historians would be correct to say that the funny light he casts on our familiar texts would be something that could be corrected or refined. It is also reasonable to assume that if Carrier can be adequately explained as an outsider, then he might become more familiar with art history as time passes. His versions of our "arguments" might become fuller and more sensitive, and he might start to take account of the kind of nuance that marks the best historical writing.

For these reasons he could be read as a marginal figure, reading art historical texts but not really taking part in art historical debates. What I want to do here is reconsider this assessment and try to take his work more seriously. A preliminary reason to do so is my inability to say exactly what it is that he gets wrong. It is interesting that when I come to list his faults, I name things that seem superficial or contingent. I say he simplifies our texts; but since every account simplifies its

object, it must be more the way he simplifies than the brute facts of condensation and quotation. But exactly what is wrong with his way of simplifying? Sometimes he omits ancillary arguments, and he tends to boil down second thoughts and reservations. But do I want to say that art history is *essentially* a matter of contingencies and that our central claims cannot stand on their own? Jumbling Gombrich with Vasari is not a way of announcing a historically sensitive text, but how do I know it is inappropriate? Gombrich took an entire book to tell his version of pictorial naturalism, whereas Carrier sometimes takes a sentence or two. But what criteria tell us Carrier is too hasty? I say he uses words strangely, that he cites oddly; but why should those be faults? What is it, after all, that makes me wary of his brand of encyclopedic citation, since that is also a cardinal habit of contemporary art history? I say his argument is too brisk, that it flits from place to place; but why shouldn't it? Are words like "drama," "argument," and "objectivity" signs of imminent misreading? And how might I know that? Certainly I do not mean to say that I would be suspicious of a text just because it is not written in a familiar way, but it is not easy to come up with objections that do not amount to that claim. The explanation of Carrier as an outsider is especially prone to these same ideas. He could refine his account, I might say, and as he reads more, he might come closer to the spirit of the art historical enterprise and might see how to ask the questions he wants to ask in the ways we might prefer them to be asked. But do we really want to make this a matter of etiquette? Do we require our interpreters to be "refined"? Does art history depend on something as nebulous as a "spirit"? Questions like these provide the entry point for a more vigilant reading of Carrier's work, because there is a disparity—that so far seems inexplicable—between the ease with which I can find objections and the difficulty I have in explaining those objections.

Let me open my reading by considering some cardinal features of art history as it is seen in *Principles of Art History Writing*. In each case my first purpose is to say how the account works and then what seems to be wrong with it, and I frame my descriptions in order to bring out the disparity between my spontaneous objections and my lack of substantial reasons for those objections. The supposition, as I would put it at this point, is that the disparity might be a significant sign of how well we understand our own enterprise, since it may be read as indicating not only a limit of what Carrier knows but a limit of our own comprehension of what we do.

Carrier's central thesis is that art history is not getting closer to the "truth" and that changes in our writing are to be referred to changes in writing conventions. We write according to modern and postmodern agendas, and there is no external authority to whom we might appeal to say whether we are closer to the truth than Vasari or Winckelmann. When it is put nakedly, as it often is, this claim is both unconditionally acceptable and absolutely out of the question. I do not know

any art historians who would be willing to say that their profession has *nothing* to do with the way the objects are and everything to do with the manners of the late-twentieth-century writing. To say so would be to give up any workable sense of art and its history. But at the same time, the way Carrier says it, the "claim that artwriting is a form of writing seems obvious" and even harmless (5). Naturally conventions determine what we write; naturally we write and think in conventions. It is an instance of an uncanny claim—both obvious and subversive, both common knowledge and poisonous fruit.

Other ideas that elicit unfocused discomfort have to do with the notion of writing in general, and they seem easier to pin down. When Carrier pursues his assertion that "artwriting is a form of writing" by comparing samples of artwriting with novels, his strategies are almost entirely structuralist. He analyzes "style" and "narrative" or "literary structure," meaning "the ways in which art historians have emplotted their narratives" (5, 6). His sense of plot, in turn, is limited to the interplay of "argument" and "poetic" concerns. The reason John Ashbery's poem *Self-Portrait in a Convex Mirror* is not art history is not that Ashbery makes "oblique" references and "personal statements" or that "one can make out individual words or phrases, but has no clear idea what the speakers are talking about" (as he says, quoting Marjorie Perloff's *Poetics of Indeterminacy*), but that it is "too wide-ranging to count as an interpretation" of Parmigianino's painting of the same name (175, 176). What Carrier sees when he asks questions about art history, novels, and poems is argument, embedded in other concerns. This idea is of a writing like a conglomerate stone: small hard inclusions—the "arguments" and "descriptions"—are frozen in an indeterminate matrix of other compounds. Foucault's argument about *Las Meninas,* for instance, is divided into "The Argument" and "The Style," but Carrier ends up describing the latter in terms of the former, so that style becomes emplotment of argument (172, 173). The tools that allow him to separate the arguments from their matrix are differences of "style," "genre," "rhetoric, emplotment, and the tropics of discourse": in other words, the disciplinary and generic conventions of narrative structure. "Writing" is a composite object, and "analysis" is the process of separating its one known part from its many unnameable parts and mixtures. One piece of evidence of this bifurcated idea of writing is Carrier's assertion that some historical debates could be solved by more-explicit logical criteria and "rules of debate" (39, 43). For that to be true—and it is a hope that I think is widely shared among art historians—writing would have to be something that could be reined in by rules of argument, instead of an unruly activity that makes many uses of rules and logic.

The "standards of objectivity" that art historians are said to depend upon turn out to be "defined by these rules," so that "objectivity is possible be- cause (nearly) every serious scholar obeys the same rules" (6). The thesis that

art historical writing is not approaching its "goal" is made dependent on the "relativist" position that shared conventions determine "truth" (45). "The truth of present-day interpretations," he says, "is measured by the consensus among professional art historians" (237). The "consensus" decides if descriptions are "original, suggestive, and plausible" (46, 199). Successful accounts must also have "closure" and be "persuasive." "Objectivity" becomes the name of this hodgepodge of criteria, and it is largely a criterion internal to the texts. To use the old distinction, "objectivity" now operates within the coherence theory of truth as opposed to the correspondence theory: it is judged by criteria within the texts rather than by links to the world. But at the same time—in the kind of immediately available contradiction that I have already noted several times— there are still the "objective" "facts" of the artworks, and artwriting is beholden to them. "Objectivity" is a spiny word in this text: like a hedgehog it sticks no matter which way it faces. "Artwriting," Carrier says, "differs in two essential ways from fiction": "novels do not claim to be truthful," and novelists are not constrained by the need to describe the same objects. But why, we might ask, is it not possible to say that novels "claim to be truthful," since Carrier has just defined truth as a matter of internal consensus? And how can he say that novelists do not also "describe the same objects," if those objects are psychological types, places, or "emplotments"? Carrier identifies himself as a "relativist," meaning he does not admit there is a "convincing noncircular standard" for judging rival accounts (31). When he says "the relativist argues that change does not mean progress," he means there is no progress in "truth" and all interpretations work by consensus. This is relativism in a weak sense, since he still wants to say art historians, unlike novelists, "are describing the same artwork." A stronger relativism would entail the conclusion that different historians see different artworks: if interpretation is mobile and standardless, there is no way to speak coherently about a "single object." In Carrier's own terms, there should be no clear way to distinguish novelists from artwriters: both "claim" the "truth"; both require consensus to be judged persuasive, "original, suggestive, and plausible."

It is tempting to say that what we are dealing with here is a sense of consensual truth that has been half thought through, so that it can easily be made to display internal contradictions. But again, in the face of this objection comes the difficulty I have in saying what exactly is wrong with his account. As historians, we cannot jettison the correspondence theory of truth and say that we are truly writing fictions. Though we may understand the links between our writing and the world to be deeply problematic, ideologically laden, unconsciously driven, or even fictional in the sense that we can no longer clearly say how they work, we need the concepts of correspondence and coherence; they are indispensable in the construction of the kind of writing we know as history. Something in Carrier's way of putting it—something in the almost blatant self-contradiction

of his formulas, something in the ragged dichotomy of convention and truth—appears to be essential for historical writing.

One feature of Carrier's thinking here that can help resolve the quandary is the unaccountable way he sometimes merely stops reflecting on an issue where an art historian might expect him to continue. A good place to see this is in his treatment of the interaction of biography and history. Even though the historian's life and the autobiographical voice are crucial to his argument (since they show historians are "involved" in their material as "subjective narrators"), he mentions them only in the most telegraphic manner:

> Gombrich and Steinberg were both emigrants. Gombrich, who chose to live in England, developed a theory of interpretation that emphasizes that successful images are unambiguous; he is not at home even with cubist art. Steinberg, a New Yorker by choice, is concerned to place the spectator in relation to the work. . . .
>
> My aim is not to present a "psychobiography" of these men, but to indicate how their views of the spectator might be linked to their lives. What I seek is not to explain, or explain away, their work by appeal to their lives, but to note how artwriting involves personal concerns. . . . But if all strategies of emplotment have an inescapable personal dimension, how can there be objectivity in art-historical interpretation? (174, 175)

I have not left much out of this account, which races by in two short paragraphs. (Fried and Foucault take another sentence each.) It seems there is very little to say about the connection between lives and views, even though the "inescapable personal dimension" is a cardinal obstacle in the way of "objectivity." Why should there be so little to say? Even if we can read this sympathetically (as if it were sensible to connect cities or countries with modes of interpretation), why is it not worth explaining, exploring, and qualifying? Why is it not necessary to determine if the "inescapable personal dimension" is negotiable—or else demonstrate that it is intractable? Under what circumstances is this a sufficient way of saying that an autobiographical voice can be heard in all narratives? But again, we need to be careful in what we demand. Though the account is threadbare, it is not easy to say what is missing. Exactly how should Gombrich's adopted Englishness be read in his works? How does New York reverberate in Steinberg's writing? As writers or as literary theorists, we might be happy to entertain the curious problems of autobiographical voice, but they have not yet been opened within art history, and once again there is something about the nakedness of Carrier's description that seems right.

A similar dynamic animates other leading concepts. Carrier claims "the goal of art history is to re-present the mental states of the artist," and one of his recurring

theses is "artworks cannot be understood by appeal to the artist's intentions" (6–7, 21, 210). Again, I think a consensus of art historians would split on this issue. On the one hand, few people would be likely to say that their "goal" is simply to understand the artist's intentions. Relatively little art history is still written with the express intention of communicating a sense of an artist's personality. Some branches of art history (especially the recent study of mannerism, and the social histories of art) have expressly renounced psychological speculation. But as the critique of subjectivity demonstrates, a less straightforward notion of an artist's personality remains a strong support for a wide range of art historical writing. This is the same peculiar dynamic: Carrier puts his issue with unnatural vigor, pushing "intention" into the narrow matter of explicitly setting out to determine artists' conscious wishes and thoughts. It seems wrong, since that kind of intention is no longer the issue. But no matter how careful we are on the subject of intentionality and the places of psychological reconstruction, there is still the raw question to contend with (the particular instability of accounts that depend on reconstructions of intention). and that question, or rather the rawness of it, is expressed in Carrier's exposition.

One more example will round out this survey, and then I want to stop and to begin considering what these reactions might mean. If the major voice behind Carrier's sense of "emplotment" is Hayden White, the principal source for his sense of history as a whole is Hegel. Neither author is used in any extensive way (White seems to provide only the idea of narratology and phrases such as "emplotment" and "tropics of discourse"),[2] but Hegel becomes important when it comes time to ask how certain historical readings are justified over others. Carrier describes the form of his book by saying it makes a parallel between the development of painting, from naturalism to self-referentiality, and the development of artwriting along the same lines (176). "This book achieves narrative closure," he says, by "linking" the two movements (235, 242). There should be a parallel between the histories of "visual representation" and "the verbal representations of artwriting" (216). The appropriateness of a given description of an artwork tends to be judged by whether the description and the artwork belong to what would once have been called the same Hegelian moment. This is driven by the unreliability of accounts based on the artist's intention, so that in Carrier's view the historian's problem is choosing an appropriate interpretive methodology from the panoply of historically available styles; and Hegelian parallelism presents itself as a sensible way to choose methodologies.

2. Carrier cites White in ibid., 45. White is responsible for Carrier's "ironic" reading of Foucault (that Foucault's mistake in *Las Meninas* is an appropriate one, since his theme is the paradoxes of representation). See ibid., 169 and 232ff., esp. 233 n. 35.

In Manet's case, for example, the choice is said to be "between applying traditional art-historical methodologies developed by late nineteenth-century artwriters" and "seeking novel interpretive strategies" (211). This would all be rather strictly Hegelian if it were followed up consistently. The idea would be roughly that interpretation should be an expression of the same stage of the Spirit as the work, since the two are conceptually bound to one another, and since they represent equal stages in the emergence of self-consciousness (216 n. 57). In another chapter, "When Is the Painting?" Carrier names a number of interpretive strategies that could account for the way that some artworks, especially seventeenth-century paintings, seem to take place at several different times at once (for example, in the "present" and in a Biblical past). The strategies he lists are roughly contemporaneous (chiefly the *ars memorativa* and Elizabethan masques), and they are "present within the culture of Rembrandt's and Poussin's time" (196). This is standard art historical practice—explaining a phenomenon by contemporaneous evidence—and we might conclude Carrier is implying that art historians need to believe in some version of Hegel's schema of history in order to think it is sensible to make such explanations. At the same time, Carrier is prohibited from claiming that his historical research has yielded a more truthful account, because he believes contemporary conventions determine objectivity and truth. An interpretation from the seventeenth century need be no better or worse than any other. And this in turn sparks a critique of the very Hegelian parallelism that he had begun to approach. "What perhaps discredited traditional holistic historical explanations was the Hegelian belief that a given culture at a given time must possess a unity," he says, but unusual works disrupt that belief and show "that we cannot predict how best to interpret a work" (198–99). Yet he is tempted by Hegelianism, and he repeatedly looks for interpretations that show self-consciousness and self-referentiality that seem "parallel" to the works. In this case, as in the others, he does not conclude that *ars memorativa* and Elizabethan drama are optimal parallels to Poussin and Rembrandt, but he is clearly attracted to the idea that they fit well. Several essays in *Principles of Art History Writing* could be conventional Hegelian explanations if it were not for the caveat of relativism that he adds at the last moment. Hegelianism is tempting—so much so that it can briefly eclipse a writer's awareness of its shortcomings. Some parts of Carrier's essays are Hegelian in this sense (they pursue contemporaneous modes of explanation with enthusiasm and critical naïveté), and others are sober reflections on the senselessness of that same impulse. Critical reflection is definitely not in control at all times, and the right hand does not always know what the left hand is doing. And this is the quandary: we can see the problem he posits; we know how difficult it can actually be when it is developed with more precision and greater attention to the philosophical texts; but we cannot reject his jaunty manner.

Things are more complicated, certainly, but things are also just as simple as he puts them.

At this point I want to pause and consider the nature of these "errors." It appears as if ideas such as history, writing, intention, progress, truth, convention, relativism, explanation, autobiography, and Hegelianism are defined somewhat restrictively, narrowing and delimiting Carrier's account. Writing, for example, appears as a simple amalgam of logical claims ("arguments") and ancillary, ornamental, or preparatory material that might be melted away. Explanation is the business of setting rival arguments side by side and watching how they interact. Carrier's philosophical grammar appears a little vague, or rather it has an inappropriate degree of definition, so that his words do not name what I often want them to name. This would seem to account for the feeling I have that his conclusions are at once true and irrelevant. It is true that history does not progress, but it is also unimportant, since art historians do not deal with either "history" (in any monolithic sense) or progress (in any explicit sense).

But these problems of definition and usage cannot be fully explained in this way. If it were only a matter of usage, then it would be possible to dissociate our position from Carrier's and say where we stand in relation to his formulations. But I have suggested that the persistent feeling of truth about his explanations is at work *especially* when they seem raw or incomplete. What I am aiming at here is the idea that some of Carrier's "limitations" are ours, so that in the end he is, despite his apparently skewed viewpoint, describing what we do. My first piece of evidence for that assertion was the unsettled dissatisfaction I think art historians might feel with Carrier's treatment of these themes—reading both "unsettled" and "dissatisfaction" as clues to our close involvement in Carrier's version of art history. Reading Carrier on the subject of writing or progress is like feeling that something is coming back to us from our own writing. We also have a hard time talking about progress and about what we want to put in its place. Within art history, conversations on that subject sometimes have the same choked quality, and even the shrillness, of Carrier's way of announcing the death of progress.

For Freud, the uncanny is the name of something in the past that has undergone repression and is now returning. Carrier's "wrongness" is uncanny in this sense because it is a ghost, a *revenant,* of art historical thinking. There are things about our ways of thinking that we do not like to address, and Carrier shows us what our critical issues can look like when they are seen head on. If it is hard to object when he imagines writing as something that consists of arguments and an indeterminate matrix, that may be because our own idea of art historical writing is based on just such a model. If he patches his relation to Hegel in such an unresolved way, our dissatisfaction is only more acute if we recognize something of ourselves in his account. When he launches a comparison of Freedberg and Ashbery, or art historical writers and Jane Austen, his happy gaucherie has an

unpleasant taste because it is the kind of comparison that our own ideas of our writing might lead us toward—and with the same weak results. Our lack of eloquence on the difficult topic of the connection between a historian's life and writing is mirrored, unpleasantly, by Carrier's quick-fire list of historians' biographies. Our indecision on the importance and place of artists' intentions is reflected back at us by Carrier's dogmatic insistence on the topic.

Carrier's search for clear concepts is simply sanctioned by our indecision. It may well be that the art historical texts Carrier reads invite the kind of readings he has been making over the last ten years, so that, far from being an inappropriate, ham-fisted account, his version of art history is an appropriate and firmly grounded response to the ways we write. I want to be clear about this: I do not think it is difficult to say where Carrier's accounts go wrong, if we are willing to restrict the conversation to the concept of fiction, or narrative, or the heritage of Hegel. It is not that his accounts would be difficult to deconstruct or elaborate. In later chapters I explore various ideas that appear here—the naked insistence on argument, the structuralist conception of writing, the uncompromising critique of progress—and I have already considered the questions of intentionality and objectivity. But when it comes to writing art history, our understanding of these issues sometimes runs parallel to Carrier's.

This reading is also a way of explaining why it appears that Carrier's "mistakes" are matters of style as much as substance. Given that art historians generally avoid exploring concepts such as objectivity and progress, it makes good sense that someone who made a point of mentioning them would seem to be breaking some rule of etiquette, rather than a rule of logic or history. Perhaps the most interesting quality of Carrier's accounts is that some art historians find them *annoying:* that is, not merely wrong but somehow grating. If we read his work as a mirror of our own writing, that feeling reveals itself as a dissatisfaction in our own way of addressing these topics. In psychological terms, it is not likely that his transgressions would be annoying unless we also saw ourselves in the transgressor. Reading Carrier this way puts his "errors" in quotation marks and lets us see his worst qualities as traits of the kinds of art history we practice. His resolve is an inverted mirror of our irresolution. His harshness is our coyness, his logical analysis is our discursiveness. Our writing holds a great deal in abeyance, and that is enough to enable critiques like Carrier's.

This reading can be deepened and brought toward a conclusion by asking about Carrier's concept of what art historians think they are doing. In his view, the claim that art historians are not getting closer to "the truth" about artworks is something that needs repeated mention. But the "art history" portrayed in the pages of *Principles of Art History Writing* could easily become aware of that claim: it seems, on reading Carrier's account, that the art historians would only need a moment, even an instant, to reflect on their traditions, and they would

see they are not progressing. The fact that Carrier does not raise this possibility is itself intriguing. He must think that art historians do not know what he is arguing; otherwise his book would have no public, or he would have to say why we continue to write as we do in the face of such contradictions. But why does he think that art historians do what they do? It cannot be that they think they are getting closer to "the truth," because then they would have seen what Carrier has seen. So we need to find a way to explain why he takes his version of art history to be adequate.

There is an unusual passage in the essay on Manet in which Carrier leaves off cataloguing historians' opinions and proposes a reading of his own. He quotes a letter in which Manet says, incongruously, "Impossible to do anything worthwhile with the fan you sent me" (211). No one knows what to make of this, Carrier says, because the letter is not addressed. Carrier says the letter might have been meant for Berthe Morisot, who holds a fan in the painting *The Balcony* in the Musée d'Orsay. There is no evidence this is right, and Carrier acknowledges as much. The little explanation is partway between a historical hypothesis and an example serving his larger argument, and it slips back and forth between the two. (It is like the parallel he nearly draws between Poussin, Rembrandt, the *ars memorativa,* and Elizabethan theater.) At one moment it seems his explanation of the fan is to serve as a genuine, plausible historical explanation. "Focussing on a fragment of Manet's oeuvre and this one fragment of a letter," he writes, "is an appropriate procedure when dealing with an artist whose work is so involved with fragmentation." But if Carrier is a "relativist," how can he assert that Manet's work is fragmented? (Perhaps, he should say, that is the way it appears to late-twentieth-century taste.) And worse, the Hegelian thesis that an interpretation should be consonant with the state of the art—a thesis he had already expressed doubt about several times—is here reapplied without comment. It is perilously close to what historians do. He is even willing to misread a text by Derrida in order to propose the "fan motif" as a possible historical "truth": he says he was "inspired" in his reading of Manet's letter by Derrida's meditations on the fragmentary text in which Nietzsche says, "I have lost my umbrella."[3] But Derrida was not trying to depict German society or arguing that "fragments were important in late nineteenth-century culture," as Carrier then asserts (213). It is not wholly convincing to read Carrier's explanation of the fan as an element he needs in his larger argument about interpretation, because he could easily have taken such an explanation from the literature. There is a certain joy to it, even a little coyness: "As an astute reader may have guessed by now, the interpretation of Manet's fan motif is my own invention" (214).

3. From Jacques Derrida, *Spurs: Nietzsche's Styles,* trans. Barbara Harlow (Chicago: University of Chicago Press, 1978).

As a "plausible" art historical interpretation, the fan motif is deliberately fragmentary, a tiny detail in Manet's correspondence and in three of his paintings. It fits better with the idea that *The Balcony* is a realist work, and a little less well with other readings by Fried or Mauner; but basically, it does not add or subtract much from any existing account. It is a source of some pleasure, dampened by its tininess and by its function in a text that is supposed to describe interpretations rather than correct them. There is a sense in which these are general traits of Carrier's prose: he writes in a fragmentary style, moving rapidly from one problem to another, and he is ambivalent about an art history he both enjoys and disparages. His essays jump from historiographical theses to lists of interpretation, and it can even be claimed that he sometimes loses track of where he is going, because he becomes engrossed in the minutiae of historical explanations.[4] The closing pages of some chapters in *Principles of Art History Writing* are mopping-up operations. They are moments of reflection, when the author puts down his reference books and looks around. "What then is gained?" he asks toward the end of one essay, and in another he reminds himself that without revision and recollection, "[n]othing is gained" (45, 199).

In reading the fan motif as a self-portrait of its author—a fragment, lost in the byways of art history—I want again to turn his account toward our own writing and say that this kind of fragmentary, skittish text is a principal kind of self-reflection that art history inspires. It is a dark mirror of our own scattered selves—by which I mean that the ways we tend *not* to see where we are going have their parallels in Carrier's ways of writing. The whimsical collages of his prose may be read as evidence of an originary unfocus in art history. When Carrier loses himself in art history, "mistaking" logical speculations for "plausible" art historical interpretations, then he is behaving as historians do. It is in moments like these that his affection for art history gets the better of him, and he does what he imagines art historians do: he forgets where he is, just for a moment, and thinks he is explaining Manet.

So if Carrier believes that art historians do not already know what he is arguing, it may be because he sees art historians as people who are bewitched by artworks and enchanted by the minutiae of history. We do not notice our logical difficulties, he might claim, less because we are "too close" to the material than because we do not *want* to see. Our happiness is bound up with not seeing the messes we get ourselves into—just as a more sharply logical eye might want to excise the entire fan motif because of its questionable dependence on notions inimical to relativism and skeptical Hegelianism. In Carrier's model an art historian is a person who is sometimes reticent to step back, reflect, and

4. See, for example, *Principles of Art History Writing,* 171 bottom, where he temporarily abandons the subject he has announced at the beginning of the chapter.

consider what is happening. In the next reading, I develop this unfocused sense of reticence into the stronger claim that we are not able to articulate certain things. In that way I hope to gather questions of limitation, oddness, skittishness, coyness, harshness, and solecism into a general theory of repression.

ONCE MORE THE THREE-STEP CRITIQUE

Donald Preziosi's *Rethinking Art History* is the occasion for this reading, not because it is along some trajectory from philosophy to art history, but because it allows me to consider the question of repression in a particularly characteristic setting. Since I concentrate on the motion of repression, this is not a full response to *Rethinking Art History,* but I want to begin with the incisive review by Max Marmor that appeared in *Art Documentation.*[5] Marmor accuses Preziosi of basing his book on a relatively small number of secondary sources, especially the introductory essay in W. E. Kleinbauer's *Modern Perspectives in Western Art History.*[6] (Marmor notes that Preziosi does not use "our two most important histories of art history," and he names—perhaps surprisingly—Udo Kultermann's *Geschichte der Kunstgeschichte* and Germain Bazin's *Histoire de l'histoire de l'art.*)[7] To Marmor, this is evidence that Preziosi has not achieved the "total immersion" in the field that he himself advocates. As other reviewers have noted, there are only a few places in the book that make contact with problems of specific objects, as opposed to questions of epistemology and method. *Rethinking Art History,* Marmor says, is "heavily dependent" on works by Hans Aarsleff, Carlo Ginzburg, Frances Yates, and a few others. For Marmor, that accusation is sufficient; but to take his reading forward from a sharp invective to a more careful account, it would be necessary to ask how we are to imagine "total immersion." The absence of historiographical detail, as well as the paucity of specific problems, paints a particular picture of art history—one quite different from, say, the encyclopedic scientism of Hans Tietze's *Die Methode der Kunstgeschichte* (another book Preziosi does not use).[8] But how are we to recognize when a general account is an uninformed account? How can we know if a half

5. Max Marmor, review of *Rethinking Art History,* by Donald Preziosi, *Art Documentation* 9, no. 1 (1990): 22–24. I thank Whitney Davis for this reference.

6. W. Eugene Kleinbauer, *Modern Perspectives in Western Art History: An Anthology of Twentieth-Century Writings on the Visual Arts* (New York: Holt, Rinehart & Winston, 1971).

7. Udo Kultermann, *Geschichte der Kunstgeschichte* (Vienna: Econ, 1966); Germain Bazin, *Histoire de l'histoire de l'art* (Paris: Michel, 1986).

8. Hans Tietze, *Die Methode der Kunstgeschichte* (Leipzig: Seeman, 1913; reprint, New York: B. Franklin, 1973), is cited in Marmor, review of *Rethinking Art History,* 23.

dozen secondary sources might not be enough for an interesting account of art history? What is "total immersion"?

I would distinguish this aspect of Marmor's review from the more specific claim that Preziosi does not observe scholarly propriety in his citations. Marmor rather pitilessly demonstrates how Preziosi quotes at second hand, citing primary foreign-language sources as they appear in English-language secondary sources, without giving credit. "In quoting Alberti on painting, for example, Preziosi cites Spencer's translation of Alberti but actually takes his (mis)quotations from an article in a British film magazine that he cites several times." "In chapter four, Preziosi's quotations from John Locke, Thomas Carlyle, and William Whewell are silently borrowed" from Aarsleff's *From Locke to Saussure*.[9] In Marmor's opinion this habit is serious, and he describes it in a way that is reminiscent of academic invectives against plagiarism: "Preziosi's unusually heavy reliance upon secondary sources is itself 'unsettling, tedious and disconcerting' [as Preziosi had described his own journey into art history]. Unfortunately, this dependence goes well beyond what he documents in his 64 pages of endnotes—arguably, beyond the bounds of scholarly propriety" (23). Here the question of indecorum, which is a matter between Preziosi and his unacknowledged sources, may be separated from the question of pastiche, which is a matter for Preziosi and his readers. The importance of decorum and "propriety" in art history runs beyond questions of citation and acknowledgment and reaches into matters of style, tone, and voice. In later chapters I take up these questions, which circle around the curious word "coy" in Preziosi's subtitle, *Meditations on a Coy Science*.

The other aspect of Marmor's verdict—what it means to call Preziosi's book a pastiche—is more directly relevant to my initial purpose here. Marmor presents enough hard evidence to place the book within the ranks of pastiche and dilettantism, though he does not make either claim explicitly. Here again what seems to be a straightforward judgment ("pastiche" is both a description and a verdict) proves difficult to pin down. How are we to know if pastiche is an inappropriate "strategy" for the "bricolage" of art history? And in general, if a text sets out to question a given disciplinary practice, what habits should it replicate? What rules should it eschew or "misuse"? What is fidelity in such a case? In *Rethinking Art History*, art history is imagined as a strongly disunified, "heterotopic" practice. At the same time, art history "masquerades" as a conceptually unified practice, showing itself to the world as a "utopic face" or "sacred island" (xiii—xvi). It is possible to posit this as a conditional definition of the discipline, in which case I

9. Marmor, review of *Rethinking Art History*, 23. I have omitted Marmor's citations to pages in Preziosi's book. Hans Aarsleff, *From Locke to Saussure: Essays on the Study of Language and Intellectual History* (Minneapolis: University of Minnesota Press, 1982).

would say that whatever art history is, it is beholden both to some kind of unity and to its "heterotopic" methods. In its disciplinary aspect, art history *is* that dilemma.

The readership of *Rethinking Art History* might be divided into two camps: on the one hand, there would be those who are, in Norman Bryson's words (I am quoting from the encomium on the dust jacket), "concerned with the present condition and the future direction of visual studies." The language of *Rethinking Art History* helps place those readers: they are people with some familiarity with Derrida, Lacan, and Foucault, each of whom is mentioned without extensive explanation, and they are people more or less at home with Preziosi's choice of critical jargon. The book itself sketches a picture of such readers, who are inevitably not unlike Preziosi himself: they are open to deconstructions of their assumptions and methods, ready to rethink their relation to hidden ideologies, amenable to the possibility that they may want to shift their position so far that they find they are not doing art history at all (179). On the other hand, there would also be those practitioners who constitute the bulk of the discipline and who provide Preziosi with the substance of his critique. They would be those historians who are (more or less, indifferently, inadvertently, or intermittently) working under the assumption that they are describing the world in a transparent, unproblematic manner or according to some scientifically defensible regimen of empirical precision. They would believe (roughly, occasionally, informally, privately) that art history is amassing a body of neutrally verifiable facts about artworks. That group, as its outlines emerge from *Rethinking Art History*, is the bulk of "normal" art history, both in the present and in the past.[10]

The more sympathetic audience is defined for us by its affinities with Preziosi's own beliefs and hopes for art history. Such readers would have no insurmountable difficulty in following Preziosi from the "unitary," "monolithic," "mythical" coherence of the older version of art history to the "complicated and highly contradictory range of practices" that is the actual state of affairs (I am quoting again from Bryson's response, on the back cover of the book). The other audience,

10. In view of the fact that Preziosi critiques one of my own essays for repeating the theory/practice dichotomy, I should add that in making this distinction I am not subscribing to the division between theory and practice that is doubted in *Rethinking Art History*. At the very least, that which appears in our lectures and texts as facts, dates, and names may be reread as covert theory. Theory and practice cannot be opposed in that way without making practice into something devoid of ideology, desire, and assumptions (that is, as Preziosi says, one of these things that happens to practice in art history), and conversely, such an opposition would narrow theory into something that is applied to practice—the precise conundrum that I considered in Chapter 1. Dividing theory and practice as I have done in the opening chapters of this book is not a truth-claim but an interpretive strategy. It creates a drama whose players are continuously at loggerheads, and by doing so it allows us to speak from a position other than that from which we speak when we emphasize the impossibility of dividing theory from practice.

which is identified as art history (as it is used on the front cover of the book, in the title itself), would have more trouble. If art history is endemically divided, so that it is "beholden both to some kind of unity and to its 'heterotopic' methods," then it is not clear how that second audience is to respond to the portrait Preziosi paints. It seems to me they cannot respond, because they are constitutionally—or, to put it more strongly, congenitally—incapable of acknowledging that division.

This is the problem of the gap between the second and third steps of the three-step critique I explored in Chapter 1. It is not a matter of finding a way to convince some recalcitrant readership, though there are moments of enthusiastic polemic throughout the book, and it is also not a matter of choosing to write a descriptive, rather than a prescriptive, account. What is at stake here is that Preziosi does not acknowledge how art history would find it impossible to respond to what he says. In that specific sense *Rethinking Art History* is a book without an audience: either a reader knows what Preziosi is saying, and does not write art history, or else the reader does not know, and cannot use the information without ceasing to write "art history." Preziosi breaks off whenever it comes time to ask how his version of art history might be incorporated into existing practice, even though nothing in his account tells us why that problem cannot be explored in the text itself. That, it seems to me, is the central difficulty of *Rethinking Art History,* and the primary challenge for a serious reading is to account for why Preziosi does not mention it.

Let me put this first as a theoretical problem, and then look into the text to see how it operates. One of Preziosi's guiding tropes is the "double bind," a condition in which a person cannot bear to choose between two alternatives and also cannot resolve the dilemma in order to see it "from the outside."[1] A double bind is distinguished from a contradiction, antimony, or dilemma by the phenomenological status of the solution: in the latter cases, it may be difficult or even impossible to construct a solution, but the *form* of solution will be apparent—its general outlines, its language, its possible relations to the two given terms. In a double bind, the *idea* of a solution is inconceivable to the subject experiencing the double bind. An accessible example of a true double bind is a contradictory experience in a dream. The dreamer is tortured by awareness of an impossible choice, and then doubly tortured by the constricted logical world of the dream that prohibits any escape from the immediate awareness of choosing. If art history finds itself caught on the horns of some dilemma—in the example I have been using, it is the question of its ostensive unity and its unacknowledged diversity—then it could "theoretically" acknowledge that fact, as Preziosi does, and try to move on to other ways of understanding itself. In that case the dilemma would be a simple self-contradiction, and the acknowledgment would take art history forward according to the old machinery of the Hegelian *Aufhebung.*[11] But

11. Whitney Davis, review of *Rethinking Art History,* by Donald Preziosi, *Art Bulletin* 71 (1990): 165.

to do so, it would first be necessary to make the "metacommunicative statement" that there is a self-contradiction and to observe it "from the outside." (Davis notes that in psychoanalysis the impossibility of taking this step "outside" is known as the "tertiary negative injunction."[12]) In a true double bind, that step cannot be taken. There is no possibility of "self-conscious critical knowledge . . . that labels metaphor as metaphor, disagreement as disagreement, and so forth."[13]

Although Preziosi uses the phrase "double bind," he usually seems to mean what Davis calls "garden-variety metaphors, disagreements, contradictions, and self-contradictions taken up by art historians from philosophical traditions."[14] He does not mention that it might be impossible that art historians become aware of problems in the discipline, and he treats dilemmas as if it were necessary, sufficient, and unproblematic to describe and analyze them. His own acts of description continually violate the "tertiary negative injunction" by directly setting forth the terms and conditions of the dilemmas. Because of this, it is not clear how Preziosi means to use the term "double bind," and some of *Rethinking Art History* can be read as the explication of "garden-variety" dilemmas. But two things make this simplification inadequate. First we would have to explain why the art history he addresses has not come out of its unreflective stupor generations ago; and this is the same question I put to Carrier's account of art history's lack of "objective truth" (that it should have been obvious to any historian). The Hegelian dialectic is both inexorable and swift—meaning that those who know of the dialectic are rapidly swept toward its "higher" stages. If there were no double bind, historians would have written *Rethinking Art History* back in the eighteenth century. The reduction of the double bind to the simple contradiction is inadequate for a reason internal to Preziosi's text: his own descriptions of art history underscore the fact that its dilemmas are constitutional or congenital— that they are deeply rooted qualities of art history and even conditions for the existence of the object "art history." Preziosi often describes them that way, as if they have been growing inside art history since its inception; and if that is the case, then it is inadequate merely to describe them.

At this point we are again approaching the question that interests me the most—Why does Preziosi not see that it is a problem to let his explanations stop where they do?—but I want to keep going on this track for a while longer before trying to answer the question directly. In the review Davis remarks on the absence of the "all-important 'tertiary negative injunction' " and says it comes from the "institutional organization" of art history, "a matter that is still outside the frame" in Preziosi's analysis. In effect, Preziosi is still "inside" art history, even if he is inside a "nonconformist" part of it, so that the double bind

12. Davis quotes Gregory Bateson, D. D. Jackson, J. Haley, and J. Weakland, "Toward a Theory of Schizophrenia" [1956], reprinted in *Beyond the Double Bind*, ed. M. M. Berger (New York, 1978), 10–11.
13. Davis, review of *Rethinking Art History*, 165.
14. Ibid.

imposed by the discipline still binds him to silence: "How and why does Donald Preziosi write the book *Rethinking Art History*, published by a major press whose list includes classic texts of art-historical logocentrism, and how and why does Whitney Davis (both of us, predictably, coming out of the Fogg and now teaching in purportedly nonconformist departments [Northwestern University and the University of California at Los Angeles]) review it for the *Art Bulletin?* Are these topics still too explosive? Preziosi's ability to comprehensively rethink art history is double-bound by art history's prohibition against speaking its real names."[15] In Davis's account, therefore, the double bind remains invisible in Preziosi's account because he remains "within" the discipline (in a sense, this is the opposite of Max Marmor's claim that Preziosi is "outside" the discipline). But do we want to choose "institutional organization" as the site of the limits of our thinking? It seems at least possible that Preziosi and Davis are far enough "outside" art history, and that the readers and editors of Yale University Press are liberal and committed enough, to let Preziosi speak the "real names" of art history. And what is it in the institution that can encompass and silence as versatile a critique as Preziosi's?

The question of the nature of the things that institutions prevent us from seeing is a large one and perhaps too unfocused to be of much help in this instance. That is one reason I want to turn the direction of the argument away from external injunctions and toward internal ones. It seems better in this case to explain institutions in terms of the people who made them, rather than vice versa. Why do we want to create and support an institution that prevents us from thinking just these thoughts? Why do we continue to live inside such institutions, even when we have doubts as severe as Preziosi's? It is not only that art history is in a double bind and therefore cannot see certain things, it is also that there is something here that art history does not *want* to see, something that it constructs its institutions in order not to see. The explanation that Davis offers, in which the double bind is in the institutional frame, can be seen as a reflective—but bound—version of this same desire, since he chooses to point to "institutional organization," rather than at himself or ourselves, as that which lives within the discipline. The institution is ostensibly external, something that we are beholden to, even as we become increasingly aware of how it works to guide our thought; but desire, in whose direction I have been going in this critique, is internal, and it creates both the institution and the strategy of pointing to the institution in order to account for the moments when we can no longer explain what we are doing.

This is where coyness enters, because—as Davis goes on to point out—"a person becomes 'coy' " to soften the pain of the double bind; "otherwise, the bind

15. Ibid.

shatters and paralyzes."[16] Coyness is conscious avoidance of a problem, and so it may signal a partial awareness of the double bind (there is no full awareness from within the bind itself), a way of acknowledging that the bind is insuperable or not fully amenable to rational description. But coyness is also a mannerism, and so it might denote an accustomed way of dealing with the "tertiary negative injunction" by turning aside when the force of the injunction is first felt. As I read Davis's account, he is willing to attribute either of these to Preziosi, and I would agree, although I lean more toward the second. If it were the first, Preziosi might have been expected to make concerted efforts at acknowledging the injunction, or at least to write a text that would be troubled by half-acknowledged difficulties; but his book runs all too smoothly from beginning to end.

In these ways, the double bind leads to questions of partial awareness rather than situations in which awareness is wholly impossible or canceled. The phenomenological status of that incomplete awareness reaches to the heart of my project in this book, since most ideas I describe in the next chapters are in one way or another incompletely visible while we practice art history. I have mentioned Preziosi's call for the discipline to become more inclusive, to study the "the entire set of processes whereby artifacts are produced and reckoned with in the engenderment and sustenance of individual and collective realities," the "total activity" of production (xx). Inclusion, increased complexity, and greater self-consciousness are Preziosi's principal wishes for art history, and they are repeated throughout the book. There is an interesting contrast between these simple, undetailed diagnoses and the discipline itself, which he finds so deeply divided, "distorted," "impossible and contradictory" (xvi). When the close imbrication of disciplinary methods and the "heterotopic" regimes of art history come into contact with his simple open-ended diagnoses, there are precipitous drops in narrative tension. The diagnostic moments tend to come at the close of chapters or sections, where their somewhat unfocused monadic nature is partly ameliorated by their function as ornamental unifying perorations to stories that are necessarily only partial. These questions of narrative flow and balance are important and substantial enough to open an inquiry into the nature of his diagnoses, but there is also the matter of the flow of theory, of its inner logic and its directed energy. The diagnoses break the chain of theory at the very place where theory would have to be applied to the texts.

In Preziosi's second chapter, for example, the topic is the logocentric paradigm that imagines the artist as active producer of meaning, and the viewer as a passive recipient. The passive/active polarity, according to Preziosi, has had a limiting effect on art historical studies (46ff., 110). He points out that there is an open-ended field of alternate possibilities to the "logocentric paradigm": "[A]ll

16. Ibid.

signifying activity is, in varying degrees, referential, self-reflective or autotelic, allusory, territorial or phatic (signaling various degrees and levels of individual or collective identity), emotive or expressive, and didactic, directive, or conative. Varying degrees of dominance among these dimensions might be attested in the reconstructed intentions of makers as well as (and thus not necessarily in identical ways) in the reckonings of users with respect to the same work" (50). Several passages in the text provide such expanded alternatives to the passive/active model of meaning, and they are placed in closing or penultimate positions in the narrative. In this case, the fact that such a large number of alternative modes of signification exist outside those countenanced by art history points to a systematic exclusion performed within art history, and the chapter closes with a thought about historians' awareness of that narrowness. Art history, Preziosi says, "frequently knows what it does. And it frequently knows why it does what it does. What it knows less well, however, is what *what it does* does. The pursuit of that understanding, which entails the re-remembering of the lines of rupture and contradiction papered over by art history as it perpetually misreads its own history, is surely our most pressing task" (53). This is the end of the chapter, and the choice of the word "re-remembering" shows that the force of the "tertiary negative injunction" remains invisible. These are the first two steps of the three-step critique: Preziosi imagines the process of rethinking art history as the identification of problems or limitations in the text of art history, and he completes his account by offering rectified or expanded theories. There is no third step, no inquiry into what happens when the explanations meet the existing practices. How do the new methods modify the old practices? What is lost when a practice is described, as it is by Preziosi, in terms of its masked ideology? Is it disabled? Or does new knowledge of unexamined assumptions grow harmlessly alongside the assumptions themselves? In the original clinical use of the double bind this is a dangerous moment, carrying the possibility of fresh repressions or a psychotic break. But in Preziosi's text it appears to be simply absent.

Preziosi does not suggest "re-remembering" might be difficult, and if he sees a problem in becoming more inclusive, he does not think it is necessary to mention it. And it is not enough to explain this as a legitimate ending point for his meditations on inclusiveness, because if there was to be a problem in "re-remembering" and it was not acknowledged, then the entire purpose of the preceding pages would become questionable. How would those pages then be read? Those feeling the pressure of the double bind would find them incomprehensible, irrelevant, or annoying (as some readers have), and those outside the double bind (as the author would then be presenting himself) would still have an interest in inclusion, complexity, and self-consciousness, and so they would welcome the addition of the new theme. I would read this passage as an absolute absence—a negative sign, meaning either that the author was

never aware of the difficulty or that, following the logic of the double bind, the difficulty has been entirely repressed. Only the sudden changes in narrative flow and in theoretical rigor signal its absence.

After the first sentence in the passage I have just quoted, Preziosi inserts a footnote citing and quoting an essay of mine, "Art History Without Theory," to the effect that "art history is in an amazing position: it is made possible by unstated notions and beliefs which cannot be brought to light. If they were, they would be contradicted by what practice is actually doing, or else they would collapse under the weight of their own inconsistency. At the same time art history depends on the repression of such ideas and cannot accommodate their discussion." I would no longer want to defend everything I wrote in that essay; at the time it seemed adequate to use the language of psychoanalysis (especially repression and the return of the repressed) without asking how it could be related to other ways of recounting the same phenomena.[17] But the meaning of the passage is decisively altered when Preziosi quotes it here, since it is immediately followed by the injunction to "re-remember." The passage I wrote argues precisely the impossibility of "re-remembering." Any success we might have in "recalling" the ideological meaning of our interpretations would, in my view, disrupt them so severely that it would prevent us from continuing to make the same kinds of art history. Davis reports that according to the original psychoanalytic theory of the double bind, the consequence of the unrelenting pressure of the tertiary injunction is schizophrenia, and we might also recall Freud's and Jung's warnings against the premature or forced introduction of unconscious ideas into the clinical setting. It is risky to bring repressed ideas to light, and it is a risk that is missing from Preziosi's account.

If I read Preziosi's text the way I read Carrier's, as a reflection of the discipline, these lacunae are easier to understand. They become signs that the entire problem of the double bind, and of the repressions that make our practice possible, are beyond our interpretive horizon. Just as "art history" does not see them, so Preziosi does not. I think it is a reasonable guess that most art historians will have thought of many of the things Preziosi says, even though we may not take them seriously, or take as much time with them as he does, or use his language to express them. The variety within the discipline and the ideological force of "objective" and ostensibly nontheoretical methods are widely acknowledged. Occasionally someone will point out, as Davis does, that new methods such as those introduced by feminist art history and social art history rarely escape from old assumptions. But we do not see what binds us to these themes, what keeps

17. James Elkins, "Art History Without Theory," *Critical Inquiry* 14 (1988): 377, quoted in Preziosi, *Rethinking Art History: Meditations on a Coy Science* (New Haven: Yale University Press, 1989), 200 n. 86.

us milling about in the same dilemmas, and the absence of a full account of the double bind is accurately mirrored in Preziosi's account.

This is how I would make the transition from the "unfocused sense" that we are "reticent" about some things, which I was drawing out in Carrier's text, to a developed theory of repression. It seems to me that if art historians do not escape from certain assumptions or methods or dilemmas, it is because we do not want to. We manage to continue doing what we want by excluding the relevant critiques from our texts and from our thoughts; we repress ideas that have the power to release us from the double bind or to reveal the mechanism of our repression. Even Davis's account of Preziosi's book, which is to my mind the most vigilant record of the repressions of disciplinary practice, may include a figure of that repression in its identification of the "institution" as the locus of the double bind.

Mourning the Cloud of Unknowing

Most of my interest is in the way the repressions work, and so I tend to part company with Preziosi when he imagines the unaware, idyllic art history as something less interesting than the many possibilities of an opened, inclusive, self-conscious art history. It seems to me that more normative art history is *more* complex than the "heterotopic," "anamorphic" analysis and directions that are figured in Preziosi's account. Despite all appearances, his call for complexity is essentially a call for simplification: it is wrong—or rather it is wrong for the moment—since the possibilities that recent theory has provided are not yet as rich as the old practice. I would not claim that the practices of art history have not been ideologically naïve, or shot through with unexamined assumptions about objectivity, science, and the passive observer; but I would say those practices are less known, more interesting, more ingrown and dense, than even the most seductive theory. The discordances of the existing practice are more engrossing than the anatomies Preziosi offers, and the tangled self-contradictions are more engaging than his teasing, coy analyses. The passage from one to the other, from the old and unaware to the newly aware, is a sad one. In Preziosi's account it has no emotional valence, since it is simply a matter of adding self-reflection and complexity to a closed practice. But in my view, when the old practice is changed, it is violently and unpredictably torn. We do not know much about what we are doing: we do not have a clear understanding of what our theories allow, and we are far from clear about the problems of adopting new theories. "Saying what we are doing" is not only difficult: it is painful. The nostalgia that E. H. Gombrich feels about medieval art—he thinks that Renaissance theories have permanently

erased the possibility of a certain kind of naïve, pious picture-making—has its echoes here, since the art history of Preziosi's title fades even as he tries to "speak its real name."

Needless to say, I have no stake in preserving the "heterotopic" "bricolage" of methods from their impending ideological and epistemological critiques. This book is evidence enough for that. But as we slowly learn ways of saying what we are doing and move away from what we once were, it seems important not to forget that violence, mourning, and nostalgia accompany all change. Models of art history that imagine new theories being added to old ones, or describe new theories without saying what might happen to old problems, or picture a discipline gradually coming to its senses and "re-remembering" the effect and meaning of its practices, are unthinking simplifications of the act of change.

6 UNEASE AND DISEASE

> The philosopher's treatment of a question is like the treatment of an illness.
>
> —Wittgenstein, *Philosophical Investigations*

Part of the constitution of the discipline of art history in the past three decades is an uncertainty or unease about itself. This feeling typically appears as a medical metaphor: a disease or a "crisis in the discipline," with "symptoms" such as parochialism, moribund methods, or lack of intellectual force.[1] Theorists rush at it like doctors, clamoring to be the first to pronounce a working cure. Some are prescriptive, setting out conservative canons (one such is W. M. Johnson, *Art History: Its Use and Abuse*)[2] or agendas of expansion and reform (such as Moxey's *Practice of Theory* or Preziosi's *Rethinking Art History*). Others are more descriptive, and imagine their purpose to be the representation of the current state of affairs (for example, Carrier's *Principles of Art History Writing* or Mark Roskill's *What Is Art History?*).[3] To a third group, the patient has already died, and the task is to think ahead, to plan art history's successor (here one might name Hans Belting's *End of the History of Art?* despite its author's protestations that he is not writing about the end of art history).[4]

Through all this the patient—whatever conservative "art history" is named by these texts—generally remains silent. It is less than happy with the wealth of attention and sometimes maintains that it is not sick, or at least not in need of examination. Often it claims there is no "crisis" or that "crisis" is not the right word for a discipline as healthy and thriving as it is. But anxiety finds voice in the way the patient behaves. To avoid mentioning its illness, it has to speak in a rigid, formulaic manner, sometimes stopping abruptly when it is on the brink of

1. Henri Zerner, ed., *The Crisis in the Discipline,* special issue of *Art Journal* 42, no. 4 (1982): 279.
2. W. McAllister Johnson, *Art History: Its Use and Abuse* (Toronto: University of Toronto Press, 1990).
3. Mark Roskill, *What Is Art History?* (New York: Harper & Row, 1976).
4. Hans Belting, *The End of the History of Art?* (Chicago: University of Chicago Press, 1987).

acknowledging its condition. It talks very little about itself, and prefers to think about things that seem unimportant. In particular it has a strange fascination for decor and often speaks about that to the exclusion of all else.

I take it that this allegory is the principal emplotment of discourse about art history. It provides another way to define the division between art history and visual theory or criticism, so that "visual theory" in general becomes the agent of cure, promising improved ways of interpreting artworks, and "art history" remains bounded by metaphors of illness, listening to voices of authority, attending to whatever advice it might be given. The allegory also nourishes the illusions of illness and insufficiency together with their attendant symptom of unease. Especially for those historians who do not see themselves as part of this story, it is important to note that there need not be anything as overt as a declaration of illness, parochialism, or crisis to put the drama in motion: any historical paper that polices itself by introducing its method to the reader will raise the simple possibility that without such policing—without the method in question—the art object would be seen in a less satisfactory manner. The unsupervised, uninspected procedures might be revealed as iconography, or even style history, or some outmoded form of social history. Even with the intervention of an authorial voice to orchestrate interpretive approaches, that manner of "natural" seeing—the approach that came before the newer methods—risks appearing inadequate, simpleminded, out of date, or theoretically irresponsible. The writing can then divide into two voices: one that is natural to the writer and is for some reason suspect, and another that is imported and serves to adjust, correct, or cure the first. This situation only intensifies when the historian, following a current custom, makes use of a wide variety of methods in order to speak about an artist or a work; in that case, the inevitable difficulties of adjudicating disharmonious theories leads to an even stronger feeling that what is at stake is some drama, in which the author's native way of thinking about objects seems to require elaborate intervention. The intentionally polymorphous or pluralistic methods advocated by writers such as Preziosi and Moxey put the very subject of methodology into question and can create readers hypersensitized to the objectionable remnants of discarded methods. In general, the coexistence of explicit methods, some representation of writing done without those methods, and an authorial voice legislating the relation between the two will *necessarily* put all three elements into question: and that is itself enough to start the drama of illness and recovery.

And just as any writing that juggles methods entails metaphors of crisis and even illness, so those metaphors should be understood as a given condition of writing that mixes theoretical agendas and some preexisting practice. Pathology or lack can be reimagined as something that inheres in a certain dramatic scenario, so that metaphors of illness and psychic unease take their meaning from the way

we have given voice to our writing—the way we have allowed into our writing a certain voice that speaks with the authority of theory, and another whose speaking is constrained, unconfident, sometimes inaudible. One might imagine, as a thought experiment, an art historical text in which the favored interpretive strategy was presented without confidence or allowed to proceed invisibly, so that it coincided with moments presented as unmediated understanding: the result would be a different scenario, where tropes of medicine and psychic unrest could not find purchase.

Though art historians have mostly stopped referring to the disciplinary "crisis," I would argue that the general condition I am calling "unease" persists, and that it reveals itself whenever a historian writes about the way theory interacts with the discipline or with a specific text (so that this book, entirely aside from what I might claim, is a symptom and agent of unease). As long as there are elements in art historical writing that speak *for* some practice (in the terms of the first chapter), the scenario of illness and unease will remain a problem that cannot be cured once and for all. Yet the illness itself is not incurable: if we want to move beyond this allegory—and I present some second thoughts on that at the end—then we can do so by paying attention to the kinds of writing that are taken to describe the discipline.

The Patient's Voice

The sameness that I explored earlier is pertinent here because it also names an effect of theory. When an author speaks in the name of a theory or in the voice of a theory, the strictures and obligations of the theory produce a certain uniformity: in these terms, it is the voice of authority that is also heard in a doctor's speech. Practice, as the patient, remains largely silent: it speaks only to answer the doctor—that is, to provide evidence for the theory. Yet theory does not speak entirely in the pure voice of authority: it has some human nuance, and practice is not entirely inexpressive in its choice of responses.

I think it can be argued that our habits of reading fictional narratives cause us to fill in the blanks of the distanced, unemotional, reticent, sometimes insecure voices of art history with all the intimate figures that we would expect in a first-person narrative. We fasten on some underdeveloped crumb and project onto it all the inappropriate and unformed feelings, all the figures of biography, of private life, of motivation and purpose and personal engagement, that we think might be true of the author. We need very little incentive: it may be enough if the author thanks someone politely in a footnote, or uses a slightly harsh turn of phrase, or pauses to tell a personal anecdote. Anything will do, and any

voice, no matter how ill fitted, can come to serve as the authorial voice. Since theoretical platforms are usually stripped to the bare necessities (an allusion to a text of Freud's or Lacan's, a mention of a deconstructive term, a rapid review of some construction of gender), they cannot often carry the expressive burden that readers intuitively expect of full writing. The same can be said of the voice that presents the theories, advocates them, and applies them to the works: it tends to be too businesslike, too formal, and too tightly serious to let itself open into an authorial voice in any wider sense. As readers, we may be forced to look for expressive values in the nearly mute voice of pretheoretical or untheoretical practice. In much of art history, that voice is so nearly inaudible that it persists more as a possibility than a developed character; but it is the patient's voice, the one that represents historical knowledge (as opposed to the theories applied to it), and the one that answers passively to the demands of theory. In other cases the voice that presents theories and manages the narrative carries the burden of a writer's voice. No matter which strand of the narrative a reader chooses, the act of reading necessarily entails some sense of the "author-function"—or, to put it in non-Foucauldian terms, some idea about the person who wrote the text. Art history and related disciplines impose difficult, underdeveloped acts of reading, because art historians are largely invisible in their writing, even when the topic is the construction of gender or the place of biography in historical narrative. No matter how passionately argued a text may be, and no matter how its dryness or professional distance is modulated by signs of engagement, normal art history lets the most basic functions of first-person narrative fall silent.

It may seem inappropriate to hunt among the desiccated narratives of art historical texts for voices that are expressive in a fuller sense. If I do so, it is not because I hope to recover hidden biographical details; there are more appropriate and reliable forums for the writing of biographies. Nor do I want to show the influence of historians' politics on their writing, not least because that can be done through the explicit content of the texts, without reading "voices" in this sense at all. And I do not want to reveal art historical writing as an equivalent of fiction writing: I am not sure what such an equation would mean, given the many differences and sometimes disjunct interpretive communities for fiction and academic scholarship. My purpose is to demonstrate how the stifled expressive content of art historical narratives might be exploited, not only to make our writing more interesting—a theme that will preoccupy me increasingly from here to the end of the book—but to decisively disrupt the scenario of illness and recovery.

The best way into this subject, I think, is head-on. The best questions are also the least modulated, the most nakedly opposed to the historical project. What kind of person, I want to ask, is implied by what we write? What desire for order might lie behind a decision to spend months, perhaps years, researching

Mondrian? What affinity with radicalism, in thought or in politics, might inform
an interest in the early Picasso? What personal engagements, what constructions
of illness, what experiences of sexuality, might propel a study of artists "born
under Saturn"? This is not a question of some facile explanation, in which the
historical narrative might suddenly be revealed as a figure for an author's life
history (as Rudolf Wittkower does in the book *Born Under Saturn*). It is a
matter of hearing another voice through the official, faceless voices of practice
or theory. There are faint voices beyond the cryptic silence of the third-person
reports of "normal" art history. There are voices behind the insistent booming of
our theoretical constructions—their loudness, it might be said, in proportion to
their insecurity, as a young doctor might bluster his way through a diagnosis.
Those voices are so little known that we may want to flesh them out too
quickly, with the most inappropriate, lurid, even pathetic or bathetic personal
and biographical tales; but the rush to interpretation is itself a significant aspect
of how art history works.

In the readings that follow, I try to sleuth the undisciplined authorial voice. The
cliché disclaimer of movies applies here, since I do not have any way of knowing,
in most of these cases, whether my construction of the authorial voice has any
particular correspondence with aspects of the authors themselves, as they might
be revealed in conferences, to their friends, or to themselves. Naturally I suppose
as much—any reader must—but I have no special claims on that kind of truth.
Instead, I am concerned to show how the voices in our texts might be developed
as voices in order to disturb the figures of illness or unease and make our writing
richer and more challenging. Full writing, loosely defined, is optimally and freely
eloquent and rhetorically resourceful, and it intentionally develops self-reflexive
moments (it is "literary," in Paul de Man's sense). The fuller writing is, the more
questions can be asked of it, and the more it repays full attention: that is my
simple conviction, here and throughout the book.

As texts I consider several essays from the collection *Visual Theory*, with con-
tributions by most of those who are actively writing—Linda Nochlin, Norman
Bryson, Rosalind Krauss, Richard Wollheim, Michael Podro, Arthur C. Danto,
David Summers, and a dozen others.[5] My initial concern with these essays is
not with questions of truth or even of interest. Several of the contributions are
provocative and closely reasoned, but here I am reading them as if they were
all without referents. The question is only how the voicing of the texts might be
related to the places they reach dead ends, and my answers are set within rhetoric
(broadly construed as the form of argument) rather than within epistemology
(understood as the referents of the argument). It is not that I disbelieve there

5. Norman Bryson, Michael Ann Holly, and Keith Moxey, eds., *Visual Theory: Painting and Inter-
pretation* (New York: HarperCollins Icon Editions, 1991).

are interesting questions that can be posed and solved within the conventions of current writing; it is that I find the question of the conventions of current writing the most interesting of those questions. If we can gain a sense of how the form of art historical writing can work to delimit further discourse, we stand a chance of comprehending why the doctors have not been able to cure the art history that they imagine to be ailing.

DEFLECTED ANGER

The essay by Rosalind Krauss in *Visual Theory*, titled "Using Language to Do Business As Usual," examines "something of a perverse twist" in the reception of French theory by American art history. Krauss argues that we do not always get it right and that the simplified and misguided versions of theory that occur in American writing impair understanding of our "social and symbolic systems" (93). One of her two examples concerns Michael Fried and his essay "Art and Objecthood."[6] Fried's essay describes an opposition between two versions of modernism: on the one hand there is "presence," the "brute, physical condition" of the work, and on the other there is "presentness," denoting "a situation that transcends the merely physical, one that in a certain mood we might characterize as an opening onto Being (or meaning/being)." (I am quoting here from Krauss's summary of Fried's argument.) On the one hand is reductive, literalist "objecthood," and on the other is the possibility of transcendence, in accord with a sequence of three moves that lead away from "objecthood": a sense that the object is "without weight and without density," an illusion that "the viewer is similarly bodiless," and finally that "there can be an instantaneously but forever complete experience of knowing, within which this object and this subject can be utterly transparent to one another." Krauss quotes Fried's term "grace" to describe this sense of unmediated "presentness" (88).

The account in Krauss's essay concerns an exchange she had with Fried in 1987, in which Fried had said that "Art and Objecthood" was about a "syntactic" quality in art, something he found particularly in Anthony Caro's work. Fried describes an instantaneous recognition that "Caro was a great artist," and a subsequent explanation of that feeling. Caro's sculpture, according to Fried, has a particular way in which it is "fundamentally *not* like an object" such as the body, and that difference seems to be related to something Merleau-Ponty quoted from Saussure, namely, that "the power of language to signify does not

6. Michael Fried, "Art and Objecthood," in *Minimal Art: A Critical Anthology*, ed. Gregory Battcock (New York: Dutton, 1968).

lie in any of its positive terms but in the difference between its terms" (90). It is this use of Saussure that attracts Krauss's criticism, since in her reading "Art and Objecthood," as well as "all [of Fried's] subsequent work," is about "presentness," "an experience of intense, abstract presence," which cannot be reconciled with the Saussurean "differential model" of language. The one calls for "instantaneous plenitude"; the other denies any such possibility.

Fried had replied that nothing in the words "deferral" or *différance* speaks against the instantaneous understanding of a word or object. Differential structures such as Saussure's model of language can yield instantaneousness and immediacy in addition to deferral. Krauss agrees, and notes that various categories of signs such as the syncategoremes ("like the personal pronouns 'I' and 'you,' or the deictics, 'here,' 'today,' 'now' ") allow the fiction of full unmediated possession of intentionality. Much the same point, Krauss argues, can be seen in Saussure's distinction between *langue* and *parole* or in Barthes's assertion in *S/Z* that denotation follows connotation. But all of that also argues that "we cannot analyze the production of illusion at the same time as we are having it." An experience of "utter transparency" in front of Caro's sculpture is *parole,* and the Saussurean text that Fried has adduced to support it is *langue* (93).

The dialogue here, which has already passed through several exchanges, is not in danger of faltering, but it is also not nearing resolution. Although the bibliography is expanding—Krauss cites or alludes to Lacan, Merleau-Ponty, Saussure, Derrida, and Barthes—it is also working to restrict the purview of the exchange. "Using Language to Do Business As Usual" has a specific avowed purpose, to adjudicate a misuse of theory, and Krauss does not claim to wish to do more. She does not doubt that Fried had an experience of "presentness" in front of Caro's work, but she does doubt the theoretical description of that experience, and it is not incommensurate with her critique that she has her doubts about the experience itself, aside from the question of how it was described. This is implied in two ways. First, there is an unexplored contrast between her claim that theory is something that needs to be gotten right because it has consequences for "our understanding of our social and symbolic systems" in general, including our experiences of Caro's sculpture, and her interest in the place that this untheorizable event has in Fried's thinking: Fried's misappropriation is more than just an affectively neutral example in an argument about theory. Second, there is an undeveloped disjunction between the mastery of theory that the essay advocates and the inaccessibility of the experience in question to that very theory. By its own construction, the linguistic theories that Krauss reviews prohibit the simultaneous analysis and experience of the transcendent moment, but there is a surplus in Krauss's essay—a surplus of interest in the intractable moment that survives the theoretical disquisition. In relation to the first point, the unexplored contrast between the manifest importance of "our

social and symbolic systems" and the "case," as Nietzsche would say, of Fried's experience produces a surplus meaning—a sense that more is at stake than a theoretical corrective. Together the two contrasts imply that Krauss's target is something other than a defensible reading of Saussure and that perhaps it is the inaccessibility of the experience itself. Krauss's critique is demanding, precise, and exigent; but Fried's position in that critique is undecided, exiguously sketched, and insufficiently placed in relation to the theories.

So my supposition is that Krauss's essay itself, by its structure rather than by its actual claims, shows an open-ended interest in the experience itself—an interest that cannot be resolved by placing it with increasing accuracy in various theoretical frames. But to open a critique of Fried's experience that would take the position of denying the importance, authenticity, or even the usefulness of such an experience would demand arguments other than those Krauss has set herself in the symposia and essays leading to "Using Language to Do Business As Usual"; hence the essay functions in part to question the experience without questioning it at all. By situating Fried's "presentness" as an inenarrable experience falsely supported by theories of language, she makes it impossible to continue with the critique. The most that can be done is assert that the experience of transparent immediacy appears, from another linguistic perspective, as an illusion. Under a Saussurean banner it cannot be claimed to be inappropriate, merely misinterpreted. It is almost as if the theory wants to say his report is invalid, but cannot.

Read in a normative fashion, the exchange seems to be largely hopeless: the gathering references only make it heavier and harder to dislodge. But if the essays are read more fully, they reveal the constrictive action of theory: clearly something more is at stake than it seems possible for either author to name. In terms of the medical metaphor, this is a debate between doctors, both claiming to diagnose the other, and neither willing to break off long enough to speak without medical jargon or to address his or her own "illness." Of course, these are not illnesses; they are questions of experience and belief that are eluding the ordinary protocols of art historical exchange. To move forward it is only necessary to acknowledge and develop the affective force of convictions on both sides.

In Krauss's essay, that would mean speaking more directly about what seems wrong with "presentness"—perhaps beginning from the fact that her essay itself implies an author with more curiosity about "presentness" than its theories can support. In Fried's it might mean opening the question of "presentness" in relation to theology, and in particular to the numinous, the nineteenth-century German concept of empathy (*Einfühlung*), and other terms for immanence. Either of those strategies—and there certainly could be others—would begin to flesh out the psychological, personal, and experiential issues that are already everywhere implicit. A theological investigation, for example, could reveal something of the

dynamic between the unvoiced theology of Fried's writing and its opposite in
Krauss's essay, which could be described as antinuminous and programmatically
maieutic or elenctic.

I am asking here for something rather personal, since it would have to do
directly with belief and with the most deeply held convictions about writing and
history. Ultimately, and with a complexity that presents daunting problems to
any expositor, Fried's project has to do with questions that are both intimate and
nearly uncognized: immediate experience, conviction, absorption, and present-
ness. A theological discourse is one possible route into that territory. The affective
qualities of Krauss's work may be even less accessible to public debate. Consid-
ered purely as writing her texts present a bristling, nearly inhuman precision
and a sometimes chilling control. They communicate theories about artworks,
but they *express* a nearly intolerable pressure—something that, if the writing
presented itself as fiction, would have to be read as anger inexplicably reined
by rhetorical and epistemological constraints. In *The Optical Unconscious,* she
juxtaposes first-person narratives with more normative, emotionally distanced
expository passages in order to call readers' attention to the places of subjectivity
in historical writing. But in my reading, the book only reinforces the sense of a
beleaguered authorial voice, because its first-person narratives are still narrow
expressions of her dislikes (especially of Fried and Clement Greenberg). Nothing
in *The Optical Unconscious* effectively enlarges the authorial voice: it remains
machicolated by an unmoving, monotonic anger.[7] (That is evident most clearly
in several passages describing Clement Greenberg; they are near repetitions of
one another, and their differences are not expressively significant. It is as if—and
I take it this is intentional—they were repeated symptoms of some inaccessible
idea, working to reinforce the apparent impossibility of exploring the deeper
sources of her dissatisfaction.)

I want to be clear about my claims here: I am not finding flaws in the theoretical
positions, but trying to speak about the essays as writing. The question is not
what counts as a fault, but only what makes the writing engaging, what sparks
interest, what compels conviction. For me, one of the central interests in Fried's
work is precisely the expansion and elision of certain ways of talking about
his personal experiences in front of artworks. The moments in which he defers
speaking about a certain experience, or cleaves to a linguistic account instead of a
theological one, or casts an uncognized reaction as a theory, are generative for his
texts: they are a large part of the texts' "essential tension." Similarly, what brings
me back to Krauss's writing is not just what she has to say about artworks, but

7. This is not to say that rhetorical questions overwhelm reading. A substantive analysis of some
of Krauss's more interesting and difficult claims (with no exploration of rhetorical or writerly proper-
ties) is made in my *Pictures, and the Words That Fail Them* (Cambridge: Cambridge University Press,
forthcoming).

the peculiar tension her writing sustains as she reins her dissatisfaction over some flawed account. Her writing would not be the same, would not have an equivalent force, if it were placidly reconciled to other peoples' foibles. In my reading, the expressive voice and the ostensive narrative are already deeply entangled, and so it does not make sense *entirely* to rescind the possibility of writing with increasingly reflexive attention to the emotional properties of the prose—even though it is not possible to say what effects such a change might bring.

Visual Theory also includes a response to Krauss's essay, Norman Bryson's "Politics of Arbitrariness." Bryson addresses the problem of applying a theoretical program, in this instance the Saussurean model of language, in a transhistorical manner, or "on the plane of essences," particularly when the text is a historical interpretation of historical material. A certain twentieth-century author encounters a certain twentieth-century sculptor, and the author's account is doubted on the strength of an early modern theory of language; but perhaps all those events need to be placed in history rather than treated as timeless truths. Bryson identifies several elements in art historical discourse that lay it open to ahistorical theory: "a 'universal psychology,' which ends up making us all the same; an art historical formalism that eliminates contextual differences of history and culture in order to produce the homogeneity of all art—and the decontextualizing power of the modern museum" (99, 100). There is an oddity in this argument, since ahistoricism cannot merely or simply be pointed out: any such assertion must be defended as an ahistorical truth or addressed as a symptom or sign of yet another historical position. (In philosophy, this is the logically flawed argument in favor of relativism.[8]) The anti-universalist stance necessarily carries its own agenda. When Bryson says at the close of his response that we should "see what historical processes may be shaping our own discussion of the issue," the words could well be reflexively applied to the sentence itself, and the mention of history as cause could be added to a list of traits of the current position. These logical and historical difficulties are sometimes irrelevant to the discourses they seek to encompass (for example, when the "positions" that the relativist identifies are themselves inchoate, and therefore not susceptible to a somewhat intricate logical critique). But in this case they are relevant for reasons of voice as much as logic: Bryson's theoretical comments may be read as an oblique response to the tensions of Krauss's essay, in that they approach but do not address those moments in Krauss's critique of Fried's explanation of "presentness" that can be read as occluded critiques of "presentness" itself. Bryson speaks about historical enframement and touches on the problem of absolute "truth," "on the plane of essences": both issues that echo, without directly answering, Krauss's doubts

8. For a clear exposition, see Stanley Jeyaraja Tambiah, *Magic, Science, Religion, and the Scope of Rationality* (Cambridge: Cambridge University Press, 1990), 128.

about Fried's report of his experience (and, ultimately, about the experience itself, its "truth" and its possibility). Essences, pure presence, and ahistorical immediacy are in the air, but they cannot be linked, because they are compartmentalized by the three theoretical agendas. They speak, instead, in the figurative language of the three texts. Bryson's response makes use of the terms but does not address them as such, and I read that as an aftereffect, a sign of the lingering echo of partly unresolved ideas in Krauss and Fried. The texts are built from theoretical positions, but they are static; at the same time, Krauss's words reverberate with "presentness" even though it is not allowed any latitude to speak within the text. "Presence," "presentness," and related terms seem to call for an answer, or for a critique that would allow itself to work more freely with the resources of writing.

It may well be that Krauss possesses such a critique; but until it finds a way to speak alongside the sanctioned voice of theory, the exchange will be channeled into matters of academic protocol and proper reference. Psychoanalytic, autobiographical, theological, or ethical critiques would leave the writers more freedom to speak about their deeper intentions, so they could span the gulf, visible in each of these texts, between ostensive subject and inaccessible goal. It is not easy to see where such critiques could find common ground with visual theory as it is presently constituted, and that difficulty alone might be sufficient to account for their absence. Once again, the sameness of theory acts as a buffer or an excuse for keeping the dialogue in check, and it also ensures that metaphors of complaint and cure will remain in force.

THE PATHOS OF DISTANCE

The editors of *Visual Theory* locate their texts within "two distinct approaches": one that "argues that representation is always a matter of convention, not of essence," and another that "seeks, in Aristotelian fashion, to define an essence of art" (1). To a large degree this corresponds with the essays' proclaimed intentions, and the truth of it is brought home by several texts that seem to have been written in parallel with one another. Michael Podro's "Depiction and the Golden Calf" and Richard Wollheim's "What the Spectator Sees" are an eerie example of this. The editors note that their terms are "extremely close," especially when Podro speaks of a "symmetrical relation" between the "dual aspect" of pictures, which contain both surface and virtual depth, and Wollheim speaks of the twofold, "distinguishable but also inseparable," aspect of a phenomenological movement he calls "seeing-in," according to which we are aware of surface and also something "in" it. "Twofoldness" and the "dual aspect" may (possibly? essentially? ultimately?) be the same thing (6, 105, 172). These

are more striking and more specific than what I had in mind with the notion
of theoretical sameness, but I would assign them to the same property. Like the
larger sameness, this "coincidence" may be read in two ways: perhaps it is a
sign of healthy science, in which a group of people work on the same problems;
but perhaps it tokens stagnation, in which thought runs more and more easily
in well-worn channels. There are reasons to doubt that the first of these is as
important as the second. In some of the essays in *Visual Theory* thought proceeds
with fluid ease from topic to topic, almost as if problems of representation,
convention, and realism were as easily recited as a simple catechism or a child's
rhyme. Some responses, too, have an automatic quality, like the responses in
a Catholic Mass. In the introduction, the editors suggest that Wollheim and
Podro have written a "minimal or reduced" account of "elementary kinds of
recognition that all human beings are able to perform," thereby missing the
"enormous range of visual experiences" that are peculiar to certain cultures
and times (8, 9), and I have mentioned some possibilities of that "enormous
range" in Chapter 2. But simply noting the omission, as the editors do here,
is a particular kind of theoretical sameness. Wherever the terms "universal,"
"rudimentary," "basic," "essential," "preexisting," and other figures of origin
predominate, they set in motion a simple reaction: one then queries the absence
of their opposites. As the essays and the introduction are structured, this polarity
between stated terms and their apparently absent opposites is itself an ultimate
term, promising a transcendent critique but delivering only a change of mode,
within which the arguments can proceed unmolested. It might be interesting,
therefore, to reconfigure the rhetorical frames (without necessarily adjusting the
arguments themselves), in order to postpone this moment.

Perhaps the most fully argued essay in *Visual Theory* is David Summers's
"Real Metaphor," which is abstracted from a work in progress titled "The
Defect of Distance" (246). There is dense argument in "Real Metaphor"; for
the present purpose, the essay can be described as an attempt to provide a realm
for the visible separate from the linguistic, thereby achieving three ancillary but
profound goals: to repeal the ethnocentric devaluation of "conceptual" images
and concomitant privileging of "perceptual" images, to show a way around
the "linguistic imperialism" that sees language and semiology as the models
for visual art, and to demonstrate the relation of visual art to the size and
movements of the body and to "human spatiality" (248). The essay turns on
scenes in two texts, E. H. Gombrich's "Meditations on a Hobby Horse" and
Freud's *Beyond the Pleasure Principle.*[9] Freud explains the *fort/da* game as the

9. Sigmund Freud, *Beyond the Pleasure Principle,* vol. 18 of *The Standard Edition of the Complete
Psychological Works of Sigmund Freud,* ed. James Strachey and Anna Freud (London: Hogarth Press,
1955).

infant's effort to master the instinct to cry when his mother leaves. Since the child controls the presence or nonpresence of the toys, he achieves pleasure by creative reenactment. Summers juxtaposes this story with part of the argument of the "Meditations on a Hobby Horse," an embattled text of Gombrich's describing how a child might play "horse" with a stick that does not look like a horse.[10] "Freud explicitly rejected the idea that play is primarily imitative," Summers writes, "and Gombrich rejects the idea that images must be regarded as primarily imitative" (242). In that sense they are both stories about the way that imitation is subsidiary to creation, and Summers notes that Lacan has used Freud's story as an allegory of the beginning of language (another nonimitative activity). But Summers especially wants to stress the physical and spatial characteristics of the two stories, and he insists that "the substitution of a *word* for the mother cannot simply be equated with the substitution of an *object* for the mother." The toy becomes "a *present* object," unlike the word, and the hobby-horse stick has certain qualities that make it useful as a horse, unlike a word, whose sound and appearance need bear no resemblance to the signified. Both of these distinctions open the way to an account of visual art that stresses its relation to context, the spatial realm of the body, and to the body's symmetries. This is the locus of the essay's title, since a "real metaphor" is described as the spatial "analogy underlying metaphor," "something present at hand [and] able to be a substitute" (245).

This is enough to show how the polar machinery that I have described comes into operation. David Radcliffe, the first of Summers's respondents, questions taking "origins for essences" and the use of "origin myths" and "fundamental," "essentialist categories." He would prefer to stay away from those problems and analyze "continuities and discontinuities between the elements" of a work. "A vast number of works, perhaps even the majority, combine images with written texts," and we might pay attention to the modes of mixture rather than the myths of purity (261–63). In outline this is the motion I described in the editors' response to Wollheim and Podro's samenesses: that is, it marks an opposite motion and is presented as a necessary and sufficient critical comment. The second respondent, Shelly Errington, uses different terms but has similar thoughts on essentialism. She wants to expand the debate from images, which she sees as a Western interest, to "artefacts," and she points out that artifacts function in many ways other than substitution: "Not to sound like a linguistic imperialist, but rhetoric long ago invented and discovered figures of speech, metaphor, metonymy, synecdochy, allegory, contrastive opposition, and many other ways that sentences can mean other than by univocal denotative reference" (271). These two responses are

10. E. H. Gombrich, "Meditations on a Hobby Horse or the Roots of Artistic Form," in *Meditations on a Hobby Horse and Other Essays on the Theory of Art* (London: Phaidon, 1963).

apposite, since they react to exclusionary strategies in Summers's text, but they are also what I have called "automatic," since they rehearse the ruling polarity between the guiding metaphors of a text and their "missing" opposites.

Summers is well aware of his choice of essentialist argument, and he might also point out that his scheme does not exclude history or heterogeneous functions of artworks. The question is therefore not the viability of his argument but the rhetorical frame that makes it so easy to point to the opposite possibility. It could be that an introduction discussing the justification and limitations of the argument would delay the kind of reaction recorded in Radcliffe's and Errington's replies. But it might also be that such an adjustment would not suffice, because it is the impetus for the argument, rather than the kind of argument, that seems to ask for response. The case would therefore be parallel to Krauss's disagreement with Fried, where the provoking agent is an experience rather than a theory, and where it is doubly provocative because it cannot be legitimately addressed by the surrounding theory. In this instance, Summers describes a particular kind of spatial interaction with artworks, captured by the title "The Defect of Distance" and the passage from *Beyond the Pleasure Principle*. It is a version of art in which physical absence, longing, desire, and presence interact in a kind of pathos of distance. Apartness is contrasted with "manageable objects—the stress falling on the root *man-*, as in *manus,* hand"; and the metaphorical space of linguistics is contrasted with the "real metaphors" of hidden, retrieved, supplicated, and "tended" objects. These things are said to be "constitutive of human behavior" (244). The operative terms are substitution and presence, and the stage is human spatiality. Whatever is unrelated to them, in Radcliffe's words, is refigured as "marginal, accidental, or derivative" (262).

This grammar of pathos has its historical antecedents: one respondent mentions Heidegger, and certainly the tropes of yearning and suffering absence recall Romantic figures such as *Sehnsucht*. Summers's position might be elaborated by taking in the history of such ideas, but the text itself suggests more. His examples are simple stories, what contemporary theory sometimes calls "origin myths," of human desire in the face of inevitable absence. "Real metaphors" answer to the need for presence better than disembodied language, and in a more deeply reassuring way. The authorial voice tells the same story: it is uninflected, plain, careful, and serious, and it measures its judgments the way that Freud's child measures out presence and absence. Summers's writing is full, weighted with feelings of nearness and distance, separation, and the simple direct manipulation of objects. Inevitably, a fuller reading begins to focus on the contrast between the expressive scenes and the relatively affectless account of the theory itself.

Once the voice is heard, it is hard not to put certain questions to the text, especially concerning the sources of its interests. Why, aside from reasons indigenous to the theory, such as explanatory power or the adjustment of ethnocentric

formulas, would Summers want to separate the visual from the linguistic in exactly these terms? Do Gombrich's and Freud's stories point toward another story, one that has not been told? It may be that the theoretical apparatus serves as a vehicle for a personally inflected pathetic allegory of human action: at least such a possibility could be addressed by a critique that did not hesitate to address the relation of the text's expressive power to its ostensive claims. At any rate, such an inquiry would decisively stop the self-production of sameness, the predictable oscillation of opposites that guarantees such questions remain unasked.

THE VIRTUES OF UNEASE

Certainly it is not easy to imagine what these psychological, fictional, ethical, or theological stories might do to art history's accustomed ways of speaking. They would open new kinds of questions, new constructions of authorship and personality, and new senses of the role and meaning of both our regnant theoretical platforms and our impoverished personal narratives. "We," the historians who pose problems of language, "presentness," semiotics, "seeing-in," and "real metaphor," would be very different if we allowed ourselves to place our ideas in more variegated narratives. To some degree this is nothing new, because any reading will take note of clues about the writer's life and expressive purpose, but usually we are stopped short by the unpleasant prospect of some psychobiographical exposé. The kind of fuller reading I am proposing here means taking account of as many meanings as the occasion permits, and it is my contention that a vigilant reading will rarely allow itself to find bald clues to the author's personal life. Writing is more complicated than that, especially when it is not managed with an eye to expression.

Reading with an eye to expressive moments may have many consequences for art history; but it would almost certainly disperse the medical metaphor. Theory presents itself as the cure for practical ailments, but when it becomes apparent that it serves some *other* purpose, that it is also beholden to some unexplored agenda, then the entire complexion of the writing changes. The writing remains history, and the theoretical platforms might still be useful, but the meanings of the text itself change fundamentally. Theory is no longer the only passage into the work, and it no longer speaks with a single purpose. Things are more complicated for writing that allows itself to be widely and freely read.

But I do not want to close on a sanguine note, since my purpose has not been to lobby for the immediate dismantling of "sameness" or the quick dismissal of the medical dramas of dour practice and corrective theory. Even though the medical metaphors can seem crippling, it is also apparent that we enjoy what we

are already doing. By the same token, even though the signs of authorial voice and expressive intention are already there in the texts, we habitually decline to read them—at least not as part of the formal procedures of art history. We do not write short stories, invectives, parables, or allegories of ethics, and most of us do not even try to mix genres (that is, other than the expected collage of theories borrowed from other disciplines). All of this is free choice: practice is not reined in by unspoken institutional bylaws, since we are the authors of those bylaws. No one stops us from writing more fully or reading more fully. In short, "we" are people who, for reasons not very well known to ourselves, prefer to remain patients. The medical allegory is the name of a certain configuration of speech and silence, insistence and misunderstanding, each nourishing the fiction that visual theories can meaningfully describe existing practice and that a harmonious confluence of theories will produce salubrious interpretations. The medical allegory has its virtues: it is itself a medicine.

Preziosi names art history's illness as a disconnection from "important philo-sophical, cognitive, and psychological issues." His diagnosis is entirely uninter-esting: even if it were possible to "reconnect" the discipline, the result would be a salve, something to soothe the burning disorder of art history. Krauss's essay in *Visual Theory* is a juridical examination of the transmission of theory from one discipline to another rather than a philodoxic look at the state of theory in art history, and as such it is unconcerned with the possibility that a misun-derstanding of French theory, even an egregious misreading, might underwrite an interesting and even helpful dynamic within the discipline. "Mistakes" and "misunderstandings" can generate compelling readings, and they have expressive value: they help define the writer's historical moment and give voice to a certain way of understanding artworks. In the case of Bryson's essay, it might be asked why it is undesirable that an account "exhaust itself," betray a certain "poverty," or depend on "darkly inter-related columns" of social events and paintings (63, 64). Poverty, exhaustion, and darkness are all interesting properties, and so is unease. And who is to say whether they are closer or farther from truth, whether it is "complex" or "simple," "trivial" or "banal"?

If we were fully to address possibilities like these, our visual theories would lose their position as arbiters of interpretation, and that is the strongest evidence I know that we wish to remain in a state we will have to continue to call illness. A great deal has to be unsaid, even uncognized, about what we are doing. But this is not, it seems to me, a negative condition. If we are to retain the medical allegory, it would be in order to insist on, rather than deny, our illness. As Freud knew, people who are cured are not interesting. It is the phobic reaction, the Censor, the "reductive" persona, the machicolated defense, and the repression formation that demand attention, not the healthy patient. Pathology brightens the therapist's gaze. When I said at the beginning of this chapter that art history, as a

patient, has a peculiar fascination for decor, I meant that in some ways art objects are substitutes or figures for concerns that cannot speak in art history texts, especially for the stifled authorial voice, shorn of "interpretation," "authority," "method," and "theory," without clarity or confidence, stumbling around among the artworks.

7 THE HISTORY AND THEORY OF MEANDERING

. . . should not the framing up of such figments in the
evidential order bring the true truth to light as fortuitously as
a dim seer's setting of a starchart might (heaven helping it!)
uncover the nakedness of an unknown body in the fields
of blue . . .

—Joyce, *Finnegans Wake*

Does the "evidential order bring the true truth to light"? At first the principal
issues in art historical writing do seem like juridical problems: we decide issues
locally, one case at a time, on local rules of evidence. There are permissible
and forbidden inferences, interpretive protocols, proper and excessive jargon,
and they combine to adjudicate disputes, weed out dilemmas, and discover
solutions. Slowly, unevenly, with little sense of the distant future, art historians
weigh each other's claims and sift valuable insights from the chaff of excessive,
mistaken, and misguided interpretation. In this account it stands to reason that
art history would sometimes progress: on certain restricted problems it would
move forward, getting closer to a reasonable account.

In practice, I think we do think something of the kind, though it is seldom
put as legalistically as I have. Some art historians might not want to say some
part of the discipline is moving toward something called the truth; but where
the rules of interpretation are fairly stable, it can be easier to agree that we are
building toward a true account or at least working on the same problems. (And
"true" can always be given its more exact and minimal meaning, where it has
to denote the largest, most stable consensus available at any one time.) Some
art historians might want to modify these formulas and say instead that some
things art historians uncover are new truths and that those truths accumulate

no matter what happens to the majority of the discipline. Perhaps it would be easiest to achieve a consensus that, at its best, art history can be imagined as working toward more interesting ways of thinking about artworks. In that case, art historians would share questions and topics, and the conversation of art history would be primarily about insight. I can imagine several other nuances of these positions. All of them, however, share the common assumption that there are mechanisms for comparing and contrasting various thoughts on a given problem, and that assumption in turn has to depend on some preliminary moves that may be called "legal" or "logical." If art history is "building" accounts (or truth) or "moving" in any comprehensible sense through time, then there should be a way to describe what customs govern adjudication and assessment in any given instance.

It takes a fair number of hypotheticals and conditionals to describe how art historians think—or do not think—of "truth" and "progress" and other words that are so openly named in the sciences. I think it is fair to say art history is haunted by these specters. There is always the thought that truth, evidence, and progress should be straightforward; it is a dream that swims through David Carrier's essays. He knows it is hopeless, but he keeps returning to it anyway. "Making the implicit rules of . . . argumentation explicit is one way to attempt to solve these puzzles," he says, musing on the disconnected accounts of Piero della Francesca's paintings. And he is not alone in this hope; he quotes Marilyn Lavin's "principles" for clean and thorough interpretation and Michael Baxandall's criteria, "the avoidance of anachronism, coherence, and critical necessity." To many art historians it has seemed that economy of explanation is a good idea, and perhaps even sufficient as a guide to interpretation. Economy, coherence, lack of anachronism, efficiency, and thoroughness are among the rudiments of a *corpus juridicum,* a legal system in the making. But it is a disappointing project. "Once we descend from this statement of principles to particular cases, we find much disagreement,"[1] Carrier admits: it cannot be right for art history, and yet nothing else can be right. I call this conflicted state of mind the *dream of the law,* to bring in some echoes of Kafka's sorrow and fascination about the impossible and yet unavoidable legal system. The dream has its specific functions and settings.

It is, to begin, a seductive dream. Within Carrier's texts, legal matters appear as temptations: the laws of evidence and deduction are the only logical routes if he is to understand how art history *works,* as opposed to what it studies or how it sounds or who practices it; and yet the laws are impossible to apply. The art historical traditions are too ragged, too much at war with themselves, and it appears no judge could straighten out their rival claims. This is the limit of the

1. David Carrier, *Principles of Art History Writing* (University Park: Pennsylvania State University Press, 1991), 39.

theme in Carrier's essays: logic and legality appear repeatedly (it is difficult to suppress them in a discourse that is, after all, rooted in logical analysis), and they repeatedly fall to the simplest signs of the "evidential order." Carrier's analyses go through this cycle of disappointment: the traditions are haggard, they need ordering, adjudication is in order, but it does not work, something else is happening. . . . At that point, I would invoke the dream metaphor and say he dozes off, and when he wakes, the cycle begins again. Like Lavin, Baxandall, and others who have occasionally tried to set forth the rules of historical deduction, Carrier is forced to abandon the project after succeeding in finding only the simplest, most abbreviated rules. As a discipline, art history tends to account for this habit by saying the evidential order is so complex that it upsets any fixed rules of interpretation. Art historians adjudicate when they have to—in introductory chapters of books, in reviews—but with the sense that there is something more engaging to be done. We doze, and when we wake, we are back in history.

Does the "evidential order bring the true truth to light"? Already in this text I have summoned a number of potential rules that could govern the comparison of rival explanations: among others are coherence, persuasiveness, closure, originality, thoroughness, lack of anachronism, economy, critical necessity. Surely the evidential order is often a euphemism for evidential disorder, and if there is a central dogma in meditations on truth, evidence, and art history, it is that the chaos of history dispatches all attempts at universal criteria of truth. When attempts to construct a legal code for art historical writing begin to seem a little strained and the hypothetical laws of deduction and evidence start to appear weak or irrelevant, it is because history reveals itself as a strong force of disorder. Perhaps, therefore—so the common account might run—there is no need to pay attention to any attempts to legislate the logic of art history or to spell out its ways of reasoning, because no rule will hold out against the tumultuous and utterly specific facts of history. The unexpected and unpredictable facts that come out at us from history can easily take care of any wayward theories. Unfortunately a moment's reflection shows that cannot possibly be the case. To see that there is more involved than the simple overwhelming of rules by empirica, it is enough to notice that there is a great range of "rules," and it is unlikely they would all be toppled in the same way or with equal force. It is interesting, too, that this apologia for history is generally our *only* way of explaining why legal recourse is never enough to solve historical debates. It is as far as we think about the problem.

Authors such as Carrier are aware that art historical awareness of this issue is not complete. The legal solution presents itself to us (from where? in what contexts?) and falls (why? by what rules?). This happens over and over—often enough, and in enough contexts, to make it appear to be an intrinsic gesture in art history: a ritual and an incantation as much as a half-hearted attempt

to make order, or a wistful inappropriate hope. In art history, bowing to the protocols of the court is a matter of politeness. Some authors prefer to make very quick, shallow bows, almost imperceptibly noting the presence of rival arguments, and others make places in their texts for the full-fledged question of evidence. Words such as "logic," "hypothesis," "evidence," and "argument" sit around like visiting dignitaries, and there always comes the moment when they are ushered out and the evidential disorder takes control.

The repetition of this drama (the invitation of logic, the brief speech of logic, the dismissal of logic) also lets us see that we do not really see the problem at all. Perhaps we are dreaming again; probably we dream whenever we think about logic in these contexts. Or perhaps it is daydreaming, since we know full well when we are about to succumb to some fantasy that art history might be well ordered and logical. Either way there is a pervasive sense that the law has some further meaning and force beyond its appearance in art history and that the discipline is somehow breaking the law by not coming to terms with it. I do not want to put this too severely: laws of historical evidence and deduction are occasionally taken very seriously, and historians routinely weigh previous accounts. I want to stress, however, that this weighing is also a matter of protocol; there is widespread acknowledgment that art historical accounts do not tend to do justice to previous accounts or to the laws by which they proceed. We often do not notice that the drama itself—by which I mean the entire enactment of questions of evidence, comparison, adjudication, defense, counterargument, and summation, no matter where they may appear in a text—might be that which allows our narratives to go where we want them to, entirely aside from whatever position we might take in regard to the actual rules at work in the text. When we work with legal questions, what are we really doing? The proximate answers—that we are trying to stabilize our accounts, set them opposite earlier accounts in a comprehensible way, give them useful rhetorical frames, get them ready for possible attacks—are only partly correct. Since the lawyerly gesture ultimately fails and the evidential disorder prevails, we must also be rehearsing something that helps us get on with the writing of history, something that would have to be imagined as the departure of legal reasoning and the ascendance of . . . what?

Certainly one reason art historians routinely abandon the dream of the law is that when it is given free rein, as it is by Carrier, it ends up producing the most comically impoverished verdicts. *History does not advance on the truth,* Carrier concludes, or *Rules of interpretation are inadequate.* Either art history *progresses,* or it is *fiction.* These are ridiculous formulas, and it is no wonder historians have not spent time on them. At the same time, they are the inexorable end of the dream of the law, they are what happens if we do not doze off. What I

want to do here is begin again with those callow phrases and see if I can push past them and say something more about the place of the law in art historical writing.

A RUDE STORY ABOUT FLAGELLATION

The first story I would like to tell concerns the interpretations of Piero della Francesca's *Flagellation* in Urbino, and especially the three mysterious figures who loom on the right side (Fig. 14). This is a famous problem, one that has swallowed numerous litigants, like the monstrous case of Jarndyce v. Jarndyce in Dickens's *Bleak House*. Carrier has looked into it and found four mutually contradictory, incommensurate interpretations. Actually the literature is more involved than that, and on a rough count there are eighteen interpretations of the three figures. To put it briefly—and here I am behaving as if this were a court brief or a legal aide's list of precedents—the three figures have been identified with Guidobaldo, Oddantonio, Federico, Guidantonio, Vangelista, and Bernardino, all of the Montefeltro family; with their contemporaries Manfredo del Pio, Lodovico III Gonzaga, Ottaviano Ubaldini, Giovanni Bacci, Tommaso dell'Angello, and Caterino Zeno; with "some Christian minister of the Gospel in the East," "a type of learned Greek," "a person of rank," Emperor John VIII Paleologus, Judas, "an Elder," three heresies ("oriental or Jewish," "Greek paganism," and "European heresy"), "a learned philosopher," "princes," the Greek prelate Bessarion, Buonconte da Montefeltro, and "figures of no iconographic significance."[2] (This last entry is nearly universal in lists such as this one. There is frequently a historian who comes in late and claims that identification itself is a misguided enterprise.)

This is the type of interpretive dilemma that Carrier recounts. The manner in which he recounts the interpretations is also significant: he snatches quotations and pits them one against another. In his telling, Gombrich comes first, then Lavin, then Ginzburg. Typically Carrier compresses the authors' positions in the way I have just done: "Perhaps the bearded man in the trio is Bessarion,

2. To sample this literature, see F. Witting, *Piero della Francesca: Eine kunsthistorische Studie* (Strassburg, 1890), 123; W. G. Waters, *Piero della Francesca* (London, 1901), 77–80; Kenneth Clark, *Piero della Francesca* (London: Phaidon, 1951), 19–20; Roberto Longhi, "Piero della Francesca e lo sviluppo della pittura Veneziana," *L'Arte* 17 (1914): 198–221; E. H. Gombrich, "The Repentance of Judas in Piero della Francesca's 'Flagellation of Christ,'" *Journal of the Warburg and Courtauld Institutes* 22 (1959): 172; Creighton Gilbert, *Change in Piero della Francesca* (Locust Valley, N.Y.: J. J. Augustin, 1968), n. 58; Philip Hendy, *Piero della Francesca and the Early Renaissance* (New York: Weidenfeld & Nicolson, 1968), 115; Charles De Tolnay, "Conceptions religieuses dans la peinture de Piero della Francesca," *Arte Antica e Moderna* 21–24 (1963): 205–41; and Carlo Ginzburg, *The Enigma of Piero: Piero della Francesca: The Baptism, the Arezzo Cycle, the Flagellation,* tr. Martin Ryle and Kate Soper (London: Verso, 1985).

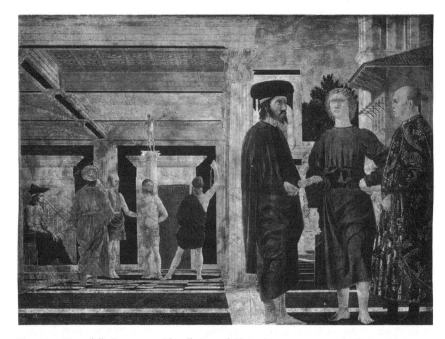

Fig. 14. Piero della Francesca, *Flagellation of Christ*. Tempera on panel, 58.4 × 81.5 cm.
Urbino, Ducal Palace

a Greek prelate who came to Italy to appeal for a crusade; he stands before
Federico da Montefeltro with a young man, his pupil. The work is a political
allegory. The trio stand by as Christ is flagellated." And he tends to present his
conclusions immediately afterward: "It is hard to give a convincing argument
against any of these proposals, and easy to see how to generate more such
accounts. Lavin studies the perspective; Gombrich, other flagellations; other
commentators, the relation of Italy to Constantinople and Jewish history. They
can argue with one another because they can agree, more or less, on what kind
of evidence is relevant" (35). When things are put this way, with no qualifiers
and no breathing room between claims, and when the case gives way instantly
to its conclusions, then there is nothing to conclude except that the argument
of art history is in shambles. One might say, *Art historical traditions involve
contradiction and assertion rather than argument,* or else *There is no agreement
on rules of interpretation.* Whatever is concluded has to be said quickly. There
is no way to expand the account, to take it a little more easily, to bring some of
the thousand-odd pages of surrounding material into the courtroom. Everything
is irrelevant except conclusions, and Carrier is not incorrect in thinking so: he is

echoing what happens in the interpretations themselves. The authors sometimes write at fair length, but to a legal eye there is little in what they say that bears directly on their findings; they tend to write on many things, and then present their conclusions rather suddenly. It is not that Carrier could not talk at great length about the pros and cons of the Bessarion identification, or any other; it is that if he were to do so, he would be forced to try to support the legal argument with quotations from the sources, which could only seem irrelevant.

In the end, the summation is apt to be unpleasant. If we are on the prosecutor's side, arguing against the proposition that the figures in *The Flagellation* will ever be securely read, we might say that the essays differ in what they intend to explain, so that they talk at cross-purposes. We might point out that some essays want to explain the left half of the painting, others the figures, and others the right half. To one author, the figures are evidence proving Piero's interest in perspective, and to another, perspective proves Piero's interest in the figures. And in concluding, we would have to underscore the fact that the authors rarely weigh previous accounts and virtually never provide a concordance or bibliography of previous opinions. The legal conversation, like the inevitable verdict, will remain rude, harsh, and clipped.

THE THORACIC VEINS ON THE PARTHENON FRIEZE

It may seem that this story is too unrealistic to be a good representation of the way that evidence and arguments are weighed in art history—too narrow, perhaps, or incompletely drawn. Here is another story, this time one that Carrier does not mention. In the nineteenth century it became apparent that the Greek sculptor Phidias could not have carved the entire frieze of the Parthenon, since some figures are quite impressive (Fig. 15) and others flat, awkward, or "childish" (Fig. 16). In a number of articles and books it was argued variously that Phidias had supervised the entire frieze or that more artists had been involved. The classicists and art historians who wrote those opinions never resolved their disagreements, and eventually the subject fell into a kind of quiescence. My own Figure 17 summarizes five scholars' opinions regarding the Parthenon's north frieze, whose 130 figures are distributed among forty-two stone blocks (as shown on the scale at the bottom). Each of the five bars represents one historian's theory, and the bars are divided to indicate the number of sculptors that are said to have worked on the frieze. The earliest paper, by Carlo Anti, proposes a "Master of the Spondophoroi" (named after his scenes of women carrying vessels of oil) and a "Weeping Master." An indeterminate middle section, he thought,

could be a assigned to a third sculptor. After Anti's paper, scholars began to
see more differences between the figures, and Ernst Kjellberg thought he could
distinguish about twenty-one different hands. To Ludwig Curtius it seemed that
each individual figure could have been done by a different carver (I have made
random divisions in his scale to reflect that idea.) From there, the lumpers had
it over the splitters, and the divisions became larger: W. H. Schuchhardt saw
sixteen hands, and Ernst Langlotz divided the frieze less strictly into workshops
reflecting "early," "high," and "late" Hellenic styles. Looking down the table it
becomes apparent that there is neither consensus nor progress. If there were any
continuity of opinion, some of the divisions would line up one under another, but
the only division held by all five writers, the one between blocks ten and eleven,
is provoked by an accidental loss of several scenes.

The table is the graphic equivalent of Carrier's lists of interpretations: How
could it yield anything except the harshest judgments against art history? (And I
note in passing that it may not be entirely unreasonable to speak of "art history"
as a collective entity here, since formal analysis is not the only interpretive method
that yields these results. The first example, of Piero's *Flagellation*, is iconography,
and its contributors have drawn on large numbers of documents.) In the gauche
formula, we might say *There is no rational comparison of competing views.*

Fig. 15. The Parthenon frieze, west side, block VIII

Fig. 16. The Parthenon frieze, north side, block xxiii

And more damaging for the hope that art history might be following some less common rules of adjudication, there are few moments when the authors even try to compare their positions to previous views. Kjellberg says Anti was right but did not go far enough, without saying how he knows how far is proper.[3] Schuchhardt finds Kjellberg's analysis unfruitful because it is "incoherent" and "overly detailed," but he does not defend his own level of detail. He writes much more than Kjellberg, but ends up with about the same number of divisions.[4] Hence, *There is no agreement on criteria.* Curtius asserts that disparities between the figures show that Phidias could not have provided a drawing for the entire frieze, but he does not say what degree of consistency might have permitted him to say that Phidias had provided an overall sketch.[5] Therefore, *There is no agreement on what is being analyzed.* Langlotz faults Schuchhardt for not attending to the rhythms of the bodies, but does not say why that one criterion is a necessary and sufficient addition to the traits Schuchhardt had examined.[6]

This way of judging is so swift and sure, and the cases so open-and-shut, that the thinking can become both strident and incomprehensible; perhaps this is one of the possible fates of legal thinking in art history. The difficulty in forming *any* judgment of these five authors is that their criteria change so radically.

3. Ernst Kjellberg, *Studien zu den Attischen Reliefs* (Uppsala: Almquist & Wiksell, 1926), 45.

4. W. H. Schuchhardt, "Die Entstehung des Parthenonfrieses," *Jahrbuch des Deutsches Archaeologisches Instituts* 45 (1930): 220.

5. Ludwig Curtius, review of *Zu Phidias et al.,* by H. Sitte, *Gnomon* 2, no. 1 (1920): 22.

6. Ernst Langlotz, *Phidiasprobleme* (Frankfurt: Klostermann, 1947), 27.

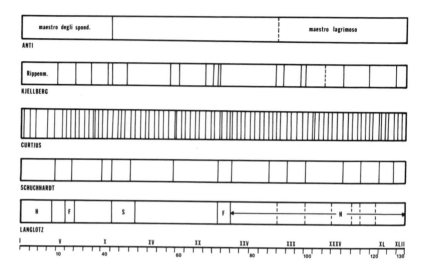

Fig. 17. Attributions of the north frieze of the Parthenon

The earlier writers are strict Morellians. Later the criteria become fluid, and even vague. When Langlotz says that a certain figure is "decadent" or that it "tames . . . the peculiar power that rests most powerfully within itself" (*in sich selbst Ruhende am stärksten*), he is so far from the Morellian diagnoses of Anti or Kjellberg that it is no longer possible to know how to compare them. In the end, however, Langlotz's poetic evocations are no vaguer than Anti's naming of hair or muscles as defining criteria without fully describing them. In both cases it is difficult to see exactly what the authors are looking at, and when it is possible, the criteria slide into one another. What is the difference between "rippling muscles" and "well-defined muscles"? When does the "early style" become the "high style"?

A determined lawyer might want to establish a more uniform roster of forms that are to be analyzed, perhaps by finding an element so small, so crisply defined, that it could be described with minimal ambiguity. This, of course, was also Morelli's problem. Sometimes it is not the whole ear that counts, but just the lobe, or just part of the lobe. And what is the difference between flared nostrils and a nose with wide wings? And what exactly is a broad philtrum, as opposed to a normal one? Figure 18 is an indulgence along these lines, a tracing of some thoracic veins on the horses' bellies at the end of the north frieze. The diagram represents six similar groups of thoracic veins, arranged in separate rows. A Morellian analyst might conclude that one artist sculpted horses 86 and 88 and

that another did 93, 94, and 96—indeed such an analysis would be forced to conclude something of the kind, if it were to work on this level of detail. But in forcing the issue this way—and I mean to imply that any quest for clear judgment will find itself in an analogous position—I have arrived in a rather strange place, counting branches of thoracic veins, and it is not even a place that, by providing sure criteria, repays the trouble it causes. Sometimes it is assumed that Morelli's flaw was in neglecting the whole for the part. But it was worse than that: *there was no part.* Morelli, together with his predecessors the eighteenth-century connoisseurs, anatomists, and physiognomists, was lost in a perdition of misguided research: the whole was too vague, too unscientific, but the part never entirely materialized; instead, it kept dividing and subdividing until no clear boundaries could be located. Everything here exfoliates into innumerable questions. Is number 93 really more like number 94 than some other number? And how do we know that? Should we count branches of veins? And if not, then why not?

This place—this twilight zone, where nothing is what we thought it was—is actually on the main road of legal questioning. Problems in the essays themselves lead toward this kind of inspection. As it is, the need for comparable criteria is so strong in the texts that it works to prevent further discussion: it provokes the abbreviated retellings that I have exemplified in *The Flagellation*. But at the same time, the legal reasoning that brought us here is somehow deeply misguided. Would any historian wish to take the question of criteria in this direction? Even Morelli shied from these issues. Where are we, exactly, when we find ourselves asking these questions? Are we anywhere near the literature? Perhaps we are outside art history, and in something else—but what? Classical epigraphy? Enlightenment physiognomics? The philosophy of conventionality? Something is making both the questions and the art historical texts look a little absurd, and yet we are here because this is where legal reasoning has put us—in a jail, locked away from the images.

ON BEING OUT OF BREATH

These are rum stories. They lack the conversational tone that is, in one way or another, an essential voice in humanistic writing. Instead, they are lists of deductions, claims and counterclaims, numbered pieces of evidence, mindless concatenations of index entries. The historians and the historiographers who collect previous opinions speak at breakneck speed. Almost before they have begun, they are winding down. Even this last inquiry, which was about the law itself, ran down and stopped far more quickly than the historians themselves.

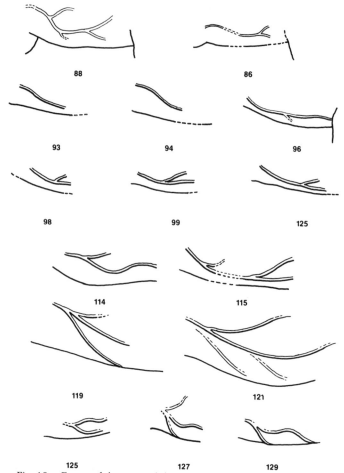

Fig. 18. Forms of the external thoracic veins of horses in a portion of the
north frieze of the Parthenon

Most art historians have at one time or another had to face a tradition like this.
And most of us have felt something of the strain of trying to come to terms with
previous accounts that are all at odds with one another. A common answer is the
concordance, the table of attributions that accompanies *catalogues raisonnés*.
Occasionally it seems to make sense to do what Marilyn Lavin did with Piero's
Flagellation, and take the time to lay down interpretive rules by which to judge
rival accounts. All of this is integral to historical scholarship, and it can work
in context and for a limited time. When it is fished out, it looks funny. It casts
doubt on the entire enterprise, and on itself, and it yields these oddly flattened

looks at our discipline. It shows us ourselves sitting around, disconsolate at the ruins of the logic of the profession. *There is no progress in art history,* we say. *We are not getting closer to the truth. We speak at cross-purposes. There is no coherent sense of argument in art history.* The choices are stark: either *We have a coherent tradition,* or else *There is no nameable direction to art history.* When art history appears this way, there is nowhere to go except relativism, nothing to do except collate warring texts.

The way this works reminds me of a parable, near the beginning of Wittgenstein's *Philosophic Investigations,* about two workers who have a "complete primitive language" made of words like "block," "pillar," "slab," and "beam." Worker A names what he wants, and B brings it.[7] The workers do not inquire into their language as they use it; to them, it is "transparent," which is to say, unproblematic in practice. They are absorbed in making their building. When legal critiques take notice of problems in the workings of art history, they immediately try to explain them and, in that immediacy, do not notice that they have just stopped doing what the historians do and have begun doing something else. In Wittgenstein's terms, the "complete primitive language" is only a problem when someone comes along from outside and begins to study it. Periodization, style analysis, and any number of other activities that art historians have pursued are not self-questioning activities, and it is up to the explanatory account to acknowledge and analyze what it means to stop doing one thing and start doing another. Some particular misunderstanding of the unselfconscious activity has to be perpetrated in order to make that kind of change without seeing it as a change.

ON MEANDERS

> waking
> doubting
> rolling
> shining and musing
> before halting
> at some latest point which crowns it
> —Mallarmé, *Un coup de dés*

Thinking about questions of adjudication, I am thrown into this dilemma: either I ignore the findings of writers like Carrier (or the rules devised by Lavin, Baxandall, or Ginzburg) and go on behaving as if art history is building accounts

7. Ludwig Wittgenstein, *Philosophical Investigations,* trans. G.E.M. Anscombe (New York: Macmillan, 1968), §2.

of objects, or else I bow to skepticism. It is a false dilemma, since it does not offer the alternative of what art historians actually do. Our sense of interpretation and adjudication in history remains nameless. What I would like to do in the remainder of this chapter is work on an alternative account, in which art history neither stumbles blindly nor marches resolutely, but does something a little more like wandering. We work, we think, we write, and when we are finished, we find we have moved. That motion is not blind chance, and it is not predestined logic; it is something in between, which needs at least a provisional name.

I think "wandering" is a beautiful word, but it implies something a little too adventurous, too open-ended, more like a nomad's journey than a stroll. What we have in art history is a kind of writing that shifts, not drastically, and not always without bridging passages, but steadily and without stopping. Art history is not usually radical thought, though it is often confrontational and not infrequently catty. It "muses," "shines," and "doubts," to use the words Mallarmé chose to express the randomness of all thought. It is rarely out to undermine itself, or even seriously interrogate itself: we do not tend to begin art historical essays with systematic doubts about value or purpose. Yet it does shift and sometimes mutates. (Metatheoresis is always a possibility.) The traditions that address Piero's painting and the Parthenon frieze have their rhythms, their general directions, their swerves and turns. "Meandering" may be the closest word for this kind of change, and I mean it in at least these four senses:

1. Meandering is gentle, steady, unpredictable change. Sometimes a person, meandering through a forest, will stray from the path or intentionally take a detour, and then later chance on the trail, and even repeat part of it. We do this in art history when we return to some reading that has been forgotten, or when we revive our sympathy with a text that has been doubted. To meander is, as *Webster's* says, to "wander aimlessly or casually and without urgent destination," in this case among the works and texts of the history of art. Even Carrier does this when he becomes absorbed by some picture and loses track of where he is. At times, to be sure, there may be both purposiveness and legal urgency, and I will consider cases of both. But they apply more to individual essays and monographs, and not to the pageant of art historical writing over decades and centuries. This first sense of meandering is also a way of rethinking the idea that critical consensus or a stable interpretive community might help a tradition of interpretations to become more coherent or truthful. There is always shifting, and it is always unpredictable. What appears to be a group of scholars at work on one passage of one picture for one reason may really be a "constellation," as Mallarmé says, of bodies on different trajectories. As soon as they converge, they diverge.

2. Meandering is also geometrically complex. A person who is meandering does not accomplish directed work, such as mapping, building, or surveying;

each of those activities is more programmatic than meandering. The interest that works of art accrue when they have been treated to generations of essays is a matter of the complexity of the accumulated opinions, not of their linear relation. In history—and here I am including also the histories of science and ideas—explanations are interesting not because they can be pictured as a chain of successive accounts, leading onward to the explanation that is taken to be definitive, but because of the muddle, the tangle of crossing paths that eventually issue in the favored account. In the history of art even more than in the history of science, the complexity of traditions is their beauty. Their unpredictability enhances the richness of art history, since it is unbounded by the interpretive constraints that apply to more rigorously defined disciplines. We are not constrained to forget errors and falsifications in the way that working scientists are.

3. And meandering is furtively autobiographical. A hiker strolling through a wood may think of many things; when I am out walking, thoughts may guide my movements in ways that I do not notice. Some choices seem intentional (a detour to see a view, a quicker pace to get home), but even there, other reasons may be at work (the view may be an escape from a dark thicket, and home itself may be an escape from some other place). As thoughts occur to me, my steps and movements may reflect them imperceptibly. Art historical writing is like that, except that it preserves a record of the walk. The patterns of moving, pausing, sitting, glancing, and moving on all find voice in the narrative and—to extend the metaphor—in the succession of narratives on a single object that form the kinds of tradition I have been sampling. The autobiographical voice is woven into the text of art history, and the metaphor of meandering is another way to begin thinking about it.

4. Like art history, meandering is inconsistent even though it can appear deliberate. A meandering stream is an inconstant thing, sometimes flooding its banks, other times receding and forming short-lived islands or creating brakes and backwaters, and always dividing and redividing itself. Yet there are at least three senses in which a meandering stream appears to be constant. If I look at only a few feet of it, the water seems to be moving rapidly in a single direction, and I might say the stream looks as if it has unity of purpose. And second, if I consider a portion of the stream over the span of a lifetime, it appears to be relatively stable, since houses along its banks do not often have to be moved. Some political boundaries are marked by places where rivers *used* to be, for example, the Illinois-Kentucky border, which is surveyed according to the eighteenth-century position of the Ohio River. Property that shifts because of sudden avulsion (unexpected or catastrophic change in the position of the riverbank) is much rarer than property that is adjusted for reliction (the imperceptible withdrawal of water). Third, in a geological span of time, the stream is compressed in a valley, an alluvial plain, or a "water gap," a place where it has forced its way through a mountain range.

Like a Greek meander on a frieze, the stream remains in a fixed compass. The first of these sources of constancy has its analogue in the ephemera of art history: the single colloquium, the brief monograph, and the specific argument can all appear to have a single purpose and direction. The exchanges in such formats can be pointed and specific, but they are not likely to apply to wider instances. The second source of constancy names a kind of tradition that we know is transitory but that we prefer to treat as if it were permanent, as in the sequence of hypotheses about the figures in Piero's painting: they seem to have a unified purpose, even if their methods and findings are widely disparate. But nothing human has much to say about the third source of constancy, since we do not yet have power over the placement of mountain ranges. It is therefore the name of a tradition that has to be assigned to the natural or eternal. The very idea of writing about pictures is an example of these largest sources of coherence. I would argue each of these fictions of stability has its place in the historiography of art history: the discipline has at least these ways of presenting itself as if it were stable and directional. None of them is incommensurate with the meandering, sometimes directional, but ultimately purposeless art history that I am proposing here.

Before exploring the ways that meandering happens in art history, I want to say something about the purpose of redescribing our traditions in terms of such a pliable metaphor. It may seem that the idea of meandering is overly general, but if it is going to be off the mark, I would intend it to err toward generality rather than specificity. What is needed to make the accounts of the discipline more sensitive is an alternative to the harsh opposition of progress and relativism. Neither one seems right for history (they have traditionally functioned better in the philosophy of history), and the theory of meandering is a way of getting a conversation started without shutting it down in the specifics of some period or practice.

THE DECADENT NUMINOUS

The example I consider for the remainder of this chapter concerns Chinese bronze vessels, and especially the enigmatic faces that peer out at us from their sides and handles (Figs. 19 and 20). The vessels are unusually isolated in time and space, so they are in some ways a particularly clear example of the interpretive quandaries that set art historical debates in motion. They come from a civilization that has left few other traces, so there is little external evidence to explain the hypnotic faces, their variety of shapes, their partly undeciphered inscriptions, and their original uses (which probably included filial piety, the ostentation of nobility, and alchemical experiment). The bewildering animal-like "masks"—no Western

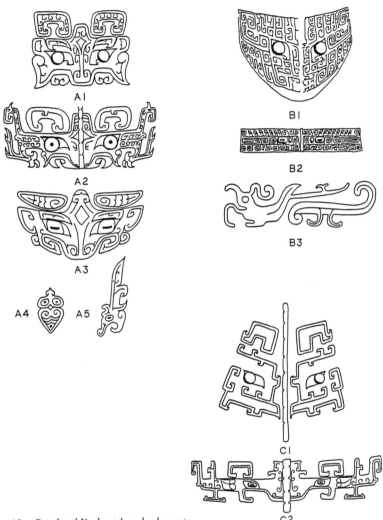

Fig. 19. Bernhard Karlgren's style elements

term will quite do to characterize them—are traditionally and erroneously called *taotie* (pronounced "dowdyeh"), after a twelfth-century Chinese usage. They are not representations of any single species: their forms center around those of the dragon, but they also drift toward bears, oxen, cats, and snakes, and in later vessels taotie appear as rivals of birds and cicadas. They have an oddly unfixed identity, so that it is not possible to say if they were intended to mimic human

I

II

III

IV

V

Fig. 20. Max Loehr's five Anyang styles

forms, animal forms, or even any living forms (whether they are anthropomorphs, theriomorphs, or zoomorphs).

 They range from what is conventionally termed "realistic" high relief to "decorative" or "abstract" patterns of intaglio or stringwork. "Realistic" taotie have eyes, horns, teeth, noses, sometimes feathers, and sinuous bodies with legs and tails, but all their anatomic parts are negotiable, subject to degrees of what Western observers have called abstraction. In the extreme case, all that remains is a single eye staring in a sea of spirals; but there are also taotie that seem to

have been forcibly dismembered or empatterned, so that they perch somewhere between unbodied face and faceless design. The early scholars noted an involved play of motifs, with enough recurrences and similarities to suggest one of two possible developments: either the primitive, numinous taotie had dissolved into an aestheticizing, "decadent" play of lines, or else they had had a mysterious beginning in the far reaches of "abstraction" and had gradually coalesced into more prosaic, literal masks when the suggestive magic of the original images was no longer felt. These two conflicting etiologies spring from two alternate Western ways of accounting for abstraction. In the first version, abstraction is a late stage in a degenerative history, in which the rough, naïve realisms of a golden age of Shang Dynasty taotie collapsed into a historicizing Iron Age of Han Dynasty patterns. The animalistic and animistic vigor of the early artists was loosened and lost in reticent magical patterns. On the other hand, it has also seemed that abstraction is a primal impulse, as in Greek geometric art; and in that case, the "decadent" period was assigned to the late Shang Dynasty "realistic" taotie. Like the modern account of Greek art that sees virtue in geometric archaism and sometimes demotes the sophisticated Hellenistic figures, this version would make the earliest Chinese artists masters of abstraction and the Han artists limp followers of realism.

These two conflicting stories about the history of realism and abstraction led several early analyses, those by Bernhard Karlgren, Max Loehr, and Herlee Creel, to contradict one another.[8] In the case of Loehr and Karlgren, the assumptions were so clearly formulated and so inexorably opposed that they resulted in opposite chronologies and a disagreement that lasted as long as Karlgren lived. Behind them—very close behind them—are the differing suppositions about the birth and nature of abstraction.

A-C-B

The analysis of the vessels was never a simple matter. Karlgren's first article on Chinese bronzes (1936) divides neatly into two halves. It begins, following

8. See André Leroi-Gourhan, "L'art animalier dans les bronzes Chinois," *Revue des Arts Asiatiques* 9 (1935): 180ff.; Ludwig Bachhofer, "On the Origin and Development of Chinese Art," *Burlington Magazine* 393 (1935): 251–63; Max Loehr, "Beiträge zur Chronologie der älteren chinesischen Bronzen," *Ostasiatische Zeitschrift*, n.s., 12 (1936): 3–41; Herlee G. Creel, "Notes on Professor Karlgren's System for Dating Chinese Bronzes," *Journal of the Royal Asiatic Society* (1936): 463–73; J. L. Davidson, "Toward a Grouping of Early Chinese Bronzes," *Parnassus* 9 (1937): 29–34; Bernhard Karlgren, "New Studies in Chinese Bronzes," *Bulletin of the Museum of Far Eastern Antiquities, Stockholm* 9 (1937): 9–118; and later C. Grassl, "New Researches in Chinese Bronzes," *Art Bulletin* 25 (1943): 65–78. Additional references are in an earlier version of this chapter, "Remarks on the Western Art Historical Study of Chinese Bronzes, 1935–1980," *Oriental Art* 33 (1987): 250–60.

the nineteenth-century philological tradition and drawing on the newly revived interest in Shang inscriptions, with a statistical analysis of the inscriptions on a thousand vessels.[9] On the basis of three recurring characters, the inscriptions are assigned to the Shang or Chou (1122–249 b.c.) Dynasties.[10] The first part of Karlgren's essay closes with a list of over seven hundred reliable cases for which he had access to photographs or rubbings. The second half, which begins independently of the first, is a corroboration of the epigraphic evidence, provided by a set of "style criteria."[11]

In the second article (1937) the style analysis is extended and elaborated.[12] There he divides "regularly occurring décor elements"[13] into three groups, which are worth considering in some detail (see Fig. 19). The A group, called the "genuine t'ao-t'ie," contains six elements, including three kinds of taotie (numbered A1 through A3). The "mask t'ao-t'ie," A1, is a "face, well contained as a unit, but [with] no trace of a body." A2, the "bodied t'ao-t'ie," "has elements at the side of the face representing the body," so it is at once a mask and two body profiles—the characteristic "conflation" that appears in various non-Western traditions. A3, the "bovine t'ao-t'ie," possesses horns "so realistic . . . that they sometimes break loose from the surface and protrude plastically." The remaining three elements of the A group, beside the "t'ao-t'ie elements," are the "cicada," A4, the "vertical dragon," A5, and the "uni-décor," A6 (not illustrated). This last is not an independent form but rather indicates "that there is no division into horizontal zones of the décor of the belly."[14]

Each of the groups, A, B, and C, begins with forms of the taotie: the second begins with B1, the "dissolved t'ao-t'ie," in which "only the eyes are left intact, the rest of the face . . . having been dissolved into a maze of spirals and hooks"; and B2, the "animal triple band," in which "the body is in several 'stories,' one

9. See William Watson, *Ancient Chinese Bronzes* (London: Faber & Faber, 1962), 18, and Wen Fong, "The Study of Chinese Bronze Age Arts: Methods and Approaches," in *The Great Bronze Age of China,* ed. Wen Fong (New York: Knopf, 1980), 20–21.

10. The characters are *Ha-ying, si tsï sun,* and *kü.* See Karlgren, "New Studies," 21, and see 19–85 for the assignment of inscriptions.

11. The terms "style criteria" and "style elements" are Karlgren's, and are used interchangeably.

12. Karlgren, "New Studies." The schema in this article is, with minor modifications, the one Karlgren retained throughout his career. The most important later publications are the three "Marginalia" essays: (1) "Marginalia on Some Bronze Albums," *Bulletin of the Museum of Far Eastern Antiquities, Stockholm* 31 (1959): 289–331; (2) ibid., 32 (1960): 1–24; and (3) "Some Characteristics of Yin Art ["Marginalia" number three]," *Bulletin of the Museum of Far Eastern Antiquities, Stockholm* 54 (1962): 18–28.

13. This means, in his words, "the *décor of the body of the vessels* [italics in original]. I entirely disregard, for the time being, all other parts: legs, ears, handles, lids, stands (supports). . . . I shall also regard as belonging to such accessories of the bodies the protruding vertical flanges . . . and finally also the 'free animal's heads.' " Karlgren, "New Studies," 13–14.

14. Ibid., 15–17. Throughout I have omitted Karlgren's qualifying phrases where they are only matters of restricted applicability. For example, element A6 is said to be "of primary importance as far as Ting, Li-Ting, Kuei and Yu are concerned." Ibid., 16.

marking an elongated wing . . . and above it there crop up vertical feathers or quills."[15] B3, the "de-tailed bird," is the first of the nontaotie forms of the group.

The C group begins with the "deformed t'ao-t'ie," C1, with its "entire mouth section . . . replaced by a stylized maze of curious lines." The C group also contains the "dragonized t'ao-t'ie," C2, with an "elongated form [that] brings the dragon impression into the foreground."[16]

Even a cursory glance at this material shows the richness of forms—which is another way of saying that it sorely tempts a Western eye with thoughts of classification, sequence, and development. The concept of abstraction looks unavoidable, and like later Western scholars Karlgren found it hard to avoid mixing in terms like decoration, realism, and naturalism. Yet in the essay, at first it seems that Karlgren is doing something else, since his analysis is fundamentally statistical. A review of 1,288 vessels, including a list of every style element on each vessel, brings him to the conclusion that A and B elements do not appear together on a single vessel: hence they belong at different ends of the sequence of taotie evolution.[17] The style development, he claims, is away from the figurative A group, through the C group, and toward the B group. In a word: figurative became abstract.

INADVERTENT PERIODIZATION

> Modern scholarship has become increasingly skeptical of periodization.
>
> —Panofsky, opening of *Renaissance and Renascences in Western Art*

> The historian cannot help dividing his material into "periods."
>
> —Panofsky, opening of *Gothic Architecture and Scholasticism*

Every step of this process is open to the kind of logical critique that we have seen at work compressing the histories of the explanations of the Parthenon frieze and Piero's *Flagellation*. There is Karlgren's initial list of "style elements," distilled without explanation from the bewildering variety of forms, and there is the list of three "groups," again compiled without explanation. And following that, the periodization. Where do the "elements" come from? By what rules

15. Ibid., 19–20.
16. Ibid.
17. Ibid., 72.

are they divided and numbered? How do we know that A and B groups must
be separated in time, just because they do not tend to occur together on a single
vessel? Why does rough realism precede abstraction? Is abstraction a more refined
or intellectual activity?

A logical critique would not fail to point out the assumptions, and they can
be listed, like the charges in a legal case:

1. Style elements exist.
2. Style groups exist.
3. Style groups change through time.
4. Style change is organic, not abrupt.
5. Different styles do not coexist.

It is essential that these operations take place "before" the text has begun, outside
its rhetorical frame. The "elements" and the directions they develop are not
worked out from absolute disorder: they are simply *there*—they arrive before
the text has begun, and they sit waiting to be analyzed. Every mask taotie,
A1, is always already different from every bodied taotie, A2. No intermediate
form needs to have a separate name. It is always apparent which direction
the development runs: the sequence A-C-B is, in Karlgren's mind, the only
available choice.

Panofsky was interested in this kind of automatism, in the way that histori-
ans automatically arrange unfamiliar material into periods—or, to put it more
accurately, the way they discover the periodization already in place when they
begin. He found periodization essential for historical thought, but unsatisfactory
because of its apparently unmediated self-genesis. In art historical texts there tend
to be two sites of periodization: one in an artificially constructed location within
the body of the text, and another prior to the beginning of the writing of the text
itself. In Karlgren's essay, the periodization A-C-B pretends to take place after a
massive statistical, stylistic, and epigraphic effort, near the close of the paper: but
it is already present in the first exposition of the "style elements" and "groups."
Assumptions about sequence occur alongside the assumptions about evidence—
about what constitutes a "group" and which elements are important enough to
be named—so that definitions become inseparably mixed with the chronologies
that are supposed to follow from them. Though Karlgren presents the following
passage as a definition of style elements, and though it occurs pages before the
statistical analyses that are intended to support conclusions about chronology, its
narrative is already propelled by figures of development (which I have italicized):
"[T]he *transition from* the bodied t'aot'ie *to* what I call the 'dragonized t'aot'ie'
[A1, A2] is marked by so many degrees of variation that it is impossible to find a

definite limit between them. . . . Much more elongated and *decidedly on the way* to becoming the 'dragonized t'aot'ie' [A3] are, for instance. . . . Slightly *more advanced* are the dragonized t'aot'ie."[18] Karlgren had an immediate sense of the sequence of the taotie, and he constructed his statistical analyses knowing which outcome was right. The statistical analyses cannot overturn his sequence, both because they are applied to groups and elements that are already defined and because they only yield a synchronic classification. It is up to Karlgren to provide the diachronic dimension. There is no unusual impropriety here: this sense that a sequence is inevitable or natural, that it could be no other way, that it is somehow given, is familiar to every working historian who has seen new material. Vigilant description, like Karlgren's statistical analyses, can set up oppositions against what appears to a logical critique as the inevitable partial corruption of the results, and a historian may on occasion be persuaded of some other sequence. But far more often the "natural" sequence does not appear as something that needs questioning.

Karlgren's text does not so much attempt to erase this logical transgression as it ignores it. He did not write fraudulent scientific papers in which egregious errors are cleverly disguised: he wrote strongly argued essays that are largely oblivious—and sometimes contemptuous—of such "errors." The assignment of elements, groups, sequences, and periods takes place somewhere to one side of thought. How, then, are we to understand where Karlgren's mind was when all this was happening offstage? By what mental economy was he shielded from these all too obvious problems? One way to locate his conscious attention is to ask where the pleasure of writing is most evident. Certainly there is absorption in the long passages of statistical tabulation, where his eye and ear are fully occupied in accurate amassing of details. But there is pleasure, as well as concentration, in the definitional passages I have quoted, where the prose is energized with stories of the discovered "style groups" and "elements." If anything he has written will endure the ongoing revisions of the field, it is those pages. Part of their success as stories is precisely the freedom from matters of evidence, warrant, and conclusion. They are places where he is outside the law, free to muse, to count, and to build an interpretation as he sees fit. There is a certain grateful liberty in those passages, and even in the strict enumeration of data, *because they avoid something,* and because they are self-absorbed. Would it be wrong to read them as traces of that moment, "before thought," where thoughts of periodization were formed? Could it be that those half-remembered freedoms are captured or recaptured in passages such as these? If the nebulous creation of order is a moment of joy, and if that order cannot be mentioned (since it is utterly at the

18. Ibid., 17.

mercy of the sinister power of legal critiques), then perhaps the principal place where some pleasure can be recuperated is in the descriptions, the statistics, and the lists.

B-C-A

What I am trying to do here is rewrite certain logical "flaws" in our texts—particularly those that have to do with periods and the definition of the objects of analysis—as a kind of pleasure that is taken in undirected musing. This pleasure is part of an economy that is rather strictly balanced: the acts of periodization and classification take place to some degree outside conscious awareness, "before" writing, and practically "before" we see. It would be easy to topple the illusion of such delicate moments, but since there is joy in the reduction of chaos and the creation of order, historians like Karlgren prefer to turn the force of criticism to one side and let it work on the objects *after* they have been ordered. That affords opportunities to repay the pleasure that the objects have given by an evocative and careful description. A great deal of what is at stake here, it seems to me, is oblivion: at first, oblivion from the moment in which the new forms first made sense, and later, oblivion from the pressures of logical critique. One part of him *knows* where he is going with his "elements" and "groups," and another part chooses not to know.

I take this as exemplary of a great deal of what art historians do, no matter what interpretive strategies are being employed. Any historian who has encountered new material has experienced this sense of inevitable order—whether it is stylistic or social, chronological or conceptual. The very fact that we may think we know what to look for shows how much has been done "for us," largely by the uncognized accumulation of previous analyses. All this is commensurate with the metaphor of a meandering art history, since it would imply that rules are incompletely present in the texts. But before I will be ready to claim that art historical traditions meander rather than progress, I need to take the argument a little farther. Historians rarely feel certain about their intuitive hunches, and it is usually taken for granted that further efforts might overturn first impressions. The natural growth of facts is often credited with this revisionary power, since it can falsify earlier chronologies (even if it has little power over the choice of "elements" and "groups"). And the steady application of persuasive assessment is normally credited with the power to redirect a wayward analysis or tradition. To say that art history meanders, therefore, I also need to show why it can be reasonable to claim that neither of these correctives can set interpretations on a straight path.

According to Max Loehr, the first Anyang (late Shang Dynasty) style, which is now called Loehr I, has a "light, airy effect" and "simple forms" (Fig. 20, top). Its ornaments are "executed in horizontal friezes" and disposed in "thin relief lines."[19] Loehr II has incised ornaments and "harsh, heavy forms." In Loehr III "only the eyes of the theriomorphic designs protrude[, and the] patterns around the eyes become very regular, even, and uniform." Loehr IV is "characterized by the emergence of the *lei-wen* ('thunder pattern') background." (The "thunder pattern" is like the Greek meander, except that it is not constrained to linear tracks.) In Loehr IV, "motifs and spirals are flush" with the vessel's surface. And finally, "designs in low, and, gradually bolder relief are the innovation of Style V, which is the last of the Shang styles."[20]

Roughly speaking, Loehr's sequence is the opposite of Karlgren's, since Loehr takes the direction to be from abstract to figurative, instead of vice versa. In that sense, Loehr's version of Karlgren's sequence would be something like B-C-A. In accord with the traditions of art history, there is little direct conversation between Loehr and Karlgren—I will quote some of it in a moment—and basically the two accounts are independent. How do they stand in relation to one another? How might their differences be adjudicated?

An article by Alexander Soper attempts to correlate Loehr's five Anyang styles, which "it is no longer possible to reject," with Karlgren's A, B and C groups. Loehr I and II, he suggests, are unclassifiable in Karlgren's system: "I and II [Fig. 20] are obviously B-like, but neither of their typical motifs, the symmetrical grouping of lines around two eyes . . . and the even more cryptic maze around a single eye, can be properly accommodated in the standard B vocabulary. The first is not yet the 'animal triple band' [Fig. 19, B2], since its horizontal elements are not strongly tripartite[, and] the second is quite unnamable." Loehr III, on the other hand, can be placed in Karlgren's system, where it corresponds closely to his "dissolved t'aot'ie" B1—but as Soper notes, it has an entirely different meaning in Loehr's scheme. Since Loehr's posited development is from abstract to figurative, his style III is, in Soper's words, "a further stage toward the consolidation and clarity of the classical A style of [Loehr] IV," whereas Karlgren meant it to be a "dissolved" form of an earlier A style taotie.[21]

19. For recent assessment of Loehr's styles, see A. Spiro, "Max Loehr's Periodization of Shang Vessels," *Journal of Asian Culture* 5 (1981): 107–35. Loehr's five Anyang styles are available in Max Loehr, "The Bronze Styles of the Anyang Period," *Archives of the Chinese Art Society of America* 7 (1953): 42–48, and idem, *Ritual Vessels of Bronze Age China* (New York: Asia Society, 1968), 13. See also the summaries in Wen Fong, "The Study of Bronze Age Arts," and in Alexander Soper, "Early, Middle, and Late Shang: A Note," *Artibus Asiae* 28 (1966): 5–38, esp. 37–38. The descriptions vary in each. The last phrase quoted here, "thin relief lines," does not occur in the 1968 summary. Unless noted, quotations are from Loehr's original 1953 article.

20. William Watson, "The Five Stages of Shang," *Art News* 67, no. 7 (1968): 42–47.

21. Loehr, "The Bronze Styles of the Anyang Period," 13 n. 45.

A second obstacle to concordance is the differing definitions of "style element." Loehr takes his own Style I to be equivalent to Karlgren's "animal triple band" (compare Fig. 19, B2, with Fig. 20, I), but William Watson and Soper disagree.[22] Soper places B2 "after the domination" of Loehr III.[23] The remnants of quills (visible at the top in B2) are explained by Karlgren as vestiges of the more figurative A group.[24] Hence (and here we encounter the intricacies that attend any archaeological reconstruction) the "animal triple band" can fit in the sequence Loehr I–II–III–Karlgren B2–Loehr IV–V, or the sequence (presumably acceptable to Karlgren) Loehr V–IV–III–B2–II–I, or, finally, the sequence (implied by Loehr) Loehr I/B2–II–III–IV–V. A complete analysis is out of reach because of the differing definitions of style elements, in this case the presence or absence of quills.

For these and other reasons, a concordance of Loehr and Karlgren cannot take place. Each schema is predicated upon the dismemberment of the other. Here we have in simple terms a situation that occurs each time a period, a work, a sequence, or an artist is redescribed: it is not that one account contradicts another (as they would ideally in rival scientific theories), but that they cannot be compared at all without destroying one another.

AGREEING NOT TO PRESS MATTERS

I would like to read this incommensurateness as a safeguard, allowing later writers to go on their way. As long as the historians cannot address each others' hypotheses with any thoroughness, as long as they are permitted to talk past one another by limiting their direct addresses to previous scholarship, they gain freedom to write as they wish. When logical confrontations occur, they are disfigured by a desire to preserve that freedom. Several early writers, including Loehr, held that Karlgren's claim that "figurative forms became abstract" was essentially opposite the truth.[25] In Karlgren's own description of Loehr's work,

> The first stage would have been the most dissolved one: only a pair of eyes surrounded by a maze of spiral lines, purely geometric adornments [Fig. 19, B1], and then gradually the playful artist would have turned those eyes into the contours of a face and body [C1], and there would have been two dragons confronting one another; these would have drawn close together, their heads would have coalesced [Fig. 19, C2], and there [would have been] the elongated t'aot'ie; this would have been concentrated [Fig. 19,

22. Soper, "Early, Middle, and Late Shang," 29–30.
23. Ibid., 30.
24. Karlgren, "New Studies," 77–78.
25. See Loehr, "The Bronze Styles of the Anyang Period," n. 1.

A2] and there [would have been] a final step to the true, vigorous realistic t'aot'ie [Fig. 19, A1].[26]

It is consonant with this that where argument is dangerous—where it could lead to the destruction of the cherished encounter with the objects—it needs to be cut short:

> Primitive art would not from the first stage—eyes in a maze of spirals [B1]—have chosen, as a second stage, to draw a row of quills at a certain distance from the eyes [B2], and then gradually fill in the body. . . .
>
> A single glance at the animal triple band will convince any art historian that it is the end of an evolutionary process, not its beginning: it is the final stage of a most typical process of stylization and dissolution.[27]

The most that can be hazarded is an acknowledgment of the absence of logical debate; anything more would be treacherous. At one point Loehr says simply that Karlgren "does not offer a logical explanation of the supposed . . . changes, a history of styles."[28]

This is not, as critiques such as Carrier's would have it, only a matter of defective or impoverished reasoning. Here we are witnesses to an *agreement,* since the partners express a mutual unwillingness to forgo their accustomed writing. Let us agree, they seem to say, not to press this matter too hard. Assertions and charges are bereft of disruptive power as long as they do not acknowledge the offstage logic of the enterprise as a whole.

ATOMIZATION AND THE PERSISTENCE OF MEANDERING

> [After] the great methodological debate over Bachhofer's [periodization] . . . in the late 1940's, most younger scholars seem to have . . . turned instead to the safer grounds of data gathering and research on specific topics. . . . [Even so,] the techniques developed by stylistic historians have remained the only tool available to the modern student.
>
> —Wen Fong, *Great Bronze Age* exhibition catalogue

It may be objected that the various traits of meandering scholarship that I have begun to sketch here only apply when the material is new to history, so that

26. Karlgren, "New Studies," 77.
27. Ibid., 78.
28. Loehr, "The Bronze Styles of the Anyang Period," 42–43.

it does not come to us with archaeological dates or archives to put a check on unrestrained musing. The later history of Chinese bronze scholarship, when facts and dates did become available, shows why this is not the case. (In considering this material, I pose the problem as if it were a matter of something called "style analysis" coming up against something that is often called "positive fact." Though I think the observations I have been making apply with equal force to any moments of aporia, certainty, and interpretive pleasure, I also recognize that fact and style tend to be imagined as the extreme ends of a scale from certainty to slipperiness. By centering attention on the pleasure of description, I mean to decenter this polarity and eventually to dismantle it by showing that "style analysis" and "positive fact" both depend on the sources of pleasure.)

The slow disappearance of style analysis is an exemplary case of the apparent victory of reason over pathless intuition. Style analysis has been criticized for various inadequacies and has come to occupy the position that discarded methodologies traditionally have: it is the vilified old way, castigated and charged with any number of transgressions that may not be relevant. In contemporary historiography it is a commonplace that facts control the speculations of style analyses, that style analysis is associated with discreditable ideologies such as aestheticism and elitism, and that it is epistemologically narrow, so that it cannot deal with social and gender questions. More recently it has been said that there might not be a determinate reason why style analysis is misguided or narrow, that it might not even be irreparably compromised, but that we have decided to ask other questions instead. In accord with my larger purpose of describing the economy of our texts, I do not want to explore these questions further, but I would remark that the nearly universal insistence on our power over style analysis should give us pause: it is also possible that we need repeatedly to claim our independence precisely because we have not achieved it.[29]

Let me consider only the most easily argued of these assertions, the one that holds that positive fact controls errant style analysis. In recent decades a great influx of archaeological information has effectively prevented style analyses from being as dramatically dissimilar as Loehr's and Karlgren's. This slow constriction has been the characteristic mechanism of refinement over the last five decades, and it has been maintained that it has altered the style analyses themselves, bringing them more in line with what has become known. Where Karlgren had a thousand years of undated material, today historians are more likely to have twenty-five or fifty years' uncertainty, within which they can hypothesize a style sequence until another date comes along to correct it. I call this *atomization,* since it entails the gradual chopping-up of large sequences of undated material.

29. For an analysis, see my "Style," *Macmillan Dictionary of Art* (New York: Macmillan, forthcoming).

Ludwig Bachhofer's "The Evolution of Shang and Early Chou Bronzes" (1944) attempts to resolve the disputed transition between Shang and Chou by distinguishing three groups of *yu* (bucket) vessels.[30] Vessels in Group I (Fig. 21) have "bodies, feet, and lids covered with animal décor" (the decoration is omitted in the diagram), with flanges and a knob on top.[31] Those in group II have no flanges, and their décor "is restricted to two or three narrow friezes."[32] Their lids, unlike those of the first group, have no projections at the sides. *Yu* vessels of the third group share the same "relationship of decorated and undecorated surfaces," but their lids have "shield-like protuberances on either side" and "oval feet" in place of the central knob of the Group II lids.

Along with his catalogue of style elements, Bachhofer uses a number of readily distinguished interpretive assumptions. I consider three of them and briefly follow their atomization in the subsequent literature in order to see how style analysis has been altered, but not extinguished, by archaeological facts.

1. The first assumption is that one style must reign supreme at any one moment in history. Without it, sequences of styles could not exist, since all style might be coetaneous. Nevertheless, this idea was recognized as problematic from the outset. Bachhofer stated his position this way: "There can be no doubt that

Fig. 21. Ludwig Bachhofer's three types of *yu* vessel

30. Ludwig Bachhofer, "The Evolution of Shang and Early Chou Bronzes," *Art Bulletin* 26 (1944): 105–16. Only Bachhofer's initial schema, as presented in his figures 1, 2, and 3, is discussed here. Bachhofer's descriptions are much more involved than those of Karlgren or Loehr (his definition of three groups takes three full pages), and I have only reproduced the salient points for this discussion.
31. Ibid., 107.
32. Ibid., 108.

one style reigned supreme at one time. . . . Two vessels in two successive styles [found at one site] are not necessarily a contradiction: they merely suggest that the change took place during that period. But when works of the earlier style are dated at a much later time, no such explanation is possible. One cannot maintain that the struggle . . . dragged out so long."[33] The year after printing this statement, *The Art Bulletin* published a critique by Otto Maenchen-Helfen, who argued for the use of epigraphical evidence and cited examples to show that more than one style had existed at a time without a "struggle" and consequent evolution. Disagreements over the exact date of a motif, wrote Maenchen-Helfen, "are unavoidable. But that does not mean to say that we may let ourselves be carried away by 'intuition' or 'sensitiveness.' "[34]

The exchange was unresolved,[35] and it has since been widely affirmed that two or more styles may coexist.[36] Even so, the corrective of positive fact has not effected a cure, which would demand a renunciation of the primacy of the idea of artistic sequence in favor of static pluralism. Loehr, for example, allowed that large styles, such as his own five Anyang styles, might overlap slightly, because of the complexities of culture; but at the same time, there was a level at which the law of the single style continued to operate. In 1968, Watson wrote of Loehr's styles that "every slight difference, it seems, must imply an earlier and a later: as when a *fang ting* [square tripod or tetrapod], on a finesse of rendering, is said to be 'unquestionably' a little earlier than [another design]."[37] In this way, by allowing larger categories of style to be simultaneous, while holding that on a smaller scale one style follows another, Bachhofer's assumption was refined— atomized—rather than decisively critiqued.

2. Bachhofer also assumed that Western art historical periods apply to Chinese bronzes. Where other students of Wölfflin had been content to apply the terms "classic," "Renaissance," and "baroque" to unusual contexts, Bachhofer had already felt it necessary to modify the explicit period names. Alexander Soper has noted Bachhofer's reticence and his concomitant dependence on Western periods: "Though he had not used the terms, his sequence had powerfully suggested the passage from archaic to classic, from classic to baroque his 'ornate,' from

33. Ibid., 111–12.

34. Otto Maenchen-Helfen, "Some Remarks on Chinese Bronzes," *Art Bulletin* 28 (1945): 238.

35. See Alexander Soper, review of *The Freer Chinese Bronzes*, vol. 1, by John Alexander Pope et al. (Washington, D.C.: Freer, 1967), *Art Bulletin* 53 (1971): 105–9.

36. Perhaps the most widely known example of the defense of a plurality of styles is Otto J. Brendel, *Prolegomena to the Study of Roman Art* (New Haven: Yale University Press, 1979), 152–53. In recent decades the idea has become ubiquitous, and is no longer taken to be restricted to particular epochs (as in Jacques Bosquet, *La peinture manieriste* [Neuchâtel: Ides et Calendes, 1964]). Still, the dissemination of the idea should not obscure the fact that it is not simply a one-directional development from claims like Bachhofer's to an acknowledgment of the universal possibility of a plurality.

37. Watson, *Ancient Chinese Bronzes*, 115 n. 45.

baroque to neo-classic—his 'severe,' and thence into something like nineteenth century detente—'languid, limp.'"[38] Bachhofer used only the descriptions that underlay the terms (words like "controlled," "flamboyant," "severe," "noble"), and he substituted neutral names ("Group I," "Group II," "Group III") for the explicit "Renaissance/baroque," "neoclassical," and "Romantic" or "fin-de-siècle."[39]

A recent tendency has been to relegate references to art historical periods to less formal settings such as reviews and introductions. J. L. Davidson, in his review of George Weber's *Ornaments of Late Chou Bronzes* (1973), reads into the style of the late Chou vessels a *Zeitgeist* comparable to the Renaissance, and he also mentions classic, baroque, and rococo.[40] Weber's book is one of the most dry and careful studies yet undertaken of Chinese bronzes. Both Davidson and Soper, who wrote the introduction, express mild dissatisfaction that Weber "did not permit himself" speculations about larger questions of meaning; but when they sketch out the kinds of meaning they find absent, they use the Wölfflinian Western art historical periods whose gradual disappearance from the literature had culminated most recently in Weber's book.

Writers also felt uncertain about the sweep of the style periods Bachhofer and Karlgren used. The latter encompassed all of Shang and Chou, roughly 1,200 years, in two monumental groups. Bachhofer used three groups for Shang and early Chou, with some subdivisions; and Loehr saw five styles in the Anyang alone, with six more in the Eastern Chou.[41] Weber's elements at first seem similar to Karlgren's in that the motifs are isolated from their contexts.[42] He uses more categories than Karlgren had: four basic groups, divided into "families," divided into individual "types."[43] Further, he names his groups and forms more elaborately—for example, the "modelled dorsal zoomorph with split body." But the underlying difference from Karlgren is that Weber's categories, families, and types do not form an overarching A-C-B as Karlgren's do. In Weber's case, the "families" of styles that make up the larger categories are left intact and unassimilated, and each is dated separately to the nearest one-quarter century. The result is a list of highly specific terms, instead of a unifying scheme.[44]

38. Soper, review of *The Freer Chinese Bronzes*, 105.

39. Loehr's five Anyang styles were also given neutral names. In the 1953 article ("The Bronze Styles of the Anyang Period") he referred to them as "First Style (Anyang I)" and so on; in the current literature they are called "Loehr I," "Loehr II," etc.

40. J. L. Davidson, review of *The Ornaments of Late Chou Bronzes*, by G. W. Weber (New Brunswick, N. J.: Rutgers University Press, [1973]), *Art Bulletin* 57 (1975): 266.

41. Loehr, *Ritual Vessels of Bronze Age China*, 15.

42. Weber provides charts of the elements at the end of the book, something that neither Bachhofer nor Loehr did.

43. Weber, *Ornaments of Late Chou Bronzes*, 541.

44. As in the case of Karlgren, Weber's categories are composed of different kinds of style elements. Bachhofer's and Loehr's, by comparison, have greater uniformity of elements between groups.

In this way the style periods have been atomized until they are relatively brief. A single style, within which no significant changes are perceived, has shrunk from a span of several Dynasties to only twenty-five years. Despite this they remain periods, and periods whose meaning, as Soper and Davidson demonstrate, must still be conceived in terms of Western art historical periods. Here I would claim we continue to see Western periods in any sequence of objects, and also that we continue to see *by means of* Western periods, even though we have become careful enough not to say the original names. The ways that Western art is said to have changed are still paradigms for our thinking, and they harbor atomized rules of stylistic change.

3. A third assumption operative in Bachhofer's work is that all style elements can be studied with a single classification. Along with this decrease in the length of periods went a division of the subject matter of style analysis. Bachhofer, like Karlgren, chose a heterogeneous group of style elements: the *yu* of his Group I (Fig. 21) are known by three criteria of form (their outlines, their proportions in cross section and elevation, and the orientations of their handles), two criteria of decor (their flanges and their knobs), and one of the disposition of decor (what Karlgren had called the "uni-décor").[45]

The new Freer catalogue, published in 1971, took this even further: its approach, in Soper's words, is "four-fold": a detailed description, a section called "Style and Chronology," one called "Technical Observations," and a fourth on "Inscriptions." Style analysis figures in all four sections. The third, "Technical Observations," includes an analysis of "signs of early patching or imperfections or of recent repairs," "the technique of the inscription, if any," and "the character of the patina," all requiring formal analyses inherited from more general style analyses.[46]

In this way style analysis evolved into several distinct subdisciplines, each relatively methodologically pure. The style content of these new areas of inquiry is not always apparent at first, but often they prove to be revised versions of the unacceptably wide-ranging inquiries of earlier decades. The later style analyses, such as those in the Freer catalogue, have atomized to the point that style judgments are lodged piecemeal among the results of laboratory analyses. The same thing happens, I think, in any number of contemporary approaches to art history, from feminism to psychoanalysis. Nothing in what is understood as the evidence or the facts of history prevents us from achieving the moments of pleasure that accompany our chosen methods.

45. Karlgren, "New Studies," 107–8. See also Watson, "The Five Stages of Shang," 43.
46. The fourth section, "Inscriptions," also uses style criteria in dubious cases. See Soper, review of *The Freer Chinese Bronzes,* 108.

A Certain Kind of Writing

With these three examples I mean to suggest that the meditative freedom apparently afforded by the chosen approach to the artworks—in this case, style analysis—remains intact in the interstices between whatever is perceived as unarguably the case: in the example, the dates provided by archaeology. The latter neither reformulates nor corrects the former, but atomizes it by restricting its purview. In the case of Chinese bronzes, the periods have become shorter and styles more exhaustively defined; but unlike the increasing number of dates, their precision is an illusion, since they are all, even the largest, without the possibility of appeal except to the mélange of assumptions that produced them. And such an appeal is impossible in practice, since the assumptions used to generate the periods are largely unknown.

Far from being a speculative activity grounded in unalterable fact, art history gains a sense of purpose by imagining that it is so grounded. To say that a certain interpretation is falsified by a certain fact, and to draw the conclusion that facts check hypotheses—and therefore, ultimately, by whatever circuitous route, to claim that part of what we do might build, or move, or even progress toward an improved account—is to ignore two things: the reason why the new fact came to light at the moment that it did, and the persistence of the desire to explain the fact in a certain way. We have very little idea how we choose facts or how we deploy them, and even less idea how we arrange or apply our interpretations. When do we become aware of new "elements" and sequences? What motive, what desire causes us to see what we do just when we do? Where does the feeling of inevitable order come from? Why do we persist in our tendency to create certain kinds of order?

The apparent mastery of style analysis is an instance of a general motion I would like to call *restriction,* where a way of encountering the works is judged to be unreliable and is confined in particular ways. The act of restriction is understood as a way to control or expel unwanted ideas; in the case of style analysis we believe we eliminate some sources of illogic, such as the unhelpful appeal to intuition or the connoisseur's unimpeachable eye. But we also agree to preserve a certain kind of writing, not least by allowing the forbidden practice to continue in other forms. And although style analysis per se has not been my subject here, I would argue that it is no less logical, no less susceptible to reasoned argument, than any other theory currently in use, and that we tolerate it—albeit under different names such as formal analysis, as some other method, or just as "description"—far more widely than the theories currently in favor can admit. In general, every restriction is a contract, or an agreement: a way of preserving whatever economy of truth and falsehood, of circumspection and

oblivion, of analysis and description, might allow us to continue finding pleasure in our writing and our work. The "logocentric paradigm" and the sameness of theory are both examples of restriction.

This is roughly why I find meandering a more interesting metaphor than linear progress or the disorder of relativism. It helps describe the way that art historical accounts shift and elide without entirely disengaging from one another, and it helps show how there can be active debate about interpretations without either logical consistency or pointless irrelevancy. Ours is not an unresolved position, poised between the incoherence that critics such as Carrier find and the logical rigor they may be inclined to favor. The stories that I began with are coarse because they imply that kind of double fate: the version of art history they recount is unstable and open to easy attacks. Instead, I would propose that we consider the discipline as a balanced activity, with its own economy and its own way of dreaming about legal certitude. What happens "automatically," "immediately"—the sudden burst of order where there was disorder—is, in my account, a strongly pleasureful experience. Our agreements and restrictions, our measured oblivions, and our truncated debates may all be understood as stratagems allowing us to recuperate some of that pleasure as we write about the artworks. This, I think, is what we want to do: and to do it, we will meander anywhere that thought seems to take us.

felicitous turns of speech, the order in which they present their material, what they choose to exclude and how they exclude it, when and where they publish, and a stock of personal reminiscences and anecdotes. The penumbra is what is loosely called "a lifetime of experience," but it is experience that has been taken in in a certain way, with an intention to conserve, to memorize some facts and store up others. It is a carefully tended region, ordered and read in a certain way so as to serve our rational purposes. Often the penumbra is more engrossing than the simple discoveries and interpretations announced in each new essay, even though the argument may claim our attention at first. The real bases of our knowledge, and the proximate causes of the complexity of our texts, are these immense and delicate structures of memory. And with this initial metaphor in mind, I turn to the particular example that occupies most of this chapter: the question of the authorship of the frescoes in the Brancacci Chapel in the Carmine in Florence.

PAINTING THE BRANCACCI CHAPEL

> For decades now, in Italian schools there has been a standard,
> classical, elementary exercise familiar to everyone: distinguish
> between Masaccio and Masolino on the basis . . . of their
> similar frescoes . . . in the Carmine.
> —Luciano Berti, *Masaccio*

The "elementary exercise" was not always so. From the 1820s to the 1930s it was considered quite difficult, if not insoluble, and certainly not a matter for students. It went by names such as *vexata quæstio, intricatissimo subietto, Rätsel* (riddle), and *ewigen Streitfrage* (unending controversy). After 1848 the Brancacci Chapel problem was sometimes thought of as "the most important question in the history of art"—Gaëtano Milanesi appears to have been the first to say this—and to August Schmarsow, writing in 1898, the Brancacci Chapel frescoes stood "at the beginning of the question of style itself."[2] An opinion on the proper attributions of the frescoes was recorded in 1510, forty years before Vasari, and the literature grew rapidly from the late Renaissance until the third decade of this century. It is only since 1940, when Roberto Longhi published his "Fatti di

2. See Vasari, *Vite,* ed. Gaëtano Milanesi (Florence, 1848), 2:297ff. Schmarsow places the Brancacci Chapel "at the beginning of the question of style" because Masaccio was a "developing artist" (he calls him "den werdenden Masaccio") and is therefore not easy to distinguish from his close contemporary, the more static Masolino. August Schmarsow, *Masaccio oder Masolino?* vol. 4 of *Masaccio, der Begründer des Klassischen Stils der Italienischen Malerei* (Kassel, 1895–1900).

Masolino e di Masaccio," that scholarship has relinquished the question and it has become a school exercise.[3]

Though I believe it is demonstrable that the tradition at its peak came no nearer the correct solution than it was at the beginning (and I will present evidence for this after reviewing the texts), there is nevertheless a certain feeling of progress. Clearly the essays were developing, going *somewhere*. As in the traditions explored in the last chapter, the essays on the Brancacci meander: they follow one another, but not in a strict progression. Here I want to propose another way of understanding the concept of an art historical tradition, this time more suited to the investigation of individual texts and their logic. Let me suggest that the overall sense a reader gains of a directed and yet nonlinear sequence may be an effect—almost a hallucinatory effect, one not necessarily linked to the actual arguments of the essays—of the slow emergence of the *expressive purpose* of the writing. What can appear as the indeterminate "matrix" of nonlogical forms in art historical writing is also the place where the writing can become most expressive, and I will even go so far as to claim that the moments of actual logic and connected argument can function principally as *advertisements of logic:* claims we advertise to ourselves and to others in order to get on with the business of writing in a fuller sense. As art historical writing becomes more self-reflective, and as the historiography of the discipline deepens, it can happen that the expressive purpose becomes paramount and the claims shrivel away. In this respect, writing art history is the activity of describing an intuitive feeling for an artist or an artwork, mingling and disguising that depiction with the resolute structures of logical argument. Without the latter, what we do could not appear under the name of history, and without the former, it would be a lifeless catalogue.

It is a commonplace critical observation to say that intuition guides art historical research or that nonverbal appreciation plays a definitive role in writing about art, no matter how rational it may become. I am claiming something more than that, since I want to argue that art history does not begin from the

3. Frederick Antal suggested in 1947 that "the religious story probably carried patriotic and economic implications," and his lead has been followed by de Tolnay, Hartt, Meiss, Pope-Hennessy, Procacci, Molho, and others who have explored social meaning rather than matters of attribution. Investigations of style have focused on other works, including the *Reggello Madonna* and the lower section of the *Trinity*. See, for example, Anthony Molho, "The Brancacci Chapel: Studies in Its Iconography and History," *Journal of the Warburg and Courtauld Institutes* 40 (1977): 50–98; Frederick Hartt, "Art and Freedom in Quattrocento Florence," in *Essays in Memory of Karl Lehmann,* ed. Lucy Freeman Sandler (Locust Valley, N.Y.: J. J. Augustin, 1964), 114–31; Millard Meiss, "Masaccio and the Early Renaissance: The Circular Plan," *Acts of the 20th International Congress of the History of Art* (Princeton: Princeton University Press, 1963), 2:123–45; Ugo Procacci, "Sulla cronologia delle opere di Masaccio e di Masolino tra il 1425 e il 1428," *Rivista D'Arte* 28 (1953): 3–55. For the original thesis, see Frederick Antal, *Florentine Painting and Its Social Background: The Bourgeois Republic Before Cosimo de' Medici's Advent to Power: Fourteenth and Early Fifteenth Centuries* (London: K. Paul, 1948). See also the acute formal analysis in John Shearman, "Masaccio's Pisa Altarpiece: An Alternative Reconstruction," *Burlington Magazine* 18 (1966): 445–55.

ineffable encounter with the work and then grow away from it and toward more secure claims, but it *is* that encounter, elaborately dressed for presentation and partly repressed in the name of history. In this view, the most successful art history takes place where the entire elaborate apparatus of the discipline (all the rules of narration and evidence, all the visual theories) is put to work expressing that inchoate encounter, rather than smothering it in the name of propriety or rationality. Needless to say, in most texts this must be an unconscious operation, since the writer must continue to believe that the text is potentially rational, reliable *history,* colored by description, and not—as it might seem to a writer suddenly aware of another purpose in the writing—poetry with a veil of facts.

If this is true, and if art historical writing sometimes bends its argumentative framework to support a cryptic expressive purpose, then it stands to reason that on those occasions it may seek to dissolve its logical forms into something more closely resembling the object that is being described. In one way or another, I think, pictures are the ideal models for art historical prose, and pictorial structures, properties, and effects are among the best ways to explain what happens in some of the most interesting writing. When the logic of art historical texts deliquesces in the name of the emulation of affect, it seems to me the writing often becomes picturelike, adopting modes of relation and structure that are found in pictures. One of the reasons this might be so is a dimly perceived coincidence between two contrasts, one in writing and the other in pictures: in writing, the contrast of necessary logical argument and "ornamental" matrix in our texts; and in pictures, the contrast of signs of realistic depiction and signs of inner or formal coherence in the paintings. Like texts, pictures have their necessary elements, which have normally been requirements of realism, and also their opportunities for purely pictorial meaning. Portrait painters make use of certain expected conventions: a few strokes of vermilion around the nose and eyes, perhaps some scraping with the brush handle for thick hair. The artist hopes such gestures will be taken as adequate signs of the patron's idea of a good likeness. But a painter alert to the possibilities of the medium will also be drawn toward relations and harmonies within the work. How does the ultramarine glaze of the collar go with the cobalt blue pupils? How should the rough texture of the clothing respond to the smooth contours of the head? Should the background be a little warmer and lighter around the face, and cooler toward the frame? As the portrait comes nearer to completion, questions of relation take precedence over the established signs of literal likeness, without ever wholly supplanting them. Relational issues become ever more difficult and engrossing, and correspondences ever more routine. This is not a sign of imprudent ignorance of realist conventions or of a shrinking aestheticism, but of the demands of a picture that has become complex and eloquent on its own account. Realist strategies blend with strategies of relation, and correspondence with the sitter mixes with coherence within

the picture. As Hubert Damisch, Yve-Alain Bois, and others have urged, these relational problems are signs of the kinds of thinking that are proper to pictures themselves, as opposed to signs of the relation between pictures and the world, or signs of some imposed linguistic code such as a narrative or a symbolic agenda. The thought that takes place in pictures, I would add, can be echoed in texts about pictures when they allow themselves to develop beyond the litany of necessary facts.

I call this second metaphor the *pictorial text*. Like the penumbra, it is a way to reconceive the separation of logical argument from "optional" narrative. The indispensable facts, dates, names, hypotheses, and proofs would then be less anchors lodged in some actual history than signs of realism—the texts' "reality effect," as Roland Barthes put it. What is at stake here is the way we mingle purposive reason with descriptive setting in order to balance the two in the same way as pictures appear to balance them. Reading the pictorial text is another way of finding meaning in the apparently dry monographs that are the everyday fare of art historical research. If the most emotionally distant, "professional" essay, written entirely in passive voice and couched in tortured, formal syntax, can be reread as a partly thwarted attempt at *expression*, then the archives of art history can take on new meaning. The gradual development of art historical writing could then be seen as a determined (if largely unconscious) attempt to let the experience of pictures pull free of the straitjackets of formality.

FROM VASARI TO RUMOHR

[H]ere we find ourselves caught in a most intricate labyrinth.
—Berti, *Masaccio*

In the first three centuries the subject of the authorship of the Brancacci chapel does not seem to have been a pressing matter, and the opinions that have come down to us are brief.[4] The writers do not provide reasons for their assertions, but rather juxtapose attributions (and contradictions of previous work) with appreciations in a rather stark manner. Vasari's *Vite* is part of this tradition of contradictions, even though he offers a fair amount of descriptive material

4. Romano Albertini's *Memoriale di molte statue et picture che sono nella inclyta ciptà di Florentia* (Florence, 1510) is the earliest. Albertini says only that half the chapel is by Masaccio and half by Masolino, "with the exception of the *Crucifixion of St. Peter*, which is by Filippo [*sic:* Filippino]." He is imprecise regarding Masaccio's share ("mezza di'puo mano, et l'altra di Masolino") and seems not to care much about the distinction between the two. *The Codice Magliabechiano* records only a collaboration. See *Il codice magliabechiano*, ed. C. Frey (Berlin, 1892), 82.

alongside his attributions.[5] What interlards the spaces between assertions is the Vasarian mixture of what we would call psychological, ethical, and formal criticism.[6] Vasari ascribes the fresco known as the *Tabitha* to Masolino (Fig. 22), accompanying his attribution with this description: "The figures are made with very good grace, and they show grandeur in the manner, softness and harmony in the coloring [*morbidezza ed unione nel colorire*], and relief and force in the drawing [*e relievo e forza nel disegno*]."[7] Vasari's attributions vary in different *Lives* and between the two editions of the book, but for the most part he is self-consistent. Figure 23 is a later diagram of the chapel, showing Vasari's attributions to Masolino, Masaccio, and to Filippino Lippi, who completed the chapel later in the fifteenth century.

In the two centuries following Vasari, Masaccio was sometimes said to have painted the entire remainder of the chapel after Masolino's part.[8] A chain of

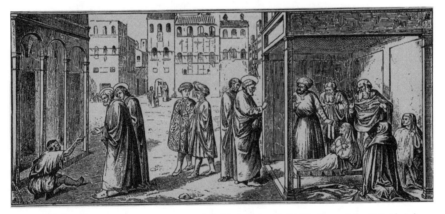

Fig. 22. Engraving after *The Resurrection of Tabitha and the Healing of the Cripple* (also called the *Tabitha* and the *Doppelbild*). Fresco. Florence, S. M. del Carmine, Brancacci Chapel

5. Vasari mentions the problem in three *Vite* (di Masaccio, di Masolino, di Filippino Lippi).

6. The revised passage on Filippino in the second edition of the *Vite* may indicate nothing more than a desire to list portraits instead of paintings, and the change from "et non finito di Masaccio" to "e non del tutto finita da Masaccio" may not be significant. The wider availability of the second edition, however, led the succeeding generations to think Vasari had realized Filippino had a smaller share in the chapel. See Vasari, *Vite*, ed. Milanesi, 2:297 and 3:462.

7. The passage continues: "[T]he work was esteemed for its novelty . . . but, being overtaken by death, [Masolino] left these scenes unfinished [le quali storie . . . lasciò imperfette]. Vasari, *Vite*, ed. Milanesi, 2:165.

8. Raffaello Borghini read the second edition of the *Vite* and insisted in *Il riposo* (Florence, 1584) that Filippino had done only one fresco, *Theophilus's Son*. At the close of the century another guidebook, Francesco Bocchi's *Bellezze della città di Fiorenza* (Florence, 1591), records Masaccio as the author of

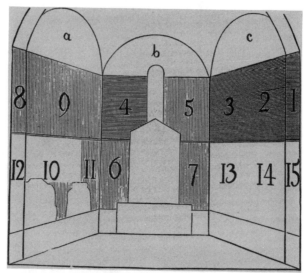

Fig. 23. Vasari's attributions of the Brancacci Chapel frescoes.
Vertical shading denotes Masaccio's work; horizontal shading,
Masolino; and white areas, Filippino Lippi.
(1) *The Fall*, (2–3) *The Resurrection of Tabitha and the
Healing of the Cripple*, (4) *St. Peter Preaching*, (5) *Baptism of the
Neophytes*, (6) *The Shadow Healing*, (7) *St. Peter Distributing
Alms*, (8) *The Expulsion*, (9) *The Tribute Money*, (10) *The
Miracle of Theophilus's Son*

similar judgments along this line was broken by Carl Friedrich Rumohr's *Ital-
ienische Forschungen* (1827–31). As Julius Schlosser notes in his edition, the

the entire chapel. Bocchi was writing for a less specialized audience than Vasari, and his opinion may
show inattention to what he may have considered an irrelevant distinction. When Cinelli's edition of
Bocchi appeared in 1617, the passage was curtly annotated ("one thing that cannot be passed over in
silence . . .") and brought into line with Borghini.
 The exclusion of Filippino persisted through the eighteenth century. In 1770 Tommaso Patch and
Antonio Cocchi gave the entire chapel, including the *Crucifixion,* to Masaccio. Patch was among the first
to present a kind of evidence for his conclusion, since he identified a youth in a "baretto e capo" at the
right of the *Proconsul* as a self-portrait of Masaccio (Tommaso Patch, *The Life of Masaccio* [Florence,
1770]). Luigi Lanzi's *Storia pittorica dell'Italia* (Bassano, 1789) partly corrects Bocchi and Patch and gives
Masaccio back the *Tribute Money, Baptism,* and *Shadow Healing.* Lanzi's position is therefore a partial
return to Vasari, who has also named other frescoes as Masaccio's work.
 At the end of the eighteenth century and the beginning of the nineteenth, the tradition exclud-
ing Filippino continued largely uninterrupted. Luigi Lanzi's *Etruria pittrice* (1791) and J. B. Séroux
d'Agincourt's *Histoire de l'art par les monuments* (Paris, 1823), 3:124, both assign the *Proconsul* to
Masaccio. D'Agincourt gives Filippino *Theophilus's Son,* but calls him "Filippo" (following Vasari) and
provides no other discussion, so his understanding of the matter is not clear.
 For other sources during this period—including Filippo Baldinucci, *Notizie de'professori del disegno*
(Florence, 1728); M. Pittaluga; I. de Sandrart, *Academia nobillisimae artis pictoriae* (Norimberga, 1687);
Mengs; and Luigi Lanzi—see Mario Salmi, *Masaccio* (Milan: A. Pizzi, 1951–53), 91–93.

work appeared during the last years of Goethe's life, and it is informed by a love of "ordinary nature" and of painters' struggles toward naturalism. (It is not coincidental that Rumohr was one of Hegel's principal sources for art historical information.) Rumohr is skeptical of most earlier attributions, and in general he mistrusts connoisseurs who, he says, are given to careless observation. "Everywhere copyists fall like meteorites" is his summary opinion of artists who fail to grapple directly with nature.[9] He uses realist criteria to place Masaccio at the inception of the Renaissance: "Masaccio," he writes, "undertook to explore chiaroscuro [*Helldunkel*], relief [*Rundung*] and the configuration of groups of forms [*Auseinandersetzung zusammengeordneter Gestalten*]."[10]

The character of Masaccio comes out best when Rumohr compares him to Filippino Lippi. Masaccio, Rumohr asserts, had a strong intellect, "ruled by a certain seriousness and moral dignity [*sittliche Würde*]," while Filippino possessed a great, "but volatile and skittish [*flüchtig*]" talent that resulted in a prolific, but uneven career. Masaccio had to "strive" for relief, and often "exaggerated [it] unnecessarily," but Filippino found such things "easy play." Masaccio "neglected" landscapes, or, rather, "treated [them] sculpturally"—presumably as a consequence of his "seriousness"—whereas Filippino enjoyed them and rendered them "with felicity and taste." In terms of pigments, Masaccio preferred his "pasty" to aid his efforts at modeling; Filippino liked his thinner and more fluid to assist his greater facility. And each painter treated drapery "in his own manner: Masaccio wanted large, simple masses. . . . Filippino, who later fell into rather tasteless, arbitrary arrangements"—on account, one assumes, of his "skittish" talent—"was at his best here, and inclined toward strong but small folds."[11]

In passages like these there is a marked family resemblance between Vasari and Rumohr, and it is possible to sketch the way one has developed into the other. Both authors still abut attributions to paragraphs of descriptive narration, but that narration is growing richer and more nuanced. This is visible in the way that

 9. C. F. Rumohr, *Italienische Forschungen* [1827–31], ed. Julius Schlosser (Frankfurt: Frankfurter Verlags-Anstalt, 1920), 376–81.

 10. Ibid., 376. It is probable Rumohr was influenced here by L. Oken, *Lehrbuch der Naturphilosophie* (Jena, 1809), as well as by Goethe's example.

 11. Ibid., 378. After Rumohr, there was a reaction in favor of the tradition that had preceded him. Giovanni Gay's *Carteggio inedito d'artisti dei secoli XIV, XV, XVI* (Florence, 1839) is an exception, but he still gives Masaccio the *St. Peter Imprisoned*, which Vasari did not mention in the second edition of the *Vite*. G. Rosini asserts in *Storia della pittura italiana* (Pisa, 1840), 2:263–86, that Masaccio was responsible for all the stories of Saint Peter except the *Proconsul*; and even Jacob Burckhardt, in *An Art Guide to Painting in Italy*, trans. Mrs. A. H. Clough (New York: Garland, 1979), 61a, gives the *Fall* to Masaccio. Meanwhile, another tradition, perhaps inspired by Rumohr, began to look at Vasari more sympathetically. Melchior Missirini's *Orazione su Masaccio* (Florence, 1846) repeats Vasari's attributions without question. It was during this period, too, that Milanesi (as editor of the 1848 edition of Vasari's *Vite*) showed the existence of a historical tradition based on misreadings of Vasari. Ludwig Schorn's note to Vasari's description was written in 1855 and reprinted at least until 1911; it repeats Milanesi and Rumohr and restores Filippino's share in works such as *Theophilus's Son*. See, for example, Vasari, *Vite*, tr. J. Foster (London, 1855–64), 1:410.

Rumohr refines and redefines the terms scattered throughout Vasari's informal biographical accounts. *Rundung,* for example, is not quite the same as Vasari's *relievo:* Vasari uses *relievo* to denote an attribute of *disegno,* while to Rumohr *Rundung* is both a tool of naturalism in general and of Masaccio's particularly rough empiricism. Rumohr's Masaccio is not only a representative of a stage of Italian painting, as he was for Vasari, he is also given qualities of a nineteenth-century *Naturforscher.* He "strives" with "dignity" to achieve something that is not merely realistic but also "moral." It would not be correct to say that Vasari's Masaccio is erased in Rumohr's version, since so much of the *Vite* is seconded in the Rumohr book. Perhaps it could be more accurate to say that Rumohr's sense of Masaccio has grown by accretion, becoming a more three-dimensional character.

CROWE AND CAVALCASELLE

In the traditional art historical reading of a tradition like this, all that counts is the attributions; but already a variety of ancillary ideas are impinging on the attributions and finding places in the text. In Rumohr, the attributions are still separated from the penumbra of associated observations, so that the text has a blocky quality; that problem of textual articulation began to break down about the middle of the nineteenth century. The first mixtures produced some especially strained texts. Joseph Crowe and Giovanni Cavalcaselle's *New History of Painting in Italy* (1864)[12] claims the entire Brancacci Chapel is the work of Masaccio, and does not adduce Vasari, Rumohr, or other authors.[13] Crowe and Cavalcaselle's principal logical figure is the comparative analogy, familiar in modern pedagogy in the form A : B :: C : D. Initially, it is used to prove the stylistic unity of the chapel:

> The Brancacci frescoes display the same principle of execution, the same technique of color, the same maxims and laws in every part, be they assigned to Masolino or Masaccio. With as much reason as one might have affirmed that Raphael's *Crucifixion* of Città di Castello was not by the same hand as the *Liberation of St. Peter at the Vatican,* because Raphael in the latter displayed a matured style, those parts of the Brancacci

12. Joseph A. Crowe and Giovanni B. Cavalcaselle, *A New History of Painting in Italy* (London, 1864), 1:519–50.

13. There were at least nine: Borghini, Bocchi, Patch, Lastri, Lasinio, d'Agincourt, Rosini, Waagen, and Burckhardt. For additional references, see G. Sortais, "Masaccio et la chapelle Brancacci," *Études* 42 (1905): 343.

Chapel which were first finished by Masaccio were compared with those which received at a later time the impress of experience and training later acquired. . . . Compare [the *Fall*], given to Masolino [Fig. 24], with [the *Expulsion*, Fig. 25], attributed to Masaccio; the nude of the latter is but a development of the style displayed in the nude of the former. Compare, again, the nude of the *Expulsion* with that of the *Baptism* [Fig. 26], also an undoubted work by Masaccio; the latter is as great an improvement over the *Expulsion* as the *Expulsion* was an improvement on that of [the *Fall*]. The study of naked form in these frescoes was developed with each successive spring which Masaccio took. Like Raphael he started timidly and reached his goal in triumph.[14]

Comparative analogies of this kind depend on claims of unity—that the two Raphael works are sufficiently similar to be by his hand, that the *Fall* and *Expulsion* are also by a single hand, and so forth—and those claims in turn rest on generalized expressions of change, including the "development" between the *Fall* and the *Expulsion*, the "improvement" and "successive spring[s]" of Masaccio's art. Nothing more specific than "principle[s] of execution," "maxims and laws," and "experience and training" appear to support these categories.

In another place, the analogy itself breaks down, to unintentionally humorous effect:

Nothing can be finer than the group of men and women by the sickbed in which Tabitha revives [Fig. 22, the right-hand scene]. . . . No doubt, they are reminiscent of the art of Masolino [to whom Vasari had assigned the entire *Tabitha*]; whether they be considered with reference to the manner in which they move, the character of the draperies, or to the soft rotundity of the outlines in the faces. But Masaccio recalls Masolino, as Raphael in certain works reminds us of Perugino. . . . The *St. Peter Preaching* [Fig. 27] is set in a fine landscape of hills. . . . Again, the listeners are reminiscent of Masolino, the figure of St. Peter equally so of Raphael.[15]

If we listen with strict attention to logic, as the argument at first seems to demand, then the second mention of Raphael breaks down the comparative analogy by implying that Raphael is like Masaccio, who is like Masolino; but clearly the passage is not meant to be scrutinized that carefully. As arguments, the analogies are both read and not read; the transparence of their A : B :: C : D structure

14. Crowe and Cavalcaselle, *A New History of Painting in Italy*, 27–28.
15. Ibid., 45–46, 49.

Fig. 24. *The Fall*. Fresco.
Florence, S. M. del Carmine,
Brancacci Chapel

Fig. 25. Timothy Cole, wood
engraving after *The Expulsion*.
Fresco. Florence, S. M. del
Carmine, Brancacci Chapel

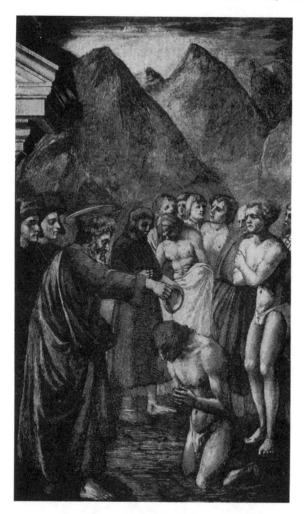

Fig. 26. Wood engraving after *Baptism of the Neophytes*. Fresco. Florence, S. M. del Carmine, Brancacci Chapel

actually helps a reader around such passages, so that the proofs are experienced as particularly emphatic kinds of assertion. There is no rigorous logic here. Crowe and Cavalcaselle's comparative analogies bear the same relation to logic as the impossible filigrees of Roman wall paintings bear to solid architecture.

Texts such as this one advertise logic, and they do so in an elaborate and obtrusive way. Their narratives are riddled with comparative analogies and other deductive forms, in marked contrast to the segregation of undefended attribution and expansive description in Vasari and Rumohr. Crowe and Cavalcaselle are the

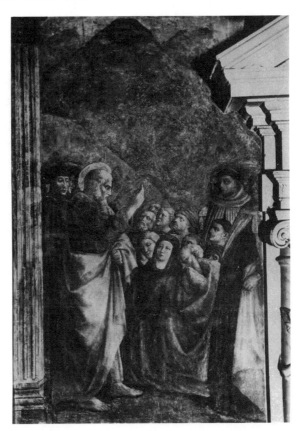

Fig. 27. *St. Peter Preaching.* Fresco. Florence, S. M. del Carmine, Brancacci Chapel

first of a sequence of texts in which logical forms of various sorts begin to find places between and within the penumbra of description and rhetoric: it is as if the authors are searching for narrative shapes that might accommodate their logical claims. Something about the narration is changing, so that it seems incomplete until it integrates the two kinds of writing.

ALBERT VON ZAHN AND MORITZ THAUSING

A chart prepared in 1869 (Fig. 28) indicates the confusion of attributions after midcentury. There was general agreement over some frescoes, such as the *Expulsion* (column I) and *Tribute Money* (column III), and continuing disagreement

	I. Austreibung.	II. Gefängniss.	III. a b. Zinsgroschen u. Berufung.	IV. c. d. e. f. Erweckung des Königssohns und Cathedra.	V. Predigt.	VI. Kranken-heilung.	VII. Taufe.	VIII. Almosen.	IX. g. h. Lahmer und Petronilla.	X. i. k. Kreuzigung u. Protomal.	XI. Sündenfall.	XII. Befreiung.
Albertini	1)	Masolino und Masaccio zur Hälfte.							—	„Philippo"	—	—
Vasari	—	Filippino	Masaccio	Massc. Filippino	Masolino	Masaccio	Masaccio	—	Masolino	Filippino 1)	—	—
Borghini	—	„	„	Filippino	„	„	„	„	„	„	—	—
Lanzio 2)	3)	„	3)	Masolino	Masolino	Filippo	Filippo	Filippino	Filippino	Masaccio	3)	3)
Rumohr	—	—	Masaccio	Massc. Filippino	Masolino	Masaccio	Masaccio	Masaccio	„	Filippino	„	„
Gaye	Masaccio	Masaccio	„	„	„	„	„	„	„	„	Masolino	Filippino
Rosini	„	„	„	„	„	„	„	„	„	Masaccio	„	„
Kugler 5)	„	„	„	„	Masolino (?)	Masaccio	„	„	Masolino (?)	Filippino	Filippino	Filippino
Vas. Lemon.	„	Filippino	„	„	Masolino	„	„	„	Masolino	Masolino	„	„
Crowe u. Cav.	„	„	„	„	Masaccio	„	„	„	Masaccio	Masaccio	„	„
Bernasconi	„	Masolino	„	Masolino	„	„	Masolino	Masolino	„	Filpo. Masol.	„	Masolino
Arundel S.	„	Filippino	„	Massc. Filippino	Masolino	„	„	Masaccio	Masolino	—	Filippino	Filippino

1) „Meza di sua mano, et l'altra di Masolino."
2) Ausg. von Tanzini.
3) „Masaccio und Masolino."
4) 1. Ausg. Vgl. Vas. Lem. Comm. III. 169.
5) Handbuch der Geschichte der Malerei. III. Aufl. ed. Blomberg.

Fig. 28. Table of attributions of the Brancacci Chapel frescoes

over others. Today the chart would be almost eight times as long and would have to include parts of frescoes under separate headings. The article by Albert von Zahn that accompanies the chart is typical of the kind of research that appeared in the next two decades, in that it mixes new genres of writing into the narrative alongside the attributions. Von Zahn combines philological and archival work with multiple style analyses, themselves written in an ornate apostrophic manner replete with rhetorical questions and strong judgments (he calls the *Fall* a "lifeless, boring composition").[16] The cobbled structure of essays like von Zahn's betrays an uncertainty over the right way to construct an art historical essay, prompted in part by a feeling that previous descriptions had somehow been inadequate. There is a growing sense that Masaccio was something more than the intrepid *Naturforscher* Rumohr had made him out to be, but the essays of the 1860s and 1870s do not express directly, clearly, or adequately what more Masaccio might have been.

Moritz Thausing's essay of 1876, in my count the sixth "answer" to Crowe and Cavalcaselle, opens with two rhetorical forms unusual in historical writing, an apostrophe and a paean: Where, he asks, was the painter who could accompany Donatello and Brunelleschi and help found the Renaissance?[17] "The answer is

16. Albert von Zahn, "Masolino und Masaccio," *Jahrbücher für Kunstwissenschaft* 2 (1869): 155.

17. Moritz Thausing, "Masaccio und Masolino in der Brancacci-Kapelle," *Zeitschrift für bildende Kunst* 11 (1876): 225. The first publication after Crowe and Cavalcaselle to treat the problem is A. H. Layard's *Brancacci Chapel and Masolino* (London, 1869). Von Zahn's essay "Masolino und Masaccio" is

strange, almost incredible: he was born in 1401, the same year as the important competition [for the bronze *Doors*], and just twenty-seven years later he sank into the grave. . . . His personality is known to history only as a vague shadow. . . . Here was a genius whose influence was incalculable. . . . The paintings, which look out at us from the half-light of the walls, are irrefutable proof of the greatest heroic accomplishments, since there can be no freedom of the spirit without the freedom of visible forms."[18] The paean is interrupted, but it breaks out several more times later in the essay, in the bridging passages between philological material, ekphrasis, and style analysis. Thausing's sense of ekphrasis, like von Zahn's, is as an occasion for dramatic scenarios: "But with Masaccio, what certainty in all the forms, what congruence between perception and expression! . . . These men, who stand like walls upon the ground, these draperies, from daintiness or stylishness, and these perfect Apostles' heads, so weary with thought, so full of deeds!"[19] Toward the end, the essay changes direction more decisively. The vacillating, imbricated genres are forgotten in a sudden veer toward an apodictic conclusion, as Thausing announces the discovery that eventually helped make the Brancacci Chapel frescoes into an "elementary exercise": "And yet! Perhaps there is a way [to distinguish the two masters] using the Arundel Society's copies or Lasinio's [engravings]. [That is, a way available to everyone.] Perhaps there is an outward sign that can be measured . . . but [will] remain bound to the masters' qualities."[20] The solution in question is the "halo criterion," according to which Masaccio first thought to put halos in perspective, while the most Masolino could manage were slightly flattened ovals (Fig. 29).

 The sense of unease over the proper method for an art historical essay, which has been simmering through each change in writing style, comes out in the envoi, in the form of a "lesson for art history": "Science [that is, art historical scholarship] should not disdain what might serve its purposes . . . this small example shows that our understanding does not need to be a matter of opinion, or

the second, and P. Saint-Maffei's *Ragionamento intorno all'antica chiesa del Carmine di Firenze* (Florence, 1869) is the third. A year after he published his own essay, von Zahn accepted a critical response, Wilhelm Lübke's "Masolino und Masaccio," *Jahrbücher für Kunstwissenschaft* 3 (1870): 280. Lübke takes most of his time in a revaluation of the Castiglione d'Olona frescoes, and he agrees with Crowe and Cavalcaselle's comparative analogies (285). The fifth work after Crowe and Cavalcaselle is H. Delaborde, "Les oeuvres et de la manière de Masaccio," *Gazette des Beaux-Arts* 14 (1876): 369. Delaborde felt that critics sympathetic to Masaccio had "transformed a great innovator into a kind of messiah without precursors." Even Taine and Stendhal, he says, had gone too far (the latter had written, "Masaccio est plutôt le créateur que la rénovateur de la peinture"). Masaccio was actually surrounded by able precursors, including Ghiberti, Donatello, Uccello (Delaborde follows Vasari's mistaken chronology for Uccello), "et plusieurs autres."
 18. Thausing, "Masaccio und Masolino in der Brancacci-Kapelle," 225–26, 228.
 19. Ibid., 236. Thausing also adduces "the powerful inner life" of the "motionless" faces (see the remarks on Delaborde and Rumohr above), the "harmony of the composition, the feeling for space, [and] the consonance of the colors [Wohllaut der Farbentöne]."
 20. Schmarsow, *Masaccio oder Masolino?* 10.

feeling, or of subjective belief, but that it can be more, as it is in other fields: it can be historical truth and even . . . an exact demonstration [*Beweisführung*]."[21] In this way Thausing's tumultuous account is counterbalanced by an Archimedean dialage, forcing the argument onto the single "exact demonstration." If the text is read in logical terms, the *Beweisführung* shores up these weaker claims; in narrative terms, the confident tone of the *Beweisführung* helps balance an incoherent richness of styles.

In such texts it becomes increasingly clear that a large and complicated sense of Masaccio is trying to find voice, and that it is experienced as a force competing with the need for logical stability. In Thausing it is not yet apparent how one should express the idea of Masaccio—in what genres and in what sequence—but the impetus to do so is strong enough nearly to rive the text and in the end to charge the logical demonstration with preternatural energy.

August Schmarsow

The move toward more intricate formulations is exemplified by Schmarsow's ninety-page monograph *Masolino oder Masaccio?* Schmarsow quotes with approbation an exclamation made by Wilhelm Lübke in 1870: "Masolino didn't

21. Thausing, "Masaccio und Masolino in der Brancacci-Kapelle," 236.

Fig. 29. Moriz Thausing's halo criterion

paint a single stroke in the Carmine!"[22] To prove that, Schmarsow marshals an extraordinary range of material, even going back to the earliest text, Romano Albertini's *Memoriale* of 1510. He defends the *Tabitha* (Fig. 22) against those who would give it to Masolino, using a two-pronged autocletic argument—drawing attention to the two "awkward" figures in the middle of the composition by announcing that he will not discuss them. First he carefully reconstructs the moments that must have preceded the scenes on either side. What, he then asks, could connect the two halves, which after all represent different times in the saint's life? A painted pilaster would destroy the balance, and a crowd of onlookers would be distracting: "These 'uninteresting figures,' who are so unlike the others in their quattrocento costumes, are not just an easy and belated solution to the problem of unifying the picture [as has been claimed by those who attribute it to Masolino]. They are also, frankly, a delight [*Wohltat*] for the eye: they help tie the rows of faces on the left and right together. . . . Their poetic content as 'unmotivated bypassers' is artistic in the highest degree, a solution of the dilemma, in spite of everything."[23] Schmarsow suggests imagining the scene without any figures *except* the two youths: the sense of balanced space, he says, indicates they must be Masaccio's.

The *St. Peter Preaching* (Fig. 27), once denigrated as a "hunchback" by Thausing and compared to a figure of Raphael's by Crowe and Cavalcaselle, is

22. Ibid., 238.
23. Schmarsow, *Masaccio oder Masolino?* 29.

here compared to Donatello: "Indeed, it is not very different from the St. Mark on the Or San Michele." Schmarsow argues this by the trope of dialysis, discounting one after another of previous explanations. The figure's immobility is recast as a virtue, an intentional strategy of Masaccio's. It is inappropriate, Schmarsow says, to expect a convincing, full-relief figure in a scene that focuses on moral authority; instead, the figure is an intensification of Masaccio's predilection for grand, noble figures with a minimum of motion.[24] Schmarsow's Masaccio is a modern artist, capable of choosing styles for expressive effect.

Here the advertisements of logic have become so diverse that it is no longer clear how a counterargument might proceed. How does one go about claiming Masaccio was incapable of painting in an intentionally "flat" style? On what does the persuasiveness of Schmarsow's description of the *Tabitha* depend? Is it the *Wohltat* of the central two figures? Their stability as attested by the thought experiment? Their "poetic content"? The two figures have been given

24. Ibid., 51. An amplification of Schmarsow's methodology is available in M. Creuz, *Masaccio: Ein Versuch zur Stilistischen und Chronologistischen Einordnung seiner Werke* (inaugural diss., Friedrich-Wilhelms-Universität zu Berlin, 1901). In Creuz's view, the *Doppelbild*, as it was then called, is a strongly unified painting, unlike Masolino's works, which "fall apart" (24). Creuz notes that an inverted V <comp: sans serif V> shape runs from the matron at the right, through the turbaned man to the vanishing point, and then returns through the saint's face (in the *Healing of the Cripple*) to the cripple, thereby exhibiting a sense of geometric construction foreign to Masolino. "The holy figures find themselves in the middle of daily life . . . what a contrast to Masolino's work! . . . Only one aspect of the *Doppelbild* can be assigned to Masolino: the mismatch between the crowded scene around Tabitha's bed and the emptier [left half]. We see such unbalanced compositions in Castiglione d'Olona" (26)par For other literature between Thausing and Schmarsow, see A.F.G.A. Woltmann and K. Woermann, *Geschichte der Malerei* (Leipzig, 1879–82), trans. Clara Bell as *History of Painting* (New York, 1885), vol. 2, and K. Woermann's extended analysis in "Masaccio und Masolino," *Grenzboten* 39 (1880): 324. Woermann agrees with Crowe and Cavalcaselle (327) and gives several further references (326). Following the backlash against Morellian criticism, he criticizes Thausing because the halo criterion is only an isolated phenomenon, insufficiently connected to the surrounding paintings (330–31). In this period, see also B. Marrai, "Affreschi della Capella Brancacci al Carmine," *Arte e Storia* (10 April 1891); and Vasari, *Vite*, ed. J. P. Richter, trans. J. Foster (London, 1892), 6:49–51, 58.

After Schmarsow, the first opinions are recorded in the English translation of Vasari's *Vite* by E. H. Blashfield and A. A. Hopkins (New York, 1897), 1:235 n. 22 and 239 n. 32. The editors say only that Crowe and Cavalcaselle are not "wholly successful" in comparing Raphael's *Disputa* to the *Liberation of St. Peter:* "The *Disputa* and the *Liberation* are more like each other than are the [*Tabitha*] and the *Tribute Money*" (236). A similar reply is to be found in Crowe and Cavalcaselle, *A New History of Painting in Italy,* ed. L. Douglas and G. de Nicole (London: J. M. Dent & Co., 1911), vol. 4, notes with asterisks on 26, 27, 28, 30, 44, 49, and 52: "The differences between the four existing frescoes assigned by Vasari to Masolino, and the *Tribute Money,* are far greater than [Crowe and Cavalcaselle] realised" (28). Bernard Berenson, in *Italian Painters of the Renaissance* (1901), is the culmination of this tendency. His attributions are also made without justification, as Albertini's had been four centuries earlier, but his description is more generous and evocative, as Thausing's are: "Dust-bitten and ruined though [the] Brancacci Chapel frescoes now are, I never see them without the strongest stimulation of my tactile consciousness. I feel that I could touch every figure, that it would yield a definite resistance to my touch . . . that I could walk around it" (50). Those writers who did look to the previous literature found it unhelpful. B. Marrai's "Masolino e Masaccio," *Miscellanea d'Arte* (1903): 164–74, is (probably inadvertently) much like Thausing's essay. Marrai praises Masaccio and his heroism, looks at the terms of Vasari's attributions, and then considers the halo criterion (169–70).

too many functions for any one to be decisive: they are anachronisms, insights, and solecisms; they are narrative, compositional, and perspectival bridges; and they are at once "interesting" and "not interesting." There is logical argument woven throughout Schmarsow's text, and it would block a critique at every turn.[25] In terms of the second metaphor, the painter/writer's attention has turned inward, and the problem has become the weaving of signs of realism with signs of coherence.

ROBERTO LONGHI

The essay that has largely put the question of the Brancacci to rest is Roberto Longhi's "Fatti di Masolino e di Masaccio" (1940).[26] It indicates at least for the present what kind of writing lies at the end of the road charted by writers such as von Zahn, Thausing, and Schmarsow from the 1870s to the turn of the century. Longhi's criteria are often multiple. He gives the two young men behind Saint Peter in the *Baptism* (Fig. 26) to Filippino for four different reasons: they are "young men" (*giovinotti*), not the "wild youths" (*giovinastri*) preferred by Masaccio; they are "detached from the rest of the scene"; they are in three-quarter view, "ineffectively repeated" (*nella iterazione inefficace*); and they are

Enrico Somaré's *Masaccio* (Milan: Bottega di Poesia, 1924) includes a list of previous attributions, but without the authors' reasons.

For further references between 1900 and Lindberg's essay, see J. del Badia, *Tomasso di Giovanni da San Giovanni, detto Masaccio e Giovanni suo fratello* (Rome, 1903), 134; Adolpho Venturi, *Storia dell'arte Italiana* (Milan: U. Hoepli, 1906), vol. 7, pt. 1; R. Pantini, "Masaccio," *Connoisseur* 21 (1908): pt. 1, p. 25, and pt. 2, p. 87; Jacques Mesnil, "Per la storia della Cappella Brancacci," *Rivista d'arte* (1912): 34; W. Woermann's later monograph *Von Apelles zu Böcklin* (Ezlingen, 1912); Jacques Mesnil, *Masaccio et les débuts de la Renaissance* (The Hague: M. Nijhoff, 1927), 56–91; A. I. Rusconi, "Masaccio e Masolino," *Il Marzocco*, 15 April 1928; Jacques Mesnil, "Masolino ou Masaccio," *Gazette des Beaux-Arts* 1/2 (1929): 206; and Ugo Procacci, *Tutta la pittura di Masaccio* (Milan: Rizzoli, 1952).

25. In the face of such virtuosity, another kind of essay tended to retreat in favor of a dry frame of attributions. Even though the story I am telling here concerns the elaboration of art historical writing, a certain reactionary poverty has consistently accompanied such traditions. A late example is Henrik Lindberg's *To the Problem of Masolino and Masaccio*, 2 vols. (Stockholm: Kungl. Boktryckeriat, P. A. Norstedt & Soner, 1931). Lindberg is hypersensitive to the logical confusion generated by texts like Schmarsow's, and he proposes to exclude all previous scholarship because it is not "scientific in a strict sense." He means to begin with a *tabula rasa*, but the ahistorical method runs aground almost immediately. In order to have a firm base of indisputable works that can serve as comparisons in judging the doubtful frescoes, he needs to accept works like the *Tribute Money*: even though "no documentation exists . . . we assume *a priori* that it is [Masaccio's]" (1:21).

26. Roberto Longhi, "Fatti di Masolino e di Masaccio," in *Studi sul quattrocento, 1910–1967* (Florence: Sansoni, 1975), 3–66. Essays between Lindberg and Longhi include Ugo Procacci, "L'incendio della Chiesa del Carmine del 1771," *Rivista d'Arte* (1932): 141; Salmi, *Masaccio*, 82–83; Mary Pittaluga, *Masaccio* (Florence: Felice le Monnier, 1935), 179; and P. Johnson, "Masolino, Masaccio, und 'Tabitha,' " *Danske Videnskarbernes Selskab* 1 (1935).

lighted flatly and modeled more simply. The *St. Peter Preaching* also contains figures behind the saint's back, and these Longhi gives to Masaccio (as opposed to Masolino), again for four reasons: first, Masaccio worked on other parts of the picture, since he did Saint Peter' s robe and feet (and there are three reasons for *this*: the toga is classical; it is "constructed in a suddenly violent light" (*in una luce di subito più violenta*); and the saint's feet are planted firmly on the ground); second, the three young men are in full-face, profile, and three-quarter views, which is evidence of a "calculated effect" springing from a new sense of space; third, they evince a "melancholy and modern feeling"; and fourth, their presence behind the saint is evidence of an "ironic," "tragic, antibourgeoisie" sentiment that Masaccio injected when he could.

Longhi's comments, like Schmarsow's, tend to be seamless, and he makes his points in quick succession. Thausing's rough blocks of apostrophe, paean, formal analysis, philology, and "science" have been pulverized, atomized (in the term I used in the last chapter), so that they follow one another too rapidly to be distinguished.[27] Longhi is also the first of the authors to acknowledge the pressure of his intuitions—his "pictures"—of the artists, and he allows them to break the usual forms of art historical narrative altogether. He writes a densely descriptive, sometimes intentionally fictional narrative (including an imagined dialogue between the artists), and he does it seamlessly, relying on the authorial voice to mend and bridge his various ideas. Where guiding ideas emerge in the text, they are eloquently but strongly qualified. The *Baptism*, for example, is said to be marked by compositional freedom, but that freedom is so elaborately qualified that it becomes something quite elusive: "Nearby, in the *Baptism*, Masaccio seems to be aiming at a sense of rapid and total circulation of light in a composition that is apparently free, yet not entirely devoid of improvisation, after the manner of Donatello."[28] Attributions have diffused almost to the point where they are as lost in the text as descriptive passages were lost in the sixteenth-century accounts. Longhi presents them as incidental matters, fruits of sustained attention to more important things.[29] The text of art history—at least here, in a writer who is among the most accomplished of the first half of the century—is becoming seamless: the penumbra and umbra are blurred together, so that the dark patches of argument are camouflaged in a dappled field of description.

27. In the original, the nimble *tempo presto* is particularly striking: "[A]nche i due giovinotti (non più giovinastri) a tergo del Santo, nella iterazione inefficace di un tre-quarti quasi identico, si staccano tanto dal resto della scena, modellata com'è, direttamente, in fiero lume, da far sospettare anch'essi un'abile inserto di Filippino in una zona che Masaccio avesso lasciata sbadatamente incompiuta o appena tracciata di sinopia sull'arriccio" (Longhi, "Fatti di Masolino e di Masaccio," 16).

28. "Li accanto, nel 'Battesimo dei neofiti,' Masaccio sembra proporre ad un tratto il senso di una circolazione rapida e totale della luce in una composizione apparentemente libera, anzi di una libertà non affatto scevra d' improvvisazione, sulle tracce di Donato."

29. Mark Roskill has called this flourishing mixture of commentaries "emplotment." See Roskill, *The Interpretation of Pictures* (Amherst: University of Massachusetts Press, 1989), 7–10 and elsewhere.

Solutions, Wide and Narrow

At this point the tradition effectively ends, in part because later writers have found it difficult to respond to this kind of sophistication and to the amount of information Longhi brings to bear. Though there have been a half dozen essays since Longhi's, none goes beyond revisions of his position.[30]

It is worth noting that there are strong reasons to disbelieve that Longhi's virtuosity correlates with a better understanding of the facts of the case. At the least, there are statistical, political, logical, and stylistic reasons for doubting his attributions. Statistically, other schools of thought on the chapel are more numerous than the one Longhi champions, since his is an adjustment of Vasari's position and most authors tend to give more to Masaccio. Politically, one should not exclude the possibility that Crowe and Cavalcaselle's view fell from favor after the First World War at least in part because it was then represented by German scholarship. Logically, it is apparent that the earlier positions were not refuted by Longhi, but rather superseded in a way we have yet to understand fully; and stylistically, although Longhi's descriptions are the most acute to date, the previous history leaves no doubt that there is room for further perspicacity and narrative density.

Some of the issues raised by the authors invite further attention. One might want, for example, to look again at Schmarsow's account of the *Tabitha* or to study the possibility that Masaccio had conscious control over a number of

30. Pierre Francastel writes in *Peinture et societé* (Lyon: Audin, 1953), 104, that "il est aventureux de faire de Masaccio l'initiateur d'une stylisation réaliste: avec Masolino et d'autres [an echo of Delaborde's gesture], il représente la très courte période où les peintres, détachés du langage plastique séculaire, reprennent contact avec la nature mais sondent les problème éternels de la vision." This strain of French skepticism continues two years later in André Chastel, *L'art italien* (Paris: Librairie Larousse, 1956), 209: "It is not always easy," Chastel writes, "to distinguish between Masaccio and his master."

Luciano Berti, *Masaccio* (University Park: Pennsylvania State University Press, 1967), has answered some of Longhi's claims, but only in passing and as examples of what he takes as Longhi's bias toward the idea that Masaccio is a wild, melancholy Romantic. Berti asserts, for example, that the three youths on the left of the *St. Peter Preaching* cannot be by Masaccio, because they are part of the same day's work (*giornata*) that includes the saint's head, which is by Masolino, and also because they do not resemble the youths in the *Baptism*. The saint's feet are also the work of Masolino, according to Berti, because the feet in the *Baptism* are not represented in profile (an echo of the halo criterion), and so it is probable that Masolino could paint foreshortened or profile feet and conversely that Masaccio may not have wished to do so in all cases. Berti posits that Longhi gave the two heads in the *Baptism* to Filippino because he thought Masaccio was "brimming over with invention and even a little 'low-life' "; but to Berti, such heads are within the normal range of Masaccio's expressiveness. Berti agrees with Longhi that Masolino is responsible for the head of Christ in the *Tribute Money*, thereby implying a limit on the amount of stylistic latitude Masaccio can be said to have possessed.

For further literature since Longhi, see Richard Hamann, "Masaccio und Filippino Lippi," in *Festschrift für Wilhelm Waetzoldt* (Berlin: G. Grote, 1941), 81ff; Giuseppe Fiocco, "Incontro tra Filippino e Masaccio," in *Saggi su Filippino Lippi* (Florence: Arnaud, 1957), 89ff.; Fiametta Gamba, *Filippino Lippi nella storia della critica* (Florence: Arnaud, 1958), 30–31, 86–87; and Umberto Baldini, "Nuovi affreschi nella Cappella Brancacci," *Critica d'Arte* 4 (1984): 65–72.

styles—an issue with interesting ramifications for our understanding of quat- trocento style in general. The *giornate* might also be reviewed: is Luciano Berti correct in assuming that a single *giornata* is the work of a single artist? As Longhi knew, the question touches the more general issue of the nature of collaboration in fifteenth-century Florence.

Though I am not exploring questions of evidence here, it is not relevant that the developing picture of Masaccio does not correspond to an advance on the narrow factual problem that the authors have always presented as their major purpose. One reason I propose thinking of these essays as moving from naked claims to *pictures* of pictures is that even as the attributions themselves swing wildly from one generation to the next, the sense of Masaccio grows steadily deeper and more convincing. Consider how jarring Rumohr's version of Masaccio would sound today: an artist singularly bent on solving problems of relief and chiaroscuro, happy with his few hard-won discoveries, but oblivious to the relation between his style and others' or to the social and religious content of his work. This is, we might say, a clumsy version of Masaccio, and its conceptual resources seem cramped and oddly deployed. The metaphor of the pictorial text may also help explain why these authors so seldom attack one another, or even mention earlier work. A picture, unlike an argument, is something that is cherished. Aside from their conflicting attributions these writers are deeply conservative, as if they were aware of being engaged on the same project, even though they might differ strongly on the ostensibly most important part of their professional duty, the obligation to present a theory regarding attribution. Most of them augment and adjust what they inherit rather than raze it. In a sense, therefore, the tradition is a single project, a picture, that slowly grows under the hands of generations of historians.

Logic, Illogic, Nonlogic, Apologic, Ambilogic

If in this portraiture, it seems that the colors do not
correspond perfectly to life, and the lines do not appear to
you exactly as they should, you should know that the fault is
a result of the fact that the painter could not examine the
portrait from those aspects and distances to which artists are
accustomed; since, besides the fact that the canvas . . . was
too close to his face and eyes, it was not possible to take the
least step backward, nor to place himself to one side or the

other without fear of making the leap [made by Astyanax,]
son of the famous defender of Troy.
 —Giordano Bruno, *The Ash-Wednesday Supper*

In the discipline as it is currently constituted, it is usually impermissible openly to
indulge the pictorial urge: not because it would lead to an account that appears
fictional rather than truthful, though that is always possible, but because we
do not have a vehicle for the full complement of emotions that the pictorial urge
engenders. As long as art historians construct texts that let facts have jurisdiction
over other means of expression, they tacitly permit the rule of logic to govern the
pictures of artists that they also mean to create.

The progressively complex prose of recent writers on the Brancacci Chapel can
be read as proof against logical critique. But it can also be understood as a strategy
to make the text more like the pictures that are being admired. Nelson Goodman,
Roland Barthes, and others have said that paintings and other works of visual art
are distinguished from language by the continuous density of their signifiers; and
the same can be said of these linguistic productions by art historians in relation
to, say, scientific papers. When the elements of logic blur, there can be no discrete
propositions. Let us listen to Rumohr again, but this time at greater length:

Now, these paintings [of Masaccio's] can be distinguished from those
Filippino completed forty years later by the impress of a strong intellect,
ruled by a serious, ethical dignity; the young Filippino was a great talent,
but volatile and skittish. Filippino was not as consistently earnest, and as
a consequence not everything he produced was brought to the same level.
The earlier and later artists can also be separated by their difference in
time: the depiction of shadows and relief, the very things Masaccio strove
for and that he could not accomplish with his unnecessary exaggerations,
were easy play for Filippino. The landscapes and backgrounds, which
Masaccio neglected completely (or, rather, which he treated sculpturally),
were handled by Filippino with his usual felicity and taste. The two
masters are also different in the ways they used the technical aspects
of fresco painting. Masaccio preferred his pigments pasty, in order to
build up the paint and attain a better sense of relief; Filippino liked his
thinner and more fluid, so they could serve him as lights and local tones.
Also, each treated drapery in his own manner: Masaccio wanted large,
simple masses, and he divided and modeled each part with great mastery,
as Raphael's contemporaries realized. Filippino, who later fell into rather

tasteless, arbitrary arrangements, was at his best here, and inclined toward strong but small folds, each with its own sinuous course and highlight.[31]

Here a consideration of the artists' personalities leads to a thought about their separation in time, which is linked to ideas about their different interests; and this in turn leads back to the frescoes, and to a description of landscape, and another on drapery. The criteria are of different kinds, and they are fleeting (none is given more than a few words). But they are not a numerable class of criteria, because they are not available for individual inspection. If Masaccio "neglected [landscapes] completely" or "indicated [them] in a sculptural manner," he did so because of his "serious, ethical dignity." The criterion of landscape takes most of its meaning from the criterion before it, and some from the lines that follow. The "neglect" of landscape is part of a story about Masaccio's unevenness, a sign of his serious, groundbreaking intellect; and that story includes the treatment of drapery and paint as well as biographical and ethical meanings. The order of the criteria is also important. The ruling metaphor is Masaccio's ethical character, and the criteria are symptoms of his mentality: each functions like an adjective or adverb in a long line of modifiers culminating in the substantives "intellect" (*Sinn*) and "period" (*Aufdruck der Zeit,* literally the "impress of the time" in which he lived). Further, terms such as "landscape," "drapery," and "intellect" have connections to other passages in the *Italienische Forschungen* and are not fully meaningful in any single context. The description of landscape as subject to unevenness, and as a thing that can be "handled" with "taste" or just "sculpturally," gains coherence from its resonance with other passages on landscapes and with Rumohr's own descriptions of Italian *vedute.* The sculptural quality of some landscapes is connected here with "neglect," itself an attribute both of a certain historical period and a certain disposition. In later passages, the term *Sinn* carries the possibility of sculpturality.

All this is like painting, with its syntactic density, its imbricated passages, and its inextricable interconnections. The argument here is less illogical than a- or nonlogical, since it is not engaged in arranging sequences of logical elements or building systematic propositional structures. On the other hand, it is certainly *apological* in places: that is, it tends deliberately *away* from logic. And in still other places it might be better called *ambilogical,* since it flirts with logic by dancing around it. As in a well-balanced picture, no single object can be removed from Rumohr's portrait of Masaccio without weakening other objects whose mode of depiction (and, secondarily, whose truth value) depend on it. In the most successful passages, logical weak links are refigured as moves from one

31. Rumohr, *Italienische Forschungen,* 378.

kind of appreciation to another. Inference becomes genre change, and proposition becomes evocation in an ongoing metatheoresis of logical structure into nonpropositional text. There is still a smell of logic to the writing, which is why I would rather call it ambilogical or apological than strictly illogical: but it is only a fading memory of logic, not logic itself.

INDUCTION, DEDUCTION, ADDUCTION, TRANSDUCTION

"Apologic" and "ambilogic" are names for intentions—they are not, strictly speaking, logic terms themselves. It is sometimes possible to see *how* they operate by comparing them to the correct application of deduction and induction. Deduction can be partly defined as a motion from general propositions to specific propositions, and (nonmathematical) induction as a motion from particulars to generals. When they are defined that way, they are the only two legitimate possibilities, but they suggest several others. W.J.T. Mitchell has used the term "adduction" to name the argument that attributes logical meaning to the motion from particular to particular.[32] To complete this schema, I propose *transduction* as the typical motion of holistic argument that seeks to prove general terms by invoking other general terms. The four can then be set out as a complete, partly logical schema:

Terms that are given

	Particulars	Generals
Generals	Induction	Transduction
Particulars	Adduction	Deduction

Logical and Illogical Inference

Both adduction and transduction have places in art historical writing. Transductive inference occurs, for example, where holistic terms help define general period names—as when the baroque is defined by "sculpturality," mannerism by "transcendence," or the Renaissance by "decompartmentalization." This is bad logic, since the period name and its putative defining term possess an equal (or equally unmeasurable) generality. Adduction is a better mimic of logical operations. In Moritz Thausing's paper, the mass of information and poetry

32. W.J.T. Mitchell, ed., *Against Theory: Literary Studies and the New Pragmatism* (Chicago: University of Chicago Press, 1985), 6 n. 3.

that precedes the halo criterion constitutes a collection of logically independent observations. But despite its logical irrelevance to the halo criterion, it lends that conclusion a certain force and conviction. The paper is more convincing with the first ten pages than it would be without them: in effect, the halo criterion is "proved" by adduction.

Illogical adduction and transduction are forces for textual coherence: they are like glue that binds logic to nonlogic. In earlier essays, such as the account by Crowe and Cavalcaselle, unsupportable intuitions needed bolstering from overtly logical sources. In more developed essays such as Schmarsow's and Longhi's, deductions grow together with nonlogical moves in a kind of garden of reason and unreason. Documentation intertwines with appreciation until the connections can no longer be unraveled.

To be thorough, I might say that this chart of logical and illogical kinds of inference is only half of a complete set of possibilities. The other half would oppose this as antimatter opposes matter: it would consist of false instances of each operation—counterinduction, counterdeduction, and so forth. The historian of science Paul Feyerabend uses "counterinduction" to denote the intentionally false inference that he finds essential to the development of science.[33] Often, too, art historical narratives veer away from logic and nonlogic alike. What should we say, for example, about the mistake Crowe and Cavalcaselle make with their own comparative analogy? Since they are not paying attention to their logic, they wind up drawing a false conclusion from a deductive process—a "counterdeduction."

Terms that are given

	Particulars	Generals
Generals	Counterinduction	Countertransduction
Particulars	Counteradduction	Counterdeduction

Incorrect Logical and Illogical Inference

I am not proposing that these eight permutations account for all the kinds of false reasoning in art historical texts, but rather that they can help us see how the essays work by breaking down logic, as if it could be decomposed into the compost pile of the surrounding narrative. Writers who reason in these odd ways do not propose they are free from reason, and most of their "counterinductions" are inadvertent or unconscious. Rather, the essays are deeply unconcerned with reason, and these eight forms are some of the ways of evincing that disinterest. Logic in these texts is the name of something that needs to be present without

33. Paul Feyerabend, *Against Method* (London: Verso, 1988), 20–21: "Knowledge . . . is . . . an ever increasing ocean of mutually incompatible (and perhaps even incommensurable) alternatives."

obtruding on the recording of intuitions or the painting of pictures. Ambilogic, the dance around logic, is one of the ways that art history tries to become painting without giving up logic.

ON SPIDER WEBS

The problem with speaking this way about logic, even about the exotic species of ambilogic and apologic, is that it preserves the very distinction that the texts work to erase—the distinction between the logical claims and what I initially called the matrix of text. The glare of logic bleaches the carefully modulated colors of art history and makes whole stretches of it appear blank. In my reading art history at its best is after something else: a bending of the two, a confusion of umbra and penumbra, a picture whose naturalism is inseparable from its internal coherence. I would like to close by offering a third metaphor, a more fruitful figure for the blending of order and disorder: the metaphor of spider webs.

Though some webs are highly geometric—especially the familiar orb webs— others are nearly chaotic. What we normally call cobwebs actually come in a variety of degrees of chaos, from nearly absolute asymmetry to a high degree of geometric clarity. In the analogy I want to propose, the web is the historian's text, and its symmetries mark the presence of logical argument. Theories and methods of all sorts, from our attributions to our doctrines of semiotics, are present "in" art historians' texts as geometric forms are present in irregular cobwebs. In this sense a historical text with a near absence of theoretical declarations— I am thinking, for example, of Longhi's nearly seamless prose—is an irregular thing, going first this way and then that, with no easily discernible structure.

Art history texts that move crisply through their arguments and methods— for example, the earlier texts in the series on the Brancacci Chapel, or else, in a general sense, texts that are dedicated to their brand of semiotics, feminism, or social history—can have transparently obvious structures. They are like perfect orb webs: planar, efficient, and economical. They "require only a few points of attachment to their environment," in the words of one biologist: that is, they can be less beholden to the minutiae of empirical data than are less overtly theoretical texts. A predominance of theory allows the historian/spider to move through history "without touching and disturbing the arrangement" of the weblike text: that is, the web/text provides a preformed structure for any occasion.[34] The lack of nuance that some historians find in such texts finds its analogue in the absence

34. E. J. Kullmann, "The Convergent Development of Orb-Webs in Cribellate and Ecribellate Spiders," *American Zoologist* 12 (1972): 395.

of asymmetrical threads in the spider webs. When theoretical texts seem spare and impoverished, it is largely because they have traded complexity for clarity. A web or a text that is irregular takes more time to construct, but it is not as easily destroyed by a wayward insect (or, in the analogy, an unexpected or unwelcome historical fact). "Under natural conditions," one entomologist says, an irregular web "is built gradually, as the spider grows," whereas orb webs remain the same through the spider's life; and in a similar manner, historians who cling to their favorite theories will end up with texts that are strongly self-similar (they will have the sameness I sketched in Chapter 2), so they do not respond well to the growth of the historian's understanding or knowledge.[35]

Between art historians who aspire to strong theory and those who eschew any but the most local conclusions are those, the majority, who try to mix their theory with their historical description. It is here that spider webs provide the most suggestive models. In the middle of some apparently asymmetrical cobwebs there is a network of paths, formed by hexagonal patterns of threads, on which the spider can run to catch its prey (Fig. 30). Such webs attach closely to every contour in the environment, so their overall shape is indeterminate, but they make that apparent chaos habitable by interpolating a structure that is tailored to its surrounding randomness. Other semiregular webs are like orb webs, but with a small tangle at one corner; still others have a "hammock" in the middle of a network, or vertical "catching threads" anchoring a floating cobweb. The variations are continuous from extravagant disorder to crystalline simplicity.

The biological evolution of webs is like the historical evolution of essays on the Brancacci Chapel. The earliest webs were apparently silk-lined holes from which a few threads extended. Those threads did not catch prey but acted as trip wires when something passed by. Like the early essays, they were neither supple nor efficient, and they did not respond to a wide variety of potential prey; in terms of the analogy, they could not recognize a number of potentially useful facts. A poverty of means corresponded to a poverty of results. Gradually, spiders extended the walls of their retreats outward, and the earliest true webs were agglomerations of flat sheets (made by extending the tunnel floor or ceiling) with haphazard lines in all directions. Later webs gave up the cobweb portion and retained the sheet, which eventually became the spiral orb of the more advanced spiders. But the majority of webs have some combination of inefficient cobwebbing, which is sensitive to the environment, and efficient orb or sheet weaving. As in the essays on the Brancacci Chapel, the orb of attribution and

35. Ibid., 399, and R. Szlep, "The Web-Spinning Process and Web-Structure of *Latrodectus tredecimguttatus, L. pallidus,* and *L. revivensis,*" *Proceedings of the Zoological Society of London* 145 (1965): 76.

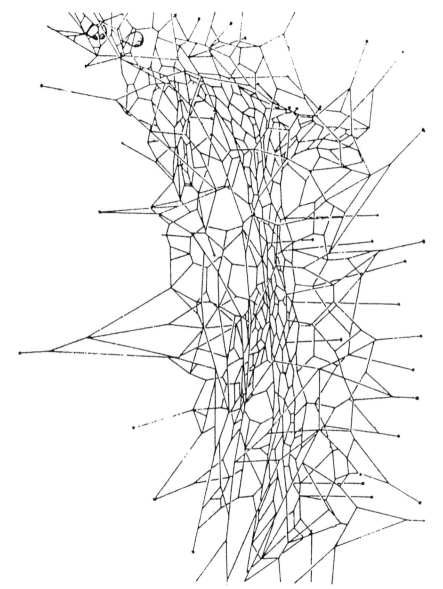

Fig. 30. Schematic view of the web of *Latrodectus tredecimguttatus*

the cobweb of narration remain separate, though they may become inextricably entangled.

This is where the parallel ends, since in the case of spiders there is evidence that the most advanced webs are simplified versions of orb webs. Some have only a few radii, and the spider becomes more active in compensation, throwing sticky threads into the air to catch passing prey.[36] History is different in this respect, since historians care about the ungeometric nature of their subjects. Still, webs like those are tempting metaphors for some postmodern theory—for example, Gilles Deleuze's "nomadic" thought, with its attention to lines of force and meaning traversing static forms. It is possible that theory is winning the day; perhaps it is in danger of becoming so preeminent in our texts that the nuance of disordered history may atrophy into the elegant, rigid lines of theory.

A Delicate Frame of Mind

The speculation appears to me so delicate and wonderful that I should not oppose it even if I could. To me it would be a sort of sacrilege to mar so fine a structure, trampling on it with some pedantic attack.

—Galileo, *Two New Sciences*

In making these descriptions I have been moving toward an account of art history in which progress, direction, and coherence are not to be properly located in the logical arguments of our texts, in the argumentative connections between them, or in the fact they sometimes solve problems, but in the way that historical prose has come to mimic historians' intuitions about artists and artworks. As we think about an artwork, our sense of it grows more complex, more nuanced, until it can no longer be adequately expressed by the rote listing of facts or the march of syllogistic argument. In my first metaphor, the strict realm of the black umbra gives way to the mottled, indistinct penumbra. Some of the inhabitants of that shadowy realm can be named as they eventually find their way into the texts. Longhi's sense of Masaccio is compounded of several hundred comparative examples, wide archival research, a particularly fluent formal analysis, psychological interpretation, reviews of the literature and its methodological problems, extravagantly invented dramas, political and social analyses, an awareness of the etymology and ideology of crucial terms, and ekphrases based on first- and secondhand examinations and discussions with conservators. "Each

36. Rainer F. Foelix, *Biology of Spiders* (Cambridge, Mass.: Harvard University Press, 1982), 145.

of these"—in quotation marks because they cannot be separated—contributes its own quality: some, like the analyses of pigments, are strictly logical and nearly contextless; others, such as the politico-ideological myths, are openly speculative, but strongly supported by their contexts. The mixtures are at an advanced stage, and few observations are isolated or awkwardly inserted into foreign material. Claims of various sorts are intricately connected to prose description; geometric argument and tangled narrative become indistinguishable; logic flees from itself and becomes apologic or ambilogic; and linear, monothematic critique gives way to expressive, evanescently shifting description.

In order to continue to write texts that can be read as contributions to a history of art, it is necessary to sustain the conviction that logical structures support texts and the traditions they constitute. Some postmodern texts that eschew logical argument or avoid "central" claims can be much less interesting than similar texts that actively take positions and pursue theses. The reason may not have as much to do with the ambilogical prose as it does with the very absence of clear argument. In the terms I am developing here, such texts decline to play the full game of art history, which demands that authors continue trying to mix the immiscible: theory has to mingle with plotless description, logic with illogic, arguments with "pictures," umbra with penumbra, orbs with cobwebs. Without that attempt even the most evocative writing will begin to lose its grip on history.

I have tried to take the inquiry to a point where my descriptions might find purchase both for philosophically inclined readers and for those who find themselves working within a tradition such as the literature on the Brancacci Chapel. To say much more and insist that art history is the inadvertent painting of portraits, with facts as mere advertisements, would be to lose touch with the discipline's sense of itself. The same problem applies to more-philosophic readers "outside" art history, because the combinations of illogic and ambilogic are already so far from conventional accounts of rational thought that they threaten to disappear into a kind of poetry of logic. But if I were to risk saying more, then the central question would be how art historical writing can be used to depict the work that we love. What are the *expressive* potentials and limitations of art history in this respect, as opposed to poetry or fiction, or even conservators' reports? Taking *all* the elements of art historical prose as expressive media, how might we adjust logic and illogic, frame and ornament, attribution, speculation, paean, formal analysis, and exposition of theory so as to express our sense of the objects most fully? It seems to me that these questions, rather than truth or logic, are at the center of the project of art history.

9 THE AVARICIOUS SNAP OF RHETORIC

> What happens here? Some particular entity, a pair of peasant shoes, comes in the work to stand in the light of its being. The being of the being comes into the steadiness of its shining.
>
> —Heidegger, "The Origin of the Work of Art"

> Alas for him, the philosopher has indeed deceived himself. He has retained from his encounter with Van Gogh's canvas a moving set of associations with peasants and the soil, which are not sustained by the picture itself but rather grounded in his own social outlook with its heavy pathos of the primordial and earthy.
>
> —Meyer Schapiro, "Still Life as a Personal Object"

> The "obliging" response of Professor Heidegger [to a letter sent by Meyer Schapiro] . . . closes itself on its author as a trap. We hear the snap: clearly. It's clear, *clearly,* the matter, the affair, is settled.
>
> —Derrida, "Restitutions of Truth to Size"

The chapter "Restitutions de la vérité en pointure" in Jacques Derrida's *La vérité en peinture* (1978) is about what Meyer Schapiro wrote about what Heidegger had written about what van Gogh had painted.[1] Derrida on Schapiro on Heidegger on van Gogh: the sound of it is so delicious that it alone might account for the

1. Jacques Derrida, "Restitutions of Truth to Size, *De la vérité en pointure,*" trans. John P. Leavey Jr., *Research in Phenomenology* 8 (1978): 1–44, esp. 14. The book *La vérité en peinture* (Paris, 1978) has been translated into English as *Truth in Painting* (trans. G. Bennington and I. McLeod [Chicago: University of Chicago Press, 1987]). A different French version appeared as part of "Martin Heidegger et les souliers de Van Gogh," *Macula* 3/4 (1978): 3–47. This includes extracts of a French translation of Heidegger's "Origin of a Work of Art," and a French translation of Schapiro's "Still Life as a Personal Object." For literature on *La vérité en peinture,* see Craig Owens, "Detachment from the Parergon," *October* 9 (1979): 42–49 (accompanying a translation of the first section of *La vérité*); R. D. Cumming,

essay's wide currency. And our sometimes quick disaffection with the essay might proceed from the echo effect of successive commentators: van Gogh's voice is loud and unclear; Heidegger's voice booms with pathos and the ground bass of the "great philosopher"; Schapiro's is thin and a bit strident; and Derrida's is weaker still, diffused through unnamed and unnumbered interlocutors. Latter-day commentaries (like this chapter) seem to inherit the weakness of the last echoes, and they have tended to be scarcely audible. Here I want to risk that inaudible quiet in order to say something about the rhetorical force of art historical writing as it is represented—inadequately, but with remarkable clarity—by Schapiro's short essay. Afterward I turn to a "case study," something less hampered by a narrow engagement with philosophical debate: Michael Fried's essay on Courbet's *Burial at Ornans,* from the book *Courbet's Realism.*

But first, to set the stage: I propose that Derrida's reading of Schapiro's essay raises an entire catechism of questions that we, as art historians, can address to our own writing. Some of these are writerly qualities—questions of rhetorical mode, mood, and tone. Though I have been exploring ways that art historical writing can be read as meandering meditation or slowly shifting "picture," there are also many works that appear quite differently. Far from leisurely evocations or essays in complexity, they are sharp, even harsh attempts to stake out some interpretive ground. They say what they mean as efficiently as possible, with a coldness and an authority that are far from the pictorial texts I have been imagining. A great deal of normal art history works this way, and I might even say that the short-essay form—of which Schapiro's essay is an example—lends itself to this kind of pointed argument. In this chapter, therefore, the emphasis is not so much on major monographs as it is on the statistically normative case of shorter journal essays on any subject. They are the place where it is easiest to observe the breathless haste that is so well illuminated by the chain of essays linked to Schapiro's "Still Life as a Personal Object."

BREVITY, EASE, SPEED, THE DASH, THE MAD RUSH

One of the themes of Derrida's "Restitutions" is the "occupation of a nonconceptual field [specifically, that of van Gogh's painting] by a conceptual force

"The Odd Couple: Heidegger and Derrida," *Review of Metaphysics* 34 (1984): 487–521; Allan Megill, *Prophets of Extremity: Nietzsche, Heidegger, Foucault, Derrida* (Berkeley and Los Angeles: University of California Press, 1986), 332–37. References to "Restitutions" are given in the text. Page numbers for English quotations refer to the translation in *Research in Phenomenology;* page numbers for French quotations refer to *La vérité en peinture.* When both are cited, English page numbers precede French.

[of philosophic and art historical commentary]."[2] In philosophic terms, that questions the relation of nonlinguistic works of visual art to verbal accounts, and in art history a related theme appears under the conceptually narrow and somewhat misleading rubric of the "word-and-image" problem. "Restitutions" takes up a particular form of the question, one that continues to interest Derrida.[3] In another commentator's words, "Restitutions" is "an attempt to unmask what Derrida calls 'discursivity within the structure of the beautiful.' "[4] That "discursivity" is a central issue in art history and is not often questioned. Julia Kristeva is particularly good on the strangeness of trying to speak for paintings:

> How can we find our way through that which separates words from what is both without a name and more than a name: a painting? What is it that we are trying to go through? . . . The question, then, is to insert the signs of language into this already-produced reality-sign—the painting; we must open out, release, and set side by side what is compact, condensed, and meshed. We must find our way through what separates the place where "I" speak, reason, and understand from . . . something that is more-than-speech, a meaning to which space and color have been added. . . . We must retrace the speaking thread, put back into words that from which words have withdrawn.[5]

This is a large and interesting field of problems, and even in this one passage we might want to question how Kristeva knows that a picture is "compact, condensed, and meshed," unless a certain understanding of language prompts her to think so. But perhaps even more intriguing than these theoretical problems— even such logically and poetically challenging ones—is the fact that they do not seem to stop anyone from writing. Kristeva mentions these issues in an opening paragraph, and then continues at length on things easier to expand upon. All the participants in this exchange (from van Gogh, whose letters provide the unwitting first documents, through this chapter) have no difficulty in speaking, and in fact Derrida's text is a signal example of his often-remarked tendency to be prolix, if not profligate. Schapiro's essay, though it is short (six and a half pages to Derrida's seventy) is also easily written. "Like ripping a napkin" is the way John Berryman described Mozart's composing, and Derrida's text is especially logorrheic—more like a spinning roll of toilet paper.

2. "[L]'occupation d'un champ non conceptuel par le quadrillage d'une force conceptuelle" (35; 88).
3. See Marie-Françoise Plissart and Jacques Derrida, "Right of Inspection," *Art and Text* 32 (autumn 1989): 20ff.
4. Owens, "Detachment from the Parergon," 43.
5. Julia Kristeva, "Giotto's Joy," in *Calligram,* ed. Norman Bryson (New York: Cambridge University Press, 1988), 27; see generally 27–52. An early text that speaks of the silence of paintings is Plato's *Phaedrus* 275 d–e.

There is thus an ease of writing and a *brevity* of exposition, and there is also a *speed* of attack. "Restitutions" circles around the way Schapiro and Heidegger both rushed "precipitously" to attribute the shoes in the van Gogh painting to a specific person.[6] Heidegger gave the shoes to a "peasant woman," and Schapiro "restored" them to van Gogh (claiming they were the artist's own shoes, probably worn in Paris in 1886–87). Both authors made a "mad dash," a "rush" to their claims, and Derrida calls both moments "blind spots" in the two "illustrious professors' " texts. Derrida himself makes fun of this "rush" by taking so long at it and by playing at rushing. He protests against his own writing: "That's to go much too fast," "Let's take our time," "We can take our time," "No, no, at least not so fast" (16–23). (There are other senses in which the rush overcomes him, too, and I will return to them.) The rhetorical speed in both Schapiro and Heidegger is unusual; Derrida calls Heidegger's passage "ludicrous and lamentable."

ATTRIBUTION

The breathless haste, the easy speed, and the "mad dash" are all in the service of attribution. I think it is a mistake to imagine that this drama is only a matter of "illustrious professors" passing their time by arguing over a unique case, and it is most especially a misreading of Derrida's text to imagine it as an exposé of historians' political affiliations. It matters that Schapiro is a Jew, used to urban life, and Heidegger a German who idealized rural German peasantry; but there is more at stake than a social explanation of hidden motives. I would rather take "attribution" to signify not only the connection of a name with a work of art, but all such identifications (between school and work, work and date, text and work, pupil and master, technique and result, style and culture, form and intention, symbol and meaning), and let me also encompass words such as "discovery," "connection," "relation," "model," "history," "observation," "revaluation" and others that occur in the titles of art historical essays. All such synonyms *attribute* by connecting artworks with singular external facts. In this sense, attribution is more than a characteristic gesture of art history: it is a central, indispensable, originary motivation and strategy in any writing about visual artifacts—a legal urge that can be read as an opposite to the pictorial texts that develop over

6. Derrida has written his own summary for the dust jacket, which can serve as an unusual "passe-partout" to "Restitutions": "Disons que, pour m'en tenir au cadre, à la limite, j'ecris ici quatre fois autour de la peinture. . . . 4. Assistant, non sans y prendre part, à un duel entre Heidegger et Schapiro pour savoir à qui reviennent en vérité les souliers délacés de Van Gogh, je demande ce qu'il en est du désir de restitution quand il a trait à la vérité en peinture."

generations or centuries and show themselves in the meandering traditions of art history as a whole. The *legal urge* operates in the space of single essays and gives them their taut, high-strung purposiveness. One might also say that pictorial texts are the effects of a desire to *remake* or recreate the artwork in, or as, a text; whereas the legal urge seeks to *take* the artwork into the text, to repossess or appropriate it, and to keep it there. This is in accord with the gentler nature of the pictorial texts and with the harsher, avaricious nature of attribution. In the first case the driving metaphor is artistic creation, however it is imagined, and the writer takes whatever care and dedication seems appropriate; but in the latter case speed and power are essential, and the only restrictions are whatever legal constraints might delay the act—for example, the need to argue the case or to exhibit the necessary evidence.

The legal urge is costly: though it succeeds in giving structure, purpose, and pleasure to texts, it also redistributes their more leisurely expositions and alters their style and tone for the worse. Attribution is a dubious activity, both philosophically and psychologically. It serves a personal, sometimes overtly selfish motivation. Derrida says, near the beginning, "Let us posit as an axiom that the desire for attribution is a desire for appropriation" (3). His reading of Schapiro's essay emphasizes this proprietary, professorial, institutional, and even racial impetus, but it reaches outward to any text that attempts, against all better sense, somehow to absorb an artwork into a written narrative. In its most general form, attribution is an attempt to locate a restrictive meaning and therefore restore a kind of ownership. To be exact, its salient feature is an insistence on singularity of meaning.

This kind of appropriative monothematomania is often precipitous, and some-times blind. It seeks "to determine a meaning through a text [read here *painting*], to pronounce a decision upon it, to decide that this or that is a meaning and that it is meaningful, to say that this meaning is posed, posable, or transposable as such: a theme [read here *a subject*]."[7] The general motion of attribution, and its more specific and personal accompaniments, occur throughout art historical writing. When we understand something about a painting and can say some things about it, then it is in some sense our property, and we can write or lecture or publish on it. A historian who can discover and master a new meaning, and successfully claim that meaning is the single essential meaning, can "own" the work, at least for a while: it becomes the historian's intellectual property, and rival interpretations have to measure themselves against the new meaning.

Talking about attribution this way has both the strength and the weakness of Nietzsche's thoughts on the "will to power": it is at once immediately, obviously

7. Jacques Derrida, *Dissemination,* trans. Barbara Johnson (Chicago: University of Chicago Press, 1981), 245.

true and somehow too naked. Part of attribution is the raw taking, but part is the fine clothing and proper—if often rude—behavior that goes into the taking. When it is not exposed to the pitiless light of Nietzschean or Derridean critique, attribution continues half-noticed in virtually all art historical writing. Attribution does not require nuanced writing. Even the publication of archival documents, from which all further narrative is rigidly excluded, provides information found *by* and *for* someone, and this information abets a historian's "grasp," "control," and "mastery" of the artist and the artwork. (Our unthinking use of such words underscores how much of attribution's proprietary dynamic is routine and uncognized.) The pride that comes with finally "mastering" the ins and outs of European or Asian archives and the abbreviations and odd handwriting of some past age is often—and often properly—taken as an essential signifier of historical accomplishment.[8] The least assuming, slimmest *catalogue raisonné,* filled with tiny details, most of them already known and all of them nearly useless, still makes its author "master" over the material.

EXCISED CONTEXTS

Attribution, as I mean it here, has three main qualities: it short-circuits the "structure of detachment" that divides wordless pictures from all language; it insists on reducing artworks to essential (or central or significant or relevant) meanings; and it seduces writers to do violence to their writing. Essays that are consumed with the desire to possess work can become cold legal disquisitions replete with arcane terms and proprietary interpretations. Some, like Schapiro's, can turn into breathless legal injunctions out to stop rival accounts. Others, like Derrida's, can swell to outlandish proportions in their attempts to engorge all previous thoughts into their own.

The generative qualities of attribution have other, less visible companions. Among them perhaps the most important is the excision of context. This may seem unlikely in the case of art historical writing, since the best writing achieves a wonderful *inclusion* of context (evidence, I would say, of a pictorial sensibility), and since contemporary art history frequently tries to include new kinds of context. Nevertheless, the motion of attribution demands excision.

Heidegger's "revelation" (his attribution, which brings with it the oblivious-ness that is also characteristic of revelations) comes in the middle of a sustained meditation on the "workly character of the work" in *The Origin of the Work of Art* (1950). Derrida writes:

8. The pride in archival accomplishment is brought out well in the interviews published as *Object, Image, Inquiry: The Art Historian at Work* (Santa Monica, Calif.: J. P. Getty Trust, 1988).

We're not only misled when academic seriousness and the severity and
rigor of tone make room for this "illustration" [*bildliche Darstellung*].
We're not only misled by the consuming dash toward the content of a
representation, by the heaviness of pathos, by the coded triviality of this
description at once overloaded and indigent . . . by the roughness of the
frame line, the arbitrariness or barbarity of the clipping out ["l'arbitraire
ou la barbarie du découpage," that is, the clumsiness of the transition],
the massive assurance of his identification: "a pair of peasant shoes," like
these, *comme ça!* . . . So we're not only misled, we burst out laughing. The
drop in tension is too great. We follow the advance of a "great thinker"
step by step; he returns to the origin of the art work and of truth by
traversing all of Western history, and then suddenly, at the bend of a
passage, we find ourselves again right in the middle of an organized tour,
as with school children or tourists.[9] (25)

Heidegger's precipitous rush to appropriate is accompanied and facilitated by
some rather violent rendings of his narrative context; and Derrida's commen-
tary on Schapiro centers on the same process. It seems there is little context
in Schapiro's text: "[D]espite a negative and punctual pertinence, Schapiro's
demonstration seems very quickly winded, out of breath [*bien vite essouflée*]"
(22; 328).[10] Schapiro's essay follows a conventional kind of art historical writing,
the "note" or "shorter notice" that usually appears at the end of journals. In
such places, the essay is itself like a footnote or appendix, and it is expected
that the problem be set quickly, the acknowledgments made, and background
literature cited, so that the argument might begin as expeditiously as possible.
The "note," and shorter, businesslike articles in general, expedite their excisions
by proscribing narrative breadth. But the active and even violent removal of
context is an inexorable accompaniment of all monothematic attribution, even
where it is not as naked as it appears in these examples.
 The same, therefore, holds true of Derrida's essay despite its extravagant
length. Remaining face-to-face with the wordless shoes, he says, one might
feel a little "strange." It is more comforting to be "oriented in thought": "I
wonder if Schapiro and Heidegger don't rush to make them a pair in order to
reassure themselves. Before all reflection, the pair assures us" (7). By playing

9. The kind of language that prompts this constitutes passages such as the following: "From the dark
opening of the worn insides of the shoes the toilsome tread of the worker stands forth. In the stiffly solid
heaviness of the shoes there is the accumulated tenacity of her slow trudge through the far-spreading and
ever-uniform furrows of the field, swept by a raw wind" (33–34).
 10. Schapiro's art historical analysis—that is, his own attribution of the shoes—is not itself in dispute:
"J'avais demandé," says one of the interlocutors in Derrida's text, "Schapiro a-t-il raison?" "Un peu trop
à mon avis" (351).

at not recognizing that there is a left and right shoe in the paintings, Derrida moves away from attribution by refusing to take that initial step. But Derrida's essay is also an attribution of an even more compelling kind in that it shows, at convincing length, that Heidegger's and Schapiro's kind of attribution is wrong, and it does so using the very language of attribution, speaking about the object and what it "really" is or is not, might or might not be. Since Derrida has fragmented his text, passages like the one on pairs succeed one another with kaleidoscopic rapidity, and at such times his text is the most rapid of the three.[11] Hence Derrida—and he knows this perfectly well—cuts many more contexts than either Heidegger or Schapiro. The force of attribution is so great that not even Derrida's extravagantly hyperbolic dialogue can absorb it all. Attribution reasserts itself, gathers his exploded text together, and begins to press it as if in a pressure cooker. The tempo gradually picks up toward the end, and the decisions come more rapidly: "So Schapiro is mistaken about the first function of the pictorial reference. He also ignores Heidegger's argument that should ruin in advance his proper restitution" (41). It is one of the virtues of Derrida's text that it makes all this visible and even accommodates the irrepressible forces it entails (he does not mention, but is certainly aware of, the allegorical rewriting of the motions of attribution embodied by his speedy ending). But his quirky "solution" to the insistent pressures of attribution is not likely to be helpful to art history, since the daily business of attribution can hardly take the luxury of resisting itself, exploiting and exposing its own momentum, and calling itself into question, every time a historian wants to write about an object: especially if the final result is *inevitably,* as I would say, another attribution of even greater force.

The same can be said of the form of Derrida's essay, because the potentially endless dialogue between unidentified speakers has not proved to be a helpful model for even the most experimental art history, despite its wide currency in postmodern theory. We may pause a moment and consider why this is so, since it bears on the question of writing, introduced in Chapter 1, that is "between" philosophy and literature. My sense of the matter is that Derrida's reciprocal contamination of fictional dialogue and factual investigation is an artificial graft that need not have been made in order for the various themes to have been opened for discussion. As dialogue, the text is continuously punctuated by the kinds of ellipses, false starts, dead ends, and incomplete allusions that we expect in any conversation (they are part of the dialogue's "reality effect"). A more strongly and consistently reflexive text can be imagined in which the implied author

11. Moving, for example, in one page from Christian allegories (the Master of Flémalle's *Annunciation* and a trap set for the devil, *muscipula diaboli*) to art historical documentation (de la Faille, a catalogue of van Gogh's paintings, and the Tuileries van Gogh exposition of 1971–72) to the Freudian fetish (the vaginal shoes, their "projection" and "fantasy") to political narrative (Heidegger's "libidinal and political pathos") to allegories of entrapment ("springes, *lacets,* snare traps, *pièges à lacets*") (14).

takes cognizance of each such moment and distinguishes those that are thematic from those springing from nameable or unnameable literary aspirations. Without such a governing awareness, the fictional contribution is flattened; it comes to signify care, slowness, ambiguity, and caution, but it does so *as a whole:* the entire dialogue "means" those things, and the individual lines cannot mean them separately. The result is a separate, unarticulated level of potential commentary that has, for reasons not present in the text, a different status from the care, slowness, caution, and ambiguity that are given to us separately and exactly in individual lines. Considering the transitions between each sentence and image would, I think, open an even more difficult arena by forcing a meditation on the *kinds of relations* between the literary and the philosophic: *what kind* of literary motivation lies behind a given interruption?—and in a complementary fashion, *what kind* of obscurity is sheltered by that interruption? "Restitutions" presents a sense of the literary that is at once too explicit and too general to be of use to the developed economy of art historical texts—it is, in this respect, a simplification of their dynamics.

To return to the theme at hand: attribution ignores the gulf that cushions silent pictures from barrages of words; it is implicated in an institutional and professional desire for appropriation; it loves speed; it mistrusts contexts; and it can build intense pressure, especially in narratives that resist it. The consequences of attribution include three in particular that are significant for art historical writing: I consider, in no particular order, rhetorical, epistemological, and "tonal" problems. Although Schapiro's essay remains the subject here, I mean these comments to be generally applicable to art historical texts. Schapiro's essay is, I believe, simply *clearer* on these points because it is simple (and simpleminded); it is neither different in kind nor somehow exemplary of his own writing or of art historical writing in general.

RHETORICAL SNAP

In starkest contrast to Derrida's essay, Schapiro's "Still Life as a Personal Object" has a deliberately transparent structure, and it can be readily analyzed in the terms of classical rhetoric.[12] The text's opening (its *exordium*, to use Quintilian's term) is only thirteen lines long, and it begins without any flourish, preamble, or circumlocution: "In his essay on *The Origin of the Work of Art,* Martin Heidegger

12. Meyer Schapiro, "Still Life as a Personal Object: A Note on Heidegger and Van Gogh," in *The Reach of Mind: Essays in Memory of Kurt Goldstein* (New York: Springer, 1968).

interprets a painting by Van Gogh to illustrate the nature of art as a disclosure of truth" (203). This single-sentence paragraph is followed by eleven lines on Heidegger's essay and a quotation of his "revelation."

This is what Henri Morier, the French rhetorician, calls an "exorde par attaque du point névrologique," an opening impatient with its own duty to summarize and introduce.[13] It is a symptom of the "simplification" that Derrida deplores, and another sign that Schapiro's essay belongs to the subgenre of the art historical "note." Full-length articles tend to multiply these opening lines, so that the initial *exordium* is followed by another, more specific one, and so forth, until the matter at hand is broached.

The essay skips Quintilian's next step, the *narratio,* and proceeds at once to examination, *probatio.* Again, there is no frame around the *probatio.* Directly after the quotation from Heidegger's *Origin of the Work of Art,* Schapiro writes: "Professor Heidegger is aware that Van Gogh painted such shoes several times, but he does not identify the picture he has in mind, as if the different versions are interchangeable, presenting the same truth" (205). The *probatio* is more like a lawyerly interrogation, *interrogatio,* where Schapiro notes that Heidegger "is aware" (read "is *well* aware"), and that he behaves "as if," the individual paintings were of no account. In the course of the *probatio,* Schapiro investigates all the paintings of shoes done by van Gogh, and wonders which Heidegger meant. The solution is presented twenty-one lines later, again without ceremony: "In reply to my question [not previously mentioned], Professor Heidegger has kindly written me that the picture to which he referred is one that he saw in a show at Amsterdam in March 1930. This is clearly de la Faille's no. 255" (205). He notes that there were two paintings at that exhibition, and then states his conclusion: "But from neither of these pictures, nor from any of the others, could one properly say that a painting of shoes by Van Gogh expresses the being or essence of a peasant woman's shoes and her relation to nature and work. They are the shoes of the artist, by that time a man of the town and city." That ends the second paragraph of the *probatio.* Schapiro then takes just two paragraphs, almost wholly quotation ("Heidegger has written: 'The art-work told us what shoes are in truth' " etc.) to set up for the conclusion, and after this setup comes the sting, the *refutatio:* "Alas for him, the philosopher has indeed deceived himself" (206).

The last two pages of the essay correspond to Quintilian's *peroratio,* a rambling (by comparison, at least, with what has gone before) epilogue with more evidence of Heidegger's mistake and his ignorance of the real circumstances. The

13. Henri Morier, *Dictionnaire de poétique et de rhétorique* (Paris: Presses Universitaires de France, 1981), 219.

demonstration is resourceful—it includes a passage from Gauguin's memoirs—and incontrovertible.

The sentence "Alas for him, the philosopher has indeed deceived himself" has considerable rhetorical force: "The 'obliging' response of Professor Heidegger," writes Derrida, "closes itself on its author as a trap. We hear the snap: clearly" (14). Schapiro's rush to make literal connections, to tighten "the laces of the painting around some 'real' feet" (41), gives his text the quality of a snare trap, what Derrida calls a "naïveté primesautière ou précritique" (22; 328). The condensed, skeletal rhetorical frame is harsh but strong: its sources of power are unornamented and clear.

The sequences in Schapiro's essay are characteristic of art history, even if there is a curt and somewhat uncivil undercurrent in this example. We might think of a more gentle and circumspect essay, where no one is being trapped and the identification—itself a milder form of attribution—takes place in a very different atmosphere. (Recall, for instance, Panofsky's elegant and gentle essay on van Eyck's *Tymotheos,* which identifies the sitter as the composer Gilles Binchois. That essay is a celebration, since the author was a fan of the composer.) But despite the civility that comes from admiration, the rhetorical structure and the intention of more generous essays are strictly comparable to Schapiro's crotchety proof. Both Panofsky and Schapiro focus on a single aspect of a painting ("the orientation of thought," Derrida remarked), review previous attributions and hypotheses, home in on their mistakes, and present the new, proper identification. Rhetorically, Panofsky's text is more like a detective story than a judicial proceeding: it draws narrowing circles around the identity of the sitter, zeroing in on Binchois. Giving a painting to a composer of whom the author is fond is quite different from taking a painting from a philosopher who is not esteemed, and much could be said about other kinds of "attributions" and their psychologies: but here, where the scaffold is bare, its structure can be seen most accurately.

This basic rhetorical frame (*exordium, probatio, refutatio, peroratio*) is a consequence and mark of attribution. In terms of rhetorical history, art historical writing descends from forensic, rather than epideictic, symbuleutic (hortatory), or paraenetic (laudatory), oration. For the rhetoricians "forensic" meant "legal," and our mode is ultimately juridical and probatory rather than descriptive. Shorter art historical essays tend to be spare when it comes to ornamenting this frame, because a decoration can quickly come to seem like an excuse: rhetorical austerity preserves the feeling of legal truth and objectivity that would be threatened by a profusion of unnecessary elaborations. Schapiro's essay is like a machine whose joints are exposed by corrosive agents—by the stark demands of concentrated argument, with all its severity and haste. His text has rusted rigid.

EPISTEMOLOGICAL CONSEQUENCES

These rhetorical traits are linked to epistemological consequences. Schapiro's essay closes with a blank assertion: the last line is "Gauguin's story confirms the *essential fact* [my emphasis] that for Van Gogh the shoes were part of his own life." In Derrida's view, that kind of immoderate behavior is made possible principally by unexamined "dogmas." Derrida lists several: that "some painted shoes actually belong . . . to a real, identifiable, and nameable subject"; that "shoes are shoes, whether they are painted or 'real' "; and that "feet (painted, phantom, or real) belong to a specific body" (42). These are not traps that most art historians would likely fall into, but they exemplify the things *to which one has to be inattentive* in order to occupy oneself exclusively with attribution or its synonyms.

A universe of ideas is excluded from the house of art history because its rhetorical structure needs first to accommodate attribution. A primary exclusion is often the discussion of theory, which usually finds a crowded place in among the *exordia* at the beginning of papers or else as a final thought—an "afterthought" in the literal sense—in the *conclusio*.[14] Papers that are more intricately articulated find other locations to introduce their theoretical platforms, and that which is identified as "theory" can be woven throughout the text; but it is my experience that, at least in the realm of normal art history, mentions of theory are embedded in the framing portions of the text. The force of this tradition makes itself felt even in our most methodologically reflective texts, since they *also* still follow the custom of placing their theoretical expositions together with other framing devices such as introductions, summaries, transitions, recapitulations, and prefaces. (Following another chapter in *The Truth in Painting*, we might open a critique of such appearances by naming them *parerga*, elements that are neither inside nor clearly outside the argument of the text.)

In normal art historical writing another epistemological exclusion is whatever goes under the label of "criticism": by which is sometimes meant, in a telling redefinition, anything insufficiently tied to indisputable fact. While an intimate aside may serve to strengthen an argument, criticism is often perceived as weakening it. Usually the reason given is that art criticism is irrelevant to art history; in this context I would also say it would subvert the apodictic tone of the narrative and dilute its legal force. (And by extension, a text, such as Derrida's, that seems to be *entirely* composed of asides would be read by art historians as being *primarily* a challenge to the way art history is written.) One of the advantages of rhetorical criticism over epistemological criticism is that it allows

14. The marginal life of theory in art historical writing is explored in my "Art History Without Theory," *Critical Inquiry* 14 (1988): 354–78.

us to reconfigure the gangly opposition of "descriptive history" and "valuative criticism" seen in Carrier's account of art history. As I argued, the awkwardness of that formula is appropriate for a certain way of construing art history's sense of itself; but that does not mean that it is not a dead end, and putting things in terms of rhetoric helps keep the critique flexible.

These acts of inattention and exclusion can be read as the outward markers of an epistemological conservatism. The "dogmas" that help drive Schapiro's essay can be read in the passages in which he scolds Heidegger for not being specific about the painting, for bringing "both too little and too much in his contact with the work," for "projecting" a "heavy pathos of the primordial and earthly," for treating the artwork like an object ("I find nothing in Heidegger's fanciful description of the shoes represented by Van Gogh that could not have been imagined in looking at a real pair of peasants' shoes"), and finally for ignoring "the artist's presence in the work," the fact that van Gogh had a personal feeling for the shoes (206). In all of these, where Derrida reads the desire to appropriate, one can also read a conservative impulse: by implication Schapiro is praising a patient, knowledgeable appreciation that remains aware it is studying objects at several removes from "reality," objects that are nonetheless invested with intimate meaning. The essay means to be careful about them—to conserve them, as Heidegger himself would have said, so they can appear in their fuller meaning. This implied conservatism is mirrored and strengthened by the conservatism of the rhetorical motion, whose comforting familiarity (apart from any conceptual issues) makes essays like Schapiro's so much easier to read than Derrida's or Heidegger's. Timidity would be the best term for this particular "structure of detachment," if it were not so negative.

MATTERS OF TONE

A third consequence, if I can number them this way, has to do with tone in the sense of the apparent mood or emotion of the authorial voice. Of all the qualities, this may be the most important, and yet it is the trickiest to describe. Schapiro's essay, a model for the properties I have discussed so far, is too desiccated to have much to tell us about tone. His prose has a tautness or dryness to it: and certainly the spare articulation of his rhetoric produces a sense of vigilant tension or at least nervous exactitude.

The same qualities, though much gentler, are visible under the beautifully fleshed-out text in Panofsky's essay in the form of a certain insistent clarity of purpose or inexorable, didactic progression. The best of Panofsky's writing mixes intimacy and detachment (a combination I recall being coached on when

I had to give my first professional lecture), and its moderation extends to many other elements of style: his sentences are never too long, but he also avoids short sentences; he is never excessively enthusiastic, but does pause briefly to praise. Those qualities can be found in nineteenth-century German scholarship, and they have not disappeared: many contemporary art historical writers retain a fundamentally calm tone, engaged with the reader just enough to avoid being aloof.

The tendency of some art history toward a kind of moderate, friendly tone is tightened—and made more interesting—when it is superimposed on the taut Quintilian rhetoric of demonstration and proof. In the last chapter I pursued this as a question of logic and its accompanying "ornamental" description. Both aspects have their tonal correlates: the logic produces a harsh tone, and the less purposive description can impart a gentler, less harried tone. In Panofsky's longer essays such as the *Early Netherlandish Painting* or *The Life and Art of Albrecht Dürer,* the Quintilian frame recedes, letting gentler styles prevail. The longer books are well known for their inimitable tone: I would describe it as impeccably calm, well disposed, and consistently detached. To say that such texts are "poised" is to praise the balance of distance and an intimacy that is continuously offered but never granted. In other writers the dissolution of the Quintilian structure opens the text to meandering thoughts that have less purchase on a steady authorial voice or tone. In my reading, André Chastel's longer texts are permeated with a kaleidoscopic joy, whose only limit is its own intermittent aimlessness.

For the great majority of normal art history, if the scale tips one way or the other, it is probably toward proof and away from play. Much of the art historical literature in the major journals is suffused with unmentioned tension: the whole enterprise of researching and publishing is too closely bound up with career and evaluation for it to be otherwise. Some essays are tense close to bursting, and they make uncomfortable reading—perhaps not simply because of their suppressed emotion, but because of the *way* it is suppressed, under a cracking veneer of confident calm. Often enough our texts are rhetorically dangerous, meaning they work to hide a burden of nervousness, without being able to contain it fully. We have seen something of the pressure of contained affective purpose in the debates in *Visual Theory,* but there the question concerned the presence of personal beliefs that could not be accommodated to theoretical discourse. In traditional art historical writing, I find that it is often a matter of preserving or projecting something that, if we are to read the texts as translucent indicators of mood, would have to be called self-confidence. Arrogance, overreaching, and bravado are never too far beneath the surface in such instances. These tensions (and their transcendental figure, the unnatural calm so strong in writing like Panofsky's) are often remarked in conferences, as speakers try to "master themselves" and read with authority; but they are not so often noted as an inbuilt trait in our

writing—a trait with wide and deep consequences for what we can say as well as how we can say it.

Here we are coming close to Preziosi's term, coyness, which I explored in relation to the double bind. Timidity, coyness, and lack of self-confidence would be central examples in a study of art historical tone. Part of the reason has to do with the nature of what any one art historian knows, in comparison with what other people in the field know. Panofsky has remarked that art history is like an archipelago in which no one knows more than a few islands. Art history may be more extreme in that regard even than sprawling disciplines such as physics, because it is not only information that is lacking when we look into colleagues' specialties, it is also language, the rudimentary ability to communicate. Working art historians need to be to some degree polylingual, but all except a fortunate few have language barriers that they have to work around (and, in some instances, to conceal) as best as possible. As Montaigne knew, evading the truth requires continuous vigilance, and here I would add that it results in sometimes unworkable rhetorical tension.

Though I have been condensing these possibilities, they could readily be the subject of an extended disquisition. The pleasantly urbane in art history is never far from the incisive demonstration, the irrefutable review of facts, or the decisive reappropriation. The characteristic tone of attribution is audible even under many others; it can modulate from the curtness of Schapiro's open-and-shut case to the meditative pleasure of Panofsky's text, but it is a constant accompaniment, a ground bass to the other concerns of the texts. I can imagine something along the lines of Nietzsche's genealogy of the types of philosophers, treating the various affects we have encountered in this book. Anger, lack of confidence, overconfidence, coyness, timidity, reticence, tension, incommunicable passion, anxiety, impatience, and displeasure would be among the terms of art history's genealogy; and how different it would be from the history of the discipline that is told in our conventional historiography! But there would be severe limitations to any such exposition, because it is superlatively difficult to produce a measured critical discourse that can tie tonal qualities, written in the language of psychology, to the specific claims and arguments of the literature. It is not sufficient to say, as I did of André Chastel, that a text is permeated with a certain aimless "joy," unless I am also prepared to say what affect that has on *what* is said. Schapiro's tone certainly has its epistemological consequences, but they are hard to list beyond a few "dogmas" and the common absence of discussions of theory.

Yet this problem of linking tone and subject matter is evident in all spheres of contemporary criticism. To name a single instance: a recent study of Paul Ricoeur by S. H. Clark mentions Ricoeur's tendency to write slow, careful prose with an "oppressive sobriety" that can be "mind numbing." That style makes

a striking contrast with Derrida's rhetorical fireworks, which Clark describes as "bizarre," "baroque," "wheedling," and "grandiose," and which Ricoeur himself calls "vengeful," with a "tone of intellectual and moral superiority."[15] But despite the many suggestive parallels those observations provoke, there is no critical discourse that knows how to give them meaning, and often enough they are merely stated, without further conclusions. There are many such examples in the literature, but this one is especially telling, since it occurs in a philosophic exposition of two writers who have spent years exploring the forms of discourse and the intersections of fiction and philosophy. And for us, there is another difficulty, since in addition to being analytically unmanageable, tones are superlatively delicate matters. They are supremely subjective—some readers may not share *any* of these perceptions—and they are tied to a number of inappropriately negative connotations. Any description of tone risks appearing as irrelevant criticism or pointless carping.

It would be mistaken, I think, to treat the tone (or undertone) of the authorial voice as a secondary phenomenon without unavoidable significance for our more "central" concerns. And this is not only because tone bears a largely uncognized relation to the avowed purposes and possibilities of our writing, or because it helps support factual claims (it is essential, even there), but above all because it is the voice a reader hears: narrative form, rhetorical structure, and epistemological suppositions only come to us through the authorial voice. The tones we hear when reading or speaking with colleagues color our memory of facts, and they return when it comes time to write. Some of the less pleasant tone qualities— anxiety, bravado, the energy of keeping up the *concetto,* as it has been called, of knowledge—are sweetened with time, and they can be softened and made pleasing by dexterous writing. But to the extent that they are endemic, they are also generative, both in writing and in daily commerce.

ON RHETORICAL FORCE

Attribution, I think, is the impulsive force behind written responses to pictures even though it may appear very differently, depending on the rhetorical form of the text. But as important as I think it is, I would not write an entire book on questions of rhetoric, because, in the Western tradition from Cicero onward, rhetoric has persistently slid away from subject matter, as if the two were not

15. S. H. Clark, *Paul Ricoeur* (London: Routledge, 1990), 7, 10, 140, 145. On tone, see also Stanley Cavell, *A Pitch of Philosophy: Autobiographical Exercises* (Cambridge, Mass.: Harvard University Press, 1994).

intimately allied through all writing. The various approaches I have tried in
this chapter are all prone to that problem: just as "logic" slides away from
"description" (in the previous chapter), so style, rhetoric, form, tone, and their
cognates detach themselves from subject matter in all literary discourse. But
whether or not it is imagined as such, rhetoric is absolutely essential to the
historical meaning of a text. Rhetoric, in other words, is the form of the subject,
and since the subject is visual art, form is exactly what is in question. Historians
only ignore the shape of what they write at the risk of introducing severe and
invisible limitations on what they can say. To suggest the importance of form in
general (and rhetorical structure and tone more specifically), I want to suspend
these theoretical speculations and turn instead to a single example where rhetoric
and argument take shape together.

In my reading, Michael Fried's essay on Courbet's *Burial at Ornans* is one
of the exemplary moments of art historical writing, and that is so for several
reasons not immediately related to its position in the book *Courbet's Realism*
or to its place in Fried's larger project. Fried's account of French painting from
Diderot onward has been slowly building over the last few decades, and it has
reached the point where it has few rivals for complexity of argument or reflexive
engagement with images and contemporaneous texts. For various reasons it has
seemed difficult either to engage Fried's arguments or to absorb them into other
historians' accounts, and his positions stand out in high relief against most other
art historical commentaries on the same material. That relative isolation could
be due in some measure to the epistemology of his texts, since they involve the
viewer in a more immediate and phenomenologically more inclusive sense than
most art historical texts—creating a kind of mutual implication that could easily
be perceived as both a psychological and an analytic threat to writing that divides
viewer from object in a less fluid fashion.

It would be possible to say much more about the reception of Fried's texts,
and certainly a critical introduction to Fried's central ideas is needed now more
than ever. (The same could be said of other writers whose works are still read
formulaically—for example, Leo Steinberg, August Schmarsow, Roberto Longhi,
Wilhelm Bode, and even E. H. Gombrich.) But in accord with the subject of this
chapter, I want to stay away from questions of the constitution of the discipline
or the presentation of historical truth.

In the particular instance of the chapter on the *Burial at Ornans,* the strategy
of the exposition might be described, in a preliminary fashion, in terms of two
concepts: a phenomenological dichotomy between *inside* and *outside,* and the
notion of *dramatic* exposition. The inside-outside relation appears in at least three
ways, two of them generative for Fried's work as a whole. Initially, describing
pictures from the "inside" means attending to the painter's body and what the
pictures have to say about it: listening in particular for those bodily positions,

motions, gestures, habits, and desires that can be inferred from the paintings and the pertinent criticism. "Outside" in this sense is the more ordinary business of art history, which attempts—as the majority of this book does—to build an account *around* or *about* a work or an artist, shoring up the pictures with observations as if they were built most importantly from what would then have to be called intellectual sources. It is not easy to describe this sense of inside and outside, because it works itself out *in* the writing: a fact that I take to be entirely intentional, and of a piece with my suggestion that rhetorical modes are most interesting and powerful when they do not exist in isolation. A second sense of inside and outside, intimately connected with the first, depends on the historian's own body and the differences between its responses and other peoples' reactions, both historical and actual. In faithful accord with Merleau-Ponty, Fried attends to his own somatic reactions to pictures and lets himself be pulled (in imagination and in fact) toward the pictures or pushed away from them. As Merleau-Ponty would say, pictures are extensions of bodily space, continuously affecting our bodies. A beholder who does not censor those reactions will intuitively match a painting's gestures, will stand where the painting demands and feel the little aches and cramped muscles that the painting entails. Historians who refuse to acknowledge those reactions as sources of knowledge will again work from the "outside": from beyond the painting's fields of force, from places unaffected by its coercive powers. In *Courbet's Realism* those two intermingled senses of inside and outside are complemented by a third, where "inside" means within the picture and "outside" denotes the beholder's places. For Courbet what is inside a picture is liable to leak outward, "back" into the beholder's space; and conversely, the beholder is prone imaginatively to enter the picture and either wander inside it or identify, more or less securely, with figures and objects depicted in it. This commonplace theme of painting is made radical by Fried's contention that Courbet's work shows the marks of his desire to merge, fuse, or flow into the pictures or else (when he paints himself) to pour outward toward and into the beholder.

These three ways of construing the inside-outside relation are inevitably and properly mixed: hence Fried's appellation, the "painter-beholder," an inextricable composite of present, past, and remembered acts of beholding. In its simpler versions, the inside-outside theme is universal in writing that is concerned with beholding; but in its more radical sense, it is very uncommon because it endangers the historian's own perspective "outside" the work.

The idea of a dramatic exposition is even more particular to Fried's writing. It is essentially the idea that a historian's task is to disclose the meaning of paintings by rehearsing their dynamics and "economies" (in Freud's sense) in the most powerful possible manner. A written account that falls flat, that does not have "life" (in the writer's sense of that word), that is plodding, systematic, iterative,

obedient to the protocols of some fixed methodology, or otherwise overly rigid, may succeed in saying a great deal that has value; but it will fail to make the attempt—always doomed to failure—to match the painting's expressive force by an account of equal and symmetrical force. A historical account, by this standard, takes as its criteria of excellence the ability to reenact in prose the relevant dynamics of the picture. Harold Bloom's ideas about strong misreadings are pertinent counterexamples, since they also stress the power and drama of "strong readings" but omit any mention of veracity or historical constraint. Fried's writing entails an equal responsibility toward the force of imagination, but always modulated by the painting's historical modes of reception. Any art historian would agree that art history should repeat whatever it takes to be the structure of the picture or of its reception. The difference is that Fried adds an extra criterion: that the historical commentary should also try to match the drama, or the energy, of the particular acts of beholding. To do less would be to rescind part of the potential of writing and to play an easier—and ultimately less interesting—game.

It is not irrelevant that the actual argument of Fried's chapter on the *Burial at Ornans* is too complicated to repeat here. (It would take about ten pages to rehearse the claims in a reasonably adequate way.) What I want to bring out is the way that the "rhetorical" aspects of the essay propel the reading (and "propel" is a word Fried uses of his own argument at a crucial point in the chapter), keeping it on course and holding it together as far as possible. I also think there is a breaking point, where the argument becomes too intricate for the discourse that supports it, and that the break is partly repaired by the very force of the reading, which "propels" the argument onward as if it were jumping over a chasm. The best way to evoke this may be to describe, in diaristic fashion, some of the articulations in an actual—that is, more or less sequential—reading.

The chapter opens with what I take to be deliberately disorganized fragmentary references to previous historians, each acknowledging the confrontational nature of the painting (Fig. 31).[16] The accounts agree, Fried notes, that the *Burial at Ornans* faces its beholders "with a vengeance—massively, conspicuously, over-whelmingly" (113). Even in the most determinedly normative historical reading, that assertion could not fail to be taken in part as an authorial apostrophe, directed at the reader. "Facing" is going to happen in at least two ways: from the painting to its historical and present-day beholders, and from the essay itself to its readers. This is not something that can be spelled out, or that needs to be, and when it is said this way, it ruins the tension by splitting the act of reading from the act of looking. The two are implicitly mutually engaged.

16. Michael Fried, *Courbet's Realism* (Chicago: University of Chicago Press, 1990), 111–13. Further references are in the text.

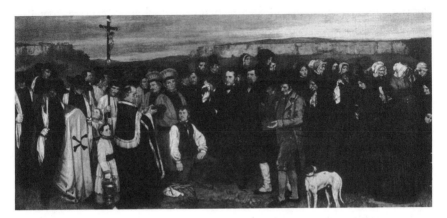

Fig. 31. Gustave Courbet, *A Burial at Ornans,* ca. 1849–50. Paris, Musée d'Orsay

Yet if any reader could then remain insensitive to the pending assault, Fried goes on to say that his own reading will begin with four common themes in the previous scholarship, which he will then incorporate into his own account, "to bring to light—almost literally to reenact—the *Burial's* engagement with the issue of beholding" (113). The stakes here are set higher than they would be if Fried had written "structurally to mimic" or "to address," or even just "to account for." The fact that it cannot possibly be clear what it means "almost literally" to reenact a picture only makes the tension greater.

As it turns out, that virtual reenactment happens in several mutually incompatible ways: first by a historiographical review of four partly failed theses, and then by a phenomenological rehearsal of the painting's power to move the gaze and the beholder. The tension between those two, I think, implies that historical accounts, written from the "outside," must give way to the coercive power of the painting itself, which is known initially from the "inside": in other words, it "almost literally" reenacts the power of beholding.

Logically speaking, the essay is a tight succession of arguments that go to prove the picture cannot merely be a confrontation—that it has to be more than a wall of black paint or a procession of staring faces. First there are the landscape paintings Courbet did in the years immediately preceding the *Burial,* which are organized according to imaginary journeys for the eye and for imagined figures in the paintings—journeys that are "slow, methodical, [and] serpentine" (121). Popular prints that Courbet may have known depict that same serpentine in long processions, ending close to the picture surface and therefore unusually near the beholder (128). The *Burial* also has places where the "pressure toward the picture

surface" becomes especially intense, for example, to the left of center where "the lead pallbearers, the crucifix-bearer, and at least three other figures including Buchon are crowded into a section of canvas no more than a few feet wide" (128). (Buchon, Courbet's friend, is the bright face in profile at the extreme rear of the mourners, left of the crucifix.)

The entire procession may therefore appear to be pressing inexorably forward until it—or the empty grave itself—breaks through the "ontological impermeability of the bottom framing-edge" of the canvas and overflows the clear distinction between inside and outside (131). The implied viewer would therefore be centered in relation to the painting, in front of the grave, or even—to put it extravagantly—about to topple into it as the procession nears. But that would be too simple a reading, both for Courbet (whose paintings are never simple spills, flowing from a punctured picture surface) and for the argument (which has developed too many qualifications, and too much momentum, to end here). Instead, there are "two distinct, apparently antithetical, modes of engagement with the issue of beholding": the confrontational push toward the boundary of the picture, and several contrary motions that place the beholder securely on *this* side of the painting (134). Fried notes the "skewed orientation" of the open grave, implying a beholder to its left; the crucifix-bearer, who looks out toward a beholder somewhere in front of him; and a pivotal incident just to the crucifix-bearer's left, where a choirboy has almost knocked against the hat of one of the pallbearers (134–35). That small drama is intended, Fried suggests, to draw the beholder's attention to the crucifix-bearer's position in the painting and to his outward gaze. The same area also reveals a "deep and narrow spatial cleft or fold" leading the eye through the twining procession to the face of Buchon at its farthest end.

Each of those observations works against the notion of pure confrontation and implies a beholder somewhere in front of the left third of the painting. Initially it seems there is no "outright conflict" between the two possible positions of the beholder, because the area around the grave is so conspicuously empty, lacking any "overt address to the beholder" and implying a position elsewhere (136–37). But the painting does not merely avoid self-contradiction; it proposes an exact "structure of beholding" that ambiguously embraces both possibilities. This is where Fried's argument comes to a head and becomes so intricate that it exceeds the capacity of his own critical language. Calling the indeterminately located beholder the "beholder *tout court*" and the beholder constrained by the various gazes and perspectives the "painter-beholder," Fried claims that "the beholder *tout court* may be intended to become aware of the second point of view and perhaps even to occupy it physically." It could be that the crucifix-bearer gazes at the painter-beholder but that the painter-beholder returns his gaze obliquely by looking past him, into the "cleft or fold" and toward the "artfully concealed, yet partly for that reason magnetically attractive head of Buchon" (138). That

disjunction therefore thematizes the "conventional relationship between painting and beholder," putting the beholder in mind of unreturned gazes and separating the sense that the painting implies a particular beholder from the sense that the painter experienced the painting as something whole to gaze upon without occupying a determinate position. This is where I would say Fried's language becomes inadequate to the task, because in his words the separation is between "what might be described as the *painting's gaze out at the beholder-'in'-the-painter-beholder* and *the painter-'in'-the-painter-beholder's gaze into the painting,* a feat tantamount to driving a wedge between the two components of the painter-beholder's compound identity" (139). Elsewhere I have called these neologisms "outlandish," and they are so by the standards of the account itself: they strain the terminology of "painter-beholder" and "beholder *tout court,*" and they strain the logical framework of the essay by implying that they are only the first in a potentially interminable chain of neologisms.[17] For example, the phrase "the *painting's gaze*" presents itself immediately as an expedient simplification, since Buchon is as much an aspect of the painter as a synecdoche for the painting. In addition, Buchon is only part of the *"painting's gaze,"* which also involves, for instance, the "cleft or fold." Buchon is a figure for a part of an aspect of the painter-beholder, and so the *"painting's gaze"* might also be called a "part of the painter-beholder's figure's gaze," and so the phrase *"painting's gaze out at the beholder-'in'-the-painter-beholder"* might have been *"part of the painter-beholder's figure's gaze out at the beholder-'in'-the-painter-beholder."* The very fact that the new terms can be ramified in this way implies the same of the analysis.

The passage is a break in the continuity of the argument, and Fried signals as much by following the paragraph with a blank line and beginning the next paragraph with a sentence explicitly about the motion of the argument: "One more reference back to the *After Dinner* and the *Stonebreakers* will help propel this reading to a close" (139). In those closing pages he works again on the relation between the two beholders, positing an "original obliqueness" to the painting and showing how it might have generated the serpentine procession (141). In the end, the painting reconciles the two points of view by giving evidence of its obliquity and of the ultimately never-quite-completed coincidence of the two beholders (142). But from the moment Fried introduces those italicized neologisms, the argument decisively ruptures. Nevertheless, it can be followed to the end, and found persuasive, without erasing that sense of interruption and analytic excess.

For me the interruption is an integral and entirely intentional strategy. The chapter as a whole marshals an unusually multifaceted argument into a series of tightly expressed claims, leading to an excruciatingly complicated partial

17. I mention this in passing in my *Poetics of Perspective* (Ithaca: Cornell University Press, 1994).

conclusion. To read the chapter is to feel the pressure that Fried had to exert to keep the argument reasonably within bounds, almost as if he were squeezing it into a "cleft or fold." At last it focuses on a tiny detail, like Buchon's head—and breaks. That break is the moment of excess that classical rhetoricians urged on their speakers as a way of compelling assent when their arguments began to seem overly complex or improbable.[18] It is still a standard lawyer's strategy: go one step too far, so that your auditors can find something to discard, and then they will assent to everything else.

The drama of the exposition seems exactly to follow the drama of the painting's "structure of beholding": it posits increasing problems with beholding and brings them all down onto the same confined bifurcated point. Afterward, it ends loosely by effecting a partly indeterminate reconciliation. But the drama would be a dry exercise, something for a student of Quintilian, if it could be so easily detached from the subject at hand. Fried's intention to look and describe from the "inside" is what binds his rhetorical strategies to the essay's historical claims, since neither the author nor the "painter" (nor the "painter-beholder," and so forth) is ever securely "inside" or "outside." As writing, the essay comes alive by the sheer force of its confrontation with its own ideas and its author's ongoing search for their proper form. The energy of the essay, and the sense of exhaustion I feel whenever I reread it, become part of the experience of the painting: that is, they become part of history. To me, this is the obvious and unavoidable importance of what has to be called rhetoric: an author who said the same things but demanded less from the act of writing would not produce an essay that compels repeated reading.

THE STEEL TRAP

As Wittgenstein knew, sometimes the problems nearest to hand prove the most difficult. The origins, structure, relation, meaning, and consequences of art history's rhetoric and tone have yet to be seriously addressed. "Attribution" as such is largely unthematized. Part of the difficulty is politeness—it seems odd to speak about an author's tone of voice—and part is a general discipline-wide lack of interest in writing per se. But our relative silence may also signal our wariness, since the coupling of rhetoric and attribution leads toward risky questions about historical truth. If I write about my desire to attribute a work and then go ahead and make an attribution, I have snagged my own argument, as if my text were

18. In this I agree with Stephen Melville, "Compelling Acts, Haunting Convictions" (review of *Courbet's Realism*), *Art History* 14, no. 1 (1991): 117–22, esp. 120.

a snake biting its own tail. And even if there were a forum for rhetorical issues, writers would still have to pick their way through the daunting entanglements between rhetorical form and argument. Tone, the most elusive rhetorical trait of all, may also be the most fundamental, since we experience writing and history through it: whatever a historical argument amounts to, we necessarily hear it speaking in some voice, and something about the voice colors our judgment. Such problems are almost too delicate to handle: like spider webs, they come apart at the slightest touch. Still, without considering them we may never understand how art historical writing vacillates wildly from living, breathing prose to dry reports—from Fried's essay, groaning under the pressure of its own demands on itself, to Schapiro's uncharacteristically clattering skeleton.

In considering restitution, identification, and their cohorts, it is important to recall the ways that art historical writing alternates the force of attribution with less hurried activities such as bemusement, meandering, and the urge to create pictorial texts. Nietzsche has a felicitous description of the kind of mixed method I have in mind. Some thinkers, he says, "are rivers with many meanderings and secluded hermitages; there are places in their course where the river plays hide-and-seek with itself and creates for itself a brief idyll, with islands, trees, grottos and waterfalls; and then it goes on again, past rocky cliffs and breaking its way through the hardest stone."[19] The stones of logic in our writing are set along garden paths: in the middle of a leisurely, even "disinterested" contemplation one might come upon a sudden claim made with indecorous, aggressive force. This is the setting of our writing, and everything I have said in this chapter should be understood in contrast to the idyllic forms seen in past chapters. On the one hand, we mean our writing to have irresistible force, and on the other, we want it to be relaxed, confident, secluded, and idyllic. The two gain meaning by their mutual contrast, and they gain power by not being addressed: held by the logic of the double bind, they operate by not existing as a problem that can be broached in our essays. I like to think of this as the landscape of our texts, an allegory of our particular way of thinking. Any number of pleasant things might happen as we meander through the history of art; but underfoot there is always the steel trap: the indispensable, dangerous tool of our profession.

19. Friedrich Nietzsche, *Daybreak: Thoughts on the Prejudices of Morality*, trans. R. J Hollingdale (Cambridge: Cambridge University Press, 1982), § 330.

10 Writing as Reverie

First, *Leibniz's* incomparable insight that has been vindicated
not only against Descartes but against everybody who had
philosophized before him—that consciousness is merely an
accidens of experience and *not* its necessary and essential
attribute; that, in other words, what we call consciousness
constitutes only one state of our spiritual and psychic world
(perhaps a pathological state) and *not by any means* the
whole of it. The profundity of this idea has not been
exhausted to this day.

—Nietzsche, *The Gay Science*

What makes art historical writing so fascinating is its mixture of practice and
reflection, of doing and thinking about doing. Each of the preceding chapters
introduces another reason why reflection cannot comprehend practice and why
their fusion cannot be fully apprehended. It may seem that with the problems
of rhetoric, tone, and mood in the previous chapter, I have come to a kind of
stopping place, where analytic clarity dissolves into the unruly disclosure of the
writer's voice. But I have not built this account toward the subject of voice.
"Style," "rhetoric," "voice," and "narrative" are all narrow ways of conceiving
what is underanalyzed in art history, and I have been arguing all along that it is
important to see how they are inseparable from the manifest claims and logical
content of the texts.

Instead, I see the chapters as different windows onto our incomplete self-
understanding. Each makes local observations about repression, double-binding,
dogma, oversight, misconstrual, or lack of conceptualization, and I have not
yet said how those unintentional acts might be related to a general theory of
the limits of our understanding of art history. I am as pessimistic about the
project of describing the discipline as the individual chapters imply: I do not
think there is a good way to understand what art history is, or how it looks at
objects, or what its texts mean, or how its theories work, or how it is argued,
or how it builds traditions. In each case something in the discipline prevents

us from seeing clearly what we are doing, or to put it more critically, we stop ourselves from looking too closely at what we do, so that we can keep working as we please. But I think we can at least come to a provisional understanding of why we cannot understand what we do. These last chapters advance two complementary theories; they can be most easily introduced by reviewing several models of inadvertence and repression that have been at work in the preceding chapters.

1. *The three-step critique* is the commonest way of accounting for disciplines. Its first step, the identification of a subtext of theory within a disciplinary practice, and its second step, the preparation of a diagnosis of refreshed theory, work together to exclude all mention of the problems that attend the third step, the intersection of new theory with existing practice. That moment lies beyond the critical horizon of such texts; in a rapid reading, it can seem merely omitted, for lack of space or time, but in a more careful reading, its omission can be shown to be necessary for the working of the critique.

2. *The double bind.* Much of what I have written about the relations of theories and practices makes art history appear to be somehow fragile or even brittle. A theory in the text of art history, when it is retrieved from the text and stated independently, will usually be revealed as a mistaken or severely fragmented theory. In each case a gentle pressure, a tap, as Nietzsche says in the *Twilight of the Idols,* seems to be sufficient to break the theory, and so the theories in and about art history have seemed to be easily breakable by nature. Clearly, this notion must itself be breakable, because art historical writing is remarkably resilient. The second model, therefore, introduces the theory of the double bind in order to account for art history's resistance to theory. If writers are somehow prevented from fully understanding what they are about, then it makes sense that accounts of the discipline can easily see what working historians do not seem to notice. All the comically fragile methods of art history—the transparent ideologies at work in our methods, the impoverished senses of historical fact, reconstruction, evidence, truth, and objectivity, all our dispassionate reserve and distance, our faith in the value of canons, our continuing naïve dependence on styles and periods, our hopeful glances at new interpretive methods—all of them would then be *necessarily* unconscious, inadvertent, or uncognized. As art historians, we would often be prevented from seeing our metaphors as metaphors (to put it the way Davis does), and we would be compelled to continue seeing them as truth: which is to say, we would not see them at all. A vigilant account of the discipline would then have to describe both the moments of blindness and the reasons why they cannot be seen within the discipline.

The double bind is an improvement over the three-step critique, and most of the chapters of this book are elaborations of it in one way or another. In accord with the psychological origin of the concept of double-binding, I have suggested that

art history contains self-imposed moments of blindness, leveled by ourselves and at ourselves in order to enable us to continue with the kind of writing that gives us pleasure. In each instance there is an unresolvable conflict between something we desire and something we cannot admit if we are to go on pursuing that desire. To take the last three chapters as examples: meandering art historical traditions repress our lack of that progress which would be an appropriate accompaniment of our ideal of objectivity; the desire to write pictorial texts, balanced by an equally intense desire for logical thought, represses a paucity of rational argument; and art history's interest in attribution and accuracy represses awareness of its strained tone and particularly aggressive rhetorical "snap," kept in place by the need to appropriate visual objects with words.

The difficulty here is that descriptions of the double bind imply a kind of absolute repression or absolute knowledge, since they purport to see not only problems within the discipline and their plausible diagnoses, but also the reasons why the application of those diagnoses would present problems. Hence the double bind is just as prone as the three-step critique to the charge of being outside art history, speaking to or even for it.

3. *The critique of half-consciousness.* The truth, I think, is more complex and more difficult. As working art historians, we are sometimes aware of these problems and sometimes not. I think that most historians, no matter what their interest in philosophy or criticism, have thought most of the thoughts in this book at one time or another. Each of us doubts that our sense of objectivity is a solid or defensible concept, and each of us has had the queasy experience of following the path of a theoretical question to the place where it suddenly seems ridiculous. That motion from lack of awareness through rudimentary interrogation to faint discomfiture and quickly back to accustomed practice is one that I examined in a half dozen cases in reading Carrier's *Principles of Art History Writing*. As I was working on the previous chapter, I had no thought of the research I was conducting at the same time (on Renaissance drawings); and when I returned to the drawings after the chapter was finished, I largely forgot about the effect of the rush to attribute. It is not that I did not know, and it is not that I did know: my awareness was somewhere in between.

The double bind is, to put it simply, too simple. Any nonpsychotic patient can understand the double bind when it is explained, and even before it is explained, we have all had moments when we have sensed that a practice is founded on sand or that a problem is dissolving before our eyes, even while we realize with increasing clarity that there is no other possible state of affairs. The challenge, therefore, is to find a way to describe this shifting awareness of something that is neither securely known nor consistently unknown. In order to give this third approach a name I call it *half-consciousness,* denoting a state that vacillates, in a manner we have yet to determine, between partial awareness and partial

inadvertence. The critique of half-consciousness is a way of formulating a precise account of the dynamic of the conscious and the inadvertent.

I have two models in mind to exemplify half-consciousness, and they occupy these last two chapters of the book. The second, which I reserve for the final chapter, is a textual explanation, which seeks to find the signs of half-consciousness by the close reading of an exemplary text. The first is a psychologistic explanation, based on the thought that the most common states of mind involving partial awareness are daydreams and reveries. When I am half-awake, or half-aware of what is happening around me, I can experience an evanescent awareness of my condition. One moment I may realize what I am doing, and the next I may forget and be immersed in a dream. In art history, I find that condition exemplified in a particular kind of scholarship: the study of the history and meaning of gardens.

WRITING MOODS

A Garden . . . is naturally apt to fill the Mind with Calmness
and Tranquillity, and to lay all its turbulent Passions to rest.
—Joseph Addison, from the *Spectator*

Garden history is an opportune place to inquire about reverie, because unlike the history of painting, sculpture, and architecture it has no conceptual foundations. It lacks the elements of scholarly and critical consensus: a conventional set of interpretive methods, agreed-upon leading terms, "ruling metaphors," and descriptive protocols. Painting, for example, has a recurring set of critical problems, including fictive space, the picture plane, the position and nature of the beholder, and notions of realism and representation. In art history, even the most abstract theoretical accounts of painting dwell on these same topics. Even accounts that are specialized in accord with some theoretical regimen return to these issues as if to a kind of home.

Garden history, on the other hand, inspires a kind of wide-ranging freedom of criticism. It seems to me—though there is no easy way to substantiate this—that writing on gardens is more heterogeneous, and its heterogeneity more central to a coherent account of its nature, than other branches of the fine arts. To some degree this makes sense, since gardens have a breadth of references that, it may be argued, paintings do not. A garden is "between" nature and culture; it changes through time in a way that painting does not; it is partly random (since the growth of plants is partly unpredictable); it has to do with the history of sacred places; and it is experienced as a sequence rather than all at once.

Gardens are involved in the histories of leisure (the *viridarium*), of social classes (the *locus amoenus*), of religious symbolism (the *hortus conclusus*), of utopia and paradise, of jokes and festivals, of journeys and exploration, and of theater; and they touch on the theories of sculpture, painting, perspective, geology, botany, medicine, and hydraulics, to name a few.[1] Cultures, genres, philosophies, and centuries all sometimes gather under the rubric of gardens.

In addition, it may be said that gardens, more than paintings or sculptures, are often intentionally vague or ambiguous in reference. Only a minority of gardens have readable iconographic programs, and even those are frequently meant to be evocative or polysemic rather than programmatic. Eighteenth-century "hermits' retreats" fall into this category, as do evocations of paintings, natural scenes, and even other gardens.[2] It is probably time to enroll the garden at Stourhead in our roster of intentionally ambiguous artworks, alongside painters such as Watteau and Giorgione. Especially if Henry Hoare's program involved autobiography, his results appear to have been intended to be ambiguous. One recent scholar has opted for a simpler program, which could be "chiefly unconscious in impact."[3] It may be that the next generation of scholarship will find the adjudication of various theories, and the investigation of conscious and unconscious ambiguities, to be a profitable focus.

Yet I would claim that scholarship on gardens ranges more freely than even this diversity of subjects and meanings might warrant—that it is, in short, often more like reverie than analysis. The exceptions are essays that set out to prove a single hypothesis, such as a garden's iconographic program or its state at a given time. But wherever the writing addresses a wider range of topics and narrative modes, including criticism and descriptive appreciation, a curious drifting sets in. It is that liminal state that is my subject here, and even though I concentrate on gardens, I want to imply that what happens there is true in a more subtle way of the project of art history in general.

The conceptual analysis of gardens is strange, I think, for at least these three reasons: (1) interpretations of gardens range more widely than discourse on other kinds of art; (2) they do so with less adherence to conventional forms

1. Jay Appleton, *The Experience of Landscape* (London: Wiley, 1975), 4ff., discusses the "diversity of disciplines" involved in landscape. The range of baroque references is discussed in Barbara Stafford, *Voyage into Substance: Art, Science, Nature, and the Illustrated Travel Account, 1760–1840* (Cambridge, Mass.: MIT Press, 1984). Recent works typical of this diversity include M. Szafranska, "The Philosophy of Nature and the Grotto in the Renaissance Garden," *Journal of Garden History* 9, no. 4 (1989): 76ff., and Tracy Ehrlich, "The Waterworks of Hadrian's Villa," *Journal of Garden History* 9, no. 4 (1989): 161–76.

2. For a critique of the idea that the picturesque English garden is modeled on preexisting paintings (instead of being a coetaneous and partly independent development), see Nikolaus Pevsner, ed., *The Picturesque Garden and Its Influence Outside the British Isles* (Washington, D.C.: Dumbarton Oaks, 1974), 3ff.

3. M. Charlesworth, "On Meeting Hercules in Stourhead Garden," *Journal of Garden History* 9, no. 2 (1989): 74.

of interpretation than histories of other arts; and (3) writing on gardens does not, by and large, address these issues. In each of these, writing on gardens is only more extreme than the remainder of art history, and not different in kind. The last point, however, is a subtle matter, because it may depend on the nature of gardens themselves. If writers on gardens go along with the reverie that gardens induce in all of us, do they do so intentionally, with their eyes open, or are they led unwittingly down the garden path? It appears that gardens have the power to soften our accustomed ways of thinking about visual art, and I will be speculating on whether they can do that without our knowledge. If I step into a bath, I am going to warm up, and perhaps gardens have that kind of control over our responses. On the other hand, it might be better to say that the reverie of gardens is only an inducement to a kind of thought that is often dormant in our professional prose.

SOME WAYS OF THINKING ABOUT GARDENS

I want to take these three claims one at a time, and begin by looking briefly at a sample of the range of conceptual schemata that have been applied to gardens. This list can scarcely be complete, and it may be a property of gardens that it never can appear to be. But I am mostly concerned to demonstrate the unusual diversity of responses to gardens, as a prelude to inquiring about the coherence of essays that try to put several schemata together at once.

1. *Gardens are representations of history.* A garden always has the potential for commemorative meaning; this was especially well developed in the eighteenth century, in which gardens were often fanciful ways of recalling or retelling ancient history. The *Ideenmagazin* and similar publications in England and France provided engravings of a wide range of ornaments, from ruined monasteries to horses' tombs, Laugier-style *cabanes*, and "sunken" pyramids à la Boullée. Occasionally the historical representations became the principal focus of gardens, and they sometimes attained remarkable complexity. Kew and Shugborough are examples of this kind of historical condensation, as is the Prince de Ligne's gardens of Beloeil, in which each garden folly had double (or triple) meanings: an "Indian temple" where the visitor could eat cream, a "Chinese temple" that was also a dovecote, and an "archi-Ostrogothic" temple doubling as a temple to Mars.[4] This phenomenon, in its wider implications, has been called "the Western

4. Christopher Thacker, *The Wildness Pleases: The Origins of Romanticism* (New York: St. Martin's Press, 1983), 220.

matrix of the learned garden": a garden that is a text, replete with cultural and historical information.[5]

2. *Gardens are representations of nature.* The very word "landscape" and its relatives "prospect" and "countryside" refer to representations of what is taken to be nature.[6] Ermenonville, for example, is an encyclopedia of landscape types, including an Arcady, an Elysium, and a wilderness (*le désert*), a farm, and a forest, as well as a castle, a dolmen, and a château, each with its appropriate landscape setting. An allegorical function could be assigned to each representation, from the melancholy Arcady, with its famous suicide, to Rousseau's cabin, with its air of natural simplicity and *lucubrationes*. In essays where this reading is privileged, one often finds its opposite correlate: that gardens are places that represent nature by declining to represent society, and in particular the injustices of labor that went into their creation.[7]

3. *Gardens are representations of painting and fiction.* The picturesque is a kind of "pictured vision,"[8] and in English gardens the pictorial is sometimes imagined as a substitute for the French perspectival: instead of views down straight *allées*, there are sudden "pictures." Most representations are not simple equalities between paintings and pictured views. The triple parallels between scenes at Stourhead, the *Aeneid,* and paintings by Claude and Salvator Rosa, first suggested by Kenneth Woodbridge, have been developed in a series of essays.[9] But gardens are often the third term in a comparison between poetry and painting, a kind of *ut hortus picturasque poesis.*

4. *Gardens are the meeting-place of various disciplines.* This is the thesis of the introductory essay in *The Meaning of Gardens,* which posits they are either ideas, places, or actions.[10] The authors assign the garden as idea to "philosophers

5. Denise le Dantec and Jean-Pierre le Dantec, *Reading the French Garden: Story and History,* trans. J. Levine (Cambridge: MIT Press, 1990), 31.

6. And likewise "garden" may derive from an Old English root for "fence," thereby showing its essential segregation from that which it represents. See Anne van Erp-Houtepan, "The Etymological Origin of the Garden," *Journal of Garden History* 6, no. 3 (1986): 227–31. For "landscape," see, for example, John Barrell, *The Idea of Landscape and the Sense of Place, 1730–1840: An Approach to the Poetry of John Clare* (Cambridge: Cambridge University Press, 1972). For "country," which derives from *contra* and so means land "spread out over against the observer," see Raymond Williams, *The Country and the City* (London: Chatto & Windus, 1973), 369. Both are cited in Simon Pugh, *Garden—Nature—Language* (Manchester: Manchester University Press, 1988), 135.

7. That does not stop gardens from becoming "site[s] of power over the labourer 'upon his knees.' " Pugh, *Garden—Nature—Language,* 3–4.

8. See J. Snyder, "Picturing Vision," *Critical Inquiry* 9 (1979–80): 499ff., for a general theory.

9. See Kenneth Woodbridge, *Landscape and Antiquity: Aspects of English Culture at Stourhead* (Oxford: Oxford University Press, 1970); J. Turner, "The Structure of Henry Hoare's Stourhead," *Art Bulletin* 61 (1979): 68–77; and M. Kelsall, "The Iconography of Stourhead," *Journal of the Warburg and Courtauld Institutes* 46 (1983): 133–43.

10. Mark Francis and Randolph T. Hester Jr., "The Garden as Idea, Place, and Action," in *The Meaning of Gardens: Idea, Place, and Action,* ed. Mark Francis and Randolph T. Hester Jr. (Cambridge, Mass.: MIT Press, 1989), 2–20.

and design theorists," the garden as place to "historians, landscape architects, and occasionally geographers," and gardens as actions to "medical researchers, psychologists, and sociologists." On the other hand, the garden in its general aspect is defined as "a way of thinking about nature." A recent book on gardens, *Reading the French Garden,* mixes history with fiction presumably in order to capture this multidisciplinary sense.[11] The authors do not provide an explanation for their oscillation between history and epistolary and novelistic fiction, though the reader assumes that the mix of genres represents the mix of experiences of the garden.

5. *Gardens are sets of polarities.* The introductory essay in *The Meaning of Gardens* also describes a garden as a "battle of seeming oppositions: male versus female, good versus evil, reaction versus revolution, self versus community, consumerism versus self-reliance, connectedness versus segregation, rich versus poor, real versus surreal, bigness versus smallness, sacred versus profane, science versus intuition, high versus folk art."[12] Garden history has also been organized around constancy and change, control and randomness, intuitive and logical thinking, right brain and left brain.[13] This essay itself might be read as a polarity, since I am interested in emphasizing the disparity between critical thinking in its most general sense and discursive thought of all sorts.[14]

6. *Gardens are narratives of human life.* This is perhaps the most general way of putting a theme that occurs in a great many forms. When an author says "the garden is also experience, a place to meditate, reflect, escape from conflict, or prepare for death,"[15] or that all gardens are metaphors of "Eden and Shambhala,"[16] the central image is life's course and the ways gardens reflect or facilitate it. One aspect of the journey of life, the domestication and enculturation of the "beast" in all of us, is one of the "primary narrative structures which frame the garden's meaning," according to Simon Pugh.[17]

7. *Gardens are open-ended sites of desire.* The same author has also said that perhaps we cannot understand gardens, because, like the incest taboo, they

11. Le Dantec and le Dantec, *Reading the French Garden.*
12. Francis and Hester, "The Garden as Idea, Place, and Action," 4.
13. The last three pairs are from C. C. Marcus, "The Garden as Metaphor," in *The Meaning of Gardens,* ed. Francis and Hester, 27.
14. The best book on this distinction in Western thought is Wesley Trimpi's *Muses of One Mind* (Princeton: Princeton University Press, 1984).
15. Francis and Hester, "The Garden as Idea, Place, and Action," 6; and see C. Howett, "Gardens are Good Places for Dying," in *The Meaning of Gardens,* ed. Francis and Hester, 252ff.
16. Marcus, "The Garden as Metaphor," 26ff. Marcus refers especially to Edwin Bernbaum, *The Way to Shambhala* (New York: Anchor, 1980).
17. He sees two "primary" structures; in the second, the "garden is set against the conservation of energy by proposing a self-yielding world that purports to lie apart from expedience, as a retreat." In one reading of his text, these two narratives coincide in the image of Eden. See Pugh, *Garden—Nature—Language,* 128–29.

are so deeply rooted in our psyche that we can only experience them as social rules.[18] In that case, according to Pugh, gardens elicit what the psychoanalyst Jacques Lacan describes as "desire": a kind of longing that operates without a specific object in mind and without relation to other people.[19] The garden, in this account, does not represent anything: rather, it embodies a psychic need.

This last schema approaches the kind of conclusion I would like to draw regarding the quality of thought that gardens induce, and so at this point I would like to leave the list and proceed to the next stage of the argument. The fact that this list could readily be expanded suggests the open-endedness of thinking about gardens: even though the other arts could easily produce such a list (and often do, especially where it seems possible to speak freely and widely about meaning), I would contend that in normal art historical writing the range of references is narrower and the interpretive regimens more constrained by conventional paths of inquiry. One effect of the license that garden writing enjoys is that these meanings can be presented as open-ended and intercommunicating, and that in turn fosters the frame of mind I am calling reverie.

THE COHERENCE OF GARDEN WRITING

Much of what is appealing about gardens has to do with a gentle, spidery mixture of these and other notions about meaning. Here I only consider a single example, which I hope is sufficiently evocative to stand for a large number of other kinds of mixture. A recent article by Norris Brock Johnson describing the Tenryu-ji temple near Kyoto mentions a wide range of sources, among them *Gilgamesh,* the golden section, Japanese geomancy, *zazen* meditation, and Matila Ghyka's number mysticism. The essay lacks certain features that could provide greater conceptual stability: there is no historical assessment of the compatibility of these sources—no question that Western and Japanese concepts, or concepts from different centuries, can be relevant to Tenryu-ji—and on a more analytic level, there is no analysis of the reasons why the author assumes they fit together.[20]

Western and Eastern concepts meet at the *shinji chi* pond, where three *shichigosan* (7:5:3) triangles are said to connect the traditional fifteen pond stones.

18. Ibid., 128. Pugh is borrowing from Claude Lévi-Strauss's work on the incest taboo, in *The Elementary Structure of Kinship,* trans. J. H. Bell et al. (Boston: Beacon Press, 1969).

19. Pugh, *Garden—Nature—Language,* 130, and cf. 133 n. 3, referring to Jean Laplanche and Jean-Bertrand Pontalis's excellent book *The Language of Psychoanalysis,* trans. Donald Nicholson-Smith (London: Hogarth Press, 1973), 481–83.

20. Norris Brock Johnson, "Geomancy, Sacred Geometry, and the Idea of a Garden: Tenryu-ji Temple, Kyoto, Japan," *Journal of Garden History* 9, no. 1 (1989): 1–19.

Since the triangles are not actually in the ratio 7:5:3, and since the other mathematical principles that the author applies are rooted in twentieth-century Western traditions of number mysticism, it may be that a Western geometric order is here superimposed on an Eastern, nongeometric order. The former may provide an interpretive frame, a paradigm, for expositing the latter. As the author says, Zen Buddhism has a concept of the interrelation of humans and the environment (*fûdosei*), but it is visualized and quantified in the article using Western plans, elevations, and perspective views. The *zazen* meditation posture ("lotus position") is analyzed into golden rectangles and musical harmonies, following a problematic Western tradition that is traceable only to the mid—nineteenth century.[21] These juxtapositions—some modern Western mathematics on some sixteenth-century Zen concepts—may have conceptual as well as historical merit, but in order to develop and defend them, the essay would require a historiographical framework relating Japanese to Western concepts of order.

Such a critique might find purchase in the precise interaction of geometries. Chinese and Japanese are rich in apposite geometric concepts. There is a reason in Chinese garden theory for the organic disorder of the pond: swirling banks help conserve *ch'i*, "the substance and flow of life as life itself."[22] And Heian and Kamakura Japanese gardens are demonstrably influenced by Southern Song Chinese landscape painting, which has known compositional forms and formats.[23] Chinese geomancy (*feng shui*) also dictates auspicious compass directions (north is "least favored," associated with the female *yin*, "cold, and death").[24] And there is the Japanese sequence of *shin, gyo,* and *so,* which denotes a progression from richly varied gardens through intermediate forms to the most austere abstract dry gardens.[25] Certainly this sense of "abstract" is not the same as our current senses

21. For nineteenth-century roots of the interest in harmonious proportions, see *Gottfried Semper: The Four Elements of Architecture and Other Writings,* trans. and ed. H. F. Mallgrave and Wolfgang Herrmann (Cambridge: Cambridge University Press, 1989), 201 and elsewhere. Early-twentieth-century interest in harmonies centered on the theosophical movement; see A. Dubach-Donath, *Die Grundelemente der Eurythmie* (Dornach: Philosophisch-Anthroposophischer Verlag, 1961). For the golden ratio, see also H. J. McWhinnie, "A Review of Selected Research on the Golden Section Hypothesis," *Visual Arts Research* 13, no. 1 (1987): 73–85; Robert Palter, "*Black Athena,* Afro-Centrism, and the History of Science," *History of Science* 31, pt. 3, no. 93 (1993): 228–87; George Markowsky, "Misconceptions About the Golden Ratio," *College Mathematics Journal* 23, no. 1 (1992): 2–19; and for the absence of the golden ratio from Renaissance art, see James Elkins, "The Case Against Surface Geometry," *Art History* 14, no. 2 (1991): 143–74.

22. Johnson, "Geomancy, Sacred Geometry, and the Idea of a Garden," 3. See Benjamin Wai-Bun Ip, "The Expression of Nature in Traditional Su Zhou Gardens," *Journal of Garden History* 6, no. 2 (1986): 125–40.

23. Loraine Kuck, *The World of the Japanese Garden: From Chinese Origins to Modern Landscape Art* (New York: Weatherhill, 1968), cited in Johnson, "Geomancy, Sacred Geometry, and the Idea of a Garden," 18 n. 14.

24. Johnson, "Geomancy, Sacred Geometry, and the Idea of a Garden," 3.

25. For examples of each, see Christopher Thacker, *The History of Gardens* (Berkeley and Los Angeles: University of California Press, 1979), 68ff. The categories are from Kitamura Enkin, *Tsukiyama teizoden*

of that word, though the way this difference is usually addressed is to speak of Western abstractions, either in concepts or monuments.[26]

The description of Tenryu-ji is successful in evoking the peculiar beauty of the place, and Johnson's cultural and interpretive eclecticism seems apposite. Because the description works, the points I have been raising are not faults in his argument. Here, as in the examples I consider later, the text is successful and at the same time conceptually scattered. Something about the garden calls— "naturally"—for this treatment. But it is strange to bring *Gilgamesh*, Ghyka, and Zen together without a theoretical justification, whether traditional (for example, a historical defense of the relevance of *Gilgamesh*) or postmodern (the essay could be presented as a "new historicist" experiment in the juxtaposition of disparate sources).

In this respect Johnson's essay is similar to David Hockney's photocollage of Ryoan-ji (Fig. 32). Hockney's photograph is a visual palimpsest of European sources, including Picasso's cubism (which is the acknowledged forerunner of all pictorial strategies that draw on the collage, the grid, and the "facet"), the Western assimilation of Japanese prints (especially in its flat field and high horizon), and some Western conventions of cartography (visible in the "mapping" of footsteps and the rectangular ground). It is the juxtapositions themselves, and the confluence of disparate sources, that constitute a large part of our pleasure in the essay and the photograph. A similar thing happens in photographic analyses of Ryoan-ji by the historian David Slawson. In Slawson's account, Zen gardens such as Ryoan-ji are energized by triangular configurations that create dynamic patterns when they are seen from certain vantage points.[27] From a point out in the gravel rain gutter beyond the walkway, Ryoan-ji presents an "arrow effect" in which several rock groups are forcefully aligned (Fig. 33). This is certainly the case, but Slawson's theory is built almost entirely on a reading of Rudolf Arnheim, who proposes such dynamic compositional patterns in books such as *Art and Visual Perception*.[28] Arnheim's approach is grounded in a particularly German critical formalism that first flourished as a response to International Abstraction, and it makes a strange—and intriguing—contrast with fifteenth-century Japanese aesthetics.

[Creating landscape gardens] (1735). Parallels are also available in other arts, including painting. The dry *bon-seki* miniatures, for example, are less ornate than *bon-sai* miniatures or *haku-niwa* miniature landscapes (Thacker, *The History of Gardens*, 67).

26. Thacker makes two interesting comparisons, one to Goethe's *Altar of Good Fortune* at Weimar (1777) and the other to Aislabie's "moon-ponds" at Studley Royal (c. 1725), which had a kind of "pure," "abstract perfection." See Thacker, *The History of Gardens*, 71–72.

27. David Slawson, *Secret Teachings in the Art of Japanese Gardens: Design Principles, Aesthetic Values* (Tokyo: Kodansha International, 1987), 76ff., esp. 101.

28. Rudolf Arnheim, *Art and Visual Perception: A Psychology of the Creative Eye* (Berkeley and Los Angeles: University of California Press, 1954), cited in Slawson, *Secret Teachings*, 201–3.

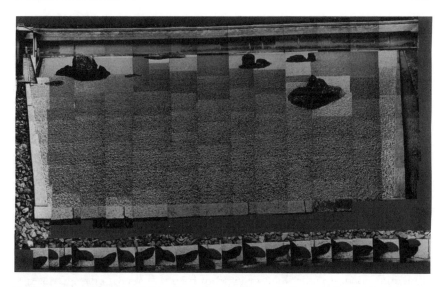

Fig. 32. David Hockney, *Walking in the Zen Garden at the Ryoanji Temple, Kyoto, Japan, Feb. 21, 1983*. Photographic collage, 40 × 62

It is important to note that this is not a problem of achieving something approaching homogeneity or purity in the sources that are brought to bear on historical explanation or pictorial reproduction. The question of how Japanese gardens such as Ryoan-ji should be pictured in order best to represent their fifteenth-century makers cannot be answered, among other reasons because we do not have fifteenth-century views to consult. Since Ryoan-ji is meant to be seen by a monk seated along one of the long sides of the garden, it might seem reasonable to photograph the garden from that viewpoint. But the result would be a perspective view—since cameras normally obey the Western conventions of linear perspective—and it is not at all clear that a perspectival view is relevant to the intentions of the garden's designer. Indeed, several things suggest that it is not. Since monks are enjoined to meditate on the garden as a whole and to hold its forms in mind, there is no particular reason to suppose that the accidental convergence of lines need be part of the experience. And the indigenous Japanese tradition of painting, which involves what is known in the West as "oblique projection," eliminates or softens perspective effects. For that specific reason *every* photograph of Ryoan-ji is a distortion. Hockney's photograph is taken from the correct position for meditation, and it severely truncates the long side in order to efface perspective convergence and let the garden look more quadrangular. But does that make it closer to the traditions of Japanese painting? Would it

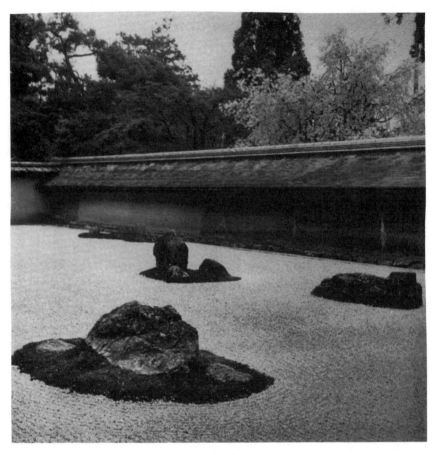

Fig. 33. The "arrow effect" at Ryoan-ji

be better to represent the garden in plan (Fig. 34)? Since Ryoan-ji may be the culmination of the art of tabletop dry-rock gardens (*bon seki*), a plan may be closer to the way Ryoan-ji might have been first worked out.[29] But even a plan has its conventions of lines and shading that belong more to architecture (whether Japanese or Western) than to the practice of Zen.

Purity in our strategies of interpretation and representation is not only unattainable; strictly speaking, it is meaningless. Mixtures of sources create meaning, and when they are unacknowledged, the result is the kind of conceptual mingling and conflation that we value in visual art—for example, in Hockney's

29. Pierre Rambach and Susanne Rambach, *Gardens of Longevity in China and Japan* (Geneva: Rizzoli Intl., 1987), 202.

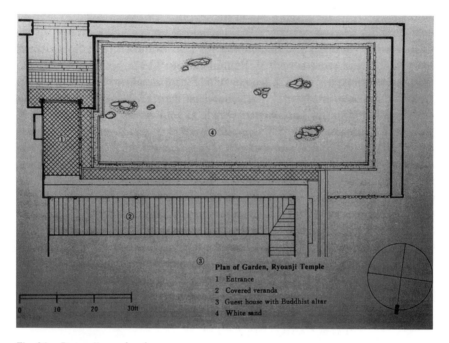

Fig. 34. Ryoan-ji temple, plan

photocollage—and attempt to analyze in historical and critical writing. What is strange here is the degree to which historical writing on gardens allows that mingling to proceed unchecked. Even though they are historical essays rather than independent works of art, Johnson's and Slawson's texts do their work through an unacknowledged conceptual blending analogous to Hockney's. For a photograph and for some historical writing on gardens, that reticence is normal; for historical essays on painting or architecture, it would be less so.

CARTESIAN EXCEPTIONS

One way to make the case that gardens provoke an unusual degree of conceptual incoherence is to look at the exceptions that prove the rule. In the case of French formal gardens, it may be that commentators tend to think more than normally in a monothematic fashion: partly because the gardens' expressive content centers on terms of power, and partly by analogy with the gardens' straight *perspectives* and *allées*.

From this point of view, it is not surprising that the exceptions to geometric rule occupy our attention as much as they did André Le Nôtre's—the flower parterres at the Trianon, the irregular Bosquet des Sources near the Trianon, and above all the seductive transition to countryside beyond the Pièce des Suisses to the south, the Neptune fountain to the north, and the gardens within the destroyed *bosquets*. The *rustica* enchants, and even today visitors oppressed by the long walks explore these byways. The same might be said of the ideas of the sublime and the picturesque, which may be understood as alternates to the *conceptual* rigidity of French formal gardens, as well as to their formal and iconological programs. In recent years the sublime has become a central concern in literary theory and aesthetics as well as in garden history, and part of its allure is precisely its conceptually intractable quality.[30] But for the most part, the French formal garden is an exception to the discussion in the majority of garden literature, and an important counterpoint to the theme of conceptual diversity that I am exploring here.

WRITING THAT WANDERS DOWN THE GARDEN PATH

So far I have suggested that gardens provoke an unusually wide array of ideas and that a certain conceptual blurring often seems to be the best way of dealing with that diversity. These are the first two points I wanted to address, and they are mainly preliminary to the third and central point, which I want to consider now: the reasons why the literature tends not to address these points.

Here I again restrict myself to a single example, this time the introductory chapter of *The Poetics of Gardens,* arguably the most critically informed and carefully written recent work on gardens.[31] The chapter, "The Genius of the Place," begins with a religious theme, as a kind of invocation. A garden, according to the authors, is a special place, like those *loci* that the ancients sanctified on account of their "living inner spirit" (1). The text then

30. Historians of the garden and of eighteenth-century studies might be interested in the following texts: Peter De Bolla, *Discourse of the Sublime: Readings in History, Aesthetics, and the Subject* (Oxford: Basil Blackwell, 1989); Thomas Weiskel, *The Romantic Sublime: Studies in the Structure and Psychology of Transcendence* (Baltimore: Johns Hopkins University Press, 1976), esp. "Approaching the Romantic Sublime"; and Neil Hertz, *The End of the Line: Essays on Psychoanalysis and the Sublime* (New York: Columbia University Press, 1985), esp. 217ff. This literature might illuminate questions of the "sincerity" of the sublime that have been raised in garden history, for example, in James G. Turner's review of *The Wildness Pleases,* by Christopher Thacker, *Journal of Garden History* 5, no. 2 (1985): 207–12.

31. W.J.T. Mitchell, Charles W. Moore, and William Turnbull Jr., *The Poetics of Gardens* (Cambridge, Mass.: MIT Press, 1988).

describes the "simple fact . . . underlying all these metaphors and mythic constructions," and that is the arrangement of land and sky. The next pages note the forms of mountains, valleys, and water, and the ways they play against one another. The authors list brooks, rivers, lakes, "hills, hillocks, swells, mounds, and bumps . . . canyons, gulches, swales, hollows, dells, and dingles . . . holes, caverns, and grottoes" (2). This is another open-ended list, like the one I made in the first part of this essay. Lists are particular dialectic tools: they have no special organization, though they often begin with the announced intention of completeness.[32] This list of landforms is organized in terms of simple polarities (here, *yin* and *yang,* hollow and hill, earth and water), so it can trail off whenever it becomes exhausted. And that is what happens: when the landforms are all named, the authors spend a paragraph on "Poseidon and Neptune, Nereus and the fifty Nereides," and then abruptly begin a new section, titled "God and Cain," which is about the interaction of man and nature. The section opens with the idea that God made the first garden and Cain made the first city, and the authors gloss: "So garden possibilities are further shaped and suggested by the balance (or tension) found at a site between natural growth and the artifices of man" (6). In a different work we might ask: Why mention Eden now, at the end of a survey of landforms? Why is a certain collection of landforms—which are after all named and classified by men, according to historical conventions—treated as if it is timeless, as if it existed prior to "the artifices of man"? What is the meaning of "further" in the transitional sentence? But this is not a text that responds to such questions, and that itself is characteristic of gardens.

It may seem that I am quibbling or reading too closely, but the same kind of transition occurs in various places throughout *The Poetics of Gardens.* Let us follow some of the later motions of the argument in the first chapters. The next section is "Sunlight and Shadow," and after that "Memory and Expectation," which briefly evokes historical references in gardens, from Proust to National Socialism. With that the opening chapter ends. The second chapter, "The Designer's Place," begins with the claim that "there are just two *Ur*-gardens," the "foursquare" *chahar bagh,* or paradisal garden, and the asymmetrical Japanese garden (13). Each is described, and sample plans are given. Then the text changes direction once more, this time to "offer . . . a catalogue of compositional strategies and moves—incomplete, but we hope suggestive" (21). This sentence is one of the few acknowledgments of the way that the narrative keeps trailing off, and it seems the only time that the authors are aware of their impressionistic method. I say "seems" because I take it that the writers know exactly what they have made;

32. For a meditation on the idea of the "catena" (chain, or list), see I. Hassan, "Pluralism in Postmodern Perspective," *Critical Inquiry* 12 (1986): 503ff.

but why, then, produce only this one passing reference to the expository disorder? The "strategies and moves" include merging, "enfronting," and "enclosing," and when they have been listed, yet another section begins, introducing the idea of a game: "Many of the pleasures of gardens come . . . from playing a game. . . . There is a collector's game, a painter's, a cinematographer's, a storyteller's, and a philosopher's, and of course there are many others, too" (23). In this case there is no sign that this is a strange transition, that "enfronting" might have some interesting relation to games, or that it should come before or after games. The successive schemata, lists, polarities, and catalogues would seem to imply the authors are trying to put some order into their experiences of gardens; but they are not trying too hard. They are trying *gently*, putting only a little emphasis on chained propositions. Why, we might ask, does the text decline to mention its disorganization? If gardens induce a reverie that the authors want to mimic, then that in itself is interesting, and could be mentioned. But if gardens induce reverie without the full awareness of the spectator, then it might not occur to the spectator that something is awry.

We do not need to go much farther into this text, but one more illustration is relevant. The section on games ends a few pages later, and a long new section, "Shaping Spaces," begins. The gaming section ends with this comment about the choice of games: "But it is worth keeping in mind a maxim of Sir Edwin Luytens . . . a garden should have one clear, central idea" (26). This maxim is not applied, either here or in the following pages. It is almost a mnemonic, like a string tied around a finger, providing an insistent and gentle reminder of something that, in the end, will probably be forgotten anyway.

REVERIE, DREAM, HYPNOSIS

I have been heading toward the conclusion that gardens are like mild soporifics, inducing a certain frame of mind, or habit of thought, over which their observers have limited control. Gardens do not induce true hypnosis, and they do not normally put us to sleep, though our writing evinces a mental state close to both hypnosis and dreaming. Without pressing the clinical comparison, one may say that, taken together, the wide-ranging associations and lack of linear argument and critical attention in these essays are certainly akin to the freely associative state that precedes sleep. Gardens seem to break down conceptual boundaries, inducing a "passive, contemplative experience."[33] They can inspire "holistic"

33. Francis and Hester, "The Garden as Idea, Place, and Action," 8.

thinking, "reconnection" to something alien called "nature."[34] To Francesco Colonna, Venus's garden is designed "not merely to stupefy the intellect, but to confound the senses," so that it overwhelms Poliphilus until he "no longer knows in what manner he exists."[35] In Addison's words, gardens are "naturally apt to fill the Mind with Calmness and Tranquillity, and to lay all its turbulent Passions to rest." But do they also lay *thought* to rest?

The text of *The Poetics of Gardens* is repeatedly expressive of a need to shape the experience of gardens, to make something that is imagined as formless into something that obeys certain rules of conceptual order. But the text keeps turning away when it is time to conclude, or develop the argument, or create a transition to another schema. It is the moments of articulation that are lost, and they become readable as moments "written" by the garden itself. In terms of the narrative voice, they come from "outside," preventing the writers from achieving self-conscious and measured transitions. Rhetorically, the text is repeatedly broken, as if a needle were skipping to different parts of a record—and the scene is made even stranger by the fact that the writers cannot hear the lack of continuity. I put it this way to underscore the mixed nature of this kind of response to gardens. On the one hand, the garden seems to induce a kind of dreamy reverie, so that writers are less likely to keep to a single topic and more likely to free-associate a chain of topics. As in any waking reverie, the dreamer is aware of what is happening, and dreams willingly. On the other hand, the garden seems to limit the writers' awareness to those passages in which they are enumerating similar concepts. Transitions from one exposition to another are lost, and their only trace is their absence. Something of the same kind happens when we slump in an easy chair and cannot be sure how many times we have fallen asleep or how long we have slept before waking. This is the reverie, the partial control and willing oblivion, that I want to associate with art historical writing that does not quite see what it is doing.

34. This meaning, and others incompatible with it, are discussed in Arthur O. Lovejoy, " 'Nature' as an Aesthetic Norm," in *Essays in the History of Ideas* (Baltimore: Johns Hopkins University Press, 1948), 69ff.

35. The first quotation is from the *Hypernerotomachia Poliphili* (Venice, 1499), vi recto, and the second is the gloss on that passage by Terry Comito, *The Idea of the Garden in the Renaissance* (New Brunswick, N.J.: Rutgers University Press, 1978), 183.

11 ON HALF-CONSCIOUSNESS

Still, there are limitations to the idea that writing is like reverie. It means that the terms of analysis have to come from whatever vague words we possess for vague mental states. Sometimes when I am exhausted and half-asleep, I become a little dizzy, or lightheaded, but how would words like those find places in the reading of a text? Here psychology (not to mention the overt psychoanalysis of the idea of the double bind, whose echoes remain in the concept of half-consciousness) is wonderfully evocative but ultimately too general and even misleading. In this last chapter I have another go at the concept of half-consciousness, this time adopting what might be called a Deleuzian aversion for psychologism. Though the construction of intentional meanings must remain central to any reading of a concept that depends on ideas of consciousness and control, I am going to try to show how half-consciousness of art history's themes, in whatever form it may appear, leaves grammatical traces in the texts.

My example is a familiar one, an old standby of art historical research: the distinction between the kinds of art that were made north and south of the Alps in the Renaissance and afterward. It is a guiding concept, with a prominent place in the way art history conceptualizes Renaissance art—so prominent, in fact, that it may be argued that we are not fully in possession of the idea; instead, it partly possesses us. Within art history, ideas as large as the North/South dichotomy rarely seem worth arguing for their own sake, since their appearances in different contexts are so disparate. Most art historical literature either does not regard the issue as a problem or else explores philosophic or political issues that do not disturb the underlying distinction.[1] But without a way to address such issues, we

1. The principal recent investigation of the North/South dichotomy is Svetlana Alpers, *The Art of Describing: Dutch Art in the Seventeenth Century* (Chicago: University of Chicago Press, 1983). See also idem, "Style Is What You Make It: The Visual Arts Once Again," in *The Concept of Style*, ed. Berel Lang (Philadelphia: University of Pennsylvania Press, 1979), 95–117. There are numerous reviews of *The Art of Describing;* most center on Alpers's revaluation of the role of symbolic images. See especially the two reviews by J. Bialostocki, one in the *Art Bulletin* 67 (1985): 520–26, and the other in *Zeitschrift für Kunstgeschichte* 47 (1984): 421–38, esp. 432–33 and n. 44.

are often at their mercy: they can direct our inquiries, tell us where to look and what to see. They can lead as well as mislead.

What I want to do here is try to suggest a reasonable way to talk about the North/South dichotomy—and, by extension, other such ruling metaphors—without letting the peculiarities of history burn away, leaving only the shining "concept." My central questions are these: Where is the idea to be located in our writing? To what extent do we understand and control it? And to the extent that it leads us, where are we going? I have chosen Erwin Panofsky's *Life and Art of Albrecht Dürer,* published in 1948, not so much because its reputation remains high as because it is a *locus classicus,* an unusually extensive exploration of the dichotomy.[2] The choice may seem a risky one: with the exception of Joan Hart's exemplary and sober work, recent Panofsky scholarship has become involved in overly quick equations between the North/South dichotomy and Panofsky's own sense of his Germanness. I am not concerned with that here, and I do not know how such claims might reasonably proceed. Nor am I interested in the wider historiography of the North/South question in Panofsky's other writing, in the writing of his German predecessors, or even in the mid—twentieth century in general. Instead, I am concerned with exactly what happens in this one text as the North/South dichotomy slowly emerges and then sinks back again, bobbing in the text like a half-drowned buoy. The half-consciousness that engenders such a motion is what permits Panofsky both to exposit the life and art of Albrecht Dürer and also to exemplify it in his own writing, both to understand it and to ignore it, to be immersed in it and to emerge from it. Half-consciousness, I claim, is the art historical dynamic *par excellence.*[3]

THESES, TOPICS, AND THE CONFLICT

A useful way to begin is to ask how Panofsky organizes his text. Certainly chronology is a primary narrative principle, and all but the eighth and final chapter follow a chronological sequence (the eighth is titled "Dürer as a Theorist of Art"). But I would argue that the chronological ordering, which is typically sufficient for the genre of art historical biography, is principally a vehicle for the theme of the North/South dichotomy. To see the relation between chronology and

2. Erwin Panofsky, *The Life and Art of Albrecht Dürer,* 2 vols. (Princeton: Princeton University Press, 1948). Citations are from the one-volume "portable" edition, issued in 1954, which contains the full text of the original, but without the handlist of works.

3. The method here is essentially due to Hans Blumenberg. It is a "metaphorology," an investigation of a leading or "ruling metaphor," and it follows Blumenberg's method insofar as it stresses the inescapable nature of the North/South metaphor. See Blumenberg, "Paradigmen zu einer Metaphorologie," *Archiv für Begriffsgeschichte* 6 (1960): 7–142.

dichotomy, we can look at the way that the latter accounts for each of Panofsky's subjects.

Panofsky treats Dürer's work to a characteristically wide range of analyses. There are discussions of formal elements such as composition, unity, and reces- sion; excurses on hagiography and church doctrine; parallels in the history of ideas; questions of patronage; chapters from the history of German language and writing; publishing histories; medical developments; social and economic influences; observations on the uses of color, the psychological content of por- traits, the peculiarities of the engraving burin, and the development of hatching in woodcuts; and botanical, cartological, entomological, and even "hippological" facts. These fall into groups in accordance with art historical practice. Discus- sions of line and color are instances of formal analysis, sometimes following Wölfflin's analysis, which Panofsky admired. When he speaks of the limitations and potential of etching, dry point, or engraving, he sounds like Semper mapping the influence of tools and methods on creative freedom. Passages on iconology stand out by their relative purity and freedom from eclecticism. Most of the rest of the analyses are studies of patronage, philosophy, or social history. In a wider and vaguer sense, all the subjects can be said to belong to formal analysis, iconology, or social history; and much of contemporary scholarship makes use of these convenient categories.

But partitioning the subjects of art history in this manner biases several issues I want to explore; so instead of speaking of analyses, subjects, or studies, let us call every such exposition a *topic,* whether it is as specific as the comparative anatomy of grasshoppers and crickets (an issue raised in connection with the *Madonna of the Dragonfly*) or as general as the economic conditions of fifteenth-century Germany. Dürer's style is therefore composed of topics, although in any given case it may be formed of an amalgamation of so many topics that it may seem holistic or indeterminate.

The guiding idea, the theme of the text, is sketched in the last two sections of the introduction (10–14). Panofsky initially calls it "an innate conflict in [Dürer's] mind" (12), a principle of "tension" (the word is used at least four times) galvanizing all of Dürer's ideas and achievements.[4] It works on each topic

4. Panofsky was aware of the history of the North/South conflict, though I do not want to pursue that here. See especially Joan Hart, *Heinrich Wölfflin: An Intellectual Biography* (Ph.D. diss., University of California, Berkeley, 1981; University Microfilms, 1981). Chapter 4 (318ff.) treats Wölfflin's *Die Kunst Albrecht Dürers* (1905), in which Dürer is described—much as Panofsky does—as an artist divided between North and South. As analyzed here, there are two generative differences between Panofsky's and Wölfflin's treatments. First, Panofsky imagined an a priori difference, a dichotomy not susceptible to solution, while Wölfflin posited a final style that was a synthesis of North and South. The 1504 *Adoration of the Kings* is described as the "first picture in German art to show perfect clarity" (quoted in Hart, *Heinrich Wölfflin,* 325). Second, Wölfflin's analysis does not articulate the possibility that Dürer was not in control of the dichotomy (see 328 and elsewhere), as Panofsky's does. Panofsky's is a more flexible

like a horseshoe magnet on iron filings: it shows that each topic has two sides, two interpretations, and that each bit of positive information we possess about Dürer is attached to one side or the other. The topics can be organized into hierarchies by accumulation or into chronologies by ordering them, but first and foremost each is split in half by the "conflict." This act of division provides the primary coherence of the text: the topics are not patternless examples of analysis but overwhelming evidence in favor of the existence of a conflict, a tension, in Dürer himself.

Panofsky notes that the conflict is incompatible with the traditional schema that divides an artist's oeuvre into early, middle, and late periods. There are some points to recommend such a division, but it is inapplicable to Dürer: "When applying this tripartite scheme to the evolution of Dürer we are not wholly satisfied." The division into the "three ages of man" is "not entirely adequate": "The influence exerted in his 'middle period' does not predominate so distinctly over that of his 'early' and 'late' productions as is the rule with other great masters. . . . [His] last works, on the other hand, though clearly distinguished from the preceding ones by a new rigor and austerity, are not so incommensurable and inaccessible as is the 'ultima maniera' of Titian, Rembrandt or Michelangelo. It is also characteristic of Dürer that he did not hesitate to execute paintings or engravings on the basis of drawings made many years before" (13). Indeed, "Dürer's evolution seems to differ from that of other artists by a peculiar invariability or constancy" (14). It is significant that when it comes to exposing this "peculiar" feature, Panofsky breaks off fairly quickly, with an extended *scientific* analogy:

> [Dürer's work] is governed by a principle of oscillation which leads to a cycle of what may be called *short periods:* and the alternation of the *short periods* overlaps the sequence of the customary three phases. The constant struggle between reason and intuition, generalizing formalism and particularizing realism, humanistic self-reliance and medieval humil- ity was bound to produce a certain rhythm comparable to the succession of tension, action and regression in all natural life, or to the effect of two interfering waves of light or sound in physics. A mutual reinforcement of conflicting impulses produced a "maximum," and each "maximum" was preceded and followed by periods of tension or release. (14)

The visual analogy is a graph in which the two conflicting impulses sometimes combine to form peaks and at other times cancel each other (Fig. 35). Like any

analysis, but the perception of control and the possibility of synthesis are both in accord with Dürer's perception as we know it from the documents.

undamped oscillation, periodic or not, Dürer's conflict contains moments that revert to earlier functional values. Panofsky mentions a late "return to painting" and to "burin work" (197) and an unrelated "tendency to revert not only to the spirit but to the style" of earlier work (132). The meandering graph does not progress toward a resolution, but ends in midcycle, when Dürer's life ended: hence, when Panofsky speaks of the "soft" style of works like the *Virgin with the Pear* as a "late style," he means only a *last* style, given arbitrary prominence by Dürer's death (205). The "new and final phase" in Dürer's work was a "reinstatement" of earlier achievements (197).

There are many definitions of the conflict. In addition to idealism versus formalism, it is "inventive imagination" versus "observation of reality" (24); the "literary and scholastic" taste of Maximilian I versus the "vital and aesthetic" taste of the Italian Renaissance (30, 175); "intuitive" imagination (*Gewalt*) versus "knowledge" (*Kunst* in the archaic sense); workshop practice versus an "intellectual" approach to art that has "impersonal clarity and calm" (43, 254); the "individual chosen by God" versus a collective awareness of schools and styles (284); an "additive method of composition" versus a "unity or continuity" in figures (120); and Grünewald's thinking "in terms of light and color" versus Dürer's thinking "in terms of line and form" (146). In the equally frequent cases in which one side or the other is the focus of attention, that side always gains its meaning by comparison with its absent twin. When he wants to make a more general point, Panofsky subsumes these infinitely flexible variants under the general opposition North/South or Germany/Italy.

The conflict itself is not analyzed further; rather, Panofsky chooses to chronicle its many appearances and transformations. The book closes with an incident that

Fig. 35. Schema of oscillating influences on Albrecht Dürer.
1. northern influences;
2. southern influences;
3. their "sum" in Dürer's art.

only repeats and epitomizes its essential conditions (causing the text to mirror Dürer's life by not concluding definitively): Dürer, Panofsky reports, assumed that a drawing he received from Raphael's workshop was by the hand of the master himself, but in Panofsky's view Raphael had only intended to "present his German colleague with the best available specimen of a style for which he felt responsible." Dürer's error shows "more than anything the irreconcilability of his point of view with his Italian fellow-painter" (284), since Dürer's German sensibility "took it for granted that an Italian master . . . could only have wanted to 'show him his hand'––the hand of an individual chosen by God."

THE CONFLICT IN DÜRER

But were their views really irreconcilable? Panofsky explores a number of synonyms for the conflict itself: Dürer's works, he says, show a "sense of balance"; they contain an "inner tension," a "duality" that cannot be overcome; at times the two sides are "antidotes" that struggle for control (3, 80, 82; 12, 82; 24, 43, 84). Dürer is imagined as floating in and out of control of these oppositions. The text implies he passed through various degrees of awareness of his relation to Italian art: the conflict is sometimes exposed as if he was an unknowing vehicle for a kind of spiritual *agon;* at other times he is in control and is said to have a "sense of balance."

At one extreme Dürer automatically expresses the native mentality of his country in that he produces no single, unified style. This is ascribed to the nature of the German *Volksgeist:* "The evolution of high and post-medieval art in Western Europe might be compared to a great fugue . . . the Gothic style was created in France; the Renaissance and Baroque originated in Italy and were perfected in cooperation with the Netherlands; Rococo and nineteenth century Impressionism are French; and eighteenth century Classicism and romanticism are basically English. In this great fugue the voice of Germany is missing. . . . German art is marked by a curious dichotomy" (3). It is in this sense that Dürer is "governed by a principle" outside his ken. In other cases the conflict is a thing that is imperfectly known to Dürer, and it impels him in one direction or another: "However, that *sense of balance* which *automatically* asserted itself at every critical point of Dürer's career *warned him* to compensate for this trend toward rationalization" (80). (Throughout this chapter I italicize phrases showing how the conflict is described.) Here Dürer's knowledge and control are not specified, although, if he was "warned" by a "sense of balance," he must have had some of awareness of the issue.

In other passages Dürer is portrayed as if he was aware and also possessed the ability to switch from one side to the other. For example, Dürer is said to have identified the "subjective," "unsystematic" German temperament with the work of a predecessor, the Housebook Master, and deliberately avoided it: "Instead of *indulging in* spirited improvisations after the fashion of the Housebook Master *he felt the necessity* of disciplining himself to faultless craftsmanship and patient study. Even in technical matters *he did not permit himself* to follow the Housebook Master's example" (24). Instead of an innate "sense of balance" that directs him "automatically," this passage imagines a choice between two separate possibilities, a kind of Choice of Hercules rather than an adjustment to restore a mean. In such a situation one side might dominate another: "[I]n Dürer's 'Weinachten' the picturesque symbolism of the fifteenth century is *controlled* by the scientific rationalism of the Renaissance" (84). There are also places where Panofsky implies Dürer knew not only the possibility of control and change but the nature of the forces on each side: "The Munich *Self-Portrait* marks that crucial point in Dürer's career when the craving for "insight" began to be so all-absorbing that *he turned from an intuitive to an intellectual approach* to art" (43). And more strongly: "In simultaneously practicing these two manners, each of which had the faults of its virtues, Dürer *was bound to realize* that perfection could be achieved only by synthesizing their distinctive qualities" (83). These are passages suggesting a continuum between Dürer the automatic exemplar of the divided German psyche and Dürer the eclectic and penetrating observer of cultural differences.

Panofsky thought of the conflict as a thing deeply rooted in the artist's mind and from which Dürer could never entirely escape; otherwise, he would have solved the dilemma and worked in a single, unified style. None of the passages in *The Life and Art of Albrecht Dürer* suggests Dürer could meditate on the conflict in its totality. We know this from negative evidence, the absence in Panofsky's text of descriptions of qualities that are not examples of one side or the other of the basic conflict. This absence operates as a lacuna around each individual description of Dürer's works. Here it is in the case of Dürer's engraving of the Nativity, which he called the *Weinachten:*

> But in Dürer's "Weinachten" the picturesque symbolism of the fifteenth century is controlled by the scientific rationalism of the Renaissance. [Other ways of effecting control are not mentioned.] Between 1488/99, when woodcuts like the *Martyrdom of St. John* or the *"Ecce Homo"* revealed a definitely medieval conception of space, and 1504 Dürer has mastered the technical rules of the perspective construction and had grasped the modern principle of composition according to which the definition of space precedes the grouping of the figures. [That is, it can

either proceed or follow: no other relations are countenanced.] . . . The values of light and dark, the relative weight of the masses, and even the accents of the narrative are subtly balanced so as to harmonize with the perspective construction [Northern qualities in need of "balancing" against a Southern one]. (84)

Each kind of description is imagined as a duality: the conflict is an ultimate source of Dürer's work, and there is no appeal to something beyond or before it.

In the introduction Panofsky takes up the question as if it were principally a matter of determining the *direction* of influence that produced the dichotomy. Did it come from Dürer's travels? he asks. Does his art manifest the split because he encountered an alien culture south of the Alps? Probably not: "[I]t would be more correct to say that Dürer's yearning for Italy was caused by an innate conflict in his mind than that the conflict in his mind was caused by the influence of Italy" (12).[5] This "conflict in his mind" is an intriguing principle of organization for a book, as well as an odd concept in itself, since it is overdetermined in application and form, indeterminate in meaning and degree of intentionality, undetermined in etiology, and it is, as its expositor readily affirms, ahistorical in the sense that it could not be resolved except by the artist's death.

THE CONFLICT IN PANOFSKY

The argument that the duality of the works is "caused by an innate conflict in [Dürer's] mind" leaves the account of Dürer in an interesting state of irresolution, since Dürer is half-conscious of his situation, half-able to change it. But I do not want to pursue that reading here, because it seems to me that it is linked to a more provocative question—one that leads into more ambiguous territory. The question is this: Might not the conflict be also in Panofsky's mind or, even more strongly, *primarily* in Panofsky's mind? To negotiate this question I want to insert a wedge between Panofsky's and Dürer's versions of the conflict in order to make a distinction between what happens "in Dürer's mind" and what happens in Panofsky's narrative.

First, when Dürer himself wrote about the North and the South, he expressed the difference as a hierarchy capable of resolution, rather than an oscillating standoff. In the *Unterweysung der Messung* (1525) he says German art is "powerful but unsound" and that it reveals a lack of "right grounding" (*Grundt* in

5. Evidence for this is contained in the analysis of Dürer's apocalyptic dream. Panofsky, *The Life and Art of Albrecht Dürer*, 12–13.

the sense of "skill" or "theory"). Dürer does not speak, as Panofsky does, of a "conflict" between grounded and ungrounded art. Instead, one naturally *corrects* the other:

> It has until now been the custom in our Germany to put a great number of talented lads to the task of artistic painting without any real foundation other than what they learned in daily usage. They have therefore grown up in ignorance like an unpruned tree. Although some of them have achieved a skillful hand through continual practice, their works are made intuitively and solely according to their tastes [*gewaltiglich aber unbedechtlich unnd alleyn nach irem wolgefalle gemacht haben*] Because such painters have derived pleasure from their errors [*yrthumben*] they [have] never learned the art of measurement, without which no one can become a true artisan.[6]

Here the "art of measurement" is a "real foundation" that can correct, once and for all, *yrthumben* brought on by the *gewaltiglich* Northern education. There is no sense of an inescapable dichotomy: as Panofsky notes, Dürer trusted geometry with the power of dispelling "errors" and "wrongness" (273). Likewise Dürer's *Vier Bücher von menschlicher Proportion* admonishes its readers to avoid geometric extremes in their newly acquired "art of measurement" (269). Dürer wrote of *Gewalt* and *Kunst* as a sequence, in which the latter corrects the former, instead of as a static opposition. Panofsky, after discussing these passages in the *Vier Bücher*, describes instead a "sense of balance which automatically asserted itself at every crucial point in Dürer's career" and warned him to "compensate." In Dürer's text, an artist who had properly rectified his "errors" did not need to worry that an impersonal oscillation might carry him away from his accomplishment and leave him where he had begun, or that there might be *yrthumben* worth preserving.

To Dürer, works based on theory could exhibit *Vergleichlichkeit*, an "equality or harmony of all parts in relation to the whole" (276). In Panofsky's writings there is an important example in which the two sides of a conflict come together in a similar kind of fusion: the "decompartmentalization" he says was effected by the Renaissance, and its restitution of "Classical form" to "Classical content." The meeting of opposing components in that case is invested with psychological force: it reinstated "the emotional qualities of classical art" and expressed its "feelings," unveiling a new "emotional aspect." This is like Dürer's aim of *Vergleichlichkeit*, but Panofsky accords such moments of "synthesis" the status of fleeting coincidences in the ongoing oscillation.

6. Albrecht Dürer, *The Painter's Manual*, trans. Walter Strauss (New York: Abaris, 1977), 36–37.

There are therefore at least these two clear philological reasons for suspecting the conflict is partially Panofsky's and not only Dürer's. We might also recall that none of Dürer's pictures is described except as a mixture of North and South. Had the conflict been wholly Dürer's, we might have expected his biographer to come up with other ways to describe the work. There is, to be sure, no necessary connection between a characteristic of something and the methods required to exposit it; yet here method and symptom coincide suspiciously. *The Life and Art of Albrecht Dürer* does not offer a way to understand Dürer's oeuvre as a single, undivided style or succession of styles, although in a primary sense it must have been.

At times, larger topics such as specific style phases appear to escape the conflict and point toward a different way of understanding Dürer's work, but each topic is trounced by the conflict and made to serve its dialectic. Panofsky does speak of coherent styles: I have mentioned the "late style," and there is also a "decorative style," a "corrugated style," and a "cubistic style" (190–91, 200, 205). But these styles only manage to elude the conflict by aligning themselves with one side or the other. Dürer's religious conversion, for example, is the reason "his style changed from scintillating splendor and freedom to a forbidding, yet strangely impassioned austerity"; but the new "austerity" is assigned at once to the Southern component of the conflict: "[E]ngraving and painting—the media antipathetic to the tendencies of the 'decorative' style and all the better adapted to a non-linear, emphatically three-dimensional mode of expression returned to favor. . . . The 'decorative style' has given way to what may be called a volumetric, or if we are careful to ignore the modern implications of this term 'cubistic' one" (199). Thus the "cubistic" style and the new "austerity" turn out to be Southern, and the "decorative style" Northern. The *Virgin Nursing the Infant* of 1519 is in the style of the conversion: it has "folds which as nearly as possible approach the form of such abstract stereometrical solids as prisms or pyramids" and a "Michelangelesque monumentality and gloom" (200).

When styles coexist in interesting ways, Panofsky speaks of "synthesis," "harmony," "fusion," or just an elimination of "disparity" (47, 57, 82, 85, 100), but in each case the "union" is either a rhetorical move or a temporary confluence, destined to dissolve. The *Large Passion* and the *Apocalypse* "represent a first synthesis between the Flemish and German traditions and the *maniera* of the Italians"; it is no more a true union than the *Feast of the Rose Garlands,* which succeeded "in one propitious moment in synthesizing the force and accuracy of his design with the rich glow of Venetian color" (39, 110). The word "synthesis" in these sentences could be "encounter" or "juxtaposition." We need only look closely at one such "fusion" to see the conflict operating at every level, even where, we might guess, contemporaries would have delighted in a unified effect:

In contrast, the *Meeting at the Golden Gate* [Fig. 36] is distinguished by balance and dignity [Southern attributes] surpassing even the composure of the *Adoration of the Magi* in the Uffizi. . . . All traces of *horror vacui* [a Northern obsession] have disappeared; the composition is built up from large [Southern] rather than small [Northern] elements; and such details as windows, doors, and arcades are integrated into a uniform whole [a paradigmatic Southern accomplishment]. The impression of three-dimensionality is no longer effected by force [a Northern necessity], but by an effective rationalization [Southern]: a clear distinction between foreground, middle distance, and background has been made [Southern], and the whole picture is viewed through the "Golden Gate" itself [again, Southern] . . . gothic fluency [Northern] and classical equilibrium [Southern] are fused into a new ideal of Christian nobility. (100)

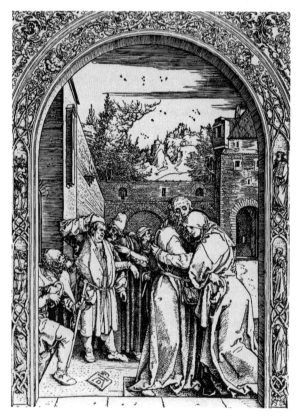

Fig. 36. Albrecht Dürer, *Joachim and Ann Meeting at the Golden Gate* (from the *Life of the Virgin*), 1504. Woodcut, 298 by 210 cm

These reasons for taking Panofsky to be part author of the conflict do not exhaust the difficulties raised by our question. Having seen that Dürer is not always credited with control over the conflict, we are naturally led to ask the corresponding question of Panofsky himself. Is there a sense in which he too is an instance of the conflict rather than its expositor? Can we name the passages, describe the mechanics of such an implication? These are treacherous waters. Control over a text or an idea is always partial, and an authorial voice that seems to have control may only have achieved effective use of certain figures and rhetorical devices. I think a reasonable way to address this is to opt for a rudimentary criterion, the presence or absence of *professed* distance in the narrative between what Panofsky believes and what he attributes to Dürer. If Panofsky unthinkingly pictures each topic as an instance of the conflict, his narrative is not likely to record his cognizance of that fact; and conversely, expositions of the distance may indicate a continuing awareness, even though they cannot prove that something like control has been achieved. I would look, then, for the distance between (1) the degree of awareness of the conflict that is attributed to Dürer and (2) Panofsky's awareness as we know it from his descriptions of the conflict. If there is no measurable difference between the two, we can consider the conclusion that the idea of the conflict is partly without conscious control.

Here is an example in which the conflict is confidently exposited, at an easily measurable distance from what Dürer himself is credited with knowing: "To some extent *all this can be accounted for* by the specifically Germanic preference for the particular as against the universal, for the curious against the exemplary, and for the personal as against the objective; and *this explains the fact* that the signing and dating of drawings did not become the fashion in Italy even after hero-worship had been extended to artists" (284). Dürer has little to say and is credited with little control: he simply exemplifies something that any of his compatriots could also exhibit if they had traveled as widely as he. Panofsky's voice, his explanation of the phenomenon, and his choice of terms ("this explains the fact") conclusively envelop Dürer's awareness. Here our criterion 1, the degree to which Dürer is said to be aware of the conflict, is practically nonexistent (since there is only a vaguely defined "Germanic preference"), and criterion 2, Panofsky's understanding of the matter, is crisply articulated. "The personal" and "the objective" are terms that occur in Dürer's writings, as I have mentioned; they are not Panofsky's own terms, but are *consciously* taken from the historical material, implying by their presence here an awareness of the need to characterize something other than Dürer's feelings.

The terms are repeated in another passage, quite different in other respects:

> [In 1500] Dürer *began to feel* that his previous works . . . were open to the very criticism which he was to level, in later years, at German art

in general: that they were "powerful but unsound" ("gewaltiglich, aber unbesunnen"), revealing as they did a lack of "right grounding." . . . However, that sense of balance which *automatically asserted itself* at every crucial point in Dürer's career warned him to compensate for this trend toward rationalization. While reducing the variety of shapes and movements to general formulae, and while subjecting the visual experience of space to the rules of projective geometry, he became all the more deeply engrossed in the minute details and individual differences of God's creation. (80)

Here Dürer undergoes a change in his degree of control over the conflict: "in later years" he saw such works were "powerful but unsound." What Dürer saw in later years is described, again, in Dürer's terms; but in the second part of the passage, what he would have seen at that time is described in modern terms. Panofsky speaks of "rationalization," "general formulae," "visual experience," and the "rules of projective geometry": all terms and ideas unavailable as such to Dürer. Some are associated with other writings by Panofsky: the "visual experience of space," for example, is analyzed in the 1924–25 essay on perspective.[7] The terms are visibly closer to Panofsky's own beliefs than are the "Germanic preference[s]" of the first passage. Here it is less easy to see Panofsky's beliefs as distinct from the terms he uses to exposit the conflict, suggesting for the first time that his manipulation of the principles of exposition is diminished.

These are elusive differences, not yet an argument for partial control. In a third passage the distance between (1) and (2) is too small to be measurable. Panofsky says that the *Self-Portrait* of 1522 (Fig. 37) "represents Dürer himself in the nude, with thinned, dishevelled hair and drooping shoulders, his body ravaged by his lingering disease. But physical pain and decay are interpreted as a supreme symbol of the likeness of man unto God. Dürer carries the scourge and whip of the Passion. He who had once styled his person into the image of a 'Beau Dieu' [in the *Self-Portrait* in Munich] now likened himself to the Man of Sorrows. He had renounced the 'fables of the world,' and he sensed that his days were counted" (241). Here are the elements of the Northern, Germanic temperament as they are given at the outset of the book, in the second paragraph of the introduction: the "extreme subjectivity," the "individualism in religion, in metaphysical thought, and, above all, in art," the invention of "specific iconographical types," the "personal 'inventions' " and the "Andachtsbilder," "devotional images of single figures" (3). But who is speaking? We do not encounter conditional or attributive phrases such as "Dürer meant to" or "Dürer expresses," or introductory critical

7. Erwin Panofsky, "Die Perspektive als 'symbolische Form,' " *Vorträge der Bibliothek Warburg* (1924–25): 258–352, esp. 260–65.

phrases such as "the image can be understood as" or "in the light of what I have been saying, it is." There is no expressed critical distance: just as the *Self-Portrait* effortlessly expresses the Northern "tendency of mind" (we do not get the impression this is one of those cases in which Dürer was out to stress the Northern over the Southern), so Panofsky's description of it effortlessly expresses his awareness of that tendency. The two awarenesses commingle, and the two sources, drawing and description of drawing, do not comment on their states, but rather portray them.

The tone is also revealing, since the passage has that intensity of expressiveness Panofsky reserves for subjects that are deeply felt. There is more than the inevitable similarity between the original expression of the conflict and the description of that expression: it is necessary to point out the iconographic change to the *Man of Sorrows,* but not to add a pathos paralleling the quality of inevitability that the expression presumably had for Dürer. Mimicry of that sort, in which an author writes as if he knew and understood nothing more about his subject than the artist did, collapses the space between our criteria 1 and 2: we would not know, from this passage, that Panofsky could also step back and express a different version of the conflict.

THE GHOSTLY DISCOURSE
OF *MELENCOLIA I*

The account of *Melencolia I* is a further step in this absorption (Fig. 38). First we are given straightforward descriptions of the Northern and Southern elements in the picture: "[The figure of Geometry] is accompanied by a morose little *putto* who, perched on a disused grinding-stone, scribbles something on a slate, and by a half-starved, shivering hound . . . she has lapsed into a state of gloomy inaction. Neglectful of her attire, with dishevelled hair, she rests her head on her hand" (156). There are also strictly Southern elements: "Two objects seem to be not so much tools as symbols or emblems of the scientific principle which underlies the arts of architecture and carpentry: a turned sphere of wood and a truncated rhombohedron of stone. Like the hourglass, the pair of scales, the magic square, and the compass, these symbols or emblems bear witness to the fact that the terrestrial craftsman, like the 'Architect of the Universe,' applies in his work the rules of mathematics" (157). These are sides of the conflict Dürer knew and deliberately juxtaposed. The figure of geometry is a mixture of the two: "Dürer imagined a being endowed with the intellectual power and technical accomplishments of an 'Art,' yet despairing under the cloud of a 'black humour.' He depicted a Geometry gone melancholy or, to put it the other way,

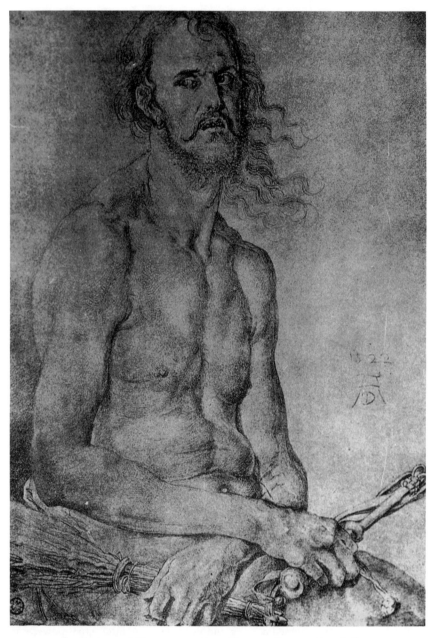

Fig. 37. Albrecht Dürer, *Self-Portrait as Man of Sorrows*. Bremen, Kunsthalle

a Melancholy gifted with all that is implied in the word geometry—in short, a
'Melancholia articifialis' or 'Artist's melancholy' " (162). Here, then, we must
imagine Dürer at his most conscious: he has manipulated an elaborate set of
symbols to articulate a coincidence of North and South, *Grundt* and *yrthumben*,
geometry and melancholy. This is also a work Panofsky did not tire of (he wrote
about it three times), and the detail of his analyses encompass almost all of the
synonyms for the conflict that are otherwise spread through his books. As in the
Self-Portrait, there is a ghostly congruence between *Melencolia I* as allegorical
self-portrait of Dürer and the description of *Melencolia I* as an expository self-
portrait of Panofsky:

> Dürer himself, then, was, or at least thought he was, a melancholic in
> every possible sense of the word. He knew the "inspirations from above,"
> and he knew the feeling of "powerlessness" and dejection. But, more
> important still, he was also an artist-geometrician, and one who suffered
> from the very limitations of the discipline he loved. . . . Thus [his] most
> perplexing engraving is, at the same time, the objective statement of a
> general philosophy and the subjective confession of an individual man. It
> fuses, and forms, two great representational and literary traditions, that
> of Melancholy as one of the four humours and Geometry as one of the
> Seven Liberal Arts. . . . It epitomizes the Neo-Platonic theory of Saturnian
> genius as revised by Agrippa of Nettesheim. But in doing all this it is in a
> sense a spiritual self-portrait of Albrecht Dürer. (171)

Passages like these express a double conflict: there is the conflict we have been
exploring, which seems to occur both in Panofsky and Dürer, and there is a law
of suppression, according to which Panofsky may not write autobiography while
writing art history. He may not, by institutional and genre decree, speak of the
conflict in himself, or—as Keith Moxey has pointed out—of his *use* of Dürer to
write an essentially autobiographical text.[8] That suppression normally does not
bother us, in part because we usually have very little emotional investment in
our subjects and in part because we understand autobiography in our texts as
something that is confined to asides, dedications, and other well-marked formats.
But as I would read this passage, autobiography is a barely controlled impulse,
and is only separated by the thinnest veil from becoming entirely explicit. (This
is not to say that the text and its author might not have easily accommodated
such discussion, only that the passage as he chose to write it represses the idea.)
 Remarkably, the text *names* the vehicles of its secret discourse by raising the
question of conscious control ("Dürer . . . was, or at least *thought he was*"), and

8. Keith Moxey, *The Practice of Theory: Poststructuralism, Cultural Politics, and Art History* (Ithaca:
Cornell University Press, 1994), 72.

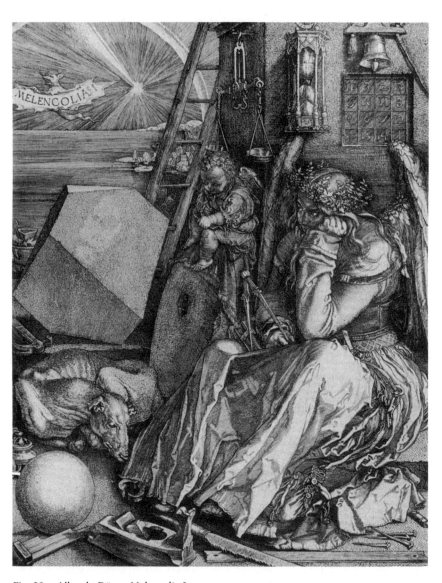

Fig. 38. Albrecht Dürer, *Melencolia I.*

by describing Dürer as someone who worked—like an art historian—within a "discipline" that he "loved" (though it also made him "suffer"). The passage is cryptoconfessional, and with the professional allegory and the terms of awareness and control, it all but proclaims its dual purpose. If we reread the last portion of the passage I have just quoted, letting the ghosts speak for themselves, it becomes apparent that an openly confessional text lies just below the one that was printed: "Thus [his, but read *my*] most perplexing engraving [read *text*] is, at the same time, the objective statement of a general philosophy and the subjective confession of an individual man. It fuses, and forms, two great representational and literary traditions, that of Melancholy as one of the four humours [a characteristic of the German temperament] and Geometry as one of the Seven Liberal Arts [a Southern, Italianate idea]. . . . But in doing all this it is in a sense a spiritual self-portrait of Albrecht Dürer [read *its author*]" (171). I only mean this partly as a joke. Rhetorically, the text could never have been written as I have glossed it, but logically, it does not bridle against the possibility. The passage is, *as the text itself proclaims*, both a "statement" and a "confession," an iconographic analysis and a self-portrait. The author supervises his text (makes a "statement") and also produces it "automatically" (makes a "confession").

This is a rich passage, and it can readily be given a higher, allegorical reading. The text's motive force, as literature, comes from its scarcely suppressed urge to speak for itself, to say the truth, to express not only understanding and admiration but sympathy. Blocking that desire are not only institutional constraint, decorum, and the discipline's inherent conservatism, but the closeness—almost like a rubbing—between Panofsky's understanding of that desire and Dürer's understanding of the equivalent desire to break out, to express melancholy without a proliferation of symbolic instruments. The degree of understanding is what prevents both text and engraving from breaking the bounds of decorum: if one knew even a word more than the other, each would speak differently. It is therefore appropriate to a text that speaks about the inability to speak that it should incorporate that feeling as an allegory: Dürer's means, the symbols and ideas of his engraving, are the instruments whose limitations circumscribe its message, and Panofsky's voice is forced to speak only through those same symbols, and never leave them.

The limitations of Panofsky's awareness may be traced in that same parallelism. Panofsky may well have been aware of the dual voice—we may imagine he appreciated how the engraving embodied some of his own interests, how it modeled his own direction as an art historian, and he may even have listened to the confessional voice—but he was not interested in breaking the law of genre and inserting an autobiographical digression into a historical text. More important from our point of view is that he was not aware enough of these forces to use them to further his inquiry. There is still no question of a third

term here, only a figure of Geometry who means two things, represents two traditions, two authors, two sets of symbols. The text representing the engraving matches Dürer's consciousness with a sympathetic parallel consciousness, and it constructs a parallel set of meanings that outline another juxtaposition of North and South. There remains no overflow, no surplus to show us what Panofsky holds that Dürer does not, what he knows or believes or controls that Dürer does not, what he can express that Dürer has not. Even the confessional voice has its *Doppelgänger* in the engraving itself, since it speaks of Dürer's melancholy and *his* limited awareness of alternatives to that "humour." The zone between unnoticed rehearsal and conscious scenario is not definable in the historical text any more than it is in Dürer's understanding of his print. The passage is spectral, and for Panofsky reading it may have been like moving in front of a mirror: the question of Dürer's conscious control is a moving shadow, mirroring Panofsky's reflected awareness. It is in this lack of difference, this mirroring between our two criteria, that I would locate the best evidence that *The Life and Art of Albrecht Dürer* is both active and passive: both analysis and rehearsal, both exposition and allegory, of a half-conscious structure.

THE EPISTEMOLOGY OF
HALF-CONSCIOUS THEMES

The two sexes offer an interesting analogy to this kind of polarity. Like the North/South conflict, sexes are a dichotomy that appears to be closed: we cannot think of a third sex whose characteristics are not borrowed from the two familiar sexes. It is impossible, I think, to look at any animal and see something in its behavior that is sexual in nature yet incomprehensible as either a male or a female attribute. Sometimes it may be difficult to find anything we can call a sexual trait, especially if the animal is something quite different from us. Many sexual characteristics may also be ambiguous: if salamanders appear graceful, we can understand that grace as either a male or a female sign, but it will never appear to belong to a "third sex." Every sexual trait defaults to male or female, and the imagination can construct a third sex only by picturing perfect ambiguity or neutral asexuality. The sexual differences and the sides of the North/South conflict are dichotomies that appear, from where we stand, to include all objects to which they are applied, and not to be included in any larger classification (sexes and ———— imagined as equivalent elements of a set). I take this to be an indication of our lack of comprehensive awareness, because they are spoken of as dichotomies and we confine our language to their terms each time we speak of the topics to

which they are applied. They are also conditions of our understanding in general: we cannot step back and see them together with whatever surrounds them.

For this reason the conflict does not *imply* anything. It cannot be assigned some logical relation such as dilemma, antinomy, or paradox, all of which lead to third terms or else can be recast as logical forms other than dichotomies. No synthesis is available. Also, the two sides of the conflict are not opposites: "inventive imagination" is not the opposite of "observation of reality," just as "Germanic" is not opposed uniquely to "Italian." If the two sides of the conflict may be said to be opposites, they are so contingently, within the limits of specific experiments, and they function in those settings less as yes is opposed to no or on to off, and more as salt is opposed to pepper: that is, they are the two working alternatives, the choice offered at the table. Like salt and pepper, the sides are provided by convention, and so, as false opposites, they can be mixed, but not united ("fused") into a single flavor.

I make these sexual and culinary comparisons to distinguish the conflict from something that might be solved by logical cogitation or increased self-reflexivity or sensitivity—including especially the double bind, so easily explicated as a theory with its own metaphorical *Aufhebung*.[9] It is apparent from Panofsky's book, and from other studies in which the conflict plays a key role, that no matter what new topics are introduced, and regardless of the artists' understanding of them, the same conflict will be applied again and again. The issue of the conflict itself—its alternatives, its resolution—is neither approached nor evaded within the texts that employ it, including this one. Increased attentiveness to this only displaces the conflict (often by creating a new version) or else displaces itself from art historical writing.

This applies also to art historians' intermittent interest in the dichotomy. If it is disparaged or avoided as a serious problematic, that is partly because it is annoyingly, *impossibly* difficult to get hold of. If the structures of desire and understanding I have outlined in Panofsky hold true for other texts and other leading concepts, as I believe they do, then analyses of our implication in the dichotomy will not be able to get beyond enumerations of passages—no matter whether we exposit them as instances of a double bind, as irruptions of the unconscious, as figures of desire, or as marks of our narrative or historiogaphic predilections. As Wilhelm Dilthey knew, things of which we are half-conscious— he was thinking of his doctrine of *Weltanschauungen*—cannot be overcome, solved, or left behind. (Dilthey calls his *Weltanschauungen* "selbstmächtig," meaning independent and not subject to proof or disproof. They are autonomous

9. Another example of such a structure is the incest taboo, as it has been studied by Claude Lévi-Strauss. See Lévi-Strauss, *The Elementary Structure of Kinship*, trans. J. H. Bell et al. (Boston: Beacon Press, 1969). According to Lévi-Strauss, only those portions of the taboo that affect us as social rules can be understood.

structures of meaning, which might coexist in a person or a work of art, but whose fusion or negation would be without meaning.)[10] The critique of half-consciousness allows us to see how art historical oblivion works: it is not an unnegotiable but readily exposed repression, as in the double bind, but an object that is seen, known, glimpsed, and missed by turns, according to a logic whose movements leave fine traces in the text.

THE SCYLLA OF HALF-CONSCIOUSNESS, THE CHARYBDIS OF COMPLEXITY

Art history is not easy to talk about. (Theory is easy, even glib, by comparison.) In keeping with the metaphors of inside and outside, distance and intimacy, with which I opened this book, I would like to close with a final analogy here from the natural sciences. In the field of chaotic dynamics, objects known as attractors are used to model various processes, from the rhythm of dripping faucets to the pattern of heartbeats. I imagine the attractors as magnets, but with complex surrounding fields that prevent a particle from coming directly to them. One way to go toward an attractor is to start out going away from it. In the example illustrated in Fig. 39, top, the particle begins by leaving the attractor, and then finds itself circling a place somewhat to the attractor's left, and finally spirals in to the attractor itself. In other instances, even this circumlocution is not enough to get near the attractor, and the particle ends by orbiting indefinitely, some distance away (Fig. 39, bottom). This allegory—which necessarily does poetic injustice to the original meaning of the attractor—can serve as a warning about the haste with which visual theorists have sought to approach art history. In order to begin to speak about what happens in the texts, as opposed to what visual theory thinks should be happening, it is necessary to negotiate a Scylla of half-conscious structures, as well as a Charybdis of complexity, repressions of reason, painted intuitions, strange forms of elided logic, the avaricious rhetoric of attribution, and the gentle meandering of attention.

When I said in the Introduction that I prefer to conceive art history as an investigation of the writer, I was thinking of Leo Steinberg's indispensable essay "Objectivity and the Shrinking Self," published in 1969.[11] There Steinberg inveighs against a timid new generation of objectivist historians who seemed to be

10. See Wilhelm Dilthey, *Weltanschauungslehre: Abhandlungen zur Philosophie der Philosophie*, ed. B. Groethuysen, vol. 7 of *Gesammelte Schriften* (Stuttgart: B. G. Teubner, 1931), esp. 82–83, 115. T. J. Young, "The Hermeneutical Significance of Dilthey's Theory of World-Views," *International Philosophical Quarterly* 23 (1983): 125–40, brings out the interpretive consequences of the *Weltanschauungen*.

11. Leo Steinberg, "Objectivity and the Shrinking Self," *Deadalus* 98, no. 3 (1969): 824–36.

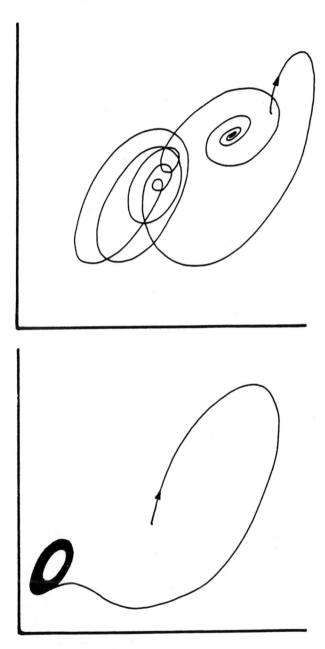

Fig. 39. Motions of a point in the Lorenz attractor

eschewing all mention of their personal involvement in their writing. He tells a story to introduce his attitude toward the "rigorous scientism" and "objective historical discipline" that he saw springing up around him: "When I was a student, a great art historian advised me never to tell my readers or listeners how I came to a problem, or by what steps I proceeded, but to come clean with my findings. His advice has remained so much alive with me that it has urged me ever since to pursue the opposite course. I admire the art historian who lets the ground of his private involvement show" (826). In the bulk of the essay, Steinberg is occupied with stories about how current events and modernist ideas have helped spark insights into the past. His examples are sometimes ambiguous (and sometimes they are about ambiguity), and I would not always subscribe to the concepts of "private involvement" or "objectively valid conclusions" that he employs to tell those stories. But I am especially intrigued by the conclusion, which follows a pattern that also occurs in various texts I have considered in the course of this book. Steinberg eventually comes to ask himself what it means to be "perpetually in danger of projecting" his "contemporary artistic experience upon the past." Leaving aside the question of when it might make sense to say one does *not* "project" on the past, there remains the "reprehensible" danger that all history might be understood as projections. It is the motion by which Steinberg excuses himself from that possibility that I want to note here. He has explained his predilection for ambiguity and "multi-storied symbolic forms," in part by connecting them to his early interest in Freud and Joyce (and here he names *Finnegans Wake,* always a telling reference in a historical text), and he backs away from the prospect of infinite "projection" by appealing to the potentially "objective" use of those interests: "But there is another way of putting the matter. If there ever were earlier artists who conceived multi-storied symbolic forms, then ours is the generation equipped to detect it, being trained, so to speak, in the reading of Joyce" (836). This argument, which he has repeated in other texts on Michelangelo and Leonardo, is a way of reconceiving the inevitable biases of the present as potential historical tools and retrieving the notion of "objectively valid" facts.

It is an unambiguous conclusion, and yet the text is not entirely stable: even as he claims that his proclivity toward ambiguity might be an asset, he is also aware that it may be only something he projects onto the past, and he is half-aware that he cannot argue the point. If contemporary historians are "equipped" to see ambiguity, they may also be equipped to see only ambiguity, or poorly equipped to stop seeing ambiguity, or only ambiguously equipped to argue about ambiguity. That trouble is what prompts me to bring in Steinberg's text here, at the end of my book. Because it can also be asked how much of *any* of our interests we can understand: once the theme of "multi-storied" meanings is set loose, how far can we follow it? Can we see what drives it? (Is it really just a disinterested,

"objective" interest in ambiguity? Is there such a thing?) Can we understand how it works in the text—how it suggests questions, how it constrains answers? Can we see how it becomes entangled in our dialectic, our logic, our rhetoric, our tone?[12] Can we know when it changes (when it undergoes metatheoresis) and finds voice as a description or an evaluation? Do we know how to find our interests, our theories and methods, or how to set them up? Do we know how they operate, why we feel we need them, how we might critique them, why we sometimes need to ignore them, how we write them into our texts, how they express what we want both by their form and their content? Do we know when they begin to control us? These questions are the topics of my chapters, in order from first to last, and each chapter can be read as another reason why full knowledge of what we do is not possible. The demand of philosophy that enjoins us to become "conscious" is simply not possible if we are to go on writing what we still want to call art history.

These comments are not criticisms of Steinberg's texts; they are criticisms of his account of his texts, and I would understand "Objectivity and the Shrinking Self" as the kind of explanation that seemed necessary at that moment, in 1969, in order to sustain the kinds of writing he wanted to undertake. The essay mentions sexuality, mannerism, Michelangelo, and several other subjects he has since explored, and it works by clearing a space for those topics—a space bounded by "subjectivity," "the self," and "personal" commitments. Those concepts are only interrogated as far as they need be to support his platform, and to that extent the essay itself is an instance of my claim that our theories are incompletely known to us: they function to keep our writing going, and they could not do so if they were pressed too insistently. Within some of Steinberg's essays that dynamic functions in much more intricate ways, weaving some of the most interesting writing in the history of art.

It can never be enough merely to identify one's interests—never enough, because it is never possible. My contention throughout this book could be put this way: these problems can only be taken as irrelevant quibbles when it is not important to understand how we write. And often enough it is not important. I am acutely aware of how irrelevant much of what I have written will necessarily sound to many readers, and I have mentioned how uninterested I have sometimes been in this project when I was occupied with historical research. It is extremely difficult to write theory or criticism that is as engaging as the texts of "normal" art history, and the evident proof of that is the way that the artworks I have discussed beckon from their Procrustean beds in this text, asking to be seen again, in more detail, and with a more careful eye. The practices of art history,

12. I explore Steinberg's essays and ambiguity at length in *Why Are Our Pictures Puzzles? On the Modern Origins of Pictorial Complexity* (Routledge, forthcoming).

emphatically including the least self-reflective "normal" art history, are eloquent enough to spend a lifetime on, but the writing about that history must still remain a sidelight, an occupation best suited for certain frames of mind. Visual theory would be a truly wonderful subject if its practitioners could manage to write as well as Steinberg or Fried.

But at the same time, texts, such as this one, that reflect on the discipline can only seem irrelevant so long as we remain immersed in the material of art history. The moment a writer takes that first step back (the step I conjured at the beginning of the book), it becomes necessary to engage the philosophic thought that seeks to describe the discipline, no matter how violent or misguided it might appear.

ENVOI, ON OUR DRY TEXTS

It would be wrong to conclude without underscoring the unimportance of all this. To say that what art historians and other academics write is rarely read outside a community of like-minded scholars is to say that it will be forgotten forever. The books we write—most emphatically including this one—are consigned to dust from the instant they appear. Some, which will never be read, turn to dust in our hands, even before they are printed. Each year there are tens of thousands of dissertations in the humanities, and even seminal texts are lost in fifty years' time. Scholarship, as Derrida says, is dangerously "biodegradable."[13]

Thinking about the differences between the kinds of writing that go under names such as art history, visual theory, methodology, and historiography, I have been led toward a way of considering the texts that is, in important respects, alien to all of them. In general terms, the readings in this book approach art historical writing as if it were expressive in intent. What I have wanted to know is how the writing stands up *as writing,* as what is uninformatively called imaginative or creative writing—as if a principal purpose of art historical writing were to act on a reader as a novel, a short story, or a poem, rather than as a source of information. In doing so I have tried to read the texts in a fuller way and to cast some light on the nature of their relation to one another; but I have also been motivated by some ideas about the value of scholarly writing in general. The conviction on which this book is built is that in the end all the questions we customarily ask ourselves regarding the choice of theories and theorists, methods and methodologies, evidence, interpretation, and the constitution of the discipline

13. Jacques Derrida, "Biodegradables: Seven Diary Fragments," *Critical Inquiry* 15, no. 4 (1989): 812–82.

are swept aside by what we actually produce. Our writing is our testament; it is what matters about what we do. And if that is the case, then our writing must be understood as an expressive endeavor, one that speaks for us and for our contemporary situation. To me art history is in a certain sense an arbitrary profession, since I tend to use it to explore my own thoughts and to learn about myself. An object is always also a mirror of what I want to see and of how I understand myself.

What this commonplace helps us remember is that even though our texts afford some challenging puzzles, academic writing may be inexpressive and in the end uninteresting because it is chosen by people who do not wish their writing to compete on a higher level. There has always been truth in Nietzsche's descriptions of scholars ("the herd animal in the realm of knowledge," and so forth),[14] and in those terms, art historical writing may be a fitting expressive vehicle: a kind of writing that is highly evolved to complement and maintain a certain kind of life. Our texts appear as history, as facts, as discoveries, as stories, even sometimes as truths, and they function in all of those capacities; but they are also our way of recording who we are. We need to begin to think about how our quizzical, convoluted, dry, and distant writing tells the story of our lives.

14. Friedrich Nietzsche, *The Will to Power,* trans. Walter Kaufmann (New York: Random House, 1967), 226.

INDEX